LENA HORNE

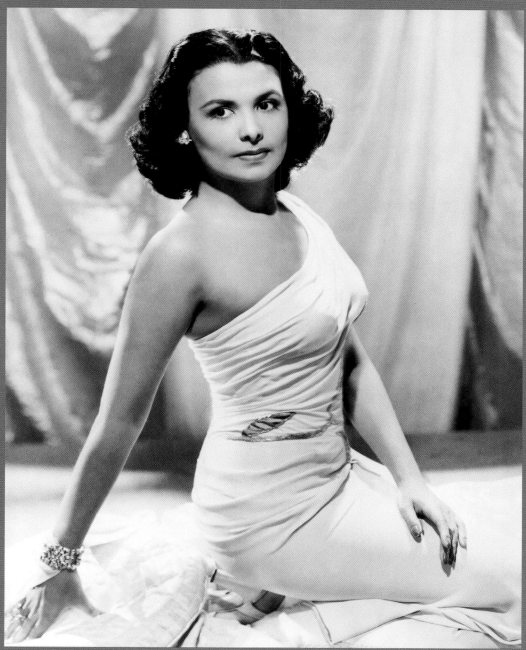

GODDESS RECLAIMED

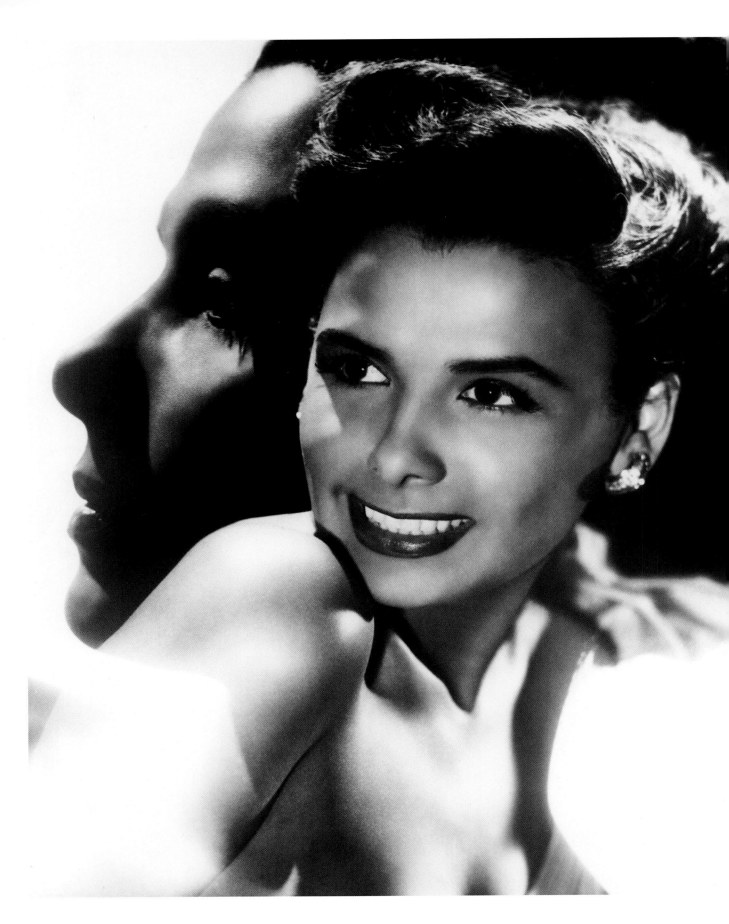

TCM TURNER CLASSIC MOVIES

LENA HORNE

GODDESS RECLAIMED

DONALD BOGLE

RUNNING PRESS
PHILADELPHIA

Running Press
Hachette Book Group
1290 Avenue of the Americas, New York, NY 10104
www.runningpress.com
@Running_Press

Printed in China

First Edition: October 2023

Published by Running Press, an imprint of Perseus Books, LLC, a subsidiary of Hachette Book Group, Inc. The Running Press name and logo are trademarks of the Hachette Book Group.

The Hachette Speakers Bureau provides a wide range of authors for speaking events. To find out more, go to www.hachettespeakersbureau.com or email HachetteSpeakers@hbgusa.com.

Running Press books may be purchased in bulk for business, educational, or promotional use. For more information, please contact your local bookseller or the Hachette Book Group Special Markets Department at Special.Markets@hbgusa.com.

The publisher is not responsible for websites (or their content) that are not owned by the publisher.

This book is published in partnership with Turner Classic Movies, Inc.

Photography credits: page 54, Getty Images/Metronome; page 117, Getty Images/ Bettmann; all other photography courtesy Turner Classic Movies, Inc.

Print book cover and interior design by Amanda Richmond

Library of Congress Cataloging-in-Publication Data
Names: Bogle, Donald, author.
Title: Lena Horne: Goddess reclaimed / Donald Bogle.
Description: First edition. | Philadelphia: Running Press, 2023. |
 Includes bibliographical references and index. | Summary: "From Turner
 Classic Movies and Donald Bogle, the award-winning author and leading
 authority on Black cinema history, this is a comprehensive and lavish
 biography of Hollywood's first African American movie goddess"
 —Provided by publisher.
Identifiers: LCCN 2022059417 (print) | LCCN 2022059418 (ebook) | ISBN
 9780762475209 (hardcover) | ISBN 9780762475193 (ebook)
Subjects: LCSH: Horne, Lena. | African American women singers—Biography. |
 African American actors—Biography. | Singers—United States—Biography.
 | Actors—United States—Biography.
Classification: LCC ML420.H65 B65 2023 (print) | LCC ML420.H65 (ebook) |
 DDC 782.42164092 [B]—dc23/eng/20230117
LC record available at https://lccn.loc.gov/2022059417
LC ebook record available at https://lccn.loc.gov/2022059418

ISBNs: 978-0-7624-7520-9 (hardcover), 978-0-7624-7519-3 (ebook)

APS

10 9 8 7 6 5 4 3 2 1

To my mother Roslyn Woods Bogle

To Alex Bogle, the little one who's not so little now

To Charlie Tabesh, a good friend and
TCM's Master Programmer

To Sally Placksin, who came to my rescue

To just a few of my former students
from whom I have learned much:
Marcel Salas, Kyle Webster, Afiya Mangum Mbilishaka,
Judith Osborne, Deesha Hill, Wesley Barrow,
Laurence Coman, David Aglow

To my Penn roundtable luncheon quartet:
Gigi Kwon, Raj Gopal, Jake Stock, and Nadine Zylberberg

And especially and notably, to those leading lights,
Robin Williams and Mia Kai Simonne Moody

To Jerry Schenck, a true film person

And to the memory of Roslynne Bogle, our beloved "Cissy,"
and Fred Paul Charleston Sr.,
who always asked, "Why?"

Contents

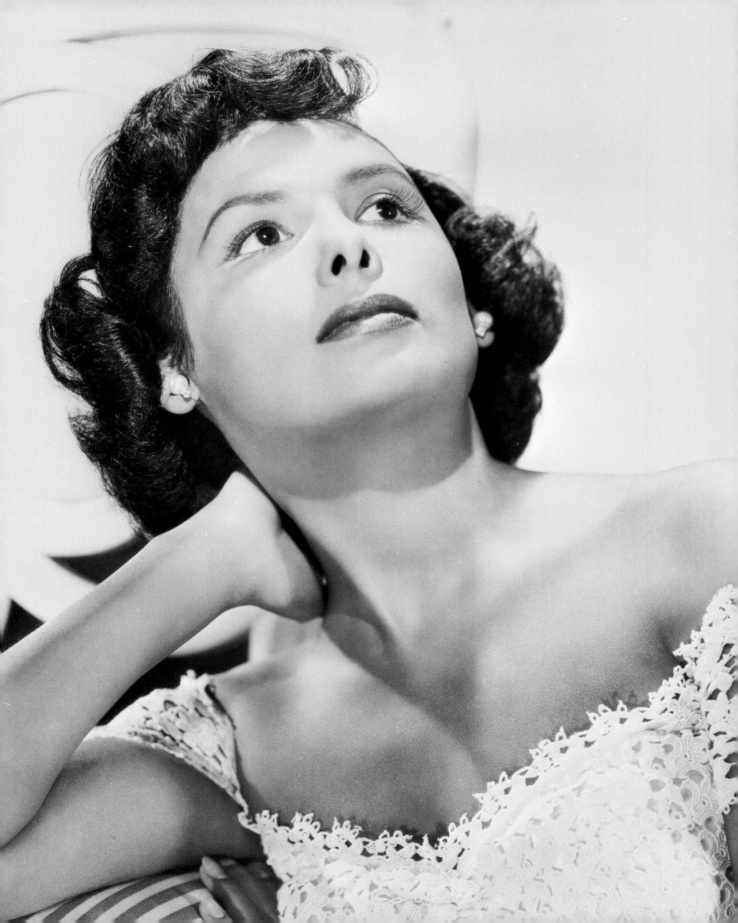

Introduction

On a Saturday in March 1993, a radiant Lena Horne entered the famous MGM recording soundstage. She hadn't stepped on the lot since 1956, when she had filmed a musical sequence for *Meet Me in Las Vegas*. Now she had returned to Hollywood to shoot a segment for the third in MGM's big anthology series, *That's Entertainment! III*, a compilation of dazzling performances from the studio's illustrious history. Watching her with admiration and a sense of awe was a lineup of starry-eyed technicians, grips, and hair and makeup people as well as the director, the camera-operator, and their assistants. By her side was MGM's master hairstylist, Sydney Guilaroff. Among the journalists who covered the event were Robert Osborne, then a columnist for the *Hollywood Reporter*, and Liz Smith, then a syndicated columnist with *New York Newsday*. There to take pictures was Roddy McDowall.

For Lena Horne, it was a bittersweet experience. In the 1940s, she had been MGM's Black Beauty in Residence, signed to a seven-year contract, and she emerged as the first Black woman in Hollywood history to be fully glamorized and promoted. MGM had taken care to find the right makeup for her; to light her in the best way; to maintain an image for her as a beautiful, sensual, yet untouchable Black movie goddess. The studio had steadfastly refused to cast her in maid roles, which had been the standard procedure for handling most Black actresses in the movie capital.

But Lena Horne's discontent, with Hollywood in general and with MGM in particular was evident in her commentary for *That's Entertainment! III*. "I have many memories here, good and bad. At that time, they didn't quite know what to do with me—a Black performer—so I usually just came on, sang a song, and made a quick exit," she recalled. "In 1946 I played the role of Julie in an excerpt from *Show Boat* in *Till the Clouds Roll By*. I was being considered for the part for the 1951 version of *Show Boat*. But the Production Code Office had banned interracial romance on the screen. So the studio

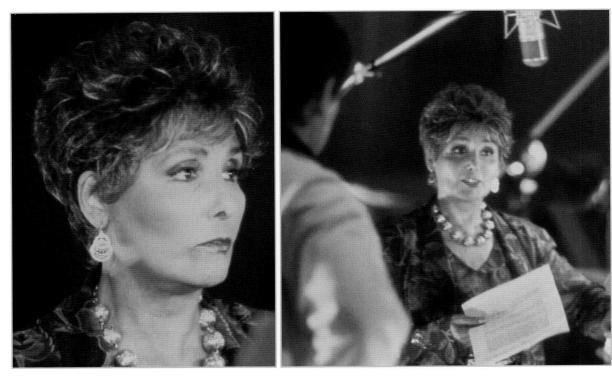

Filming the sequence for *That's Entertainment! III*. As always, the center of a flurry of attention.

gave the part to my good friend Ava Gardner, and she was wonderful in it." But not playing the role of Julie in *Show Boat* had been one of Lena Horne's great professional disappointments, and that no doubt marked her final disenchantment with Hollywood.

Lena Horne: Goddess Reclaimed tells the tale of Lena Horne's extraordinary life and career, both her pre- and post-MGM experiences, with my commentary based on archival material, interviews, family histories, and much more. But also significantly, her story is told through an array of some of the most striking photographs ever taken of the star, some rarely or never previously published. She has very much been one of Hollywood's great unacknowledged goddesses. Though many books have appeared over the years chronicling in photos the lives of such stars as Elizabeth Taylor, Marilyn

Monroe, Ava Gardner, Vivien Leigh among others, until now, no photo-filled history has been published about Lena.

While various people in this book make repeated references to Lena Horne's beauty, it has to be noted that, for Hollywood, Horne's celebrated looks conformed to an "acceptable" Western beauty standard: the "sharp" or Caucasian features; the light brown coloring or the café au lait complexion, which was the term used to describe her in the past; and the silky, straight hair. Not until later years in the twentieth century and the early twenty-first was Hollywood ready to acknowledge, appreciate, and celebrate a non-Western standard such as that of Cicely Tyson and Lupita Nyong'o. In the 1960s so startling was Tyson—with her dark skin, her magnetic eyes, her natural hairstyle, and her

sculpted face as well as her self-pride—that she can be credited with making the nation redefine its beauty standards. Lena Horne as well as other celebrated beauties of the twentieth century recognized this fact. And that should be neither ignored nor overlooked. Nonetheless, even with acceptance of Horne's beauty, the movie industry still viewed her coloring as a drawback to casting her in leading roles opposite the industry's great male stars. Of course, *mere* beauty on screen never has the impact that one might think. Always, if beauty is to be perceived as beauty, there has to be a spark—some incandescent luminance—within a star that accompanies any physical attributes. Lena Horne clearly had that incandescence.

This is not the first time I've written about her. In my book *Toms, Coons, Mulattoes, Mammies, and Bucks: An Interpretive History of Blacks in American Films*, I examined her image in Hollywood movies. In *Brown Sugar: Over One Hundred Years of America's Black Female Superstars*, I explored the ties between her career and life and those of previous women of entertainment, from Josephine Baker to Billie Holiday, Dorothy Dandridge, Diana Ross, and Whitney Houston. And notably in *Bright Boulevards, Bold Dreams: The Story of Black Hollywood*, I wrote about Lena's experiences when she first came to the West Coast from the East, the way she lived, the people she socialized with, and the frustrations she endured with the studio system.

Lena Horne: Goddess Reclaimed has given me the opportunity to explore these and many other themes and issues in her life. Here, the commentary and visuals chart her lonely childhood through her early years as a chorus girl at the Cotton Club and then her first flush of success as a singer at the

very progressive New York nightclub Café Society, right up to her smash success on Broadway in *Lena Horne: The Lady and Her Music* in 1981.

In my commentary I partly used as my guidepost Horne's 1965 autobiography, *Lena*, written by her with Richard Schickel. It's an informative book that recounts the experiences that shaped her, but as with any memoir by a star, *Lena* does not tell everything. More about Horne's early and later experiences is found in two books written by her daughter, Gail Lumet Buckley: *The Hornes: An American Family* and *The Black Calhouns: From Civil War to Civil Rights with One African American Family*. Other sources proved important in recording her life, too. Over the years while working on one book or another, I interviewed a number of performers and artists who knew or worked with her professionally—and whose observations were often fascinating and illuminating. I remember distinctly when I interviewed director Andrew Stone about his work with Dorothy Dandridge on *The Decks Ran Red*, we also discussed his direction of *Stormy Weather*. Without my prompting him, Stone went out of his way to comment on Lena, saying he could never understand why she had referred to him as cold "as the rock-bound coast of Maine" in her autobiography. He tried hard that day to explain himself and what had transpired when he directed her. When I interviewed MGM's great hairstylist Sydney Guilaroff, I was one of the first writers, if not *the* first, with whom he discussed the problems Lena encountered in MGM's hairdressing department until he stepped in. At a film festival in France, I met the veteran African American filmmaker Carlton Moss, who surprised me with his highly perceptive stories about Black performers in Hollywood.

At that time, I did not know that he worked with Lena Horne on a memoir, published in 1950, titled *In Person: Lena Horne*. Having opened up to Moss and Helen Arstein about her professional and personal disappointments, Horne was angered and felt betrayed by the book. It appeared at a terrible time for her—the same year that she found herself listed in *Red Channels*, the anticommunist publication that led to the downfall of many in the entertainment industry. *In Person: Lena Horne*, however, has a ring of truth, and I sometimes found it useful in piecing together key elements in her life.

I've also drawn on a treasure trove of archival material, including hundreds of articles and interviews with those who knew her—sometimes close friends, other times significant professional associates: the great arranger/composer/vocal coach Phil Moore, who had been so important to the careers of Horne and Dorothy Dandridge; Geri Nicholas Branton, that shrewd and brilliant observer of the social/political scenes of both Black and white Hollywood; Sydney Guilaroff; Robert Osborne; Fayard Nicholas; Harold Nicholas; Harold Jovien; Vivian Dandridge; Carlton Moss; Lennie Bluett; Avanelle Harris; Tony Nicholas; Maggie Hathaway; Juliette Ball; Etta Jones; Isabel Washington Powell; Bobby Short; and that other brilliant observer, actress/writer Fredi Washington.

Throughout the process of writing *Lena Horne: Goddess Reclaimed*, I had a rewarding and rich experience searching for and then selecting the visual images that worked best in charting and chronicling the experiences of her extraordinary life. The photographs are a telling part of the story— and often they impart powerful covert messages. Throughout, I have often thought of my impressions of Lena Horne on the two occasions when I met her. Constantly examining and re-examining her life experiences, always seeking to understand herself, the star struck me as a far more complicated woman than most may have realized. The first time I met her I was enthralled. She was a great star who hadn't lost her "common touch." She still wanted to communicate and somehow share her vast experiences in a personal and dynamic way. The second time I was again enthralled, but I realized there was something indefinable about her. She was a luminous, compelling mystery. Unlocking the doors to her identity has been energizing and revelatory. Her magnetism cannot be overstated. Her journey, as you'll see, was an arduous one. It's been significant for me to bring Lena Horne from behind the shadows, to reveal that she still has the power to entrance, puzzle, intrigue, and hypnotize not only with her beauty but with her remarkable story.

The early years of the Brooklyn girl who would grow up to be a star.

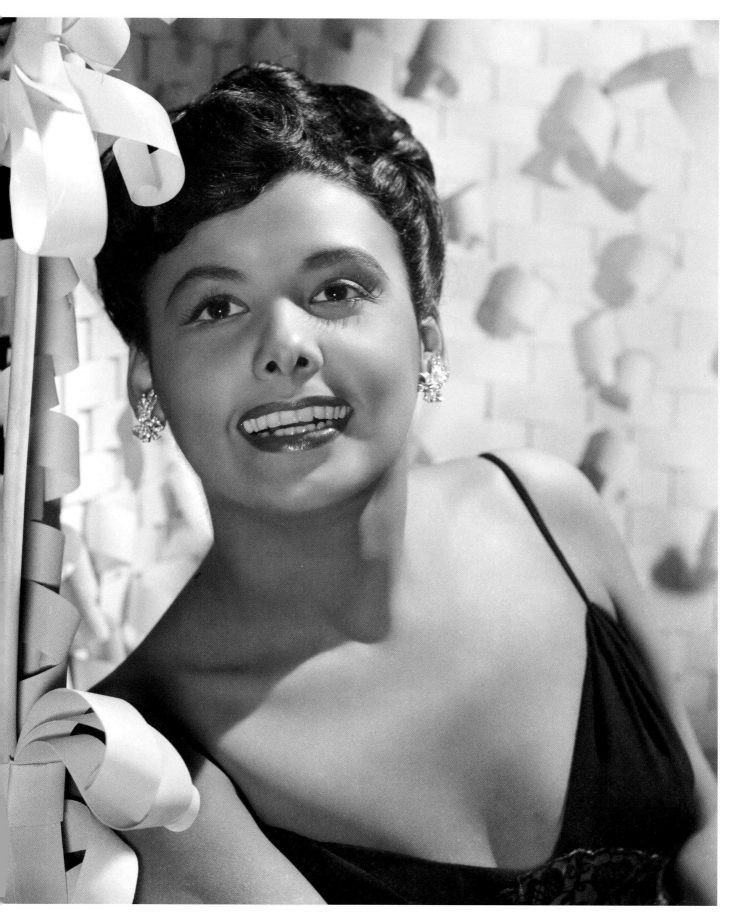

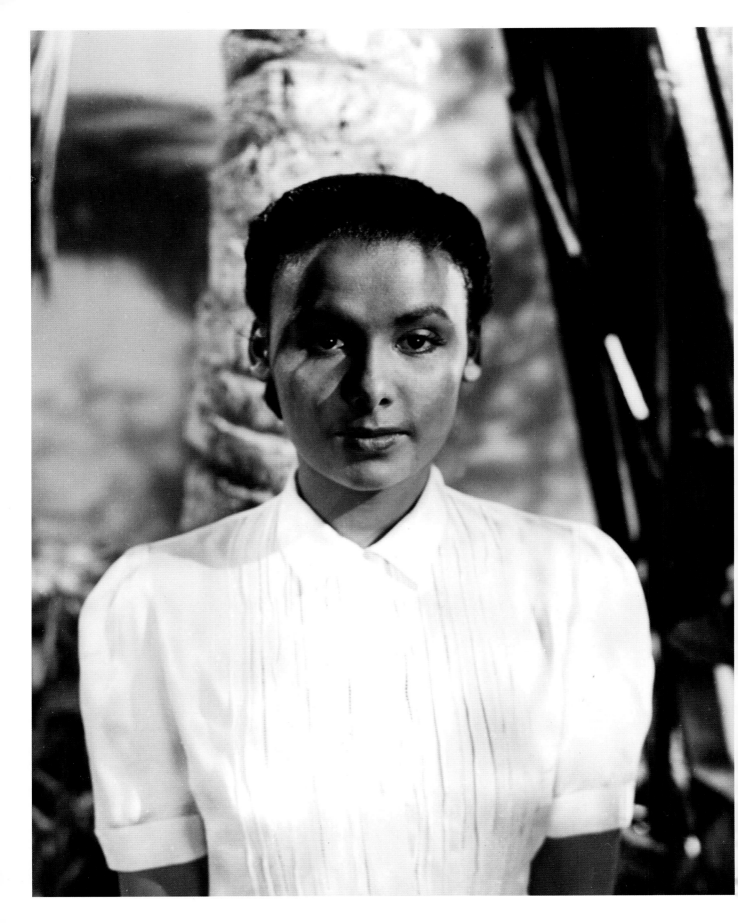

BROOKLYN

T hough hers was a relatively fast track to stardom in the 1940s, from Lena Horne's perspective, it was a journey nonetheless, fraught with its own early perils and discontents.

Lena Mary Calhoun Horne was born on June 30, 1917, in Bedford-Stuyvesant, Brooklyn. From the day of her birth, her looks were a subject of fascination and discussion. At the hospital, the nurses marveled over the little "copper colored" girl. Horne felt the attention came because the nurses were puzzled as to how her light-skinned mother could have given birth to such a brown baby. Horne's daughter Gail Lumet Buckley, however, said that the nurses were probably puzzled because Lena's mother actually had been passing for white at the hospital. But Horne's feelings aside, it actually appears even then that those seeing her were stunned by the infant's beauty. In the long run, as Lena Horne herself later said: "Most of my successes were the result of being exhibited, as I was that first day, as an oddity of color."

Unlike other Black goddesses of the early twentieth century, such as Bessie Smith, Ethel Waters, and Josephine Baker, who grew up in abject poverty and had to scrape and scrounge for everything they got, Lena Horne's background—at least at the start—was one of stability and financial security. The daughter of Edwin Fletcher Horne Jr. and Edna Scottron Horne, she was born into the upper reaches of the Black bourgeoisie and a member of one of Brooklyn's prominent Black families. Her paternal grandmother was Cora Calhoun Horne, one of whose forebears was a white slave owner—whom Lena said her grandmother never discussed—who was a member of the family of John C. Calhoun, a nineteenth century apologist for slavery. In 1881, Cora Calhoun had graduated from Atlanta University. A suffragist and progressive social activist, known to forward-looking movers in the Black community because of her affiliation with the NAACP and the Brooklyn Urban League, Cora held a position as a counselor for delinquent boys. Among her associates were W. E. B. DuBois, Walter White of the NAACP, and a young Paul Robeson, who never forgot that Cora once helped him attain a scholarship to Rutgers University.

Lena's paternal grandfather, Edwin Horn, was born in 1859 in Tennessee and grew up in Evansville, Indiana. He taught high school in Indiana and, for

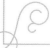

a time, was an editor of the Black newspaper *Our Age*, and also was the official Black correspondent for the white newspaper *The Evansville Journal*. When Edwin and Cora moved to New York, Edwin taught in the New York public school system for three years and then, to earn a better income, became an inspector in New York's fire department. In New York, Edwin also changed the spelling of his surname, adding an *e* to Horn to become Horne.

As emblems of the Black middle class, both Cora and Edwin were accomplished, articulate, composed, well-dressed, and attractive go-getters, conscious of their place in Black society. In Brooklyn, they resided in a stately brownstone on Chauncey Street. The couple had four sons, whom they no doubt assumed would likewise live very middle-class lives. Serving in the military, the oldest son, Errol, died during World War I but not in battle. Sadly, Errol was a victim of the devastating flu pandemic of 1918. The second son, Edwin Jr.—Lena's father—was born in 1893. A third son, Frank—handsome and serious-minded—studied ophthalmology in New York, also wrote poetry and essays, later became a respected educator in Georgia, and still later served on President Franklin Roosevelt's Federal Council of Negro Affairs (known as FDR's Black Cabinet). Light-skinned with sharp features, Frank was easily mistaken for white. The youngest son, John Burke Horne, who was called Burke, was born in 1905.

Lena's father, Edwin Jr., known as Teddy, was a born rebel who eschewed a formal education. Later Teddy, who had a wide network of associates and friends, became a gambler. He was a slick and smooth operator who would always walk his own path and live by his wits and skills outside the established system. Early on in his marriage to Edna, the restless and ambitious Teddy found the union confining.

For her part, Edna, whom Lena considered the most beautiful woman she had ever seen, was also restless and ambitious. Yet in some respects, Edna was like a character out of a Tennessee Williams play: a dreamer, a romantic, fragile, a bit lost, and delusionary. Uppermost in her hopes was to have a career in show business. That world in the early twentieth century was tough, competitive, cutthroat, and debilitating, with limited opportunities for Black women. Edna, however, never stopped believing that one day fortune would smile on her and she'd emerge as a star. She became a member of a well-known Black theater group, the touring Lafayette Stock Company, and she played leading roles in such productions as *Dr. Jekyll and Mr. Hyde* and *Madame X*. In the latter, little Lena was cast as a baby in a crib. Yet these were momentary bright spots for Edna in a life that would be an unfulfilled quest for a successful career. As Lena's daughter, Gail Lumet Buckley, would say of Edna: "Mostly, however, she was the star of her own melodramas." Without knowing it, Edna thrived on upheavals, crises, and conflicts. In the end, marriage to Teddy proved as confining to Edna as he found his marriage to her. By the time Lena was three, the marriage of Teddy and Edna had collapsed. The two separated. Eventually, Teddy got out of Brooklyn and out of New York and settled in Pittsburgh, where he created a new life for himself.

For a time, Edna tried to live with the Horne family in Brooklyn. But with totally different views of the world, she and Cora clashed. For the high-minded, politically and socially committed Cora,

Edna's dreams of a career as an entertainer no doubt seemed frivolous and inconsequential. What was one to do with such a woman? In a short period of time, Edna fled Chauncey Street and took to the road in this era when entertainers often performed in shows that traveled from one town or city to another. Edna struggled to find work in various road show companies, and in the world of Black vaudeville. But one frustration and disappointment after another plagued her.

While Edna pursued her dreams, young Lena was left in the care of her paternal grandparents in their home on Chauncey Street. She had been named after her grandmother's sister Lena. In the highly structured and disciplined atmosphere of the home, Lena was expected to live by family standards. She was baptized in the Catholic Church; by the time she was two, so Horne later said, her grandmother had also enrolled her as a member of the NAACP. A life without social or political commitments didn't seem like a life at all to Cora. Lena was sent to the Brooklyn Ethical Culture nursery school where Betty Comden—later, half of the famous writing partnership of Comden and Green—was a classmate. To the girl Lena, the atmosphere at the home was solemn and suffocating. In a household with dark secrets, anxieties, and unresolved divisions, Cora could not forgive nor forget the rumors that her husband, Edwin, might have had an extramarital affair—with a white woman, no less. Distant and always on formal terms, Cora and Edwin addressed each other as "Mrs. Horne" and "Mr. Horne." Though Lena found it hard to relate to her demanding grandmother, she and her reserved, contemplative grandfather gravitated to each other, and Lena recalled that she became his confidante

and companion. With Lena, Edwin's warmth and loving nature flowed. So did his love of the opera and the theater.

On Chauncey Street, Lena also found fun in the company of her uncle, Burke Horne, the youngest of Edwin and Cora's children, who was then still in school and more like a kindly, even-tempered big brother. Throughout her life, she had a special bond with Burke. She also had a lifelong devotion to her father, Teddy, though she rarely saw him in these formative years. Mainly Lena's was a lonely childhood. Coming home from school, she sometimes used her latchkey to let herself into a side entrance of the house and perhaps read until others returned home. Her grandfather would also pick her up from school. But mostly, the angelic little girl spent time by herself and felt like an outsider. That feeling of being on the outside, or a stranger wherever she lived, would haunt her and never be fully resolved.

By the age of seven, Lena Horne's life changed dramatically. As Horne later recounted, one day a friend of her mother's informed her that Edna was ill and wanted to see her. In the end, Edna took custody of her little girl and spirited Lena away. In some respects, it was a kidnapping. Thereafter mother and daughter lived a nomadic life. First Lena was taken to Philadelphia, later to Miami, and ultimately through parts of the South. Always strapped for cash as she struggled for one job after another, Edna found herself forced to leave her daughter in the care of others. These childhood years were spent always adapting to new places, new people, new customs and ideas, new schools, new classmates, always struggling to fit in and adjust to the expectations of others, and now faced with a new set of doubts and fears.

Though Lena never forgot the kindness of some people she encountered, others could be cruel. On one occasion, she was beaten by the woman who took care of her. Other times she was whipped by Edna. On another occasion, because of a poor diet, she suffered from rickets. Her education was spotty. At one point, she attended a one-room school for students in five different grades. Issues of her color sprang up. Sometimes students taunted her as a "little yellow bastard." And, of course, in the Jim Crow South, issues of race were everywhere—with signs that read "For White" and "For Colored." Quickly, she had to learn the codes of accepted racial behavior. On one occasion in Jacksonville, Florida, she heard talk of a lynching. Unsure at first what the term meant, she saw the terror in the eyes of Blacks around her.

Perhaps her happiest time occurred during her stay with her uncle Frank Horne, who was the dean of students at Fort Valley State University, originally known as Fort Valley Junior Industrial Institute, a historically Black land-grant institution established in 1890 in Fort Valley, Georgia. Frank simply showed up one day when she was in Macon, Georgia, and said he had come to take her with him. The gentle and thoughtful Uncle Frank took an interest in her welfare and her education, and from him, as had been the case with her grandparents, she further developed her appreciation for learning. Her father also visited her at Fort Valley. But her stay there ended abruptly when her mother uprooted her again. She took Lena to a home she had bought in Atlanta—then left her daughter with a couple while she took off for a job. Again the girl suffered physical abuse and punishment at the hands of the woman there—as well as the leering advances of the woman's husband. Edna soon lost the home and no doubt was in a panic of desperation. Again she had to give up custody of Lena.

By the age of twelve, Lena had returned to Brooklyn and some semblance of a stable home life at her grandparents' residence on Chauncey Street. Though Edna was out of Lena's life, Lena felt compelled to defend her mother against her grandmother's verbal attacks. "It was not that my grandmother disliked her, it was just that she had no respect for her. By my grandmother's standards she had no guts." Though Lena stood up for Edna, "trying to shield her from the harsher realities of the life that I seemed to recognize more clearly than she," it "was not easy. My grandmother laughed at my mother . . . Her laughter was hard to fight, but I tried." That defense of her mother brought out an emerging strength in the teenage Lena, the idea that she had to stand up for some things, the idea that loving someone could entail mixed feelings that might not ever be reconciled but which had to be acknowledged. Those mixed feelings were not only for Edna but also for her grandmother.

Then Edna returned to Brooklyn, and Lena was moved back and forth from her grandmother's to Edna's.

In 1932, Grandmother Cora died. Most distressingly, Edna had forbidden Lena to attend Cora's funeral. But Lena insisted on going and ran out of the house. It was a scandal, and the family never forgave Edna. Lena's grandfather died several years later, in 1939. With these early pillars in her life gone, Lena also began a journey in sorting out and understanding her feelings about her grandmother. Cora and Edna were the most important women in Lena's early life, perhaps in her entire life except

for her daughter, Gail, years later. Her young uncle Burke believed Lena was like Cora. "I didn't know that in scrapping with her I was coming to emulate her," said Lena, "and I certainly wasn't doing it consciously. But that apparently is what happened, and it was good."

Thereafter, she remained in Brooklyn at the home of a family friend, Mrs. Laura Rollock, with whom she had previously stayed at times when the active Cora traveled. Rollock would care for her in a way that the young Burke wasn't yet prepared to do. Lena always remembered the kindness of Laura Rollock as she did in the years to come that of other Black women who extended sympathy. Now she also had a group of teenage friends with whom she could share experiences, have fun, and participate in typical teen activities. She was enrolled in a public school and then Girls High. Mrs. Rollock also put Lena in classes at a local dance school. A performance brought attention to their dance group, and before Lena knew it, they were on stage at the Harlem Opera House. No one could have predicted that this giddy experience for the teenager might mark the start of a career, the start of performing before an audience and hearing the sound of applause. For young Lena, this brief period appears to have been relatively free of the fierce inner turmoil that had previously consumed her.

The pleasures and joys of those teen years did not last long, however. Once again her world was turned upside down in the early 1930s, when her mother, Edna, re-entered her life in a way that was jolting and that permanently reset the course of her life.

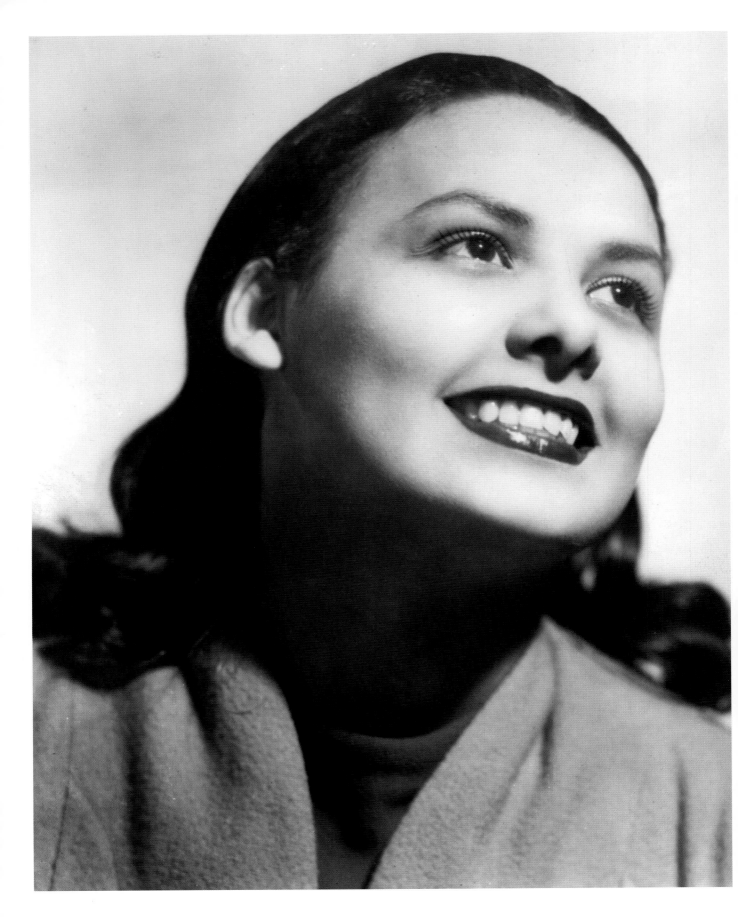

COTTON CLUB

During her time away from Lena, Edna had traveled to Cuba, where she met and then married Miguel Rodriguez, known to everyone as Mike. Now the two lived in Brooklyn. Though he was Latin, everyone in Lena's orbit, including herself, considered him a white man. That led to much discussion and controversy in the area of Brooklyn where Lena resided. In these years and for many more to come, interracial marriages were frowned upon in both white and Black America. In the Black community, resentment was open and fairly raw because of the historical reality that white men—those slave masters—had taken Black women as they had seen fit, abusing or impregnating or subjugating them. Lena felt the sting of the talk in Brooklyn about Rodriguez. Though devoted to Edna, he also arrogantly believed himself better than the Blacks with whom he found himself living. Suddenly, he took control over Lena's life, laying down the law about what she could and could not do, dictating her every move and decision. He and Lena were always at odds, and surely she must have thought back to the security of life with her grandparents—and the strong backbone of Cora. Her grandmother would have been appalled by this man that the "weak" Edna had chosen. Money problems also added to Rodriguez's tensions and anger—and to the unending conflict that sprang up in their home.

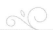

Until now, Lena said, she had never felt the full force and pressures of the Great Depression. With the collapse of the stock market in 1929, the nation's economy and its social welfare had been thrown into chaos. Banks failed. Companies folded. Homes were lost. Unemployment numbers soared with one-fourth of the nation's population jobless. Everywhere lines formed for the homeless and the destitute: soup lines, bread lines, unemployment lines. Fear and dejection were apparent in all parts of the country.

Amidst the social upheaval and the national panic, the family of Edna, Mike, and Lena moved

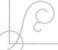

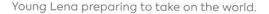

from one area to another, from Brooklyn to the Bronx to Harlem. Edna had forced Lena to drop out of Girls High. Afterward she was enrolled in a secretarial school in the Bronx. Wherever they went, they carried their conflicts with them as they struggled for day-to-day survival—and some way of making a living. For Edna, the dream of somehow making it as an entertainer must have persisted. But in an entertainment business that forever sought youth and beauty, a chance to perform in a club or in a road company or in the chorus of a show was now beyond her grasp. Instead, changing times forced her to turn her gaze upon her daughter. By now, Lena was blossoming into a very pretty girl, not yet the absolute stunner who would stop people in their tracks, but a looker nonetheless with the promise of a glorious future. And ironically, now in the worst of economic times, opportunities were opening up for pretty young women who could entertain.

Providing Americans with relief from the grim realities of the age were the shows, the theaters, the recordings, the radio programs, and the movie theaters that were everywhere you looked in a city like New York. At home, all one need do was turn on the radio for shows that offered music, comedy, or drama—such bona fide hits as *Amos 'n' Andy*, *The Shadow, Dick Tracy*, and later *The Jack Benny Program*, which featured Eddie Anderson as the clever servant Rochester. For a quarter, almost anyone could slip into a movie house and be transported. For those with a few bucks to spare, the theaters and nightclubs offered dazzling entertainment. Such Black stars as Duke Ellington, Louis Armstrong, and Adelaide Hall were marquee names that drew patrons.

From the 1920s into the Depression, the greatest of the Black female stars was the multitalented Ethel Waters, who, even at this point in her career, was also a symbol of survival and endurance. Having grown up in poverty in the Philadelphia area, she had started her career as a tall, slinky, sexy, brown-skinned singer known as Sweet Mama Stringbean, who did sensual bumps and grinds as she performed raunchy blues. In the early 1920s, Waters started recording on the Black Swan label, selling wildly to Black record buyers. Touring the country and making personal appearances, Waters packed in crowds. In the mid-1920s, Waters signed a contract with Columbia Records and soon crossed over with such songs as "Dinah" and "Sweet Georgia Brown," appealing to white record buyers as well as African American ones. In 1929, she appeared in a musical segment of the Hollywood film *On with the Show!,* in which she introduced a song that became another huge hit, "Am I Blue?" Important to Waters's career was the Negro press—a significant lineup of Black newspapers throughout the nation: the *Pittsburgh Courier,* the *Chicago Defender,* the *Philadelphia Tribune.* Waters was a rousing, charismatic sign of Black female star power, and her career was a roadmap for Black female stars that followed. That included Lena—as well as Edna. Witnessing these possibilities for a Black star, Edna understood—even if she didn't want to fully admit it to herself—that if opportunities were no longer open for her, perhaps there would be something for her very pretty daughter. It didn't seem to matter whether or not Lena had talent. Or if Lena wanted such a career.

Edna stepped into action. Through friends, she arranged an audition for Lena at Harlem's famous Cotton Club. This celebrated nitery, located at 142nd Street and Lenox Avenue, had opened its doors in

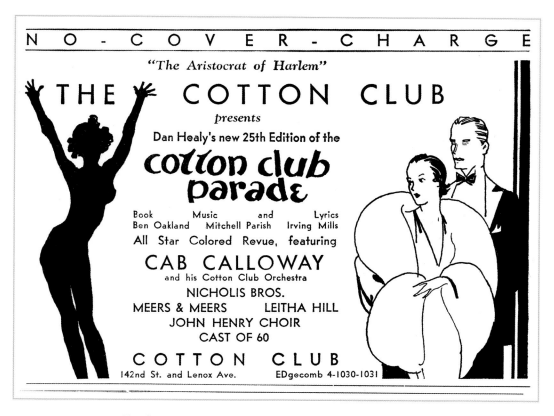

The famous Harlem nightclub known for its great stars
and its gorgeous chorus girls—where Lena got her start.

1924, during the height of the Harlem Renaissance—with its rich overflow of Black talent in music, theater, literature, and films. It originally had been the Club Deluxe, owned by the first Black world heavyweight champ, Jack Johnson, and his white partners. *Mainly his white partners.* In 1923, the club was sold to Owney Madden, a notorious gangster who had served time in Sing Sing in upstate New York and who, during the years of Prohibition, used the club to sell bootleg liquor. That was part of the appeal of this nitery and others, like the famous Connie's Inn, where the entertainment popped and the liquor flowed. Then the Club Deluxe was renamed the Cotton Club and ultimately remodeled. Florenz Ziegfeld's set designer and costumer Joseph Urban

was brought in to provide show-stopping glamour. Thus it went from being a supper club that seated four hundred patrons to one that seated seven hundred, with all its tables and seats arranged like a giant horseshoe around the stage. For a time, Lew Leslie produced the floor shows. Later hired to create the elaborate floor shows was Dan Healy, who every six months staged the Cotton Club Parade with music by Dorothy Fields and Jimmy McHugh. Starting in 1930, music was provided by Harold Arlen and Ted Koehler. The Cotton Club became a place of legend and lore.

Throughout the club were soothing reminders—*soothing* for the white clientele who opened their wallets and paid top prices for the entertainment—of

Lena with her father, Teddy Horne, (l.) and a friend.

The Cotton Club had great entertainment provided over the years by the orchestras of Fletcher Henderson, Duke Ellington, Cab Calloway, Jimmie Lunceford, and Chick Webb, and by such celebrated headliners as Waters, Adelaide Hall, the Nicholas Brothers, Nina Mae McKinney, Billie Holiday, Bessie Smith, Aida Ward, the Berry Brothers, Katherine Dunham, the Will Vodery Choir, the Mills Brothers, and later a trio of unforgettable teenage divas: the Dandridge Sisters. Its Sunday "Celebrity Nights" also featured such white stars as Mae West, Eddie Cantor, Sophie Tucker, and Al Jolson.

The Cotton Club was also known for its gorgeous show girls and its chorus line—composed of young women who were touted as being "tall, tan, and terrific." They had to be at least five feet six inches tall, light-skinned or *high yellar*, and preferably under twenty-one. "The Cotton Club and Connie's Inn were the cat's meow of the day," recalled onetime Cotton Club star Isabel Washington Powell. "The gams that crossed those stages resembled champagne bottles of the finest labels, and belonged to some of the prettiest, most talented 'high yella' girls who made their way to Harlem. They were the top of the line establishments, with doormen, beautiful women, and all the liquor you could pay for. Only light-skinned girls were permitted to dance at these higher end clubs. The country had a confused sense of beauty that excluded so many beautiful and talented darker-skinned sisters who never had the same opportunity."

Light-skinned chorus girls had been in vogue now for years. Even the hit 1921 Black Broadway

plantation days in the Old South. The new name itself harked back to the cotton fields that African Americans had worked in but had escaped for freedom and now frivolity. The décor served the same purpose. "The bandstand was a replica of a southern mansion," Cab Calloway once reminisced, "with large white columns and a backdrop painted with weeping willows and slave quarters. The band played on the veranda of the mansion, and in the front of the veranda, down a few steps, was the dance floor which was also used for the shows. The waiters wore red tuxedos, like butlers in a southern mansion."

With such imagery, perhaps it was not surprising that the clientele was almost exclusively white. Black patrons were not admitted—unless they were famous, like dancer Bill "Bojangles" Robinson.

Growing up in front of audiences.

show *Shuffle Along* was known for its light-skinned chorines. Women like Josephine Baker and Ethel Waters spoke of the color line. Baker recalled that she finally got into the chorus of *Shuffle Along*—auditioning in the lightest face powder she could find—but finding success as an exuberant comic on the line. Ultimately, she became the highest-paid and most famous chorus girl, and afterward found true stardom in Europe. Waters avoided the chorus line altogether.

At her audition, Horne recalled that she could carry a tune but was in no way a singer. Nor was she a

dancer. "I was tall and skinny and I had very little going for me except a pretty face . . . Also, I was young—about sixteen—and despite the sundry vicissitudes of my life, very, very innocent. As it turned out, this was all that was needed." She was hired for the chorus.

But the job—and being uprooted once again—unsettled her. "I cried when my mother pulled me out of school to work at the Cotton Club which was really a form of indentured servitude," Lena recalled. When she had returned to live in Brooklyn just before her grandmother's death, "I felt protected, and I knew who I was. I was a Horne from Brooklyn. All that was lost to me when my mother put me in the Cotton Club. With it, I lost my sense of wholeness. In its place, I was left with anger and an invisible wall I put up between me and the world."

During the rehearsals for the new Cotton Club show in which Horne would appear, Ethel Waters was still drawing crowds to hear her perform "Stormy Weather." It was all anybody could talk about. Irving Berlin heard her, and the following day he wanted her in his next Broadway show, *As Thousands Cheer*. Thereafter everyone considered "Stormy Weather" to be Ethel Waters's song. That included Lena Horne.

Overnight Lena was thrust into a highly competitive, demanding world known for its rivalries, feuds, and also long-lasting friendships.

"Working conditions were terrible," she remembered. "There was only one ladies' room, and the people in the show were discouraged from using it—it was for customers." Nightly, she recalled, there were three shows: one at eight-thirty; another at eleven-thirty; and then one at two a.m. She earned twenty-five dollars a week.

She also was surrounded by aggressive, horny men on the prowl. Managing the club was the brash and blunt Herman Stark. Keeping his eyes pried open to all details of the place, he made it his business to please the big spenders—the playboys, the young society guys, the out-of-towners, the restless husbands on the lookout for the exotic. It was no secret that some chorus girls were urged to be friendly with patrons. Isabel Washington Powell remembered how Stark tried to push her into "meeting" certain men, but she resisted. Other chorus girls did not hold out. Sometimes they couldn't afford to turn down offers. In certain cases, friendships with the affluent might benefit the young women living on a twenty-five-dollar-a-week salary: expensive gifts, trips, contacts, excursions into the realm of wealth, privilege, and power. The women were also aware that time was on their side when they were first hired while still in their twenties—or younger. But the flip side was the inevitable effect of time: their careers did not necessarily have long shelf lives. Once a young woman hit thirty, those giddy nights on the chorus line could come to an end. It was a brutal, paradoxical way of earning a living. Glamorous clothes, lots of attention, fun times—and also hard work that required discipline and focus. But ultimately such careers could be draining and short lived.

Very few of the fabulous-looking women on the chorus line had the staying power or extraordinary talent of a Waters or a Josephine Baker, who climbed the upper echelons of show business and stayed there. Other women had to live by their wits and always be aware of the changes that time could bring about. Interestingly or ironically, some

Ready for her closeup.

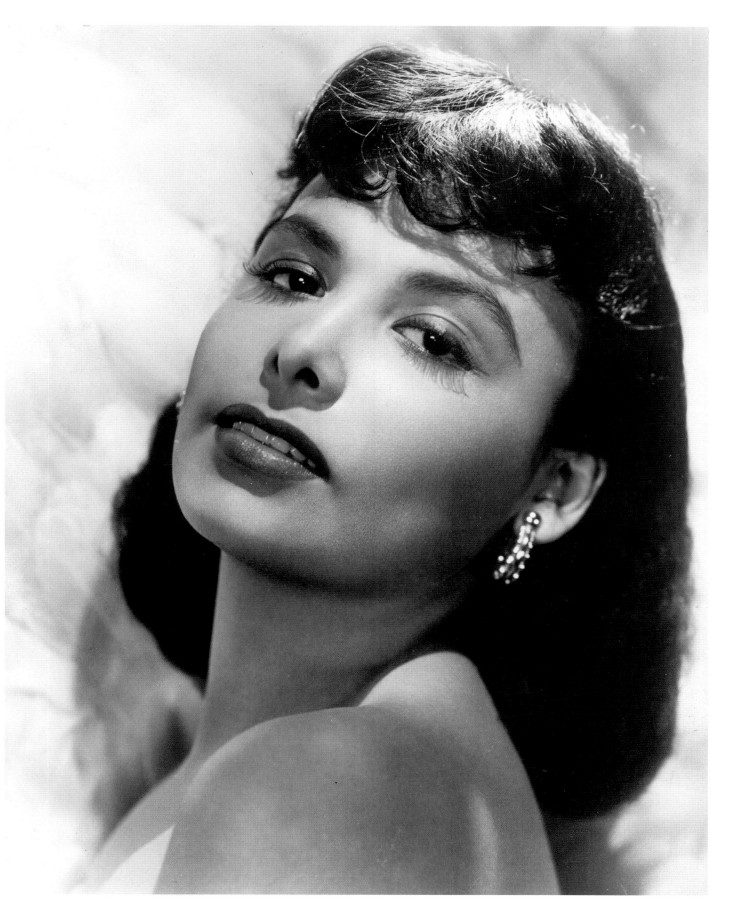

clear-eyed chorus girls ended up marrying well-to-do men who were impressed that they worked at the club but men who might not be able to get a table there: Black doctors, Black lawyers, Black businessmen. In some ways, these women shrewdly made the right moves and maneuvers for the future.

Observing the women around her, Lena was smart and perceptive enough to understand what might lie ahead for her.

Though Horne knew she was jailbait for a steady lineup of men in pursuit, her father, Teddy, had associates—men of the Black underworld—who had ties to the club and could look out for her. Then there was her mother, Edna. "Before she became of age," recalled Duke Ellington, "she had to be accompanied by her mother when she came to work at the Cotton Club." Edna literally sat in the dressing room that Lena shared with other chorus girls. Edna, and her husband, Mike, too, stayed on guard to make sure men didn't get too close to the teenager. The couple had a vested interest in her for a new reason: Edna and Mike were now dependent on her financially. Lena had become the family breadwinner.

Still, Lena struck up valuable friendships and connections with such stars as Cab Calloway, Duke Ellington, and the older female star she admired and felt closest to, Adelaide Hall. She also respected other talents at the club, like the powerful actor Juano Hernández, who performed in a stereotypical jungle routine—and had to struggle for years to finally showcase his brilliant dramatic talents in such films as *Intruder in the Dust* (1949) and *Young Man with a Horn* (1950). Then there were the choreographers Elida Webb and dance captain Clarence Robinson, masters of creating energetic or imaginative moody dance routines that brought out the best in individual performers and that startled club-goers. Musicians especially appealed to Lena in these years, and though she had yet to seriously think about voice control or vocal training, she was learning about music more than she was learning about dancing. The camaraderie and lingo of the musicians drew her in. They composed a family with connections and nonverbal ways of communicating.

She caught the eye of just about everyone who saw her.

While at the club, Lena was cast in a duet with dancer Avon Long performing the Harold Arlen song "As Long as I Live." Though used basically as a pretty face in the number, she began giving more serious thoughts to singing itself. At a theater, she also performed with Claude Hopkins and his Orchestra. Then in 1934, with the encouragement of her mother, she wrangled the nearly impossible—to get permission from management at the Cotton Club to appear in the Broadway show *Dance with Your Gods*, starring Rex Ingram and Georgette Harvey. Listed as "the Quadroon Girl" and without much to do in the short-lived production, she saw new possibilities nonetheless. In 1935, she found herself briefly dancing with other chorus girls in a short film starring Cab Calloway: *Cab Calloway's Jitterbug Party*.

In her public statements about these years, Lena Horne rarely seemed to express having great ambition or drive. It might appear as if everything just came to her, as if her looks just automatically opened doors for a rather passive young woman. But that was hardly the case. Perhaps even she didn't fully realize how much drive she had. At that point in her life—still a teenager—she may not have known exactly where

she wanted to go. But she wanted to go *somewhere*, and show business and performing were soon deep inside her. Coming of age during the Depression and knowing that a dollar had to be stretched, just surviving meant she had to keep working. Now on the road to a career that would endure for decades, she would stick to it with only one interlude in which she attempted a break from that trajectory. Otherwise, she moved straight ahead and always looked for new opportunities in the field she had now chosen for herself. But there was one dilemma holding her back. That dilemma was the Cotton Club itself.

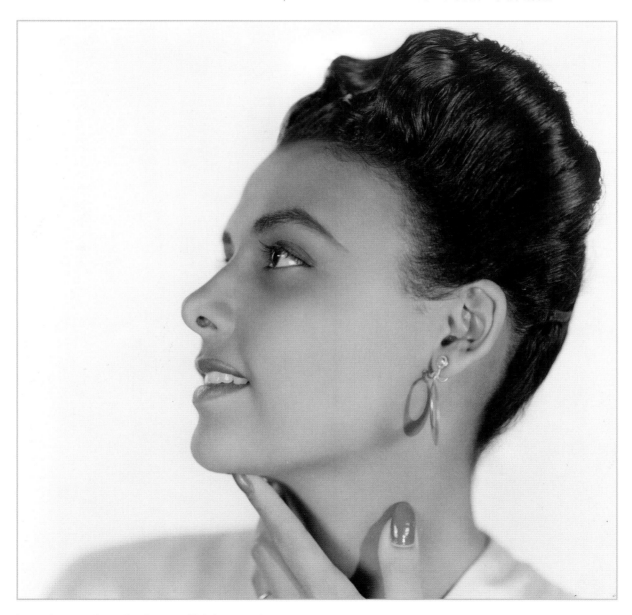

Learning much at the Cotton Club but ready to move on.

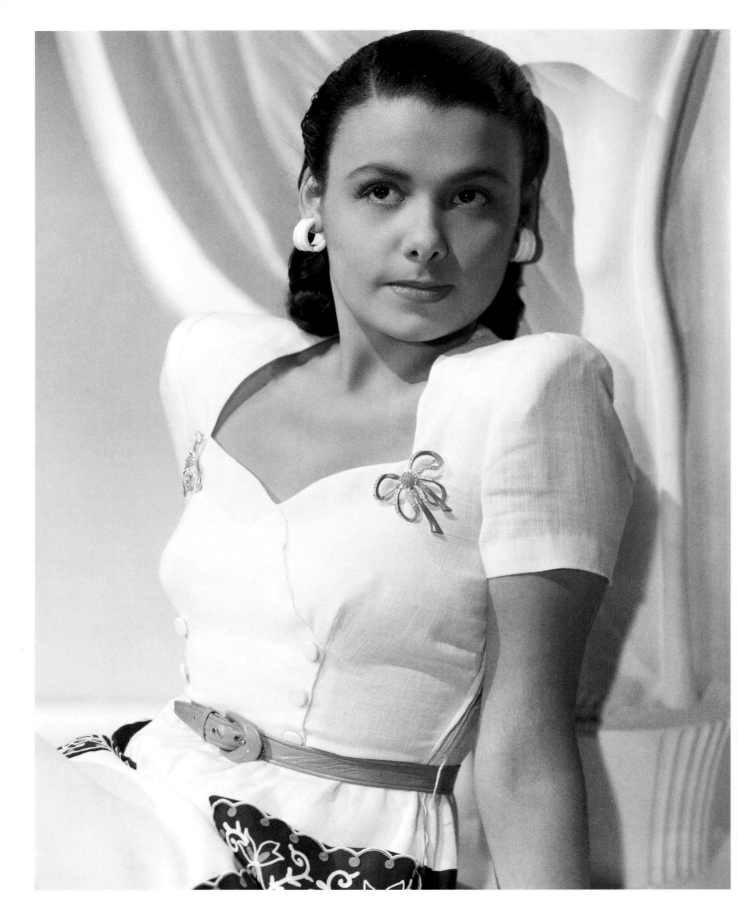

CHAPTER 3

GIRL-SINGER

On December fifth of the very year—1933—that Lena started at the Cotton Club, Prohibition ended. That meant that part of the thrill of the club—illicit booze and with it the idea of illicit activities—was ebbing. The days of the Cotton Club were numbered. Edna saw the writing on the wall.

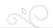

Accordingly, not that long after Lena arrived at the club, Edna and Mike made efforts to get her out of the chorus line and out of the Cotton Club altogether. A struggle ensued because the gangsters who ran the place saw the value in having such a young beauty in house as a magnet for patrons. Horne recalled that when her stepfather, Mike, demanded a release for her, he ended up being rather severely physically assaulted by the toughs at the nitery. Finally, with the help of acquaintances of Teddy Horne, she was able to strike out on her own. The timing proved perfect. The Cotton Club did not last much longer. It relocated to midtown in 1936, then closed its doors in 1940.

While free of the club, she was at loose ends and might easily have vanished from sight. To stay ahead of the financial scramble to keep herself, her mother, and her stepfather afloat, it was more vital than ever for her to find career-building jobs. Her contacts at the Cotton Club were now invaluable. In the minds of many, it was not simply her

looks that made her stand out; it was her bearing and possibly her diction, that way of expressing herself, which ultimately would prove so important in the way she put a song across. Lena Horne always spoke each word clearly and precisely. The comic Flournoy Miller—who in 1921 had coauthored with Aubrey Lyles the book for the groundbreaking Black Broadway musical *Shuffle Along* by Eubie Blake and Noble Sissle—saw those special qualities in Lena and informed her of an opening for the spot as the girl-singer for Noble Sissle's Society Orchestra.

Noble Sissle was well known and admired in the corridors of Black show business primarily because *Shuffle Along* had altered the presence of Black performers in entertainment. Now Sissle was altering the Negro orchestra. Tall, lean, an impeccable dresser, and imbued with a sharp sense of personal and racial pride, Sissle had created a band that performed at a variety of venues around the country, including Negro balls and gatherings as well as at garden parties and social functions for white

audiences. Thus he was continuing to break down barriers. Aside from providing the best in music, Sissle had uppermost in his mind maintaining dignity on the bandstand. Notably, his music was not blues or jazz; it was standards, material that would not shake up the audiences but rather comfort them for a diverting, dreamy night out.

Secretly, Edna and Lena traveled to Philadelphia, where Sissle auditioned her. Though she still was not really a *singer* and though she had stage fright throughout her career, the budding performer maintained her calm. Sissle found her appealing and, like everyone else, was struck by her youthful beauty. He decided she was just right for his girl-singer. By then, she had also taken vocal lessons.

Therein began a year of traveling around the country with Noble Sissle's Society Orchestra. For a time, she was billed as Helena Horne, and the bandleader stressed that she must always present a dignified image. "Remember, you are a lady, you are not a whore—don't let them treat you like one," she was told by Sissle. "We represented quality," said Horne. "We were not a typical Negro band. That is to say, we didn't have any of those dope-using, drunken Negro people of popular lore in our band. We didn't even play that decadent jazz."

Touring with the orchestra, Lena experienced the expected indignities of life on the road for African Americans—whether it was the openly and rigidly segregated South or the de facto segregation in the North and other parts of the country. The band could not stay at certain hotels. Nor could they expect to be served at certain restaurants. The racial status quo was a fact of life that Black Americans were forced to live with—for basic survival. As Lena would say, life on the road was mostly bad food and lousy hotels. Because of her youth, she still had to be shielded in other ways—from the advances of band members or from patrons. Sissle himself appears to have been protective. But Edna and Mike also traveled on the road with her to look out for her welfare.

The Noble Sissle Society Orchestra broke the color barrier when it became the first Negro band to play the rooftop of the Ritz-Carlton in Boston. Some hip young students from Harvard came to see the group and developed crushes on the pretty girl-singer. On another occasion, when Sissle was bedridden in a hospital after a car accident, he asked Lena to lead the group at the whites-only Moonlight Gardens in Cincinnati. Puzzled and scared, she was told by Sissle that all she had to do was wave her hands about. The band would know what to do! To the audience it would look fine.

There followed a tour of the South. Without really thinking about it, Horne was learning her craft, developing her art, very slowly creating the style that would distinguish her from other singers. Though she admired Billie Holiday and Ella Fitzgerald and was well aware of what Ethel Waters could do in communicating with a large audience through music, she knew her sound was quite different from theirs. She had to find material that worked best for her.

On a personal note, she did not have much of a romantic life, yet thoughts of marriage and of finding the right man were on her mind.

Lena's life underwent a dramatic change in 1935 during a visit to see her father in Pittsburgh, where he was living with his second wife, Irene. Among his various ventures in the city, he operated a small

hotel. But, of course, Teddy knew he couldn't make a living from this small establishment alone. Upstairs he created a gambling den, which indeed brought in the bucks. Through Teddy, Lena met a young man named Louis Jones. They took notice of each other immediately. It may not have been love at first sight, but it was clearly a *very* mutual attraction.

Louis Jones had much going for him, not only in Lena's eyes but in his own eyes as well—and certainly in those of the Black residents of Pittsburgh. Considered handsome, always well dressed, well mannered, and educated with a degree from the historically Black college West Virginia State, Louis was then a registrar in the office of the Pittsburgh coroner, a solid position, especially for an African American man. The son of the prominent minister Reverend William Augustus Jones, Louis Jones struck everyone as a young man on the way up—although no one could say for sure where he'd go, given the limited opportunities for Black men.

Pittsburgh then reigned as the nation's eighth largest city, known as the land of U.S. Steel that in the war years would supply nearly half of the nation's steel output. That industry and others brought immigrants streaming into the city, expanding its growth and vitality. African Americans also swelled Pittsburgh's population during the period of the Great Migration—when Black citizens headed from the South to the North and East in search of more jobs, a chance at a better education, and an escape from the blatant forms of racism in daily life. While Pittsburgh's white elite included such moneyed families as the Mellons and the Carnegies, the city's Black community also had its established bourgeoisie. Though Teddy the gambler and rebel operated comfortably outside polite Black society,

he nonetheless never completely abandoned it. He enjoyed the slick and smooth wheeler-dealers like himself. Yet he also showed respect for the upright movers and shakers of the Black bourgeoisie.

During her visit, Lena saw that Pittsburgh offered a new way of living, of socializing, a more leisurely pace, and different values and attitudes—both good and bad—from those of the show business world in which she was immersed. In some respects, parts of Pittsburgh were reminiscent of the Brooklyn she loved. It was a relief from the hustle and bustle of show life.

A new chapter in her life was starting. With marriage on her mind—a desire to settle down to the kind of life young women were encouraged toward—Lena enjoyed the city and was swept off her feet by twenty-eight-year-old Jones. In a very short period of time, she fell in love. Of course, Edna caught wind of the romance and hit the roof. How could her daughter forfeit a career they *both* had been set on?

Ignoring her mother's dramatic protestations, Lena focused on the fact that he was courtly, charming, and dashing with the forward-looking perspective of a young man on the move. She also paid no attention to her father's feelings that Louis was not husband material for his daughter. According to Horne and later her adult daughter Gail, Lena also liked the Jones family, especially Louis's father, who perhaps brought to mind her grandfather Edwin.

Lena may have seen other not-so-attractive traits but clearly she didn't dwell on them. After a relatively short period of dating, she and Louis Jones married on January 13, 1937, in the presence of family and friends. In its January 23, 1937, edition, the Black newspaper the *Pittsburgh Courier* chronicled

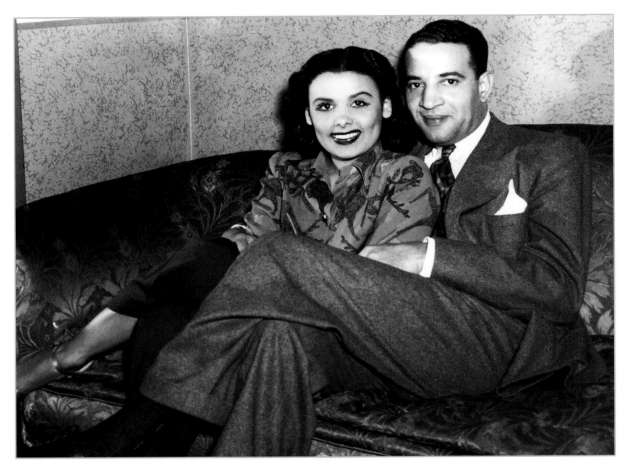

With her first husband, Louis Jones—a domineering spouse, an unhappy marriage.

the marriage of a hometown guy to a young woman of entertainment with photos and a series of headlines and subheads.

"Love at First Sight" Romance Ends at Altar
New York's Prettiest Stage Star
Deserted Footlights
For Love—She's Satisfied
Pretty Lena Horne Banishes Career
for Love and Home

"In the meantime, flattering offers were thrown at the feet of the charming Miss Horne," the paper reported. "Extravagant promises of a great stage career, a trip to Europe, were made by nationally known orchestra leaders . . . but love ruled, and darling Lena shook her head. 'It's love and a home,' she said, and no amount of persuasion could change her mind."

It was a fairy-tale story, and Lena swooned under the spell of Jones. But she very quickly had to deal with certain unalterable realities. Louis was the youngest of four children and obviously used to having his way; there was no denying he was spoiled and determined that, in his own home, his will was not to be questioned or subverted.

Lena had to adapt to a traditional domestic life as a young wife in the 1930s in ways she had not

anticipated. Unaccustomed even to thinking about running a household, she knew nothing about the basics of housekeeping, of making a home her husband felt comfortable in, nor of cooking a meal, nor doing laundry, nor a multitude of other "wifely" duties. Nor was she accustomed to a world in which she was her husband's appendage. The Joneses' home life in Pittsburgh was often centered on Louis who, in then typical fashion of males of the day, called all the shots. By her own admission, Lena had a temper that could easily flare up, but she felt she had to keep everything under control, her emotions on hold.

Before long, serious problems emerged in their marriage—yet she was elated when she became pregnant. On December 21, 1937, Lena gave birth to a daughter, Gail Jones. Their baby's arrival did nothing to stop the domestic conflicts from continuing; quite the contrary. Lena grew concerned about finances. Louis was a spender. The bills mounted, but living in debt did not seem to faze her husband or alter his habits. This was the one period in Lena Horne's life during which her focus was not on her career. She had left her old life behind, or so it seemed. But not for long.

Horne received a call from her agent in New York, Harold Gumm, who represented a number of African American entertainers, including for a time Ethel Waters. A shrewd manipulator, Gumm deftly maneuvered producers, directors, and club managers to get his clients work *and* good pay. Gumm informed her that Hollywood wanted her—not the big-time Hollywood studios like MGM, Warner Bros., or 20th Century-Fox. It was the other side of Hollywood, the world of independent Black productions called *race movies*: low-budget, quickly made films with Black casts produced outside the Hollywood studio system. Created especially for Black audiences, race films had been around since the days of silents. Filmmakers like actor Noble Johnson, who helped found the Black production company the Lincoln Motion Picture Company, and the relentlessly resourceful and productive writer-director-producer Oscar Micheaux struggled against the odds to make such movies. From the Lincoln Motion Picture Company came films like *The Realization of a Negro's Ambition* (1916) and *The Trooper of Company K* (1917). From Micheaux came such works as *The Homesteader* (1919), *Within Our Gates* (1920), *The Symbol of the Unconquered* (1920), and scores of others.

More filmmakers and production companies followed through the 1920s into the 1940s. Though many companies were white-owned, they still had the goal of producing films—dramas, comedies, westerns, mysteries, romances—for Black audiences with cultural signs, messages, and symbols that were a world away from standard Hollywood fare in which African Americans were far too often cast as comic or dim-witted servants. In the race movies, Black heroes and heroines appeared with dreams, aspirations, values that Hollywood ignored. Black doctors. Black lawyers. Black teachers. Black detectives. Black gangsters, too. The films might have had more technical problems than their white counterparts, especially in the early 1930s, as filmmakers had to grapple with the new medium of sound. Mainstream Hollywood had the same problems when talking motion pictures replaced silent features. But Black-cast films nonetheless were made. In time, some nine hundred Black movie houses around the country—in urban areas and in Black

belts elsewhere—showed these films. It was a thriving industry until the early post–World War II era.

Among the late-1930s generation of race movie moguls were the Popkin brothers, Harry and Leo, whose company Million Dollar Productions turned out such films as *Dark Manhattan* and *Am I Guilty?*, which starred the other partner in the company, Black actor Ralph Cooper. Based in Los Angeles,

Million Dollar Productions was mounting a new movie, *The Duke Is Tops*, that was to star Cooper. In search of a leading lady, initially the company had hopes of signing Nina Mae McKinney. When that didn't happen, Million Dollar Productions still had its pick of lovely, talented Black actresses on the West Coast, including Theresa Harris, who worked steadily in big studio productions playing maids.

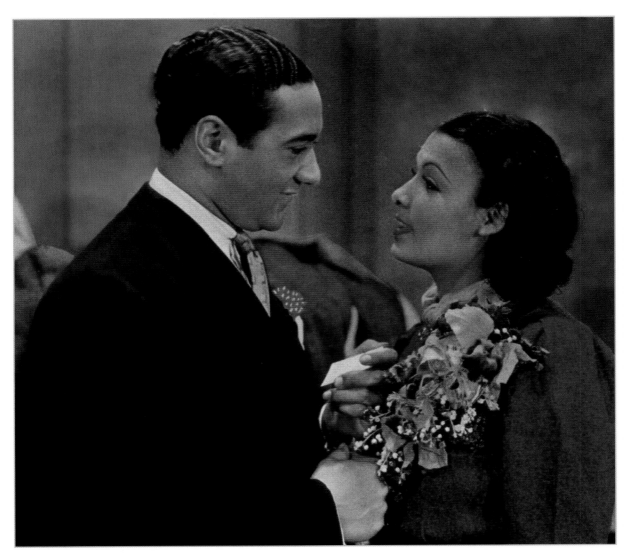

With leading man Ralph Cooper, who urged Million Dollar Productions to hire her—and bring her to the West Coast.

"There were all sorts of very pretty young Black women just waiting for things to open up, for them to have a chance to work," said entertainer Bobby Short. Yet despite all the young Black women on the West Coast, Cooper himself pitched the prospect of casting Lena. "I had known Lena since she was in the chorus line at the Cotton Club," he recalled. "At first there was some reluctance out West, because Lena's career was in eclipse, and not many people remembered her," said Cooper. "But I knew she was a wonderful talent, and my conviction about her sold the producers."

Then he had to persuade Lena to come on board.

"Lena had retired and had gone home to Pittsburgh with her husband and their new baby. Her father, Teddy Horne, was an entrepreneur who also lived in Pittsburgh," said Cooper. "So it was like pulling teeth to convince Lena to come to Hollywood, even for the female lead in my picture. She was adamant about retirement. Only after hours of phone calls and help from mutual friends, including a columnist on the *Pittsburgh Courier*, did Lena finally accept my offer."

The real drawback may have been her husband Louis, who wanted his wife at home, where he held court as lord and master. Excited by the prospect, Gumm urged her to take the role. The salary would not be a lot, but it was decent enough and this was a *movie*! Even though the company was the flip side of the movie business, it was still Hollywood. Louis, Teddy, and yes, finally Lena, decided she should do the picture. Plans were made for the care of baby Gail.

The day Lena arrived at the Pittsburgh airport for her flight to Los Angeles, Louis and Teddy accompanied her. Heading west to the land where dreams were manufactured, Lena wore a stylish hat and a borrowed Persian lamb coat. Clearly, she was excited. Lena Horne would always love the glamour of show business: the clothes, the jewels, the makeup, the lights—in the clubs and on movie sets—and the array of distinct and diverse creative personalities that swarmed around her. In show business, you were always meeting new people and always exposed to the latest ideas and trends in fashion, music, dance, and design. None of that would she ever be able to resist. Though she may not have thought seriously about all of this at the time, she was re-entering a world that, despite its problems and disappointments, she loved. Never would she turn away from show business again.

On the West Coast, the big hotels—the Beverly Hills, the Ambassador, the Roosevelt—did not accept Black guests, so Million Dollar Productions arranged for Lena to stay at the home of actress Lillian Randolph. Horne still responded to the kindness of older Black women, and she long remembered Randolph. Both Lillian and her sister Amanda were character actresses always on the lookout for work. In the end, they managed to have long-sustained careers. Amanda Randolph appeared in such movies as Oscar Micheaux's *Lying Lips* and *Underworld* and later TV's *Danny Thomas Show*. Lillian worked in the movies *The Toy Wife* (1938) and *Life Goes On* (1938), did voice-overs as Mammy-Two-Shoes in the Tom and Jerry cartoons, and she would be remembered as the domestic in Frank Capra's *It's a Wonderful Life* (1946), as the polished housekeeper who keeps everything in tip-top shape in *The Bachelor and the Bobby-Soxer* (1947), and as the housekeeper Birdie in the Gildersleeve movies and TV series. Lillian performed in Million Dollar Productions as well. Settling into Lillian's home,

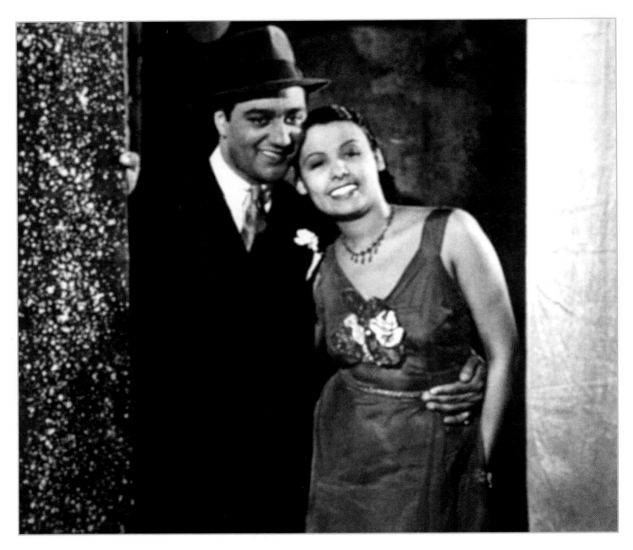

Lena in her first film role in the entertaining race movie *The Duke Is Tops* with Ralph Cooper.

Lena was now getting a taste of the West Coast entertainment scene.

But within just twenty-four hours of her arrival in Los Angeles, Lena realized that the producer was not satisfied with her. Having recently given birth to Gail, she was heavier than the company expected. But she could do little to lose weight before the film's tight ten-day shooting schedule. The attitude bothered her. Phil Moore, who arranged music for *The Duke Is Tops*, remembered "Helena Horne [as she was then still known to many] . . . hadn't quite retracted the weight she had gained during pregnancy. They insisted on her wearing a cheap white satin form-fitting evening gown that was on the bias à la Jean Harlow. This design really amplified her ample figure. I sympathize with my old friend Lena Horne every time some hungry production company releases this old film." Another problem arose: She was not being

paid. Everyone waited for more financing to come in. Upon hearing the news, Louis wanted her to quit the production immediately, but she stuck it out.

Top-biller in the film was Cooper, who not only played the lead role of Duke Davis but also was a writer on *The Duke Is Tops* and an uncredited co-director. The story itself was standard Hollywood —a backstage romance story—but with sweet twists. Cooper's character Duke is an entertainer madly in love with his show business partner Ethel Andrews, played by Horne. When presented with the fact that he may be holding her back from big-time stardom, he pretends to sell her contract to another producer. Hurt, angry, and feeling rejected, Andrews decides her romance with Duke is over and done with. Afterward Duke himself hits hard times and ends up working successfully in the Medicine Man show of wily, eccentric Doc Dorando (Laurence Criner). When he learns that Ethel's new show has tanked due to poor management, Duke rushes to her side. Her maid has revealed to Ethel that Duke always had her best career interests in mind. As the film ends, the couple is reunited during a grand finale of performing acts, and then with a song by Ethel, and a closing kiss between the stars.

Old-style schmaltz, *The Duke Is Tops* has nothing complex or complicated in its storyline nor in the way it's presented. However, the film remains surprisingly entertaining and engaging. Such acts as the singing Basin Street Boys and the musician-singers Cats and the Fiddle are just fine, and dancers Willie Covan and Marie Bryant are almost at the top of their game. In the years to follow, they'd be even better. The surprise delight of the film was Criner's performance as Doc. Speaking in deep theatrical tones and dressed in a floppy hat and jacket that looks more like a cape, he brings to mind John Barrymore in *Twentieth Century* (1934). He's an enjoyable ham of an actor, low on cash and eager to do what he can to get a decent meal and a few bucks in his pocket. He even lifts a tip that Cooper has left behind for a waitress—in a restaurant where ham and eggs are thirty-five cents. Criner brings to sparkling life a man of the theater who doesn't know when to stop acting.

Ralph Cooper, sometimes known as the "dark Gable," is nicely low-key and an assured leading man. When he goes through his shtick trying to sell Doc's elixir to a crowd standing by, he is a man pleasantly aware of what he must do to make his hustle work—and he understands the people watching him. As for Horne, her acting inexperience shows, but she doesn't get lost on screen. She also wasn't helped by the costuming, as the film's musical arranger Phil Moore noted. Still, she was at ease in front of a camera, and she's vivid enough to keep you watching. When she sings, she's not yet the vivacious performer to come but she's good enough, and you get the impression she's a star-in-waiting.

Also on the picture were a lineup of performers who composed a type of Black Hollywood stock company for future films, independent and mainstream: Monte Hawley; Edward Thompson; dancers Mildred Boyd and the stunner Avanelle Harris; Everett Brown, who was cast as the sheriff and later would play Big Sam in *Gone with the Wind*; and a future social arbiter in the world of Black Hollywood, actor Joel Fluellen. Known to enjoy friendships with people in all strata of the entertainment world—from extras to such stars as Hattie McDaniel and Louise Beavers to Burt Lancaster and Dorothy Dandridge (the star he idolized most)—Fluellen made it his

business to establish contact with Lena. He knew she had a future. Also appearing in an uncredited role was Lillian Randolph.

Though the comments and attitudes about her weight continued to annoy her and though she was *never* paid, as she completed work on *The Duke Is*

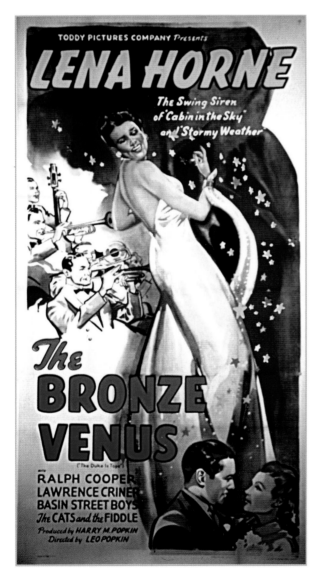

Capitalizing on her later fame, a spectacular *Bronze Venus* poster which was the rereleased and retitled version of *The Duke Is Tops*.

Tops, Lena created lasting friendships and associations (as she had done with performers at the Cotton Club) with dancer Avanelle Harris but mainly with dancer-choreographer Marie Bryant and the film's musical arranger, Phil Moore. These immensely talented young pros would make their mark in the next decade as they moved into the world of the big studios. Bryant became known not only for her work as a dancer but also as a choreographer and dance coach. Moore would become one of the first African American arrangers-composers to work at MGM. Horne responded to the creativity of Moore and Bryant—and also, in the case of Bryant, to her exuberant personality. Bryant became "one of my dear, dear girl friends," said Lena.

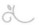

Once back in Pittsburgh, Lena returned to a claustrophobic and unbearable home life. Her husband remained controlling and overbearing. Still concerned about money and rising debts, still due in part to Louis's extravagant lifestyle, she knew an end was in sight to her marriage. When *The Duke Is Tops* opened in 1938 in Pittsburgh, the city's Black bourgeoisie was bursting with pride. Everyone was eager to see a "local girl" who had made good. But Jones—no doubt annoyed with the attention his wife was garnering—refused to let her attend the premiere. Even his family realized his unyielding decision was petty and mean-spirited.

Still, Horne tried to work things out with her husband. But the lure of show business continued.

Around this time, she made another trip to New York, to see the young director Vincente Minnelli. He'd had a big success with the 1935 Broadway production *At Home Abroad*, which had starred

Bea Lillie, Eleanor Powell, and Ethel Waters. As Minnelli thought of a new production for Broadway, "I'd become intrigued by an idea brought to me by Vernon Duke," recalled the director. "How about a musical version of *Serena Blandish*, the S. N. Behrman play adapted from Enid Bagnold's *A Lady of Quality?*" Behrman's play told the story of young Serena "being loaned a diamond for a month by a jeweler and being introduced to society by an Auntie Mame countess so that she could make a good marriage." Said Minnelli: "My approach would be somewhat different than the original. Though I would stage the play as the same very elegant high comedy, it would be with an all-Black cast. To change the concept in any way because of the cast's skin color struck me as condescension of the worst sort. I wanted to do a sophisticated Black show because I felt uneasy about the conventional stereotype of the Negro as simple, naïve, and childlike." For the role of the countess, Minnelli wanted Ethel Waters.

As he began work on adapting the new musical, Minnelli had another novel idea. "I brought former Cotton Club star Lena Horne from Pittsburgh, where she'd retired after marrying to raise a family, to read for the part of Serena." It might have been an ingenious, rather groundbreaking musical, but ultimately plans for *Serena Blandish* failed to materialize. Nonetheless, both the great star Waters and the newcomer Lena Horne were on Minnelli's radar. He would not forget the idea of casting the two together.

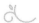

In Pittsburgh, Horne received yet another call from Harold Gumm—with another offer, this time for a Broadway-bound production, *Blackbirds of 1939*. To be produced by the well-known Lew Leslie, the musical was to be the latest in a series of lively Black revues with great singing and dancing, all-talent cavalcades that helped launch or further establish important careers. Leslie was known for spotting Black talent, primarily Black women, destined for stardom. *Blackbirds of 1928* had starred Adelaide Hall, Bill "Bojangles" Robinson, Tim Moore, and Elisabeth Welch. It also featured a lively, Clara Bow-esque chorus girl named Nina Mae McKinney, whom director King Vidor saw and soon cast in one of Hollywood's earliest all-Black musicals, *Hallelujah*, in 1929. McKinney emerged as Hollywood's first Black love goddess. Then came *Blackbirds of 1930*, which had been a vehicle for Ethel Waters in her early efforts to make it on Broadway.

But it was Leslie's original *Blackbirds* in 1926, starring Florence Mills, that enthralled Lena Horne. Though she had never seen it, Horne knew that Leslie had taken Mills abroad in the show, which triumphed in England. The Prince of Wales was said to have seen it eleven times. Adored and acclaimed, Mills, like Josephine Baker in France, had a fame new to Black Americans. In an age when such blues singers as Ma Rainey, Bessie Smith, and Clara Smith had ushered in earthy and sometimes rowdy portraits of Black women, Mills was a ladylike pixie, a gamin, a totally distinct presence, remembered for the delicacy and vulnerability she had brought to the hit song "I'm a Little Blackbird Looking for a Bluebird." The Mills legend had taken a tragic turn in 1927, when she died at the age of thirty-two. An estimated 150,000 mourners turned out for her funeral in Harlem—and Leslie had blackbirds released into the sky in her honor. No Black entertainer was held in higher esteem by audiences—or by Lena Horne, who knew she could never be an earthy blues goddess, but

perhaps she could be something similar to the lady-like Mills. She accepted Lew Leslie's offer.

In New York, Lena optimistically began rehearsals. Under the direction of Rube Bloom with a book by Leslie and Johnny Mercer, the large cast included the ribald comic Dewey "Pigmeat" Markham, Hamtree Harrington, and the J. Rosemund Johnson Choir. Horne liked Lew Leslie, a knowledgeable and vastly experienced man of entertainment, spirited, outgoing, and respectable. He in turn was one of her early great admirers, confident that she had the talent, looks, and charisma to become a star. Socializing with Leslie and his wife, Belle Baker, she was introduced to sophisticated new attitudes and a refreshing perspective on life.

But after a tryout in Boston, the show was soon in trouble. The earlier *Blackbirds* had triumphed during the roaring 1920s, when audiences wanted to break loose and throw inhibitions aside. But during the 1930s, as the nation was grappling with the Great Depression, it was in need of another kind of image. The show lacked a feel for the zeitgeist of the age. It was a flat, uninspired production.

On February 11, 1939, *Blackbirds of 1939* opened at the Hudson Theatre. The obdurate Louis arrived in the city and in his unyielding, take-charge manner, he forbade his wife to attend the opening-night cast party. *Blackbirds of 1939* closed after just one week. Horne received good notices, however, and the show served as one more rung on a ladder to stardom and took her farther than she may have realized.

Lena returned to Pittsburgh and once again tried to make a go of her marriage. She became pregnant and gave birth on February 7, 1940, to a son, Edwin Fletcher Jones, whom everyone called little Teddy.

But in need of money and some outlet for her talents, the new mother of two accepted an offer from Charlotte Catlin, an accomplished local pianist, to perform at private parties in the area. Lena would sing. Catlin would accompany her on piano. Thus she began entertaining at the homes of Pittsburgh's upper crust, the Mellons and the Carnegies. At these sophisticated social affairs, the elegantly dressed Horne was always a vision for those guests who gathered in front of the piano to hear her sing such numbers as "The Man I Love" and "On the Sunny Side of the Street." Also elegant was Catlin. Theirs was the perfect music for those occasions—not blues, mainly popular tunes. Soon it was clear that such songs worked best for Lena. Hers was "crossover" music that white audiences would feel more comfortable with. That had been the case during her time with Noble Sissle. It became even more apparent in the years that followed. Catlin always handled the engagements. Horne noted she never saw money exchange hands. But she was always paid by Catlin. Feeling appreciated and with thoughts that she could indeed entertain again, she devised a plan to get out of Pittsburgh and back to her career in New York.

Lena decided she would go to New York to find work, then return for her children. But she needed money to hold herself over, as well as to pay someone to take care of Gail and Teddy. Coming to her rescue was her father's wife. "She was one of those women who were at their best when there was a crisis," recalled Lena.

As Louis was about to make a trip, Lena confronted him and said she was leaving. He understood

there was no stopping her. Yet he may have believed she would come crawling back, unable to sustain herself and in need of his support. Women just didn't walk out on their husbands. Louis told her, simply but harshly and unequivocally: "If you go, you can come back for Gail. But you'll never get Teddy." Lena had few illusions that he would relent. The custody of Teddy Jones would prove an ongoing struggle and heartache for Horne.

Years later she would reflect on Louis Jones in a different way. "I married a man who was the recipient of all the stress, of all the cruel meaning of being a Negro man in America at that time and in that generation. He had been to college, a Southern Negro college—and he was terribly proud," she said. "But he was often refused work because of the color of his skin. When he finally got a job, it was a reward for the work he and his brothers had done with the young Democrats in Pittsburgh," she said. "They gave him a job as a clerk in the county coroner's office. God knows it was tough for everybody in the thirties—but he was a capable and sensitive man, and it galled him to see white men with less ability getting the jobs he felt he could do. And I was no help to him at all." She added: "So after a day of frustration, contending with the white man's world, my husband would come home to find a young, dumb wife who had had two children quickly, but who didn't even know how to cook or sew or keep house. I certainly was not his idea of a good wife and mother."

That reflection came decades later. But at this time, there could be no return to married life with Louis Jones.

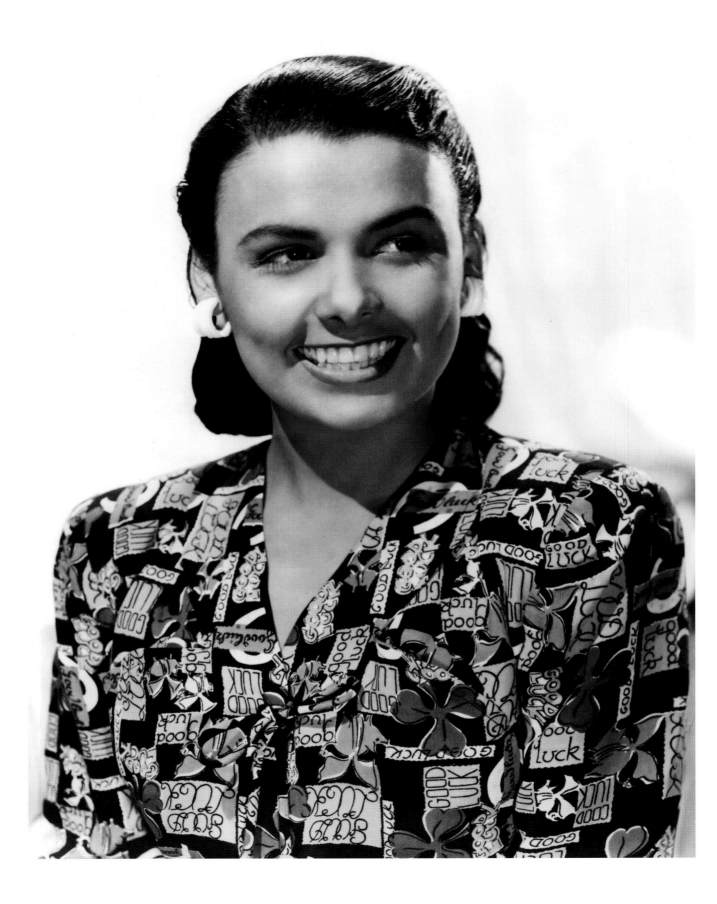

CHAPTER 4

ON HER OWN

In New York, Lena checked into uptown's Theresa Hotel, known as "the Waldorf of Harlem." The top-of-the-line establishment for African Americans in New York, the hotel had been constructed between 1912 and 1913 by German stockbroker Gustavus Sidenberg, who named it after his wife. Originally, it was a whites-only establishment, but after it was bought (in 1937) by Black businessman Love B. Woods, it opened its doors to African Americans. Now at the Theresa, excitement and glamour were always in the air—its lobby bearing witness to the glittering parade of personalities who were residents or were visiting guests that included over the years the likes of Duke Ellington, Josephine Baker, Joe Louis, Dinah Washington, Dorothy Dandridge, Ray Charles, Malcolm X, Muhammad Ali, and Fidel Castro.

Once settled in, Lena wasted no time in making a mad dash to locate friends or associates who might help her secure work. Harold Gumm did what he could but without much success. The producer George White suggested she pass as Spanish. Her sound didn't seem Black enough, nor her look. She found Noble Sissle, but he had nothing for her. When she located the choreographer Clarence Robinson, formerly of the Cotton Club but now at the Apollo Theater, she was heartsick when he said he had no path for her either. But through agent Harold Gumm, she appeared in a benefit at the Apollo, mainly in hope of being seen. She went over well.

Still, nothing was really happening for her. A few days after the Apollo performance, she slipped into an uptown movie theater—the Victoria—in need of some escapist entertainment "to lose myself in someone else's tears." Years later, she would still remember that the movie was the 1931 melodrama *The Sin of Madelon Claudet*, starring Helen Hayes as a woman released from prison for a crime she did not commit and who turns to prostitution. "I remember thinking resentfully that with all her troubles she didn't know what real heartache could be. She was white, wasn't she?" In that very theater, she noted a bit of a hubbub when who should be searching

for her amid the patrons but Clarence Robinson, who had learned she had gone there. "Come on, Lena! I've found you a job!" He informed her that the bandleader Charlie Barnet's girl-singer had taken ill, and that he needed a last-minute replacement for that evening's performance. She must go immediately, Robinson told her, to see Barnet at the Windsor Theatre in the Bronx.

Both Lena Horne and later her adult daughter Gail have said the first words to come out of Charlie Barnet's mouth when he saw Lena—completely unaware of why she wanted to speak to him—were: "Wow! Who are you?" Upon learning that she was interested in replacing his girl-singer, he asked her to wait until he completed his scheduled show. Afterward he had her sing for him, and then said he wanted her to go on with his band during the next show *that night*. Her voice was good enough. But as struck by her beauty as everyone else, Barnet understood that patrons would simply welcome the opportunity to gaze at her.

Radiating a fresh and wholesome quality.

Smooth and polished, Barnet was a white bandleader who played the saxophone and would later be known for his hits "Cherokee" and "Skyliner." Born in 1913, he came from a wealthy family with a grandfather who was a railroad executive and a banker. Educated at boarding schools, Barnet decided early that, contrary to his family's wishes that he become a lawyer, he wanted to be a musician. He pretty much lived by his own set of rules—and was said ultimately to have had eleven wives!

At various times, his band was integrated with such Black musicians as Roy Eldridge and John Kirby. To hire a Negro girl-singer to stand in front of the band as she performed could cause complications when the band toured the South, or frankly, even parts of the North and Midwest. Billie Holiday had had such problems when she had been the singer for the white band of Artie Shaw in 1938. But Barnet didn't seem to have great worries about it.

Performing with Barnet, Lena recorded two successful songs: "Good for Nothing Joe" and "Love

Me a Little." When Barnet's band toured the South, Lena was nowhere to be seen. She was left behind, but Barnet kept her on salary. His attitude? It wasn't her fault that the "crackers" would have their feathers ruffled and be foolish enough not to appreciate her.

Enjoying her time with Barnet, Horne realized that she could not stay with the band for a long time. "I knew enough about men to accept the fact that proximity in itself is likely to encourage advances. And, further, that of a given number of normal young men, a certain proportion is sure to get ideas about any women with whom they are thrown in constant contact. So I was well aware that it was quite likely some of the bandsmen would make passes at me. And I knew, too, that my appearance with a white band was sure to arouse gossip among my own people." But what of the rumors about her relationship with handsome, amiable Barnet himself? Said Gail: "Lena *never* kissed and told, so I have no idea if she had a romance with Barnet, but he was apparently a very likable guy, with no racist attitudes, and she always smiled when she spoke of him." Still, weary of traveling *and* of the guys in Charlie's band, Lena was now set on going out on her own.

When Lena returned to Pittsburgh to pick up almost three-year-old Gail, her daughter had not seen her in six months. Still at loose ends as to where they would live, she took her father's advice that she move with Gail to the house on Chauncey Street in Brooklyn.

When she informed Charlie that she was leaving the band, he was disappointed but

A new style, a new fashion statement.

also understanding. Barnet suggested that before going on her own she should perform with him at the Paramount Theater, a prized venue. There, she had a hugely successful engagement and was seen by an array of figures in the music world, including music producer John Hammond. Like Barnet, Hammond came from a well-to-do family and was under the sway of popular music—jazz and swing—from an early age. Going against family tradition, Hammond decided not to attend college and ended up producing the last recordings of Bessie Smith in 1933. That same year he produced the first recordings of a singer whose talents amazed him: the very young Billie Holiday. Knowing talent when he heard it, Hammond had a long career in which he would record other great stars of the twentieth century, from Aretha Franklin to Bob Dylan. Though he didn't appear overwhelmed by Horne's vocal skills—Horne said he thought she couldn't sing a lick—he could not take his eyes off her.

John Hammond was scouting for fresh talent for a friend, Barney Josephson, who had opened a very smart and popular club in New York's Greenwich Village. Hammond told him: "There's a girl singing at the Paramount with Charlie Barnet. You should see her."

Tough-minded and politically to the left, born in 1902 in Trenton, New Jersey, the son of immigrants from Latvia, Josephson was a onetime shoe store employee who loved jazz. Using $6,000 he borrowed from friends of his brother, he created Café Society in the basement of a building at 2 Sheridan Square. In 1938, the club opened with Billie Holiday, who there introduced one of her signature songs, "Strange Fruit," the haunting tale of a southern lynching that injected social and racial content into

Always fashion conscious in the 1940s.

popular music. The song hit New York sophisticates and the intelligentsia with a wallop. Other illustrious names followed: Sarah Vaughan, Sister Rosetta Tharpe, Big Joe Turner, Mary Lou Williams, Art Tatum, Josh White, the young pianist Hazel Scott, Zero Mostel, Jack Gilford, Carol Channing, and Imogene Coca also appeared at the club.

Having detested the segregated clientele policy at the Cotton Club, Josephson said: "I wanted a club

where Blacks and whites worked together behind the footlights and sat together out front . . . there wasn't as far as I know, a place like that in New York or in the whole country." Gathering in the club was a motley assortment of prominent artistic, political, and intellectual figures of the age, from Paul Robeson to Eleanor Roosevelt, Budd Schulberg, Lillian Hellman, Clare Boothe (Luce), S. J. Perelman, and others. Thus Café Society became a watering hole among the accomplished, the moneyed, the privileged, *and* also the seemingly ordinary working people. Nightly, the conversations were lively and highly informed. Perhaps there was some pretentiousness, but the idea also was not to get too high on your high horse. The main reason for being there was to have fun while enjoying the parade of remarkable talents.

Writer Helen Lawrenson said the club actually started as a fundraiser for the Communist Party. That would later get the owners into trouble. But nobody cared about that initially. As liberals and progressives flocked to Café Society, it was known as "the wrong place for the right people." That was the slogan that Lawrenson, who did publicity for the club, coined. It "was printed on our matchbooks and used in our ads." "It was the most exciting nightspot in town and the proving ground for more remarkable talent than any similar place before or since." It was where performers of the highest caliber got their start, said Lawrenson. "I don't mean it was the first job any of them had, but it was what made them famous."

"The person responsible for the club's success was John Hammond Jr., a crew-cut young man still in his twenties, who found us the musical talent that was to become legendary," said Lawrenson. "No one had heard of Billie Holiday except Hammond,

who first heard her singing in an obscure dump and knew she was the greatest thing since Bessie Smith." Lawrenson added: "Lena Horne had made it as far as the Paramount movie theater on Broadway, where she was singing with Charlie Barnet's band, but Hammond made her a star by bringing her down to Café Society."

Upon hearing her perform, Josephson, with his enthusiasm mainly for blues and jazz, realized such musical genres were out of Lena's range. When she sang "Sleepy Time Down South," he asked her if she knew the meaning of the lyrics. Lena knew something about life in the South, from her childhood experiences. But she was fundamentally a die-hard "Brooklyn girl," and Barney felt immediately she'd have to sing other material. Nonetheless, he ended up hiring her and never regretted it. She sang the standards in a way that was new for a Black singing star. Ethel Waters could do it, too, but she brought a bluesy tone to her pop music. She also effortlessly invested her music with an emotional level that it would take Lena some time to attain.

Lawrenson recalled the occasion when she first met Horne, who some believed looked like a young version of Lawrenson's stunning mother. "The similarity would have been due to the Indian blood in both women. Lena had long black hair hanging below her shoulders and a sort of old-fashioned classic face. This was before Hollywood makeup men glamorized her and made her into the ravishing beauty she became."

The critics loved her. The publication *PM* reported "that Lena Horne (then Helena), talented Negro songstress, was hauling them in at Café Society Downtown and thereby making the management of that bistro very happy."

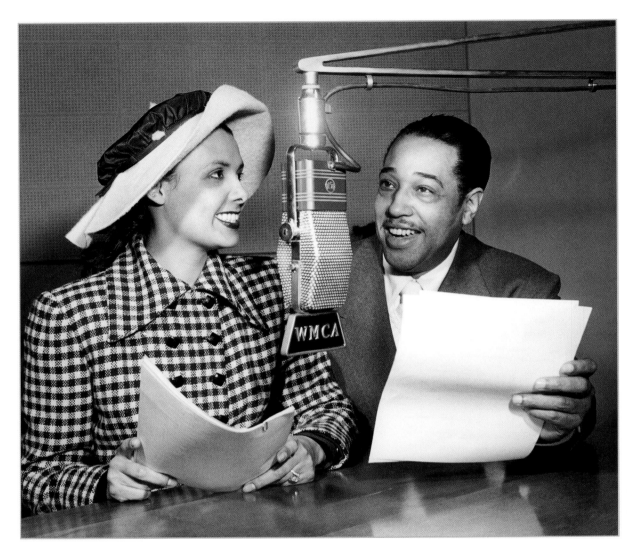

Friend and colleague Duke Ellington would be in and out of her life.

Working at Café Society expanded Horne's vision—of herself, of the world, of her own talent. She explored new musical techniques, including the masterful style of Teddy Wilson, who led the orchestra at Café Society. The young diva of music whom she grew fond and protective of was the troubled Billie Holiday—drawn as much to the singer's vulnerability as she was to her talent. "She was not, even then, as tough as I was," said Horne. In time, she would also respond to the music of Dinah Washington, who personally had a toughness that Horne must have found admirable. Ella Fitzgerald had also long been on Horne's radar. But she understood the unique styles and approaches to music of these women were totally different from her own.

Also among the many people at the club with whom Lena socialized was Duke Ellington, whom she knew from the Cotton Club, and it was possibly

around this time that she and Ellington had a romantic fling, nothing earth-shattering or madly passionate. But he was indeed glamorous and highly sought after, always immaculately dressed, and always conducting himself with impeccable manners. Known for romancing one beautiful woman after another, Ellington remained married to a woman he rarely saw, yet whom he would not divorce. The marriage became a strategic "line of defense" that enabled him not to fully commit to another relationship. Lena remained friends with Ellington over the years, but she was clear-eyed about the relationship and Duke's attitudes about women. "Duke saw me . . . as a sex object," she said.

But none impressed or influenced her more than Paul Robeson, who frequently dropped by Café Society in the early 1940s. One night Robeson spoke to her in her dressing room. He felt a connection to Lena because her grandmother had been so helpful in getting him a scholarship. Horne opened up to Robeson, expressing the tensions of show business, and as was later reported, "the racism she faced from the white establishment and the disdain she heard from Black people who accused her of 'trying to pass.' Robeson kept listening."

She told Robeson of her resentment with her "own people because I saw them pushed around and taking it. I hated whites for pushing them," she said. But one night at Café Society, Robeson "changed my whole way of thinking—if I may say so, my whole life. He knew how mixed up and miserable I was and he took the trouble to talk to me a lot. I got some idea of the greatness of our people. I

Paul Robeson, a towering artistic and political force whom Lena idolized.

learned why they were being pushed around and how big a people we Negroes can be if we learn how to see things clearly and fight."

"Finally, he exhorted her to devote her life to making the country a better place, to eradicate her pain by helping people everywhere," commented writer John Meroney. Robeson named specific groups, such as the Council on African Affairs and the Joint Anti-Fascist Refugee committee. Horne later said that though she was unfamiliar with the organizations, she "took Robeson's advice and signed up." It marked a political awakening.

Robeson's biographer, Martin Duberman, also reported that a Robeson friend and the executive secretary of the National Negro Congress, Revels

Cayton, said that Robeson once told him he had an affair with Horne. But he broke it off because Horne wanted him to marry her. Whether this story is true remains a mystery. But Horne herself told Duberman it was untrue. "It would never have occurred to me to be physical with him—he was too mythic."

Nonetheless, Café Society was an educational experience for Lena as a singer and as a future activist. She was more influenced by her grandmother than she had realized.

Lena's time at Café Society proved to be an unexpectedly sweet period of contentment. She earned $75 a week, lived with Gail in the house on Chauncey Street, and nightly took the subway back and forth from Brooklyn to the Village. Patrons at the club were enthusiastic. Everyone assumed they were discovering her. Radio performances exposed her to even more audiences.

Also sitting in the club one evening—and no doubt other evenings that followed—was a visitor from the West Coast, Roger Edens, of the illustrious Arthur Freed Unit at MGM Studios.

"Lena Horne Hitting the Big Time in New York; Gets Radio Contract" was the headline in the May 17, 1941, *Pittsburgh Courier*, which reported on her "song series on the WOR radio outlet Sunday evenings." On July 5, the paper reported on recording sessions at the Victor studios, including one with Artie Shaw. "The famed clarinet maestro was so impressed by her work when he visited Café Society downtown, where she is featured recently, that this session was the result."

Of course, there was more to the story than was reported. Well known for his 1938 hit recording of Cole Porter's "Begin the Beguine," clarinetist-composer-bandleader Artie Shaw was not only a skilled musician but a highly intelligent and well-read intellectual—an author of both fiction and non-fiction books. Born in New York, Shaw was proud of his knowledge *and* of his appreciation of beautiful women. In total, he would have eight wives, one of whom was Kathleen Windsor, author of the huge bestseller *Forever Amber*, whom he married in 1946. Four wives were Hollywood actresses: Lana Turner (in 1940), Ava Gardner (1945), Doris Dowling (1952), and Evelyn Keyes (1957). Each of the women found him captivating. Shrewd fellow that he was, he wooed them with his intelligence and with his well-known reputation as a stud, but in time Shaw's debonair appeal wore thin. For as long as she could take Shaw, Gardner was "entertained" by his behavior—until she finally had enough of his emotional domination. Turner was said to have had a breakdown because of his treatment. The exceptionally shrewd Keyes was probably the one who was a match for Shaw on many levels, but even she couldn't stay married to him.

Having been so protected by her mother, Horne was not yet knowing of the ways of the world or of the inner workings of a man like Shaw. But she found him challenging and surely a different and distinct presence in her life. When she recorded "Don't Take Your Love from Me" and "Love Me a Little," Shaw performed on the recordings and brought in such fine musicians as Benny Carter on alto sax, Henry "Red" Allen on trumpet, and J. C. Higginbotham on

Ready to announce herself to the world.

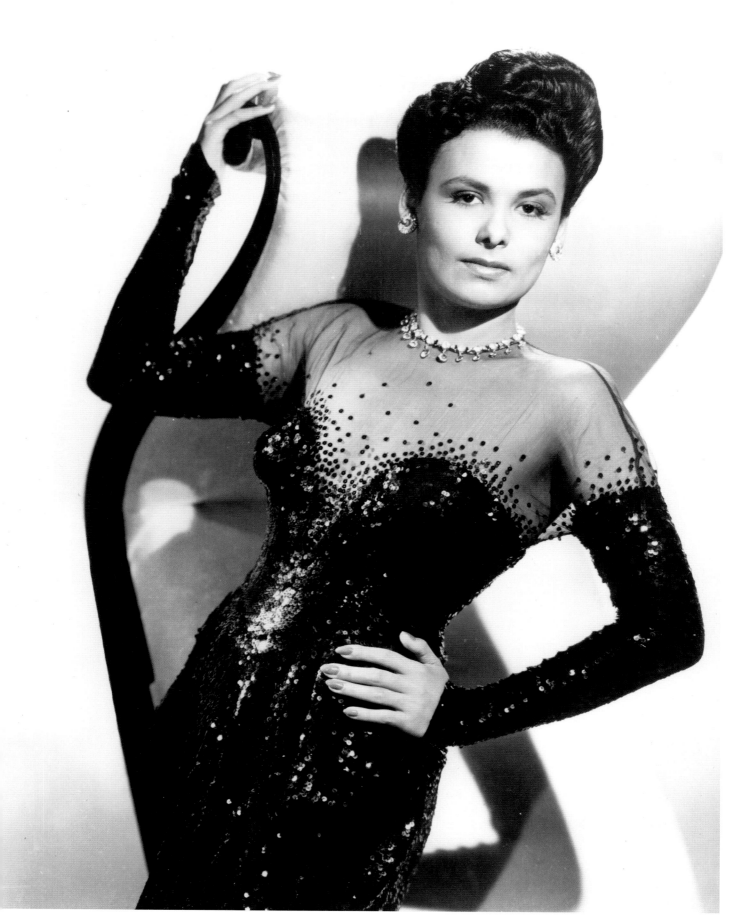

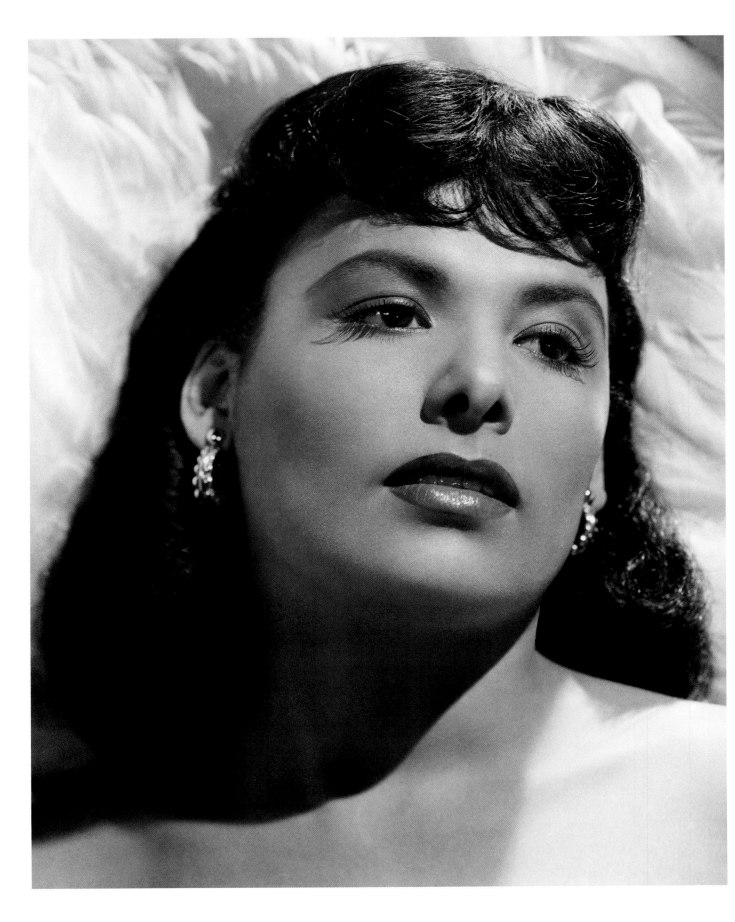

trombone, along with a four-man jazz rhythm section. It was top of the line all the way for Lena. But the recordings were not a great success.

She couldn't resist Shaw. Nor could he resist her. They fell into a passionate love affair. Together they were a powerfully sexy couple, but it's doubtful that either thought of a long-term commitment. That affair no doubt was both a personal and professional alliance. Lena saw no reason to discuss him. But if pressed about the relationship among friends, Shaw eventually openly discussed it.

The early 1940s in New York continued to be exciting for Horne. In 1941, she also appeared in the short film *Boogie-Woogie Dream*, which featured pianists Pete Johnson and Albert Ammons along with Teddy Wilson and his orchestra.

She was having her first brush with the big time. As word spread about the engagement at Café Society, Harold Gumm fielded offers for other appearances, including one from Felix Young in Los Angeles. The owner of a chic Los Angeles supper club, Le Papillon, Young wanted Horne to perform at a new club he planned to open, the Trocadero. Also on the bill would be Ethel Waters, Ellington, and Katherine Dunham with her dance company.

The idea must have appealed to her immediately—which was apparent when musician Phil Moore saw her one evening while on a visit to New York. Moore, whom Lena had worked with while making *The Duke Is Tops*, remembered he ran into her at Café Society Uptown—a second club that Josephson opened following the success of the original. "One night I was at the Café Society Uptown to

Café Society patrons were so startled by her looks that it took time to listen to her sing.

hear and hang out with the Count Basie Band that was playing there, when in walked one of the most lovely, dynamic women I had ever seen," recalled Moore. "I had not heard her, but she was singing at the Café Society Downtown, and Barney Josephson had brought her uptown after work for me to meet. Damn, she was a knockout. Gorgeous face with Egyptian fresh honey and almond complexion and nice neat little freckles, flashing intelligent eyes, fondable nearly straight hair, irresistible promising smile, fascinating mouth with fresh snow-white teeth for days, and a sculptured groovy figure. She had class to spare that was not affected, just there. The great thing about this lady was that the whole added up to about ten times the total of the components. On top of that she looked familiar."

"Phil, I'd like you to meet Lena Horne."

"Aren't you the guy that wrote the music for *The Duke Is Tops?*" she asked.

"Helena!" he exclaimed.

"I was really amazed at the transformation from her being a new mother to the way she now looked," he remembered. "Well, in L.A. I would have been shy and hung back, kinda ashamed and embarrassed at not recognizing her, but in New York we embraced like long-lost cousins."

Moore was different from many men Horne had met in the business. Cultivated and brainy, he had grown up in Portland, Oregon, the adopted son of a gambler, George Moore, who provided him with advantages denied many, Black or white. The story was that Phil, born in 1918, was actually George Moore's biological son by a relationship outside his marriage. But Moore and his wife—whom everyone called Jimmie—took the boy and raised him. The older Moore helped manage boxer Henry Armstrong

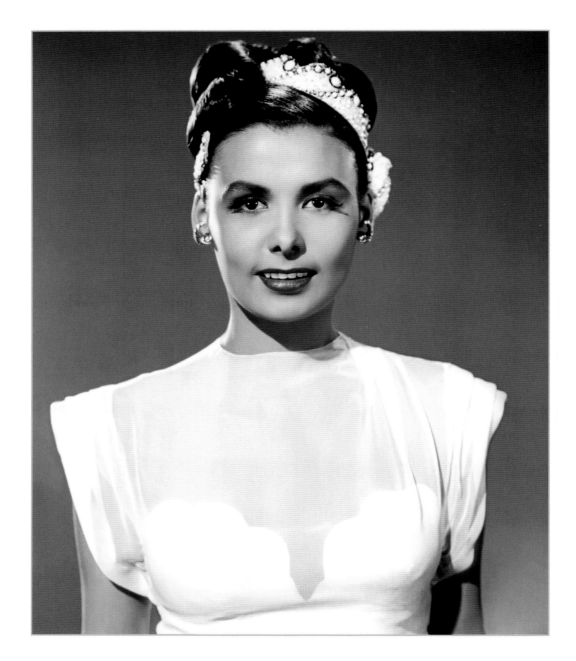

and was an investor in the hit Black musical *Shuffle Along*. Thus, he was financially well-fixed. Young Phil was educated. A child prodigy, at age twelve he debuted on piano with Portland's junior symphony; at thirteen, the kid played in speakeasies. He studied at the Cornish School and the University of Washington in Seattle.

In the 1930s, Moore moved to L.A. He worked on *The Duke Is Tops* and also MGM's *A Day at the Races*, starring the Marx Brothers, with a Black musical sequence that featured Ivie Anderson and the young trio the Dandridge Sisters—Dorothy, Vivian, and a family friend, Etta Jones. Previously, he had created material for the trio. Freelancing at

such studios as RKO, Columbia, and Paramount, he later provided music for the films *Palm Beach Story* (1942), *This Gun for Hire* (1942), and *My Favorite Blond* (1942) but rarely received credit. Though he was a bit on the heavy side with a receding hairline and hardly a handsome hunk in the manner of singers Billy Eckstine and Herb Jeffries, women nonetheless found Moore quite attractive. Perhaps it was his intelligence and the shrewd way he could detect talent and knew what to do to best showcase that talent. Often he smoked a pipe, and some might have found him pretentious. But no one could deny his creativity. Since Horne had last seen him, Moore had been able to break the color barrier at MGM, which hired him, along with African American musician Calvin Jackson. In 1941, Moore functioned at the studio primarily as a rehearsal pianist, a position he used to work his way up in the system. Later, leaving MGM, he became an important composer and arranger who worked with Frank Sinatra, Bobby Short, and Les Hite. He wrote "Shoo Shoo Baby," which was a hit for the Andrews Sisters and Nat "King" Cole. As a vocal coach, he worked with Marilyn Monroe, Ava Gardner, Joyce Bryant, Martha Raye, Ina Ray Hutton, and Mae West.

Of that night in New York, Moore remembered: "We all decided to go to Monroe's up in Harlem and hear some music. Basie, Lena, me, and a bunch of guys went and had a ball." It was memorable for another reason. Said Moore: "Way late in the morning, Lena leaned over the table and asked me: 'Next time I come to California, will you write some arrangements for me?'"

Speaking of himself, Moore recalled: "A pretty wasted Phil said, 'Oh sure, Baby . . . sure.'"

Whether the West Coast offer had actually come at the time of the meeting with Moore remains unclear. Regardless, California was on Lena Horne's mind.

When she informed Barney Josephson of her decision to accept the engagement at Young's club in Los Angeles, he was vehemently opposed to the idea. A true New Yorker and rather dismissive of Los Angeles, Josephson believed it a terrible career move. He also took her decision to leave New York personally. No doubt he had decided she was *his* discovery. Horne said he remained angry with her for some time. Others had a similar attitude. Why should she leave New York now, just as her career was on the upswing?

Nonetheless, her mind was made up.

Arrangements were made to leave the home on Chauncey Street. Her cousin Edwina—the daughter of Cora Calhoun Horne's sister Lena Calhoun Smith, whom Lena was named after—would accompany her to care for Gail and take charge of the new Horne residence, wherever that might be.

In a short time, the three boarded the Twentieth Century Limited in New York, which carried them first to Chicago. There they changed to the connecting Super Chief, which carried them to Los Angeles's Union station. Gail Lumet Buckley said that her mother didn't understand at that time that stars always left the train in Pasadena—*before* it arrived in Los Angeles. But Lena was now on new terrain—with new attitudes and values, new modes of behavior. Though perhaps apprehensive, she appeared eager to see what the future in the entertainment capital would bring.

Later the *Pittsburgh Courier* ran a picture of her under the banner: LENA HORNE OFF TO HOLLYWOOD!

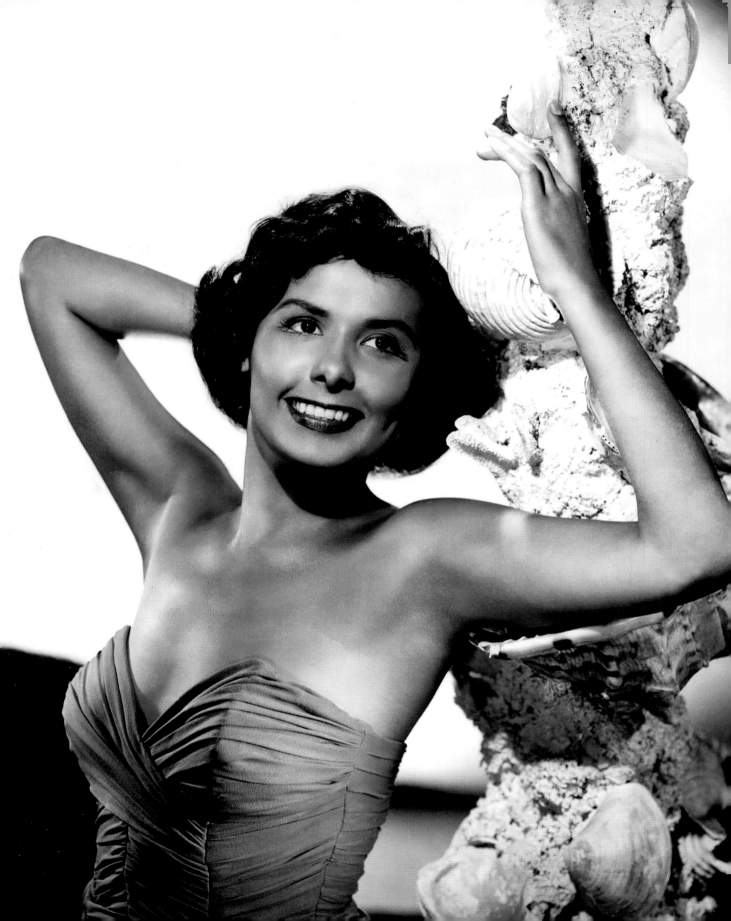

NEW SINGER IN TOWN

Newcomers to Los Angeles were almost always struck by the bright blue skies, the endless sunshine, the swaying palm trees, and the wide-open spaces. There were flatlands but also the foothills and mountains, valleys, and canyons, with vegetation distinct to the city—the enticing aroma of eucalyptus, the clinging bougainvillea. For those coming from the northeast, Los Angeles was a place without the congestion, the grime, the hectic pace they had left behind. "Once there was a time when there were no freeways or superhighways in California," recalled Phil Moore. "The roads, though not heavily trafficked, were pretty narrow and slow going . . . Every Jell-O flavor of citrus fruit orchards lined the roads almost right to the city limits." He added: "I don't recall any smog, only remember super clear crystalline air that made the high mountains circling the Los Angeles basin seem like you could reach out and run your hands through their . . . trees." Moore remembered that Los Angeles still had undeveloped areas with avocado groves and lemon and orange trees. "The lovely aroma of orange blossoms was nearly overwhelming . . ."

Los Angeles no doubt impressed many as a kind of paradise with the pulsating promise of more sunny days to come, more vistas, more opportunities. The city exuded a dreamy romanticism. Even in the 1940s, it was not hard to understand how early filmmakers were drawn to California and soon laid down stakes to remain there.

Arriving in the summer of 1941, Lena Horne, however, was not as seduced by this new city as others. She knew next to no one. Nor did she understand the layout of the city. She had to learn east from west, north from south. Just navigating her way around this sprawling metropolis could be perplexing, daunting, even draining. Los Angeles

California casual.

was also bound by racial codes and demarcations distinct unto itself. Geri Branton (then Geri Nicholas), the young wife of Fayard Nicholas of the famous Nicholas Brothers, remembered her feelings upon her arrival in the city around the same time as Lena. Having been born in Tennessee and having lived in New Orleans before meeting her husband, she was familiar with Jim Crow restrictions. But she was surprised by what she found on the West Coast. "Los Angeles was a segregated city. Totally segregated," she said. No signs were around that said "For White" and "For Colored." "But there were places you knew you shouldn't go—where Blacks were not welcomed." Initially, African Americans lived on the east side of the city and eventually pushed the boundaries westward. But moving outside the designated areas could be hazardous.

During her first visit to the city three years earlier, Lena had found comfort in the home of Lillian Randolph, and her world had been primarily within the boundaries of the old Black Hollywood. Now her situation would be different. Fortunately, she did not have to find a place to live. Felix Young had arranged for Lena, Gail, and Edwina to stay in one of his apartments on *Horn* Avenue, which was perched on a steep hill above Sunset Boulevard. Right away Lena drew attention from other residents on the block, some of whom wanted her out of the neighborhood.

Adding to her anxieties was the delay of her West Coast debut. Felix Young's new club was far from complete. "There had been a fire," said Phil Moore. Young had to construct a new nitery which ultimately would be smaller and more intimate than the one that had initially been planned—and which would be called the Little Troc. But that would take time to come to fruition, too.

Waiting for the completion of the club, Lena was often lonely as she set out to find her way around the city. At the time, she did not drive and refused to learn, opting instead to take taxicabs. Clearly, a Black Hollywood community existed, composed of Black actors and actresses, singers and dancers, and musicians who worked in movies in supporting roles or bits, who knew one another and socialized and partied together. Of course, they lived in the same areas, still confined then to the east side. Black Hollywood's main thoroughfare was Central Avenue with its shops, restaurants, nightclubs, and the Dunbar Hotel, which was much like Harlem's Theresa Hotel. The Dunbar was the gathering place for the talented and the diverse, sometimes just for people who wanted to be around the magic. The vitality of Central Avenue

Adjusting to the Los Angeles lifestyle.

and the Dunbar was palpable. Studio talent scouts were seen at haunts on the east side on the lookout for singers, dancers, and comics. Some daring big-name stars—such as Tyrone Power, Cesar Romero, Rita Hayworth, and Ava Gardner—ventured east to see the entertainment in the Black clubs. Generally, some white stars could be open and liberal-minded. It was always the studio executives who felt they had to maintain the racial status quo. Sometimes, too, white gossip columnist Hedda Hopper, who had no apparent problem with some African American personalities, was very opposed nonetheless to what was known as race-mixing. Lena was being exposed to some of these aspects of Hollywood culture;

others she would come to understand as her stay in Hollywood continued.

In the summer of Lena's arrival, Duke Ellington had a much-discussed new show, *Jump for Joy*, that opened on July 10, 1941, at the 1,600-seat Mayan Theater. An all-Black musical that satirized some of the racial attitudes in the entertainment world, it was an "attempt to correct the race situation in the U.S.A. through a form of theatrical propaganda," said Ellington. The show "would take Uncle Tom out of the theater and eliminate the stereotyped image that had been exploited by Hollywood and Broadway and say things that would make the audience think." Among the musical numbers was

"Uncle Tom's Cabin Is a Drive-In Now." An array of talents contributed to *Jump for Joy*. Among the investors were producer Joe Pasternak and actor John Garfield. Contributing lyrics for the show's music were Langston Hughes, Mickey Rooney, and Sid Kuller. Musical arrangements were by Ellington, Billy Strayhorn, and Hal Borne. In the all-star cast were Marie Bryant, Wonderful Smith, Paul White, Avanelle Harris, the comic trio Pot, Pan, and Skillet, and later Big Joe Turner. Lena knew Bryant and Harris from *The Duke Is Tops*—and Turner from Café Society. Of them all, she was especially happy to become reacquainted with Bryant. Headlining the cast were heartthrob singer Herb Jeffries (the baritone who would set women's hearts pounding with his rendition of "Flamingo") and a fresh-faced beauty that Black L.A. was already assuming might have a real movie career if the studio system opened up, the teenage Dorothy Dandridge. "The Negroes always left proudly, with their chests sticking out," said Ellington. *Jump for Joy* marked a change in Hollywood's Black images that Lena would very soon be an integral part of.

Ellington arranged for Lena to see *Jump for Joy*—and even selected an escort who would meet her at the theater, his young collaborator, Billy Strayhorn. An arranger, lyricist, pianist, and, most significant, composer, Strayhorn was known in music circles as the young man who stayed out of the limelight while he quietly contributed to such Ellington compositions as "Take the A Train," "A Flower Is a Lonesome Thing," and "Chelsea Bridge." He was also the composer of the haunting "Lush Life." Later he collaborated with Ellington on the score for Otto Preminger's 1959 film *Anatomy of a Murder*. Born in Dayton, Ohio, in 1915, Strayhorn had grown up

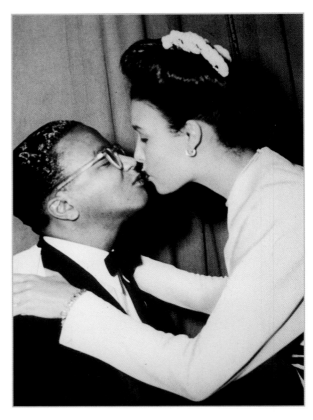

Lena with Billy Strayhorn, the man she felt was her soul mate.

in Pittsburgh. But during his boyhood, he also spent time with his grandparents in Hillsborough, North Carolina. His mother would send him there to avoid the outbursts of his alcoholic father. Strayhorn had seen Ellington perform in Pittsburgh in 1933, then met him in 1938. Thereafter he and Ellington created together for almost three decades. He was important in the composition of such songs in *Jump for Joy* as "Rocks in My Bed," "Uncle Tom's Cabin Is a Drive-In Now," and "Cindy with the Two Left Feet." But he received no credit except as a co-author of "Bugle Breaks," for which the copyright was shared among Strayhorn, Ellington, and Duke's son, Mercer Ellington. Ellington later said: "Billy Strayhorn was my right arm, my left arm, all the eyes in the back

of my head, my brain waves in his head, and his in mine."

Horne was sitting in the Mayan Theater when Strayhorn appeared. Soft-spoken and unassuming with a round face (like an owl, said Horne at one point; like an elf, she said another time) and large spectacles, he quietly stated: "Miss Horne, I've been commissioned by Mr. Ellington to keep you company. My name is Strayhorn." Horne was immediately curious *and* entranced by the man known affectionately as Swee Pea. Why had Ellington selected Strayhorn as her escort? "He wanted to make sure that no other man came after me, so he arranged for Billy to be my chaperone. He assumed that Billy was safe, which I guess he was in the way that Duke saw me, which was as a sex object." Strayhorn was openly gay, which was unusual for musicians of that period.

Though Horne rarely gravitated to people immediately, her relationship with Strayhorn was an exception. "For me, it was as if my other self came up and spoke to me—we were that much in sync." Said Ellington: "When I introduced Strayhorn to her, they immediately recognized their affinity as kindred spirits."

Though the two discussed a multitude of topics, interestingly, Horne never publicly commented on *Jump for Joy*'s star, the young Dandridge, who, after a long but steady climb, would emerge later—according to the Negro press—as Lena Horne's only rival in Hollywood.

When *Jump for Joy* concluded that evening, Strayhorn accompanied Horne to her apartment. She remembered that this was unusual for her—someone taking her to her residence. But she desired neither the evening nor their conversation to come to an end. She felt secure with him. That night he played his composition "Lush Life" on her piano. Strayhorn was from Pittsburgh, so there was discussion of the city. In Pittsburgh, he had first taken piano lessons from Charlotte Catlin, the very woman with whom Lena had performed during the time of her troubled marriage. She became aware of his curiosity about life and people and events, about art, about the way the world worked. "We talked about everything," she remembered of that night and the times to follow. "He was brilliant but gentle."

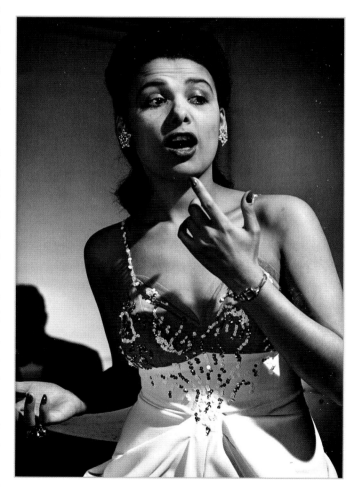

Rehearsing while awaiting the opening of Little Troc.

With him, she didn't feel the outsider as she had so much of her life.

Following that evening, she spent time with Strayhorn exploring Los Angeles. She remembered clubs like Billy Berg's and the Capri, where jazz lovers rhapsodized over the sounds, and visits to museums and restaurants. His presence helped her ward off her loneliness in the city. She had discovered her soul mate, as she would later describe Strayhorn.

Strayhorn helped anchor her—professionally and personally. But for the time being, Lena was at loose ends.

Then on Sunday, December 7, 1941, Lena Horne and the rest of America were stunned to hear the news that the Japanese had bombed Pearl Harbor—and some 2,400 Americans had been killed. President Franklin Delano Roosevelt proclaimed it was a day that would live in infamy. Immediately, America mobilized into action. Already with the war having started in Europe—when Hitler's troops invaded Poland in 1939—and with the devastation that followed, Roosevelt had begun building up munitions and a defense system to prepare the nation for the fight if the war spread, which it now indeed had.

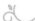

While work on the club was still in progress, Phil Moore searched for ways to supplement his income. "When I first went to Metro my salary wasn't very handsome and we really needed the loot," he recalled. "That's why I would play with my combo at various places up and down the Sunset Strip whenever I got the chance. One day I got a call from Felix Young, who owned a very tony supper club, 'Le Papillion,' located right at the west end of the Strip right at the

Beverly Hills city line . . . Felix asked me if I could come out to meet someone, and talk about some work. A little later I walked into his place and lo and behold there was that young beautiful Lena Horne."

"Felix said Lena had assured him that I would make some arrangements for her—I seem to remember what music she had was burned up in the fire." Moore was flattered by Horne's request that he provide arrangements. But he felt unsure about making a commitment. "I told Lena and Felix that at the moment I really didn't have time to do a lot of extra writing, but if they wanted, I would bring in my trio. I'd play and sketch arrangements enough for her to have a program. In this way, I could write out charts when I had a chance, but in the meantime we'd be working and building her repertoire."

An agreement was reached that Moore and his combo would accompany Horne at the engagement. Moore also noted the pressure that Horne was under. No doubt she needed the income, and she also wanted to perform. Much remained at a standstill.

"It's kinda hard to imagine the Lena Horne we've now known and admired for so many years, once being out of a job, vulnerable, anxious for approval, and scared of what was going to happen, or not happen, next, but at this juncture that's the way it was," said Moore. "I gotta say, she went through this drought period like a champ, and not like a whiner, as I've seen so many times when folks had to pay their dues. Maybe it was because her father, like mine, was a gambler, and she too had seen that winning, losing, and dealing a new hand, were all part of the game called life."

Lena worked with Phil Moore and would continue to do so. He was a master pianist and a master coach. His work with Lena Horne cannot be

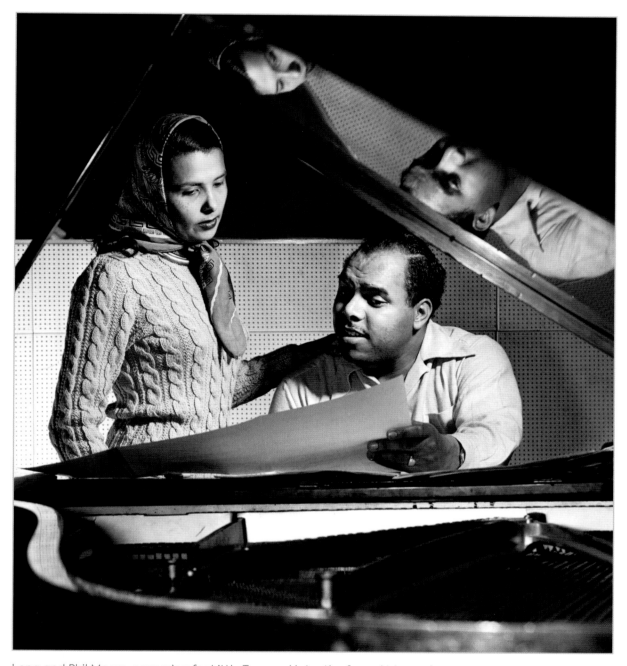

Lena and Phil Moore, preparing for Little Troc and later the famed Mocambo.

underestimated. But Lena also worked with Strayhorn and credited him with new arrangements for "Blues in the Night," "Honeysuckle Rose," "There'll Be Some Changes Made," and "When the Sun Comes Out."

She would perform these arrangements in her show when the club opened.

Finally, the construction of Felix Young's new club was completed, now a smaller, more compact

space than Young had originally envisioned. It was dubbed the Little Troc. No longer were Ellington and Waters on the bill. Now it was Lena, accompanied by the Phil Moore Trio, and Katherine Dunham and her troupe.

In January 1942, the engagement finally began—with all eyes on Lena.

"At first the audience *liked* her," said Moore, "partly because she was so sensual and yet had class, and was the most striking Black woman they'd ever seen. But, as time went on, they *loved* her because she was turning into a great singing entertainer. After a few weeks patrons and celebrities were returning to see her, making encore requests of numbers they liked, and bringing their friends."

The intimacy of Little Troc, however, proved detrimental to the expansive choreography and the sweep of the Dunham dancers. Dunham simply needed a large stage. Eventually, she withdrew from the engagement. But Hollywood had become well aware of Dunham, and in time, she would make appearances in musical segments in studio films.

Yet Felix Young was concerned after he had lost Dunham that he needed a star attraction to keep the club in business. According to Phil Moore, Young considered contacting Josephine Baker about appearing at the club. Of course, *La Ba-Kair*, as the French dubbed her, was also expansive when performing and functioned best in a larger arena.

"Phil, I've *got* to find a headliner!"

"But, Felix, maybe you've got one right here," said Moore.

"Who?"

"Lena. She's becoming the talk of the town. Why don't you check the number of guests you've had lately, and your receipts, and see how well you're doing with just Lena?"

"Felix was desperate, but something phenomenal was happening," Moore recalled. "Though we were 'starless,' business held up and got even better!"

With the club's space working splendidly for Lena, enabling her to perform invitingly with the audience without a mic, Little Troc became a very chic intimate experience, and word traveled fast of the East Coast star now in the West.

Recalled Moore: "People were calling for reservations two or three weeks in advance! 'The rope' stayed up at the club, and it was full of a very selected crowd each night."

Coming through the doors of Little Troc was one Hollywood star after another: Marlene Dietrich, Cole Porter, John Barrymore (whom Lena remembered coming several times), Lana Turner. Even the divine Garbo—one of Lena's idols—was said to have entered Little Troc to see her.

Moore also recalled that Felix Young did not want a crowd exclusively composed of movie stars. He preferred "old moneyed people." Moore also remembered Young ran a very tight ship. "If a dish was dropped in the kitchen during the show, the culprit was fired, right then! Milton Berle to this day probably doesn't know it, but Felix nearly banished him because he would always sit ringside yelling out requests to Lena, and intruding into the show. Mr. Young thought this was very bad taste."

Working to master the art of performing on radio, a medium with demands of its own.

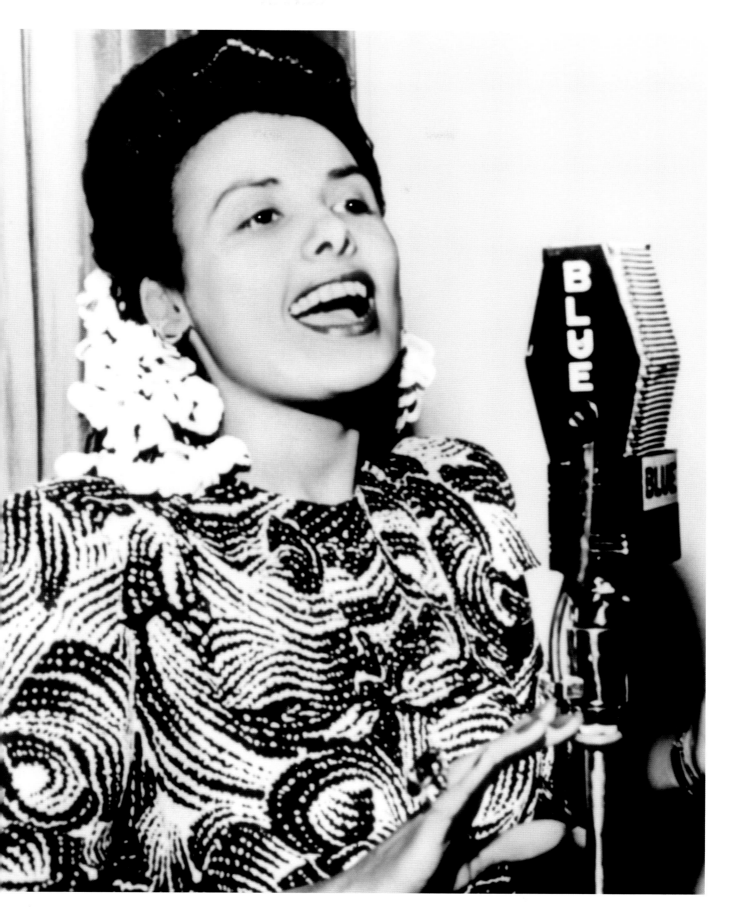

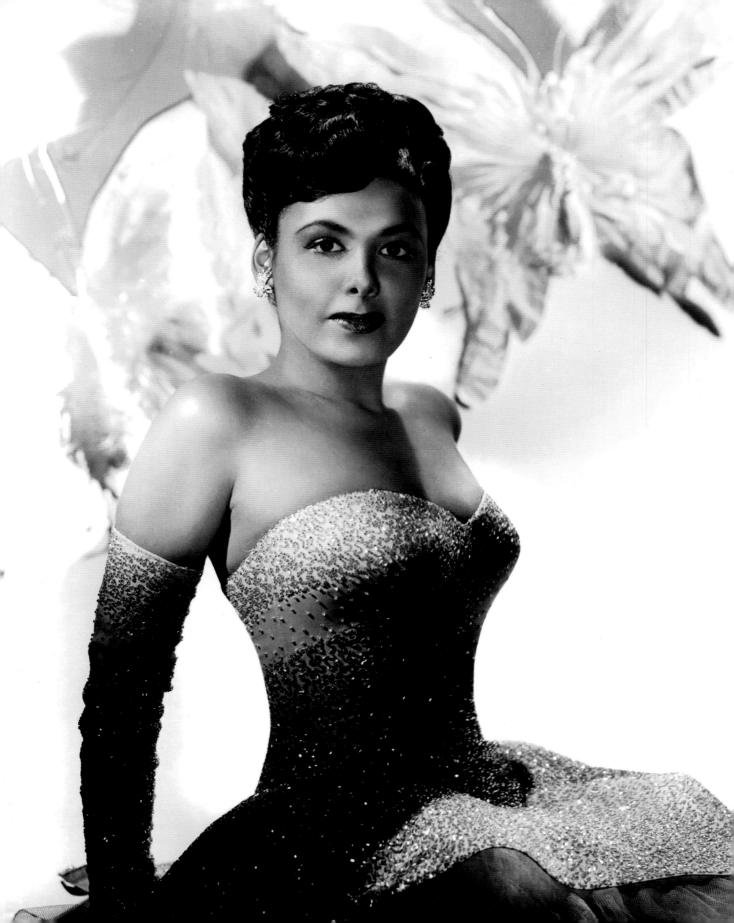

CHAPTER 6

MGM CALLING

Unknown to Lena Horne was that among the many eyes that observed her during her appearance at Little Troc were those of the astute, sensitive Roger Edens, who was an integral member of the Freed Unit at MGM Studios. Led by innovative producer Arthur Freed, the unit consisted of musical artists who created many of MGM's great musicals from the golden age: everything from *Babes in Arms* (1939) and *Meet Me in St. Louis* (1944) to such acclaimed films of the 1950s as *An American in Paris* (1951), *Singin' in the Rain* (1952), *The Band Wagon* (1953), and *Gigi* (1958). Among the unit's topnotch talents were directors Vincente Minnelli, Charles Walters, and George Sidney; as well as composers and/or arrangers Conrad Salinger, George Stoll, Lennie Hayton, Kay Thompson, and others.

Within the Freed Unit, Roger Edens himself stood out as a highly respected composer, arranger, and associate producer who eventually won three Academy Awards. Born in Hillsboro, Texas, he had been a conductor on Broadway and worked with the young powerhouse singer Ethel Merman during the early years of her career. When Merman journeyed to Hollywood in 1932, Edens accompanied her and wrote and arranged material for her at Paramount Pictures. He soon saw the chance at a new career path for himself. On his own, he stayed at Paramount in the music department, and eventually ended up at MGM, where he became vital to the career of the young Judy Garland. In some respects, Edens might be considered an East Coast kind of

fellow who enjoyed the theater, the smart, intimate clubs, the classy singers. He was always on the lookout for the new and unexpected as a way to keep refreshing the American movie musical. Though he was operating in a very commercial environment at MGM, which produced movies for the masses, not the aesthetes, Edens correctly believed that a sophisticated perspective—even one that might be considered *daring*—could enhance the appeal of full-scale, star-driven musicals.

Watching Lena Horne first at Café Society and now on the West Coast, he found her unique, talented, and perhaps a different kind of star for MGM. He pushed hard for the studio to sign her. He also knew that MGM had acquired the movie rights to

Hollywood's most powerful studio, Metro-Goldwyn-Mayer.

in for fifteen or twenty minutes."

In mid-January 1942, Lena Horne arrived at MGM in Culver City, in essence to audition. She was not sure that the meeting would lead anywhere. But she had come to know the mild-mannered Edens better. Not only did she like him, she trusted him. Roger Edens would accompany her on the piano. With his relaxed charm and reassuring manner, Edens put her at ease.

"Instead of fifteen minutes, we were in there for two hours listening to her," recalled Freed. He knew immediately that she was wholly different from any other Black performer—or white one, for that matter—that he had seen. Like everyone else, he found her magnificent looking, which was important from the studio's perspective. He decided to immediately contact studio head Louis B. Mayer. "I called L. B. on the phone and took her up there," said Freed. "I had her sing a couple of songs and L. B. went crazy." Also at the studio that day was actress Marion Davies, who casually wielded influence and power, not only as a major star but as the mistress of powerful publisher William Randolph Hearst. She too was impressed by Horne. A deal was in the making. "So instead of hiring her for one song in a picture," said Freed, "we put her under a long-term contact."

Lena herself remembered it all a bit differently. Everything was moving quickly, really too quickly, and frankly, she felt she needed advice. Though it was never stated outright, Lena Horne—like many

the Broadway musical *Cabin in the Sky*, which had starred Ethel Waters—and which had recently been on tour in Los Angeles. Perhaps Horne might be considered for a role in the movie version; certainly not in the star part created by Waters, but the second female lead.

Edens pressured MGM until finally an appointment was set up, first through Harold Gumm in New York, who in turn contacted the mega-agency of Louis Shurr, who assigned Daniel Melnick to manage her. This maneuver in itself was a significant sign. To have a respected agent—well aware of the intricacies *and* the pitfalls of the movie business—was imperative in negotiating the best deal.

When Arthur Freed was informed by the Shurr agency that there was a great young Negro singer he should see, he was hardly enthusiastic. "Here we go again," he was reported to have said. "I haven't any place for a girl like that right now." But he was urged to reconsider. "Hear her sing a song or two," it was suggested. Finally, Freed relented. "Bring her

Black entertainers who made the move to mainstream stardom out of the clubs and into the studios or major-league theater—found herself operating in an almost exclusively white world. Producers, directors, agents, attorneys, advisers were white. Few African Americans had been able to enter the upper echelons of the entertainment world—to become the people who made decisions—no matter how talented or skilled. Feeling vulnerable and isolated, Lena Horne took an unusual action that no one in Hollywood could have anticipated. "I finally got home that night, and I called my father in Pittsburgh. Real bright, sharp, and beautiful man. I said, 'Would you come out here because these people are crazy. They're talking about putting me in the movies.'" Teddy agreed to fly to Hollywood.

With the head of the Freed Unit, Arthur Freed himself.

Certainly, MGM's Louis B. Mayer must have been taken aback by the request that he meet with Lena Horne's father. Yet despite the fact that Mayer was feared as a tyrant—demanding, ruthless, and insensitive, ready to make or break a career at a minute's notice—he was also known to have a sentimental streak when it came to familial relationships, notably to those between mothers and their children. Horne herself, in public statements, did not seem to object to Mayer at this time. Thus, the door to his office was opened for a meeting with Teddy Horne and Lena, along with representatives by their side.

Horne glowed with pride as she remembered her father's presence that day. "And my dad walks in, and he's sharp. He had on a diamond stick pin and a very conservative dark suit," she recalled. Mayer and Teddy Horne talked. Making it known that he was cognizant of the history of African Americans being consigned to servant roles in the movies, he wanted Lena presented with dignity and class. Horne recalled that her father said, "Mr. Mayer, it's a great privilege you're offering my daughter." But Teddy Horne was insistent that she not be cast as a maid. "I can buy my own daughter her own maid."

"He was just *jiving*," said Horne years later.

But the point had been made. "I don't think he [Mayer] had ever been with a Black man like that." Mayer assured Teddy Horne that Lena would be treated well—and with respect.

At the same time, the NAACP's Walter White developed a keen interest in Lena Horne's burgeoning movie career. A staunch opponent of the movie industry's treatment of African Americans, White had had his fill of the giggling maids, the dim-witted butlers, the parade of nonsensical comic servants who popped their eyes, grinned, or made faces, and performed caricatured antics and shenanigans through one film after another. White was especially perturbed by the roles Hattie McDaniel played. Though she had reached the pinnacle of movieland success with her Oscar-winning performance in 1939's *Gone with the Wind*, he believed her to be detrimental to the call for new roles for African Americans in American motion pictures. In the early 1940s, White traveled to the film capital with Wendell Willkie—the former 1940 Republican presidential candidate who was on the board of 20th Century-Fox—where he met with those leaders who agreed to see him and earnestly spoke of a new depiction of Blacks in films. Mayer was actually aware that roles must change. During the war years, the Negro press also started to urge that Hollywood give Black performers different types of roles. Determined that Lena Horne not play maids, White saw her as part of a new day, ushering in a new image of African Americans in Hollywood. He also sought to integrate more Blacks into technical positions and open up the guilds. When Lena attended the NAACP's 1942 convention in Los Angeles, White told her: "You're our test case, Lena."

"I was just a pawn," said Horne. But, of course, she was altogether more than that.

On January 31, 1942, the *Pittsburgh Courier*—in the *Talk O Town* column by Jule—announced that MGM had signed Lena Horne. It was a seven-year contract. Her salary would be $350

a week for forty weeks her first year; $450 a week the next year; $100 a week raise annually afterward. Other contract stipulations included a cap on her weight: it could not be more than 122 pounds. Otherwise, during the three months of the year she was not occupied at MGM, she would be free to continue her now growing nightclub career. She could also play the Loews theaters (such as the Capitol in New York) at $700 a week. Loews was the parent company of MGM. In some respects, it was a very good deal—though her salary would later be an issue.

Once under contract to the studio, Horne fully realized MGM's immensity and was reminded every time she was driven through the studio's guarded entrance. Founded in 1924, Metro-Goldwyn-Mayer—sometimes referred to simply as Metro—was Hollywood's dom-

Lena with composer/arranger Roger Edens, who brought her to the attention of MGM.

inant studio, at one time releasing fifty films a year. Sitting on 167 acres, it was a sprawling enterprise that seemed like a city unto itself. In addition to its thirty soundstages, MGM could also boast of a zoo (with animals used in the films), a police force (fifty officers with four captains), an in-house electrical plant, a research department, seven warehouses with props and furniture, and a vast back lot used for outdoor scenes with permanent exterior sets that took up thirty-seven acres. The studio even had its own dentist and chiropractor. It owned forty cameras and sixty sound machines. Six thousand people were MGM employees. Its commissary accommodated 2,700 people. Actress Janet Leigh recalled: "It was almost feudal in the way it was so contained. Everything was grown inside. It was a complete city . . . There were people there to teach you acting and singing and dancing. And the people were like family, because everybody was under contract."

MGM boasted that it had more stars than in the heavens. Indeed, over the decades, some of

Hollywood's biggest names under contract to the studio included: Clark Gable, Joan Crawford, Mickey Rooney, Judy Garland, Spencer Tracy, Katharine Hepburn, Ava Gardner, Robert Taylor, Norma Shearer, Lana Turner, Gene Kelly, Frank Sinatra, Jeanette MacDonald, Van Johnson, Jean Harlow, the child star Elizabeth Taylor (who grew up at the studio), Dorothy Dandridge, and the most glorious of movie creations—the divine Greta Garbo. For the 1940s, Horne would be MGM's treasured Black Beauty in Residence, one of the few African American performers then under a major contract.

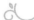

The studio poured its energies into correctly handling her. Makeup tests were in order as no one was accustomed to showcasing a beautiful young Negro woman. In the past, MGM had promoted the Black actress Nina Mae McKinney in King Vidor's all-Black musical *Hallelujah* in 1929. Some care was taken to present her as the beauty she was, yet McKinney looked darkened in parts of the movie and in the publicity stills for the film. Though McKinney made other films, she was never given the full star buildup that she deserved, and she soon faded from the limelight. Then at Universal Studios in the 1934 version of *Imitation of Life*, the very light-skinned, green-eyed actress Fredi Washington was made up much like a white actress, given the fact that she was indeed *that* light-skinned and in the film itself portrayed a young Black woman who passes for white. With Horne, MGM strove to create the right makeup for her—to highlight her skin tones yet to give a relatively natural but glamorous look. The result was a product called Light Egyptian. But it proved too dark. She looked *made up*, not at all natural. In the end, said Horne, the makeup was used only to make white actresses who played exotics, such as Hedy Lamarr in *White Cargo* (1942) intentionally darker. Ultimately, it was decided to use the same makeup on Horne as was used with white actresses at the studio, except of course with a suitably browner base, not an extreme one. MGM's Jack Dawn usually did her makeup.

At the same time, Geri Branton, who became friends with Horne, said that the singer Herb Jeffries—who starred in all-Black cowboy sagas and was also a baritone who performed with Duke Ellington's orchestra—surprisingly, knew a great deal about making up Black stars. Jeffries was a keen observer of skin textures and of color gradations as a way to highlight certain features. He understood that Black women needed a different base and a different application of the makeup. Lena also had freckles that had to be covered. "Herb devised a makeup for her," said Branton, which may have been used effectively in her big nightclub and personal appearances to come. Said Branton: "Herb later did the same thing with Dorothy Dandridge."

Then came the issue of styling Horne's hair. The head of MGM's hairstyling department was the legendary Sydney Guilaroff, who tended to the tresses of everyone from Garbo to Joan Crawford to Ava Gardner. He grew distressed and disturbed by the reaction of his staff. "No one wanted to touch Lena's hair," he said. "No one!" In the end, Guilaroff styled Lena's hair himself. But because he ultimately would not be able to be on set when she filmed, he hired a Black woman named Tiny Kyle to do Lena's hair. Horne developed a warm relationship with Guilaroff and a lasting friendship with Kyle.

The studio experimented with makeup for its future star.

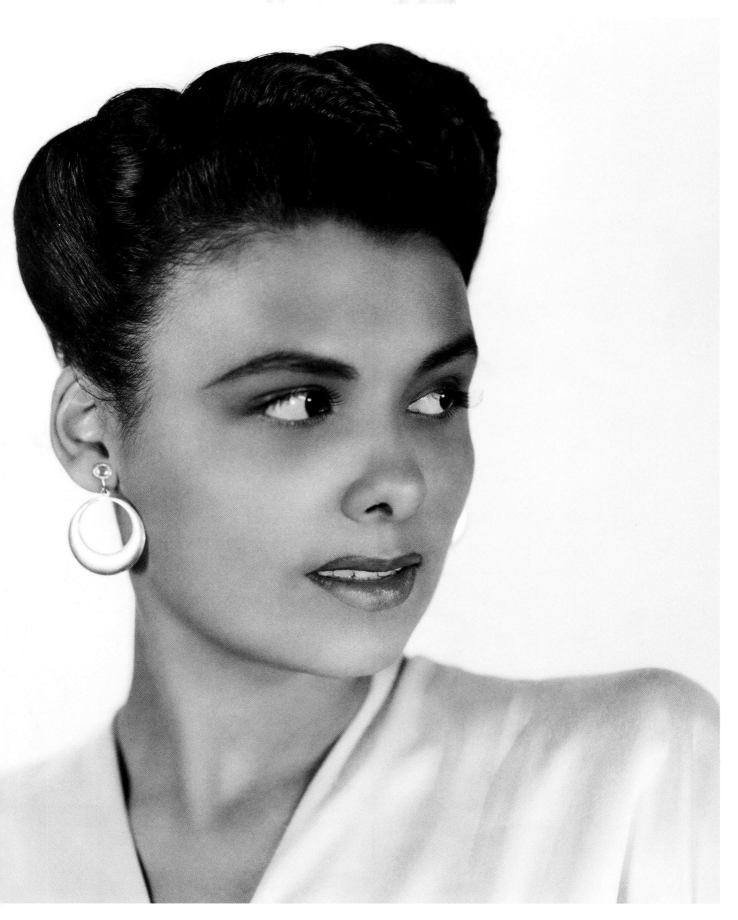

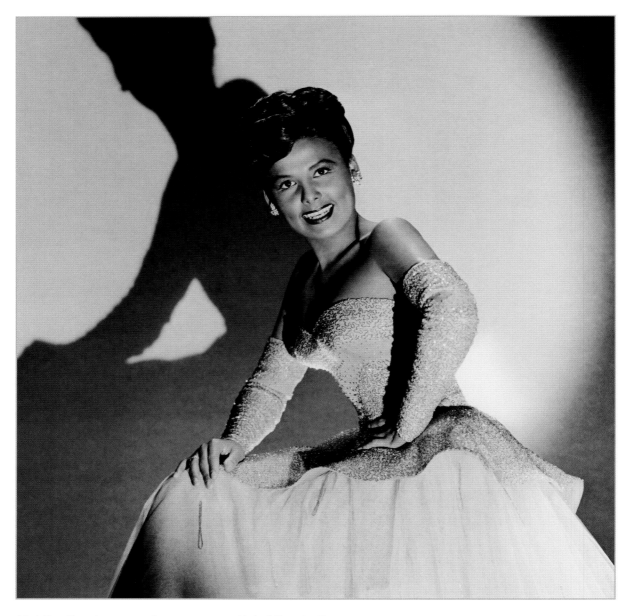

Lighting the star properly was an essential at the studio.

MGM also experimented with ways to light and photograph Lena. Lighting was crucial for all stars, but with Black performers of the time—then playing supporting roles or bits—its subtleties were often overlooked. Generally, when Black performers appeared with white stars, the scenes were lit for the white performers, and Black actors could look lost in darkness. It was to MGM's credit that the best technicians and photographers worked hard to properly showcase Horne.

Interestingly, during this very early period at MGM, a test for a new movie was shot with Horne

and one of the most popular Black performers of the time, Eddie Anderson. He had first ridden to fame on the radio as the clever, manipulative manservant—always quick with a wisecrack delivered in his distinctly gravelly voice—who attended comedian Jack Benny on the sitcom *The Jack Benny Program*. His character's name was Rochester Van Jones. So closely associated was he with the role that afterward he was often billed as Eddie "Rochester" Anderson—especially when he appeared with Benny in such movies as *Love Thy Neighbor* (1940) and *Buck Benny Rides Again* (1940).

In the test—for a movie ultimately called *Cairo* that starred Jeanette MacDonald and Robert Young—Horne and Anderson played the servants Cleona Jones and Hector. Though indeed she would have been cast as a maid, Horne always maintained that the character was well developed and not a stereotype. The test, however, proved something of a disaster. Horne's makeup had not yet been perfected, and she looked *made up*. Ironically, when *Cairo* was finally produced, the role of Cleona was played by Ethel Waters, who had forsaken New York and Broadway, due in great part to a marriage that had turned sour, and now set her sights on making it in the movies. No doubt Waters heard that Horne had been considered for the part, and the hot-tempered, often suspicious star may have seen Horne even then as a threat, a *younger* threat at that. Their paths would eventually cross. For Lena Horne,

two women would long loom in her career path whether she liked it or not: at first, Waters, the great tyrannical *older* star—and later, in the early 1950s, the luminous and younger but emotionally fragile Dorothy Dandridge.

MGM went back to the drawing board on what to do with Horne.

Lena had a great rapport and friendship with Eddie "Rochester" Anderson.

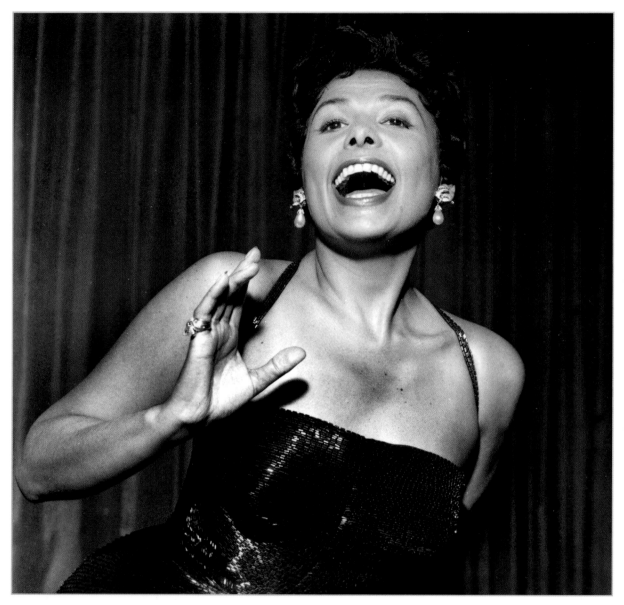

An engagement at the Mocambo brought her to wider attention among Hollywood's stars and power brokers.

Following the Little Troc appearance, Lena snagged a prime engagement at Hollywood's famed Mocambo, which along with Ciro's was one of the major nightclubs on the Sunset Strip. Originally owned by Felix Young and former agent Charlie Morrison, the Mocambo's décor—described as "a cross between a somewhat decadent Imperial Rome, Salvador Dalí, and a birdcage"—was part of its allure. Painted on the walls were exotic scenes by Jane Berlandina. Along those walls were large baroque

tin flowers. "The crowning point of the club, however," said one observer, "was a dazzling aviary of live birds that everyone was talking about. The birds, in fact, almost caused Mocambo not to open. The twenty-one parakeets, four love birds, four macaws, and a cockatoo were thought to be damaged by exposure to nighttime noise, and local animal lovers wanted them protected." In essence, the Mocambo was a set designer's dream. Also adding to the appeal were the powerhouse stars over the years who were there to see the entertainment: Clark Gable and Carole Lombard, Lucille Ball and Desi Arnaz, Lana Turner and Tony Martin, Marlene Dietrich and French star Jean Gabin, Cary Grant and Barbara Hutton, Hedy Lamarr, Henry Fonda, Cole Porter, Judy Garland, and MGM boss Louis B. Mayer. "Every evening was star night," said an observer.

Lena's appearance set her at the epicenter of Hollywood's power elite. Though she herself was not yet a part of that society, it was an acknowledgment that here she belonged. "She did fabulous business and had a sensational engagement," recalled Phil Moore, who again accompanied her.

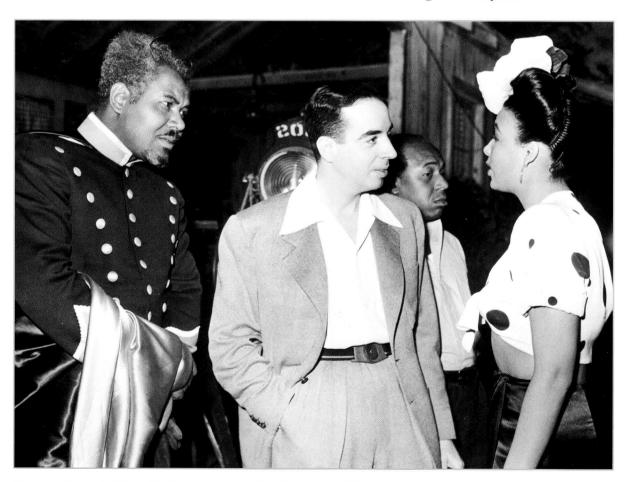

Director Vincente Minnelli with Lena and actor Rex Ingram (l.).

"Lena Horne Wins Praise of Critic" read the headline in the August 1, 1942, issue of the *Pittsburgh Courier* covering her engagement.

She also later appeared at a smaller but very "in" venue, the Club Gala, right above Sunset. Catering to an East Coast audience, eager for the sophistication of the New York supper clubs, Club Gala also drew in industry executives as well as gay patrons. Such appearances made Horne an even more successful star with diverse appeal.

During this period—and perhaps longer—Phil Moore came to terms with his attraction to Lena. "Often when I start to work with a stimulating talented woman, it seems like I fall in love, or get a severe crush," he confessed. "That's the way it was with Lena . . . Man I was . . . like an anxious school kid sweatin' for a date with the campus queen . . . Lena was real hip. She knew, a lot better than I, that her personal career sights were set on a lot more than getting involved with a panting musician . . . She was also wise enough to quell my ardor into friendship, and still, at the same time have been utterly devoted and happily working my ass off for her."

Two of the men with whom Lena spent more personal time were (still) Billy Strayhorn and the singer Billy Daniels. Good-looking, charismatic, very successful (known for years for his hit "That Old Black Magic"), and light-skinned, Daniels on first sight was sometimes mistaken for being white. Whenever she was seen with Daniels, Horne recalled that rumors indeed swirled that she was dating a white man.

Then there was Vincente Minnelli.

The two had seen each other at the studio on the day of her audition. "I hope we'll work together," Minnelli had told her. Minnelli had not forgotten their earlier meeting in New York about the proposed production of *Serena Blandish*. Lena fit in perfectly with his vision of doing a Negro film free of the old stereotypes. There had to be a way to highlight her class, her beauty, her cultural distinction.

Within a short period of time, the two saw each other socially, spending evenings together, discussing various activities at the studio, as well as plans for the future. They were cautious about being seen together in public. Each was sharply aware that any suggestion of an interracial relationship could be detrimental to their careers. "I was going to the few places I could go with Vincente Minnelli," she recalled. "And that was to people's homes, like Ella Logan and one or two others because Hollywood was very racial and also had its caste system. If you're not a big big star, you were on the lower level."

"Lena Horne and I, on our occasional dinner dates, were doing some patronizing of our own," recalled Minnelli, "at restaurants where my prior call determined that we wouldn't be turned away. I put the question to her. 'You must do it,' she urged." Nonetheless, in an industry that thrived on gossip, word of their friendship spread rapidly—which most likely reached the ears of Ethel Waters.

"He was a decent man," said Horne. "At one point, he was the only friend I had besides my Black friends, and we saw a great deal of each other."

Phil Moore continued working with Horne. But eventually he married the African American dancer Jeni Le Gon, who appeared in such movies as *Hooray for Love* (1935) and *Ali Baba Goes to Town* (1937). In the

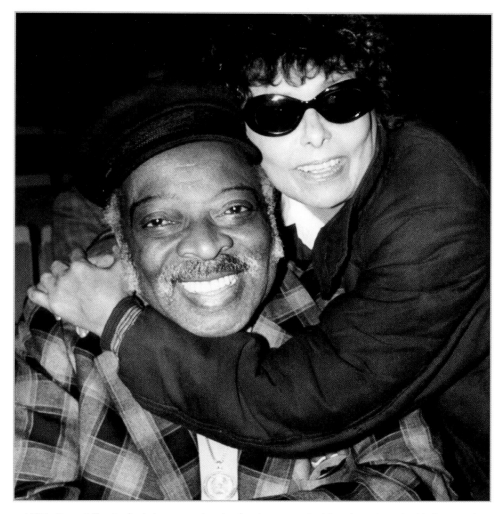

With Count Basie (in later years), who had persuaded her to return to Hollywood.

years to come, he turned his attention to Dorothy Dandridge, whose nightclub career he helped mold—and with whom he had a significant love affair. Still later, Moore worked with the young Diahann Carroll. Horne, Dandridge, and Carroll were well aware of one another—and of Moore's importance to their careers. All three had similar nightclub images with a similar selection of songs, arrangements, and an appeal to white patrons. None, however, may have been completely at ease with *her* arranger focusing on another glamorous singer.

In other corridors of Hollywood, notably Black Hollywood, problems sprang up. News of her contract with MGM, and the word that she marked a new era in the film capital that would lead to the demise of the old servant roles, was met with skepticism and anger. The Black Hollywood old guard, composed of a tight-knit community that had made its living out of playing servants—often enough skillfully and even brilliantly, while sending out covert

messages in their performances—felt its livelihood was in jeopardy. Would roles dry up for all Black actors except Lena Horne? That was the question on everyone's mind. The old guard galvanized and gathered to discuss this situation brought about by this East Coast upstart. The actors demanded that Lena answer questions.

"They had protest meetings against me which I attended," said Horne, who understood their concerns and sympathized with them. What had to be considered was that perhaps her presence would bring about more dignified and diverse roles for the entire Black Hollywood community. Still, she found it hard to make the actors understand. But then an unexpected ally contacted her—someone who offered her support.

"The one person who was wonderful to me was Miss Hattie McDaniel, who was a great, great Black star. She sent a note to me to come to her home. She had the most exquisite home I've ever seen in my life. The best of everything and perfectly beautiful taste. And she said to me, 'You're a very unhappy girl, and I can understand why. Your own people are mad with you, and the others don't even know what's happening. Let me tell you. I have worn two hats because I have a family I have taken care of very beautifully.' And she said, 'I'm a fine Black mammy [on screen]. But I am Hattie McDaniel in my house.' And that was so wonderful. 'And you've got two babies, and you've got to work.' And she said, 'Just do what you have to do.'"

Horne's other ally was Eddie Anderson. Both friendships meant much to her. "It seems significant to me that the people who had real talent, like Miss McDaniel and Eddie Anderson or the musicians, did not join in the attacks on me." Their support

was not enough; she still felt like an outsider and was distraught.

At some point in 1942, she traveled to New York for a benefit for Café Society. There was some discussion in later years as to precisely when this trip occurred. It appears to have been just before she actually went before the cameras at MGM. At this juncture, she was excited to be back on the East Coast, to see old friends from the Cotton Club and Café Society days, to hang out with musicians, and to hear music in the clubs. Taking in the sights and sounds of the Big Apple, she felt better than she had in some time. New York was aglow with its particular magic. Looking around, it was then that she decided on something she had been mulling over for "three miserable months"—that Hollywood was not the place for her. Sitting with Count Basie one evening, she told him of her new plans. She would pull up stakes and quit Hollywood and return to the clubs in New York. But Basie had other ideas. "You've got to stay," he told her firmly and decisively. But why? "Because you've been chosen and whether you like it or not, you've got to stay. Maybe they will do something with you in the movies." Basie could see a future for Lena Horne that she herself could not. But he was so adamant, indeed so impassioned, that she took his advice to heart.

Still apprehensive, still unsure if she wanted anything to do with Hollywood, still uncomfortable with her living situation and the racial atmosphere, Lena Horne nonetheless returned to the West Coast, resolved to give her situation a second chance.

In a short time, her movie work at MGM began.

Now resolved to stay in Hollywood—and make a go of it.

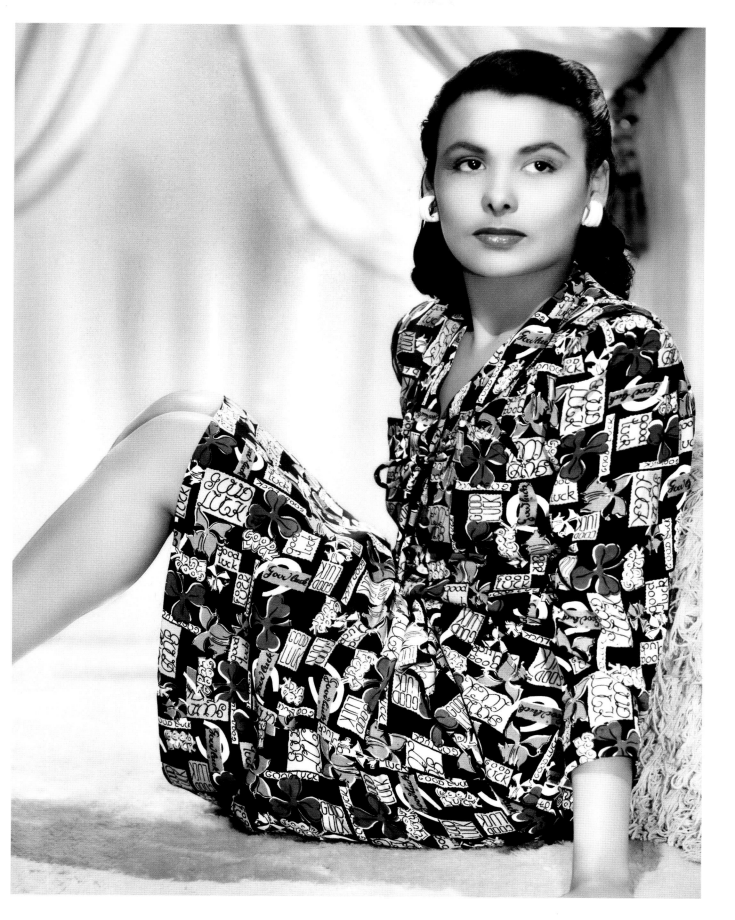

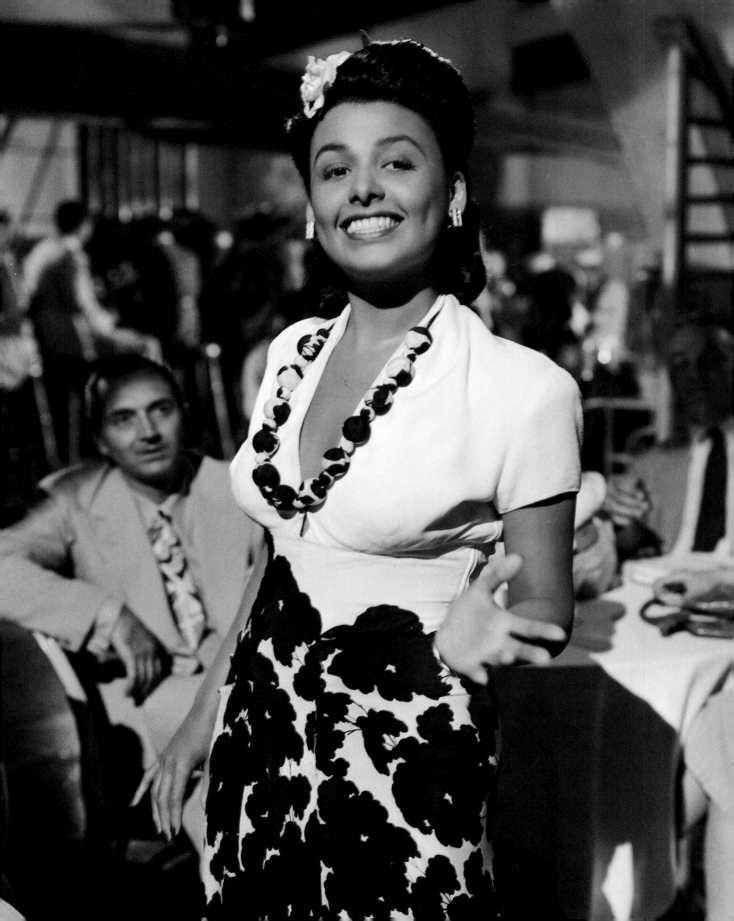

POSSIBILITIES

"**D**uring my first months at Metro," recalled Vincente Minnelli, "Lena Horne came to the studio at the same time, and my first assignments were to direct her musical numbers. Another director would do the rest of the film."

At age thirty-nine, Vincente Minnelli was a veteran who had worn various hats in his career. Early on, Minnelli had worked as a window dresser at the Marshall Field's department store in Chicago. There, he experimented and further developed his unique interest in the use of color and in interior design. When he later became a costume and set designer at the Chicago Theatre, his interest in interior design, his talent, and his ambition did not go unnoticed. He was a young man on the rise—seemingly gentle, placid, and easygoing, but fiercely determined to climb professionally. As his assignments occasionally took him to work on shows in New York, he became captivated by the city and moved to Greenwich Village. Following the opening of Radio City Music Hall in 1932, he worked there as a set designer, then set director, for its huge four-tier theater—the largest in the world for a time—which showed films and produced elaborate stage spectacles. It proved a wonderful training ground. His first significant break came when he directed the 1935 Broadway revue *At Home Abroad*. Arthur

Freed was impressed and offered him a job at MGM. Minnelli already had had a brief time in Hollywood and left discouraged. But he decided to take another chance, accepted Freed's offer, and arrived at MGM on April 22, 1940. He wanted to direct movies but understood he had to learn as much as possible about filmmaking and prove himself ready for the job. Accordingly, his first filmmaking assignment was to direct the musical segments of a film that was in trouble: *Panama Hattie*.

As a Broadway show, *Panama Hattie* had starred Ethel Merman and the young Betty Hutton with music by Cole Porter. Once the show became an MGM property, Ann Sothern was cast in the lead, under the direction of Norman Z. McLeod. Top billing went to comedian Red Skelton. Also in the film were comics "Rags" Ragland and Ben Blue, along with singer Virginia O'Brien. But when previewed on November 15, 1941, the movie version proved to be flat and uninspired, and it tanked with audiences. It had cost $872,686.17. Both Louis B. Mayer and Arthur Freed decided to do all

The mighty portals of MGM in the 1940s.

On April 8, 1942, shooting resumed on *Panama Hattie*. Roger Edens arranged Cole Porter's "Just One of Those Things" expressly for Lena. And a new song, "The Sping," was added for her as well as for the Berry Brothers, an energetic trio of Black dancers known for their splits and spins.

Panama Hattie was a significant career move for Phil Moore at MGM. "I was orchestrating more, and rehearsing piano less," he said. "Jeni Le Gon and I wrote the song Lena Horne sang in *Panama Hattie* entitled 'The Sping.' Cole Porter, who wrote the original Broadway score of *Panama Hattie*, was generous enough to let our tune be used in his score. I don't know if you can fully appreciate how rarely this kind of permission is granted by a composer of Mr. Porter's magnitude." Lena may have helped Moore in his climb at MGM.

they could to salvage the movie. Freed held meetings with Roger Edens, Minnelli, and others to discuss how to make the picture work. Then came the strike at Pearl Harbor.

Mayer pumped an additional $300,000 into the budget not only for rewrites but also for new material and new musical numbers. Though McLeod remained the acknowledged director, another director, Roy Del Ruth, was brought in to spruce up the production. In all, it took four months to revive *Panama Hattie*. Specialty numbers were added with Lena. Simply stated, specialty numbers were musical interludes that were unrelated to the storyline of a film. Generally, this was the way Black musical talents were handled. Ultimately—much to her dismay—this was the manner in which Lena would appear during her tenure at MGM with the notable exception of *Cabin in the Sky*.

MGM, almost a city unto itself.

Certainly, Edens had become familiar with Moore's work when he saw Lena at Little Troc. But Moore's presence provided Lena with a certain security. She knew him better than anyone else on the set, and she trusted him. Jeni Le Gon herself—who became Moore's wife—was an exciting dancer who understood how to move for the camera. Le Gon said she prepped Lena for "The Spring." Both musical segments in *Panama Hattie* spotlighted Lena beautifully. Minnelli was meticulously careful and creative in showcasing her talents. With "Just One of Those Things," well-lighted closeups revealed some hallmarks of the Horne style: the eyes that flashed and were rhythmically in sync with the music; the expressive mouth with its perfectly aligned teeth that also helped dramatize a piece of music; and of course, the Horne diction that punctuated and sharpened the lyrics. Enhancing everything was her smile itself, broad and enticing, it too adding drama to the proceedings.

For "The Spring," the designer dressed her "exotically" in a halter and a netted skirt as well as jangling bracelets meant to call to mind a young island woman. Here she displayed her dance training from the Cotton Club and dancing school with frolicsome body twists and a playful use of her hands. The song itself had a decidedly island sound, with its use of bongos and drums, while the lyrics spoke of Harlem and "this dance that they do/of a true Spanish brew/a twirly whirly dance they call the Spring/ From the West Indies it came/with its wild Spanish strain." Lena performed with clever shifting island accents. When the Berry Brothers joined her in the number and spun into action, it was a type of communal celebration. Certainly, Black audiences were joyous at seeing these performers in a big number

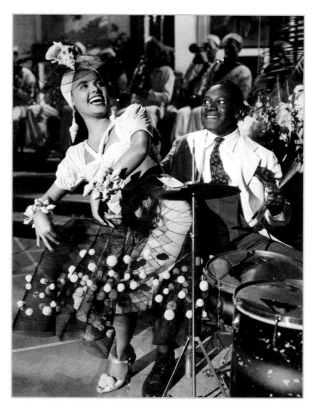

Singing and dancing to "The Sping," created by Phil Moore and Jeni Le Gon.

in a big MGM picture with high production values, expressive lighting, and agile camera movements.

In both numbers, Lena showed aspects of her talents that her nightclub audiences most likely did not see: The closeups captured an intimacy and the long shots, as she danced, captured an engaging energy. Each number was an invitingly seductive way to introduce her to moviegoers. Here too she was far more confident and commanding of the screen than in *The Duke Is Tops*. She had made an auspicious debut in a Hollywood studio film.

As was the case with some (not all) performers in specialty acts, Lena received no billing in the film. Nor did the Berry Brothers. Yet just before she performed "The Sping," Red Skelton's character

announced: "Now we'd like you to meet four people who are as famous from ocean to ocean as the Panama Canal, the three Berry Brothers and Miss Lena Horne." So her identity did not go unnoticed nor unacknowledged. Why MGM chose not to give her billing remains a mystery. Her presence clearly lifted the film from the doldrums and endowed it with vitality and style. Yet she had been "introduced" in *Panama*—an exotic setting in the minds of mainstream movie-goers—perhaps even suggesting to that audience that she was a South American singer rather than a Negro one.

Reviewing the film on July 22, 1942, *Variety* called "The Sping" a novelty number of "top rating" and added: "Two appearances of Miss Horne catch and hold attention. Same goes for the Berry Bros., col-ored dance trio who deliver some fast and furious dance steps in two spots." In the October 2, 1942, edition

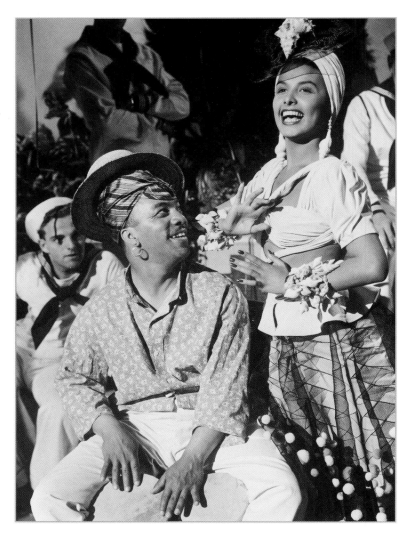

Using her training at the Cotton Club and in those early dance classes.

of the *New York Times*, Bosley Crowther called the film "a jumble of songs and dull slapstick" but sin-gled out the unbilled Horne. "Lena Horne, a new-comer from the night clubs, trills a rhumba rhythm, 'The Sping,' with plenty of spark."

After a month, *Panama Hattie* had been com-pleted at the cost of $1,097,907. Upon its release (September 18, 1942), the film grossed $4,326,000. The reviews and audience reactions snapped MGM

to attention, alerting the studio that it had a new "star" on its hands—and a noteworthy new director in Minnelli. Horne's performance had helped save what might have been a terrible bomb. Yet for the studio there would still be the issue of what exactly to do with Lena. For the time being, the decision was made to proceed with the stage property the studio had recently bought for $40,000, *Cabin in the Sky*—with Minnelli directing.

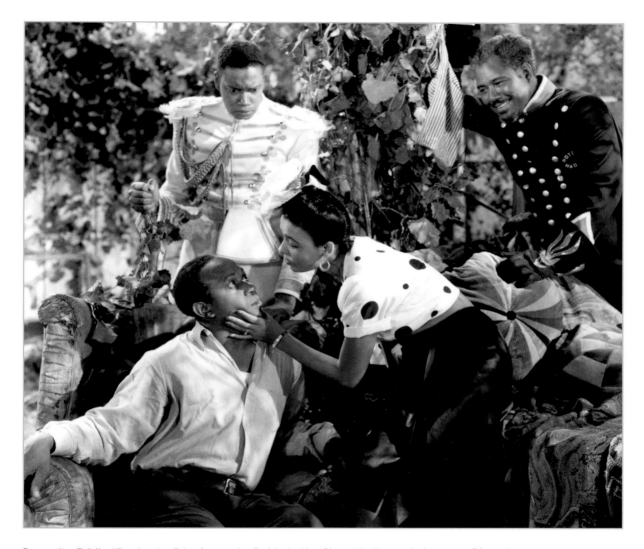

Opposite Eddie "Rochester" Anderson in *Cabin in the Sky* with Kenneth Spencer (l.) and Rex Ingram in the background.

Cabin in the Sky had opened on Broadway in 1940 to critical success. Its music was by Vernon Duke and John La Touche, with a book by Lynn Root. Yet it was hardly a great commercial hit. With the staging of George Balanchine, *Cabin in the Sky* was a musical fantasy that told the story of an errant Black man, Little Joe Jackson, who must battle the forces of good and evil within himself. On the one hand,

he succumbs to the lure of loose living: gambling with his cronies and flirting with a temptress named Georgia Brown. On the other hand, he deeply loves and values his faithful wife, Petunia, and the religious piety that she embodies. In its fantasy world, *Cabin in the Sky* literally dramatized the forces of a Black heaven and a Black hell warring for Joe's soul. It is his wife, Petunia, who intervenes with her prayers to save Joe.

Lena as the temptress Georgia Brown.

The Broadway musical had starred Dooley Wilson as Joe with Katherine Dunham as Georgia. Dunham's renowned troupe of dancers appeared with her. The centerpiece of the production was Ethel Waters. By this time, Waters was an established Broadway star. Not only had she scored major successes in the musicals *As Thousands Cheer* and *At Home Abroad*, she had also given a startling and critically acclaimed dramatic performance in *Mamba's Daughters* in 1939. No African American woman had ever attained the Broadway success of Waters. She used her star clout to insist upon changes in the Broadway production of *Cabin in the Sky*. Known for being notoriously difficult and demanding—she could fly off the handle at the slightest provocation or even the slightest *suggestion*

of a provocation—Waters was such a formidable force in the theater that no one, Black or white, dared tangle with her.

Minnelli approached *Cabin in the Sky* enthusiastically. Roger Edens was the musical supervisor. Some music from the Broadway production was dropped while new songs were added. Because Vernon Duke was serving in the military and unavailable to work on the score, Harold Arlen and Yip Harburg were enlisted to write new songs, five in total but only three of which were used in the film: "Happiness Is a Thing Called Joe," to be performed by Waters and soon to be a standard; "Life's Full of Consequences," to be performed by the characters Joe and Georgia; and a choral number, "Lil Black Sheep." Another new song, "Ain't It the Truth," was dropped from the film. Arlen used it years later in the Broadway show *Jamaica*, which starred Horne.

For the role of Joe, Minnelli wanted Dooley Wilson. But MGM decided on Eddie Anderson, who was so popular with audiences because of his role as the outspoken manservant Rochester on *The Jack Benny Program*. The role of Georgia, because of Dunham, had utilized dance. But now Lena Horne was given the role, and new scenes were created for the character. Other cast members included Rex Ingram, Butterfly McQueen, Kenneth Spencer, Oscar Polk, Ernest Whitman, Nick Stewart, Mantan Moreland, Willie Best, and Ruby Dandridge. Also appearing: Duke Ellington, playing himself, Louis

Armstrong, and dancer John "Bubbles" Sublett with his partner, Ford Lee "Buck" Washington, of the great team Buck and Bubbles. Heard on the soundtrack would be the Hall Johnson Choir. Once again Ethel Waters would star as Petunia. There had been some talk of casting Hattie McDaniel in the part. But no one took that seriously. Minnelli wanted Waters. "She'd also been in my first Broadway musical, *At Home Abroad*. She was my talisman," he said.

This would be only the fourth Black-cast feature film in Hollywood's history. In 1929, *Hearts in Dixie* and King Vidor's *Hallelujah* had appeared. Not until seven years later was there Marc Connelly's *Green Pastures*, an adaptation of his Pulitzer Prize–winning Broadway drama-comedy—a fantasy partly about an all-Negro heaven that was criticized because of its stereotyped non-threatening, childlike characters.

Minnelli understood the criticism that might be in store. The images in *Cabin in the Sky* were again of Negroes as basically naïve and childlike figures, removed from the racial realities of the age. Fundamentally, *Cabin in the Sky* depicted the nation as a land where Black citizens contentedly lived in poverty and deprivation. Now during the war, Black America was looking at theater and films in a new light. The pressure of Walter White and the NAACP was on the minds of the studios and the audiences. And the Negro press stayed on the case for Victory Abroad and Victory at Home—the idea of winning the war in Europe against the Nazis and winning the battle for equal rights in the States. Aware of the problems inherent in the work, Minnelli still wanted to do a film that expressed the humanity of its characters—and also the rich talents of his cast. "If

Georgia—observed by the wicked Lucifer Jr., played by Rex Ingram.

I was going to make a picture about such people, I would approach it with great affection rather than condescension," said Minnelli. "A portion of the militant Black and liberal white press was highly critical of the proposed endeavor, finding the story patronizing," said Minnelli. "But there were an equal number of publications supporting us."

"I wanted Petunia and Joe to look as attractive as possible, for the audience to be aware of their simple goodness," said Minnelli, who here did sound patronizing. "Making Lena into a beautiful siren was no problem at all."

Minnelli battled with the studio's art department over the living circumstances of Joe and Petunia. "When the art department showed me sketches of a dirty cabin, they discovered a temper my bland exterior usually kept hidden. How could they have missed the point? These people were poor, but not slovenly. Petunia would try to make her surroundings as pleasant as her limited funds would allow." It's not hard to understand the point Minnelli was making. But in the end, the sanitized sets at times made it look as if the film were actually glossing over the poverty—no electricity, a leaking roof—that the characters lived in.

"We started shooting the summer of 1942," said Minnelli. "The shooting went quickly." Yes, quickly. But not always smoothly.

A major difficulty arose because of Ethel Waters and her open resentment of Lena. "Suspicious and

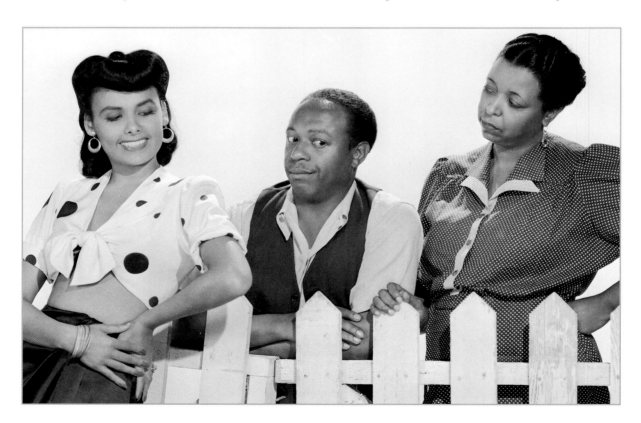

Cabin in the Sky's triangle—Lena, Anderson, and Ethel Waters.

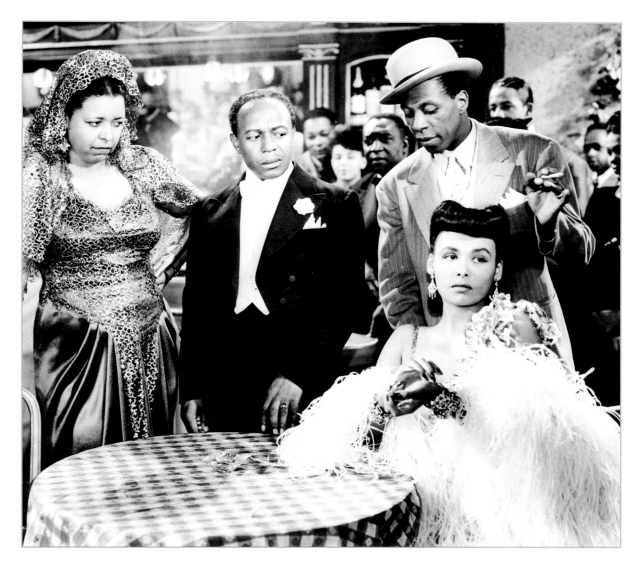

A highlight of the film—Ethel Waters, Anderson, John "Bubbles" Sublett, and Lena: fireworks both on and off the screen.

frequently paranoid," said actress Fredi Washington of Waters's behavior when she worked with her in the stage drama *Mamba's Daughters*—though Washington was quick to say that Waters had treated her well enough. They had played a loving mother and daughter, so Waters stayed in character throughout that drama. But during the production of *Cabin in the Sky*, the older Waters believed the younger Lena was getting preferential treatment from Minnelli. She was also aware of the raves Lena was getting in New York. Making matters worse, Waters did not like the way religion was portrayed in the film. But she also found herself facing other challenges. Now in her forties, she had a weight gain that bothered her. No longer that slinky singer Sweet Mama Stringbean, she battled daily to shed

pounds—and was determined to hold on to her status as a star. Frequently, she was irritable and on edge. "All through that picture there was so much snarling and scrapping that I don't know how in the world *Cabin in the Sky* ever stayed up there," she said. Of course, much of that snarling and scrapping came from her.

Early on, cast members warned Lena of Ethel's resentfulness and flat-out animosity. A sign of trouble ahead occurred in MGM's recording studio. Waters was to parody Lena's Georgia singing "Honey in the Honeycomb." She listened to the version of the song that Lena had previously recorded. Within minutes, Waters's anger shot up. How could she be expected to imitate a style that was an imitation of a style she herself had created—twenty years

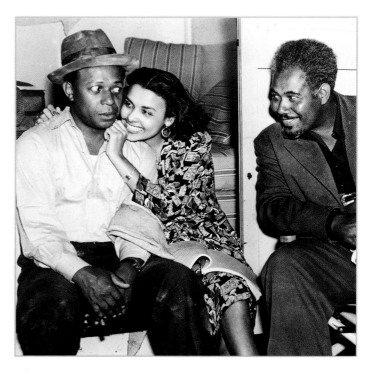

Between takes—Anderson, Lena, and Rex Ingram.

earlier, no less. "If I had imitated her, it was completely unconscious. She was a great singer, someone to be admired, and of course some of her style had come into that number," said Horne. "I'd worked hard to get it there so her parody would come off. Still, sometimes it's hard to see things that way." Years later, Lena would understand even better Ethel's feelings. Said Horne: "I'm always being told that some young singer is doing me nowadays and I'm not complimented."

The tension kept building until the day the two women actually worked together, in a nightclub scene in which they vie for the affections of Rochester. During a rehearsal with Rochester the day before, Lena had slipped and broken her ankle. Her foot was put in a cast. "Rochester made a joke about it later," Horne recalled. "He said Ethel had put

a hex on me." On set, Minnelli altered the blocking—his positioning of the actors. Now Lena would perform "Honey in the Honeycomb" while seated on the bar counter. Everyone paid special attention to her, including of course Minnelli, wanting to make sure she was comfortable. Actor-dancer Lennie Bluett recalled the way Minnelli painstakingly adjusted the folds in Lena's satin dress. "Ethel couldn't have liked that at all," said Bluett. Silently, Waters watched them "fawn" over Lena. She was fuming. Then she exploded, stunning everyone.

"Miss Waters started to blow like a hurricane," said Lena. She yelled, shouted, and let loose a profusion of foul profanity—the language of the streets that Ethel had grown up hearing. "It was an all-encompassing outburst, touching everyone and everything that got in its way," Horne recalled.

Everyone on set turned silent: the cameraman, the grips, the lighting technicians, the other actors, the extras. None had seen anything quite like this outburst. "It was actually directed at everything that had made her life miserable, the whole system that had held her back and exploited her." As much as Minnelli tried, he could do nothing to calm her down. It was the type of incendiary incident that moviemakers dreaded. The executive offices received word of the trouble. Rushing to the set were Arthur Freed and MGM executive Eddie Mannix—joined by Ethel's agent. But still she could not be reasoned with.

Minnelli stopped production. He dismissed everyone.

Work resumed the next day. Previously, Minnelli had advised Lena not to try to compete with Ethel in the scene, not to play it *big*. Ethel was too powerful an actress for Lena to compete with. Instead, Lena should play it small and coquettish, which was

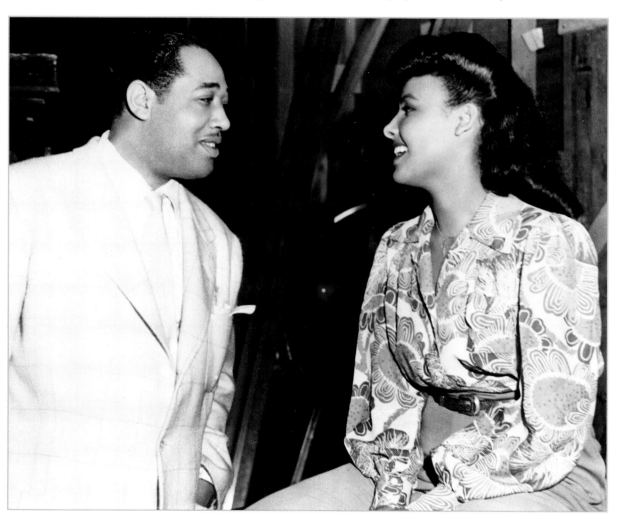

Lena reunites on set with a star from her Cotton Club days, the incomparable Duke Ellington.

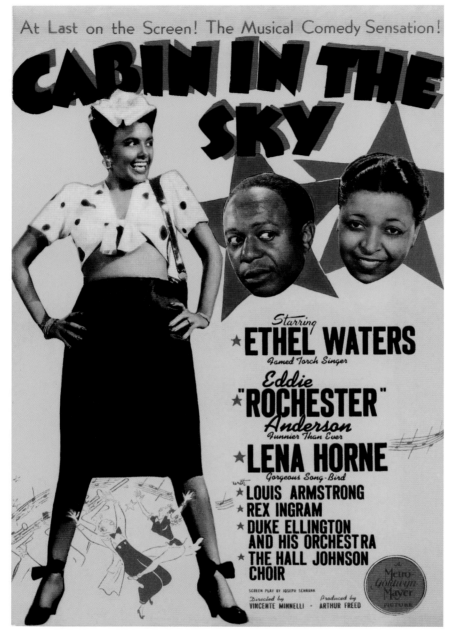

Cabin posters spotlighted Lena.

an unexpected rhythm and emotional intensity—and enliven a film with a subtext coursing through it. But after that day, Lena and Waters never spoke again, and the explosion on set became a part of movieland lore and legend. It also affected Waters's career. "I won all my battles on that picture. But like many other performers, I was to discover that winning arguments in Hollywood could be costly. Six years were to pass before I could get another movie job."

In the years to come, Lena would discuss the incident with a surprising sensitivity to Waters. She understood Waters's anger—that a star of a new generation could have such a rapid rise, and without playing the dives and joints that Waters had to endure. Waters had rightly understood that MGM sought to "protect" Lena. No one—save for the Black impresario Earl Dancer—had provided such protection for Waters. In speaking of the star, Lena would always refer to her as Miss Waters. Her daughter, Gail, would do the same. She would

precisely what she did. Ultimately, the sequence was shot without any outbursts. It became one of the highlights of the film, one of those off-screen scenarios that can infuse an on-screen sequence with

always be respectful of her talent. But the entire outburst had to have affected Lena Horne in another, deeper way. To be so ruthlessly rejected by a woman she had idolized would long be painful.

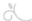

Though the completed film was mostly admired, admittedly *Cabin in the Sky* had a limited viewpoint on African American life and culture. Petunia was depicted as wanting nothing more than to get her weak husband into heaven. Her entire identity, including her religious beliefs, was tied to him. Her song "Happiness Is a Thing Called Joe" summed up the character's sense of self. And what kind of reward does Petunia hope to receive for a life of devout goodness? She sings of wanting a cabin in the sky—another shack up yonder. No comment on discrimination or a system that had relegated the characters to such second-class citizenship was to be found in the film. The fact that Joe was illiterate—unable to read a single word or even write his name—was treated comically, as was the poverty of Joe and Petunia. When Joe buys Petunia a washing machine, he comically laments that now all they need is electricity to run it. By calling him Little Joe, the film subtly emasculated the character, who must depend on his wife for guidance and supervision. The female characters were divided into color categories. The lighter Lena was the sensual, more alluring mulatto-style vixen. The browner, heavier, older Waters was mostly without a vibrant sexuality—until her nightclub scene, when she shows she's got everything Georgia's got "and a whole lot more" but does so only to win back her husband.

At the same time, Horne's sexuality became an issue for the censors in Hollywood. The Breen Office,

as Hollywood's self-censorship board (headed by Joseph Breen) was referred to, carefully and excessively monitored scripts and completed films for scenes or dialogue that violated the Production Code dictates of 1934. Horne had performed the song "Ain't It the Truth" while sitting in a bubble bath. The sequence was familiar Hollywood glamorization of desirable women. But the Breen Office wanted the scene removed. It was dropped. Curiously enough, the number resurfaced later in a 1946 MGM short, *Studio Visit*, and decades later it would be shown in *That's Entertainment! III*.

In the end, *Cabin in the Sky* told a simple story of faith and redemption with a degree of warmth. Its cast related to one another beautifully—and played off one another's rhythms. Throughout, all talents were splendidly showcased. What a relief to see Butterfly McQueen in her scenes with Waters, so different from her stereotyped yet brilliantly executed performance as Prissy in *Gone with the Wind*. Ellington's orchestra—with Lawrence Brown on trombone—was at its best. The jitterbug sequence, led by Lennie Bluett and Vivian Dandridge, as they dance from the sidewalk into Jim Henry's nightclub, was a cultural statement unto itself—stylized Black vernacular dance as seldom seen in a movie. Likewise, John "Bubbles" Sublett's superb performance of the song "Shine" is one of the great dance numbers in film history. When Waters dances with Bubbles to the "Honey in the Honeycomb" parody, she does exuberant leg kicks, shakes her hips, and shimmies, and by so doing—with Minnelli's support—she calls a lie to the Hollywood stereotype that older, heavier, browner Black women cannot be sexy.

Of the fiercely difficult Waters, Minnelli had only praise. "My good luck charm came through.

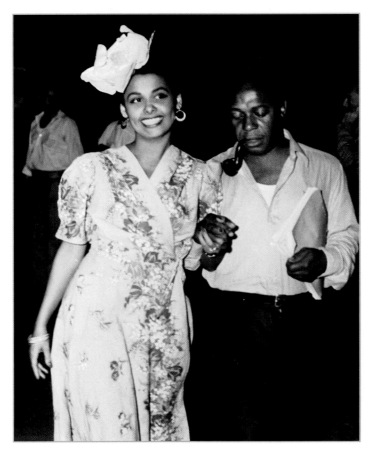

Between takes—Lena and Rochester.

Ethel translated her bravura, outsized stage performance into a more naturalistic film portrayal. She owed it to her very expressive face and eyes. Ethel, however, claimed she owed it all to God. She has a direct pipeline to Him, you know."

Interestingly, not much was said by Minnelli of Horne's performance. Yet she proved to be a delight, in full control of her dialogue and her vamp characterization. Mostly, though, the character Georgia was at heart another of Hollywood's Black women of "easy virtue," albeit softened. In one scene, as she studies her reflected image in a mirror, pleased by her own prettiness—and inviting us to look her over—she's clearly objectified, but it's so playful that

we accept it. In another curious moment in the scene when the devil Lucifer Jr. (who is invisible to Georgia) plants it in her head to seduce Joe, Lucifer is shown lounging on Georgia's bed as she dresses. Audiences don't know what may have transpired beforehand. Is it a subtext that suggests Lucifer Jr. has just seduced Georgia in her bed? To her credit, Lena portrayed Georgia without vulgarity or crassness, making the character something of an innocent. Horne's charm and intelligence prevail throughout. Her duet with Rochester—"Life Is Full of Consequences"—proved engaging, as indeed did her rendition of "Honey in the Honeycomb." Making no false moves, she held the screen, never overshadowed by the major-league talents she worked with. In the end, the studio gave her billing right below Waters and Anderson. Minnelli and Freed also decided to reprocess the black-and-white film into a sepia tint, giving *Cabin in the Sky* a special glow and gleam.

The film did have its critics. In the June 12, 1943, edition of the *New York Amsterdam News*, Ramona Lewis wrote, "In spite of this magnificent cast, this first all Negro picture to be made by MGM since 'Hallelujah' is an insult masking behind the label of folklore. It isn't folklore . . . it's an insult because it pictures Negroes, heads tied up, with crap shooting inclinations and prayer meeting propensities at a time when Negroes are daily proving their heroic mettle in battle and defense plant."

But other critics praised the cast, and *Cabin in the Sky* garnered its fair share of good reviews,

too. The fact that it was an all-Negro cast, however, raised concern about its commercial viability. "It has been made with obvious sincerity and good will but its appeal is likely to be somewhat restricted, with Ethel Waters and Eddie Anderson names as help," wrote the critic for *Variety* in its February 10, 1943, edition. "In the first place, it's fantasy, which is inclined to be tough to sell. Secondly, it's an all-Negro show, making it doubtful material for the South and likely to decrease its audience in other parts of the country." But *Variety* was also quick to point out its assets. "Lena Horne is a definite click, both vocally and dramatically." The paper noted "Ethel Waters remains the one transcendent asset . . . Her sincerity, compassion, personal warmth and dramatic skill, plus her unique talent as a singer make her performance as Petunia an overpowering accomplishment."

Even before *Cabin in the Sky*'s release, Horne's appearance in *Panama Hattie* and the publicity about her MGM contract clearly boosted her career and led to plum nightclub offers. In late 1942, Lena returned to New York for an engagement at the exclusive Savoy-Plaza's Café Lounge. She would be the first African American to perform there. But the hotel was emphatic that she could not stay there during the engagement, so Lena, Phil Moore, who would accompany her on stage, and a friend of Lena's, Zulme Nuffie MacNeal, went uptown to check into the Theresa Hotel. Nuffie was an educated, cultivated young woman, who had been a researcher for Gunnar Myrdal's groundbreaking examination of race, *An American Dilemma*. Later she would marry Cab Calloway.

As Lena prepared for the opening, she was faced with the issue of expenses for the engagement. The gowns that MGM was sending for her appearance had not arrived in time. Consequently, according to Lena's daughter, Gail, Lena and Nuffie stepped into the Fifth Avenue ultra-deluxe store Bergdorf Goodman, across the street from the Savoy-Plaza, where they found the perfect dress. But Lena could not afford it. A sympathetic saleslady contacted the store's owner, Andrew Goodman. He made it a point to come to meet Lena. "I understand that you're

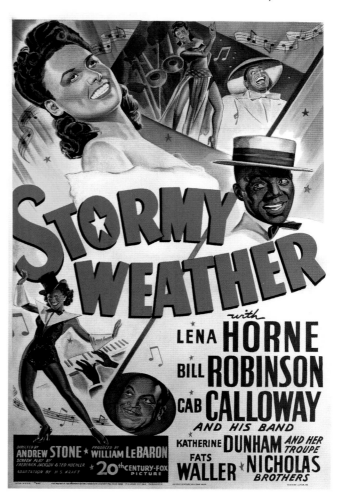

Stormy Weather's posters also highlighted Lena.

Appearing with such older, established stars as Bill Robinson and Cab Calloway, Lena received top billing.

praised her performance. "Each year in New York's after-dark world of supper clubs there appears a girl singer who becomes a sensation overnight," wrote *Life* in its January 4, 1943, issue. "She stands in the middle of a dance floor in a white dress and a soft light, and begins to sing. The room is hushed and her voice is warm and haunting. Her white teeth gleam, her eyes move back and forth, and her softly sung words seem to linger like cigarette smoke. This year that girl is Lena Horne, a young Negro who has been appearing at the Savoy-Plaza's Café Lounge . . . Singing without a microphone, Lena Horne makes old song favorites sound new and exciting."

But perhaps most flattering from Lena's vantage point was the review by Mike Levin in *Downbeat*, which was republished in its entirety in the *Pittsburgh Courier*. "Two weeks ago she opened at the Savoy-Plaza's Lounge Room, the plushiest of padderies, and stood this town right smack on its collective ear. Night club editors for every daily searched lexicons to tell their amazed readers that Miss Horne was the most sensational item 'to hit this jaded town in many, many years.' The columnists reported said fact, and the rush was on. The ropes are up, and the so-called smart crowd has discovered a new idol."

opening at the Savoy-Plaza and have nothing to wear," he told her. "We wouldn't want our Savoy neighbors to be disappointed. Why don't you take the lace dress. Charge it, and pay for it a little at a time." Gail commented, "Lena nearly swooned with gratitude. She would forever be devoted to Mr. Goodman's store."

Opening night at the Savoy-Plaza was one of those glittering, glamorous New York events that saw the likes of Cole Porter, Ethel Merman, and Richard Rodgers. Wearing that gorgeous gown, Lena astonished patrons—even before they heard a word come out of her mouth. But as she sang—such numbers as "Let's Fall in Love," "I Can't Give You Anything but Love," and "St. Louis Blues"—her dramatic way with a song stopped them in their tracks. This was what a night in New York, the most sophisticated, glamorous city in the country, was supposed to be. Her performance won her raves.

Life magazine featured a photo layout of her and

On loan to 20th Century-Fox, which went all out with a wardrobe—thanks to the ravishing costumes of Helen Rose—befitting a star.

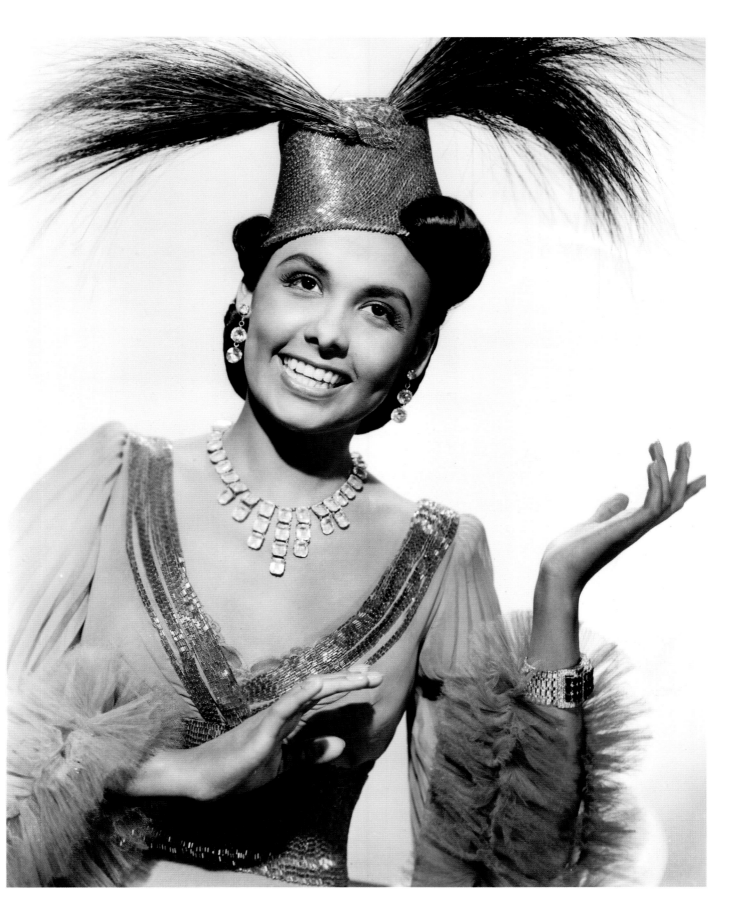

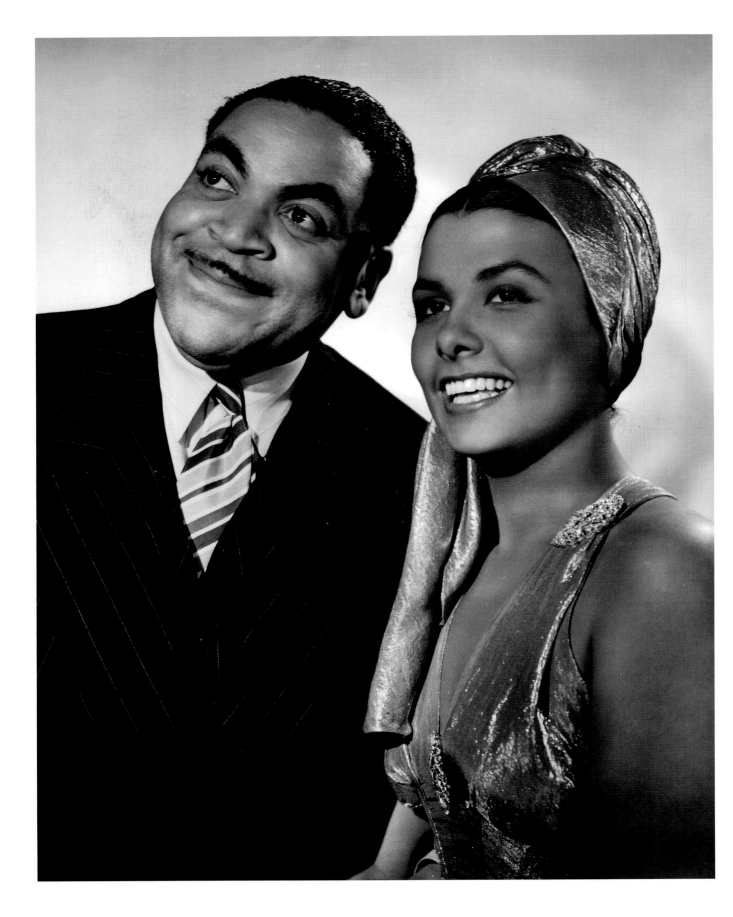

Then Levin added: "I've known Lena for some years, always admired her as a fine gal, and as the best-looking dame I've seen on anybody's stage. But frankly, when she was singing with Noble Sissle, Charlie Barnet, and later at Café Society, I thought her voice wasn't too much to listen to—that it was weak and often stiffly phrased. The difference heard on opening night at the Plaza was unlike any improvement I've ever noted before. When she went to the Coast last year, Lena worked a couple of supper clubs there that were too small for microphones. As a result, she discarded her dependence on same, and from nowhere she has found a voice—and a good one . . . Lena isn't the best singer I've heard—but she's something better: she's a great entertainer."

Nightly, the club was filled to capacity and "once or twice, the management has had to turn away up to 500 guests," reported *PM*. The engagement was an unqualified hit. Nonetheless, Lena left the Savoy-Plaza nightly to return uptown to the Theresa.

Hollywood kept work coming her way, at least for the time being. MGM lent her out to 20th Century-Fox for the leading lady role in *Stormy Weather*. Under the direction of Andrew Stone, here was another all-star Negro production with such legends as the Nicholas Brothers, Fats Waller, Cab Calloway, Katherine Dunham and her dance troupe, comedians Flournoy Miller and Johnny Lee, Ada Brown, Dooley Wilson, Ernest Whitman, and Babe Wallace.

Heading the production was Bill "Bojangles" Robinson, one of America's greatest dancers, who had risen to the top of the entertainment world first in vaudeville. He also triumphed on Broadway in

Thrilled to appear with Fats Waller.

In *Stormy Weather*, her leading man Bill "Bojangles" Robinson proved difficult to work with.

Mike Todd's *Hot Mikado* in 1939 and acquired a significant fan base in the movies as costar and protector of Shirley Temple in the Depression-era hits *The Little Colonel* (1935), *The Littlest Rebel* (1935), and *Rebecca of Sunnybrook Farm* (1938).

Not having much of a storyline, *Stormy Weather* basically traced the career of an entertainer, loosely based on Robinson, from his early to later years as he met or worked with one entertainer after another—and as he endured the separations from and reunions with the woman of his dreams (played by Lena).

Lena found herself again performing with show business veterans, some of whom she knew from the Cotton Club. They still thought of her as a pretty face. Never was she viewed as a singer on the level of Billie Holiday or Ella Fitzgerald. Yet though her talent may have been in question, no one seemed greatly fazed by that. Mainly, everyone loved the idea that briefly at this time Hollywood turned its attention to Black performers in a big way. *Cabin in the Sky* had already been filmed. And in Columbia

Pictures' episodic all-star *Tales of Manhattan (1942)*—with Rita Hayworth, Ginger Rogers, Henry Fonda, Charles Boyer, Rex Harrison, and Cesar Romero—there was even a Black segment starring Paul Robeson, Ethel Waters, Eddie "Rochester" Anderson, and the Hall Johnson Choir. Now *Stormy Weather* added to the "wave" of Black movies in the war years.

On the Fox lot, Horne had to maneuver her way around various problems. When an invitation came to dine with the all-powerful chairman of 20th Century-Fox, Joseph Schenck, she had no choice but to accept. Not much—other than boredom on Lena's part—transpired. But during another invitation to have dinner and watch a film with Schenck and others, she was seated next to him. His hand reached over to touch Lena's. It was not just a friendly, impersonal handshake. Without saying a word, Lena's attitude and stony stare let him know to forget about any kind of liaison. "She went home unmolested," commented Lena's daughter, Gail, "and never received another invitation."

Schenck's unwanted attentions were one thing, but her two primary problems on *Stormy Weather* were Andrew Stone and Bill Robinson. On screen, Robinson was warm, friendly, and ingratiating. But off-screen, he could be a holy terror—a difficult, ill-mannered, temperamental star who didn't hesitate to carry a gold-plated gun and who could easily cuss anyone out. It didn't take much to set him off. In *Stormy Weather*, the sixty-four-year-old Robinson was the love interest of the twenty-five-year-old Lena. Almost everything about Robinson irritated Horne. "Lena loathed Bill Robinson and nearly everything connected with *Stormy Weather*," said her daughter, Gail. "Robinson was a male

Dancing with Robinson.

Ethel Waters, and the biggest Uncle Tom in show biz."

Working with director Stone, whom she found cold and remote and who had no interest in helping her establish a screen career, was an ordeal for Horne. He provided none of the attention to detail nor the reassurance nor the sensitivity that Minnelli had lavished on her. The most difficult sequence came when Lena was to sing the title song—expressing her despair over a love gone bad. She was at a loss. Struggling to pry feeling out of her, Stone had no idea how to help her shape or convey her emotions. Instead, he complained that she expressed no warmth. "I spoke to her about her mother, her kids. No go," said Stone. "Well, we shot it, but when

I saw the rushes I knew it was bad. No emotion. So next day I tried again, tried for hours, still getting nowhere."

On set, Cab Calloway asked Stone: "What's the matter?" Then Calloway said: "Leave it to me." As Stone recalled, Calloway "walked to Lena, whispered two words in her ear. Just two words!" Said Stone: "I never saw such a change in a person. She was wonderful. Real tears in her eyes, a sob in her voice. When she finished the number, she had hysterics, cried for ten minutes. Naturally, I asked Cab what he had said. He wouldn't tell me."

"Cab just said something to tease me," said Lena. "He got me mad, that's all."

"Cab's idea of a pep talk was to tell Lena that she was stupid and untalented," said Gail Lumet

Buckley. "Only white people are dumb enough to think you've got something."

Writer Frank Nugent offered another explanation: "Could be, of course, that the mysterious two words were just a name. Ethel Waters." By then, everyone had heard of Ethel's outburst on *Cabin in the Sky*, and everyone also knew that "Stormy Weather" was one of Waters's signature songs. In the coming years, she would be enraged when the song was associated with Horne. Truth be told, no matter how effectively Lena was to sing it, "Stormy Weather" indeed was performed best by Waters. Even Ivie Anderson, who had performed the song with great feeling with Duke Ellington's orchestra, couldn't match Waters. Lena Horne was far too intelligent not to know this basic fact.

With Cab Calloway, who helped her film a difficult sequence, the performance of the title song.

Successfully making the best of a difficult situation and entertaining movie patrons for decades to come.

voice was reminiscent of her sound in *The Duke Is Tops*. It doesn't have great distinction. Yet paradoxically, it *does*. Basically, she sounds like a pampered middle-class young Black woman, a spoiled and solid member of the old-guard Black bourgeoisie. Her Selina is maintaining a ladylike air, perhaps something of a phony. Yet the bourgeois air and attitude are somehow deliciously *perfect*—and perhaps perversely likable because at heart Horne's Selina is a sympathetic character. It's a new image for a Hollywood film—the type of woman Hollywood didn't know existed. But Black audiences certainly did.

Otherwise, Lena seemed comfortable with her co-stars. She admired Katherine Dunham as a choreographer, a dancer, and the founder of an acclaimed dance company. She loved the music of Fats Waller. The song "Honeysuckle Rose" by Waller and Andy Razaf would become a part of her repertoire. In *Stormy Weather*, Waller was at his absolute best as he performed his hit "Ain't Misbehavin.'" And though Cab Calloway could be blunt, she seemed to like him, and later when he married her friend Nuffie, she formed a lasting friendship with Cab's young wife. It was like "old home week" to see Clarence Robinson, the Cotton Club choreographer who had once helped her audition for Charlie Barnet and who was now choreographing sequences in *Stormy Weather*. Then there was Flournoy Miller, who had informed her of another bandleader looking for a girl-singer, Noble Sissle. Like everyone else, she was stunned by the intricate and superbly imaginative dance magic of the Nicholas Brothers, whose staircase number, with uncredited choreography by Nick Castle and the Nicholas Brothers themselves,

In later years, Andrew Stone remained puzzled and visibly upset as to why Lena felt he was cold and remote.

What also made the movie *Stormy Weather* more difficult was the simple fact that Lena knew she was not playing a fully developed character. Actors rely on backstories for their characters found within the scripts—explaining who these people were, what had transpired in their lives before the action of the films. Actors will often create fuller backstories to provide their characters with nuances and depth. No significant backstory had been provided for her character of Selina. To put it mildly, the script was without fine points. Horne didn't have the experience to understand how to use personal experiences to somehow create motivation or a drive for a character. In the completed film, her unexpressive

A sophisticated look and a direct line of communication by Lena with the camera.

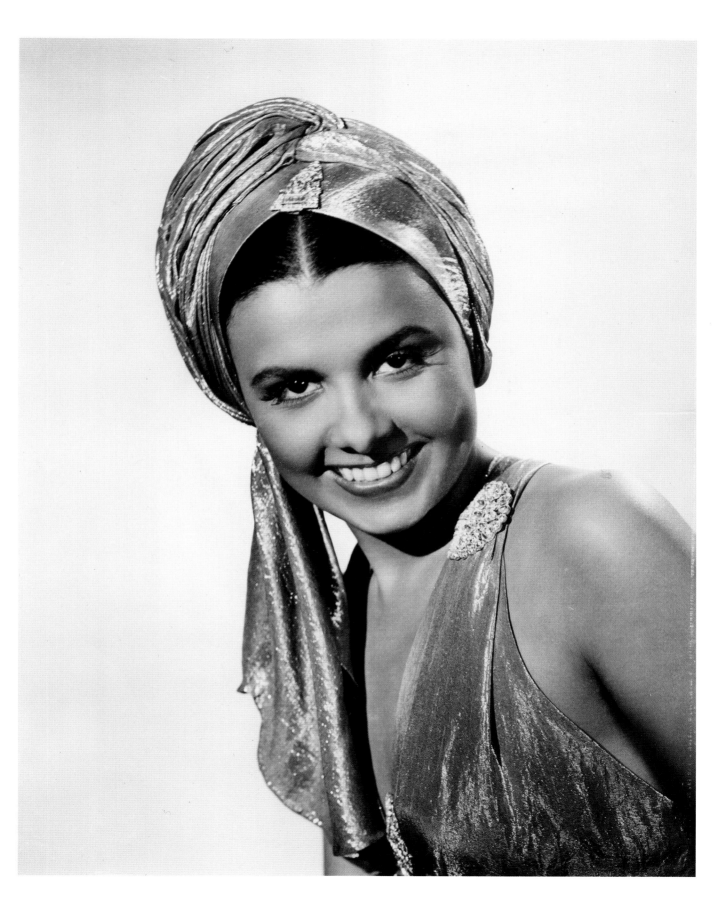

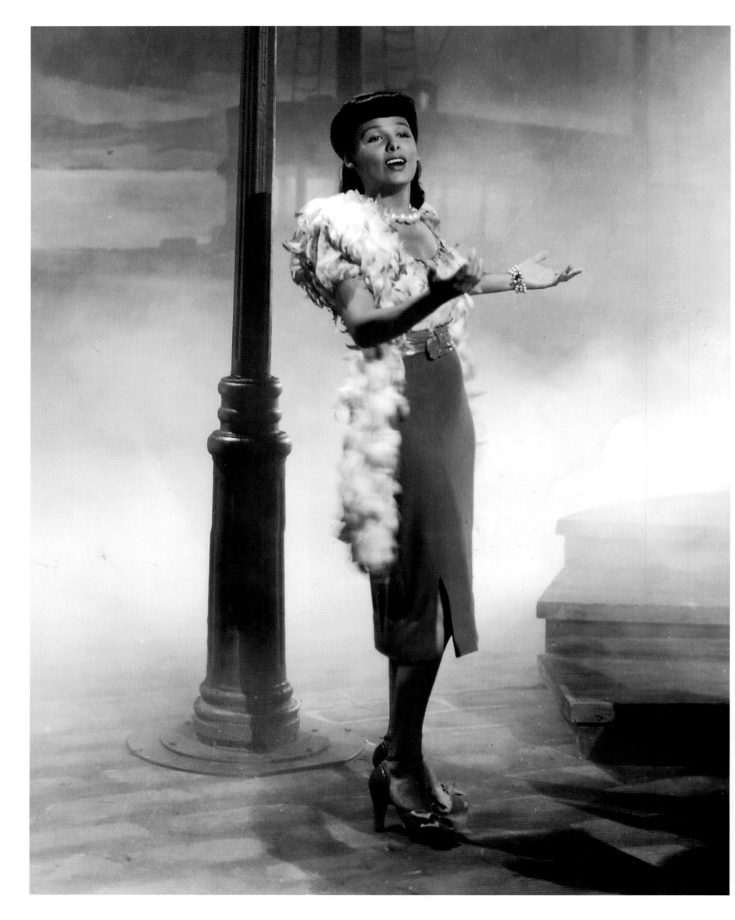

brought *Stormy Weather* to an artistic high with a masterpiece of dance.

Both *Cabin in the Sky* and *Stormy Weather* proved to be magnificent wartime entertainment that thrilled African American audiences and also, as Lena would learn, won fans among Black GIs on military bases. But the films' impact exceeded the war years. Each achieved classic status, as true salutes to great Negro talents of the twentieth century. Here were performers first discovered by Black audiences in clubs and theaters—which said much about the demands within the African American community for entertainment of the highest artistic and aesthetic standards. Those audiences initially knew the greatness that mainstream audiences only later would value. The energy in both films remains undiminished, and what shines through always is the gift of Black entertainers: They truly love their work and cherish sharing it with audiences.

Following the release of the two films, *The Duke Is Tops* was re-released and retitled *The Bronze Bombshell* with Lena's name above the title.

Soon Lena was back at MGM, where once again her performance was used to help save a picture in trouble.

Three weeks after the completion of *Cabin in the Sky*—in November 1942—Vincente Minnelli directed his second feature, *I Dood It*, a comedy starring Eleanor Powell and Red Skelton. When preview audiences were tepid about the film, it was decided to add another specialty number with Lena, this time teaming her with another movie newcomer from New York, pianist Hazel Scott. The

Lena sings of love and loneliness.

Stormy Weather's finale with Robinson.

number was shot three months after *I Dood It* was initially completed. Lena was hardly thrilled about working with Scott, considered by some to be her rival. Interestingly, at one point, Warner Bros. producer Hal Wallis had considered casting either Lena *or* Hazel Scott as the piano player in *Casablanca*, a role ultimately played by Dooley Wilson as Sam.

Scott was also known for her triumphant appearances at New York's Café Society. Born in Port of Spain, Trinidad, in 1920, she had an unusual upbringing. Her father, R. Thomas Scott, was a West Indian scholar originally from Liverpool, England. Her mother, Alma Long Scott, was a talented musician and music teacher who later formed her own all-girl jazz band. Brought to New York in 1924, Hazel

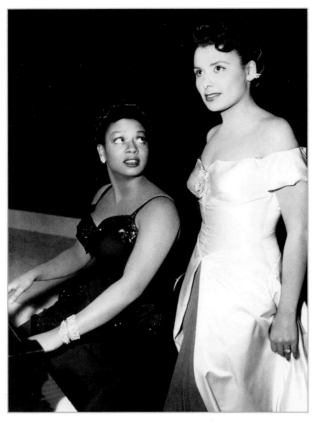

With pianist Hazel Scott in *I Dood It.*

was a child prodigy who under her mother's professional guidance brilliantly mastered the piano, and at age eight, she studied at Juilliard. As a teenage professional, she became known for jazzing the classics. Pianist Scott might begin a charged traditional rendition of Rachmaninoff, then midway shift the beat and tempo into the then popular boogie-woogie. Audiences loved it. Her appearances at Café Society, which began while she was still in school, were sold out. She performed at Café Society from 1939 to 1943.

Taking a particular interest in Scott's career was Barney Josephson. Though he had previously sought to guide Lena's career, he had more control with Scott. When offers came from Hollywood for her services, he laid down the rules and negotiated an iron-clad contract. She was not to play maids. She would appear only as herself. He also negotiated her salary. But Scott was not locked into a contract with just one studio. She would work for Warner Bros. and Columbia as well as MGM. For her services, she was paid $4,000 a week, even at MGM, far more than Lena. Finally an embarrassed MGM—with prodding from Lena's agent—agreed to raise Lena's salary to $900 a week with an annual increase of $100 a week. But the whole salary business angered Lena.

Certainly, Josephson's protective control over Scott from the wolves in Hollywood might have struck Horne as perhaps hypocritical on the part of Josephson. After all, he had been dead-set against her going to the film capital. Now he was doing everything in his power to ensure that Scott was well treated and well paid. Still, their friendship seemed not to have been affected.

"Hazel and I have never been terribly close or very comfortable together," said Horne. Yet Hazel "was an influence on me despite the frequent clashes of our temperament." Appearing more sure of herself, Scott radiated sophistication, confidence, and an air of superiority. She *knew* she was talented. She *knew* she was cultivated. Juilliard and her family had instilled those attitudes in her. She took pride in her background and her early accomplishments. Later she would become the second wife of Harlem's crown prince, the handsome minister and politician and Harlem's first Black representative in Congress, Adam Clayton Powell Jr. No one in Hollywood or outside Hollywood would push her around or try to tell her who she should be. It was wonderful to see a woman—especially a Black

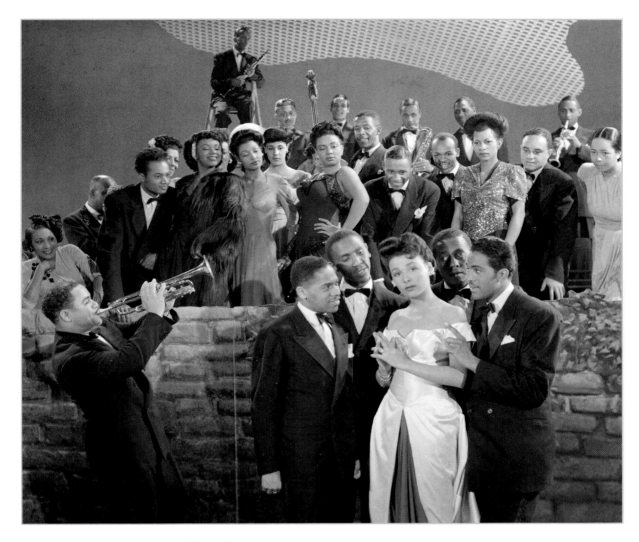

At the center of the action in *I Dood It*.

woman—with her hauteur and intelligence. That was all well and good. But Lena had to work with her—and those attitudes. Because she was now MGM's Black Beauty in Residence, she must have felt that no one was going to come onto the Metro lot and treat her condescendingly. Her guard was up.

Their sequence in *I Dood It* touched on their rivalry. Set in a theater during a rehearsal, Scott was seen first entering the premises—glammed to the nines in a fur, gown, and jewels surrounded by an entourage of debonair Black men dressed in tuxes and hats. A terrific image. Once seated at a baby grand piano with other well-dressed Black performers around her, she looked like an empress as she exuberantly played "Taking a Chance on Love." Lena arrives, also looking like a goddess, in a satiny dress. "I'm terribly sorry. I just couldn't find a taxi," she says—in that Black bourgeois voice that Black moviegoers were beginning to know they would hear. Thereafter she performs "Jericho" with others,

Lena and Hazel and Black Hollywood's stock company of singers and dancers, including Joel Fluellen (l. of Lena) and (r. of Lena) Lennie Bluett, and Vivian Dandridge..

including Scott briefly. As arranged by MGM's Kay Thompson, the song was perhaps unintentionally a mock revival number. It teetered on a stereotype but pulled back at the right moments. Nonetheless, the music proved energetic. But whether it was Lena's sequence was clearly open to question, and

Lena knew that. Still, so great was her beauty that when she was on screen, no one else could really compete with her. Hazel may have known that but then—with her healthy ego—dismissed such an absurd thought.

Lena and Hazel, two of the era's most glamorous divas.

A NEW LIFE

Away from the studio, Lena finally began to acclimate herself to Los Angeles and soon established a new social life for herself—as well as a romantic life. In time, she moved from the apartment that Felix Young had provided her and into a home at the top of a hill on the very same street, Horn Avenue. In this white neighborhood, some residents still viewed her with suspicion and then outright bigotry. A petition circulated to get her out of the house. It was one of the ugly aspects of life in Los Angeles: restricted areas where people of color were not welcomed, and where they were legally banned from living. Later in the decade, attempts would be made to remove Hattie McDaniel, Ethel Waters, and Louise Beavers from their homes in the Adams district, and when Nat "King" Cole and his wife, Maria, moved into Hancock Park, violence erupted from whites who wanted them out. For Lena, the racism of her neighbors on Horn Avenue was obviously unsettling, upsetting, infuriating. But certain residents on Horn Avenue—Humphrey Bogart and his wife at that time, actress Mayo Methot, Peter Lorre, and the politically committed writer Vera Caspary, author of the novel *Laura*—intervened and opposed the racists. When petitioners showed up at Bogart's home, he told them to get off his property. But for Lena, the petition and the racism left a long-lasting bitter aftertaste.

"She always lived in the white part of the city," said Geri Branton. That's where she had first lived in Los Angeles and where she would continue to live. "But she was a part of Black Hollywood." She would hang out at Club Alabam, which at first "was totally for Black folks," said Branton, and then had integrated audiences where everyone listened to music or laughed at comics like Redd Foxx and Slappy White, who later performed in an act there. There was also the Plantation Club, which was usually packed with Black performers seeking entertainment. "A lot of the white movie stars would

come to the Plantation Club," recalled Branton. "George Raft was a frequent visitor there. Betty Grable and Lana Turner would go to the Plantation club, too. After entertainers finished work, they'd come over to the Dunbar Hotel on Central Avenue." Horne and Strayhorn could be found at the clubs, and they still hit the jazz joints, like Billy Berg's. "It was a white-owned club with many white people," recalled Geri Branton. "Black people could come as long as they were show people, musicians, and their friends. They'd have the finest jazz artists. And all the musicians and show people would be there."

A favorite haunt was a Black after-hours club, situated in the home of its owner, called Brother's. Entertainer Bobby Short said that Brother's was run by a bartender at the Dunbar Hotel. Once he closed up shop at the hotel, he rushed to his home to open up shop there. "All the Negro entertainers knew the place," said Short. "Brother was very particular about whom he let onto his premises. He'd look out, and if he didn't think you were right for his place, he'd shut the door in the person's face." At Brother's, the stars socialized in high style. "In those days, people got dressed up. But *really* got dressed up. People were sitting around during the war in furs and jewels, you know, and dresses and dark suits. *Dressed!*" said Short. The talk was about the business, the new films being made, new musicians in town. "Oh, it was wonderful," said Geri Branton, who would go with her husband, Fayard Nicholas, his brother Harold, and Harold's stunning wife, Dorothy Dandridge, who was Geri's closest friend. Of course, it wasn't lost on anyone that two of Black Hollywood's great beauties might be present at Brother's on the same nights: Lena and Dandridge. "They'd be friendly with each other," said Branton. "But nothing big. I would get invited to Lena's house. But they didn't invite Dottie [Dorothy]."

Geri found Lena to be "very intelligent." Those early protests against her by lesser-known Black performers soon went by the wayside. Hollywood always respected success, and Lena was indeed that. At Black gatherings, Lena seemed at home and enjoyed exchanging stories with other Black entertainers. It might be that dashing Lothario Herb Jeffries—women couldn't resist him, and he couldn't resist them—or the majestic Hattie McDaniel or the forever lively Eddie Anderson and his wife, Mamie, or Fayard, always outgoing and friendly. Or Lena's closest friend in the West, dancer Marie Bryant. It wasn't hard to understand why Lena—and so many others—liked Bryant so much. If ever there were a free spirit, Marie Bryant was it. "She was all bubbles," said Bobby Short. "So much fun and so down. And funny. And yards and yards of talent. A wonderful singing style and she danced beautifully." Later Bryant assisted choreographer Jack Cole at 20th Century-Fox, and she taught routines to Betty Grable for the film *Wabash Avenue*. At MGM, she worked with such stars as Lucille Ball and Ava Gardner. And Gene Kelly enlisted her help with his "Slaughter on Tenth Avenue" in *Words and Music* (1948). She also performed a sensational, technically intricate, highly kinetic, and very sexy number with Harold Nicholas in *Carolina Blues* in 1944. And among jazz aficionados, she would be remembered for her smooth and supremely mellow rendition of "On the Sunny Side of the Street" in the 1944 short classic *Jammin' the Blues*.

Significantly, Bryant was equally at home in both Black and white worlds. Future producer Jean

Bach noted the social circles Bryant floated through—and the glimpses into her love life. She recalled seeing "framed pictures on her dressing table of Norman Granz and John Garfield. So you could tell what kind of guy she fancied." Bach felt for sure there was a Bryant-Garfield romance. In Hollywood, as Lena well understood, interracial romances always had to be conducted as secretly as possible.

Having made it in the Hollywood system, the important Black stars all understood movieland culture. Valuing their success, they made the most of it. A case in point was the Nicholas Brothers, who had signed a major contract with 20th Century-Fox, danced spectacularly in films, yet never played servant roles, and were socially among those at the top of Black Hollywood. "The town was very status-conscious," said Branton. "Stars met with other stars." Though it was not discussed publicly, Lena appeared to feel she could be herself within Black Hollywood, not maintaining an image as she would feel compelled to do with White Hollywood. They spoke the same language *literally*, used the same colloquialisms, the same slang, had the same frame of reference culturally, and understood the forces in White Hollywood, which still called the shots on their careers. Among themselves, they could express their anger—often served up with some humor as they mocked those who controlled their professional destinies. All were aware they

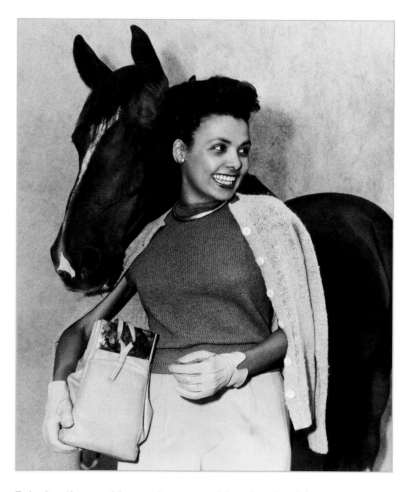

Enjoying the sunshine and a sense of freedom in wide open spaces.

were around the *ofays* (slang for whites; it was pig Latin for the word *foe*), whom they could not completely trust. The stars also loved the gossip that fueled the industry—and which could help make or break a career.

But Lena's growing success and the publicity that she generated were also putting her in another realm socially. Moreover, with her nightclub appearance at the Savoy-Place and later the Copacabana and other nightclubs, her triumphs in the East added to her status on the West Coast. New York's theaters, clubs, cafes, social life, and the media still based in the East—the newspapers, magazines, and

Ava Gardner, a close friend of Lena's.

The intellectual Welles liked beautiful women, including women of color. His romance with the ravishing Mexican-born beauty Dolores Del Río became well known throughout the industry. He married Rita Hayworth, born Margarita Carmen Cansino of Hispanic descent in Brooklyn, New York. Years later he called African American singer-actress Eartha Kitt "the most exciting woman alive." The two had an intense love affair.

In the early 1940s, Welles had thoughts of using Lena in a film he was in discussions about to improve relations with South America. Introduced to Lena by Duke Ellington, Welles soon set out to win the heart and the body of Horne. For a time, Horne herself would seldom acknowledge how far their relationship went. But indeed, it went pretty far. She was always on tenterhooks about romances, not wanting word to reach the media, especially if it was interracial. Vehemently opposed to interracial relationships, or "race mixing," as it was sometimes called, was columnist Hedda Hopper—who later had conniptions when Anthony Quinn publicly asked Dorothy Dandridge to dance and when Peter Lawford and Dandridge dated. Whispers about Lena and Orson spread around town, and eventually reached Hopper.

"Hedda had always been my defender, because I'd hired her as an actress when she was out of work," said Welles. "She always said, 'I know you're a dirty Commie Red. But you were good to me and

radio programs—would always mean something to Hollywood stars. In New York, Horne was viewed as one of its own, who was bringing class and new attitudes to Hollywood.

White Hollywood opened its doors to Lena—not all, but important sectors. Those who had seen her at the Mocambo or saw her at MGM wanted to meet her. Quiet as it was kept, she was sought by men who "dared" cross the color line. During the filming of *Cabin in the Sky*, Orson Welles launched a mighty pursuit. After his stellar career in radio in the East, he had come West, where he had directed *Citizen Kane* and afterward *The Magnificent Ambersons*.

good to my son, and I won't—' Then she added, 'But you've got to stop fucking Lena Horne.'

"I don't take instruction about things like that," Welles told her.

"You *have* to, if you care about your career, and care about your country!"

"Nobody who knew about it gave a damn that Lena was Black," said Welles. "Except Hedda, you know. But what was she gonna do? Write it in a column? I didn't give a damn. So I said, 'Hedda, you can go boil your head.' She always laughed when I insulted her. That's show business."

Of course, Welles might not have felt his career was in jeopardy because of his relationship with Lena. But Lena certainly had concerns. Both Hopper and fellow columnist Louella Parsons were too powerful to be ignored. Each could seriously damage or destroy a career, and the studios wanted no trouble from either. So stars learned to stay out of their crosshairs. In print, Parsons tended to be kinder and more supportive of Horne. At the same time, Lena was always uneasy about the reaction of Black America to stories about such a relationship.

Her romance with Welles, however, was just another indication of the new world Lena was navigating.

From her early days in Hollywood, she found herself invited to gatherings from which most other Black stars were excluded. At Cole Porter's home, she understood she was expected to sing. A mere guest she was not. She liked Porter. But she found herself enduring the racism—sometimes subtle, sometimes not—of stars like southern born and bred actress Miriam Hopkins. The words of acclaimed stage actress Tallulah Bankhead—who had been born into a prominent family in Alabama, was the granddaughter and niece of two United States senators, and whose father had served as Speaker of the House—surprised her. She complimented Lena on not looking like the pickaninnies she knew from her home state! Yet Horne actually came to like Bankhead, whom she believed at heart was a liberal.

Frequently, Lena was a guest at the Beverly Hills home of Gene Kelly and his wife, Betsy Blair, along with other stars, musicians, writers, directors: Stanley Donen, Richard Conte and his wife, Ruth, Peter Lawford, Louis Jordan, Phil Silvers, and Lennie Hayton. Lively discussions and debates about the studios or the latest films or the hot new discovery were common practice. So too were the games: volleyball, ping-pong, tennis, or charades. There was always singing, dancing, a lot of laughter. A lot of drinking, too—the cocktails kept coming—along with casual dining, often potluck dinners and desserts. Also around early in his career was keen social observer Arthur Laurents, who wrote the play *Home of the Brave* and later wrote the librettos for Broadway's *West Side Story* and *Gypsy* and their film versions.

"Gene and Betsy held open house for what the movie colony called, literally, the 'Real People.' Only in Hollywood," recalled Laurents. "The Real People didn't dress up, they sat on the shaggy rugs; they talked politics as well as movies (that was Betsy); they were liberal (also Betsy); and only the exception made a sexual pass (that was Gene) . . . The intellectual level was not a challenge but they were all young, all on the way up and every last one hellbent on arriving now, this minute. Although there were always two or three stars, no ass was kissed except Gene's and there was a line of assistants and secretaries for that."

Laurents remembered: "Lena was quiet, not wholly there; usually just sitting, sipping brandy near the piano where her [future] husband, Lennie Hayton, doodled at the keyboard—on his face a gentle, brandied half smile. Ignoring the yachting cap he always wore, she called him Daddy, not Commodore . . . Although he was a musical director at Metro, his whole focus, professional and personal, was on Lena. He radically changed her career as a singer."

Lena wasn't particularly close to Gene Kelly; in fact, she didn't care for him at all. Nor did Laurents. "It would be more true, if less lofty, however, to say Lena and I bonded because of our mutual dislike of Gene Kelly," recalled Laurents. "We didn't rip into Gene or the pretense that animated the house on Rodeo Drive; we laughed with the sheer delight of finding someone else among all those kiss-asses who felt exactly the same and could say it." For Laurents, who was gay, something unexpected happened between Lena and him. The two had an unusual bond. "It wasn't a love affair but it wasn't not a love affair. It wasn't definable," recalled Laurents.

Lena liked Kelly's wife, Betsy, an intelligent, fair-minded woman who saw clearly through Hollywood's pretensions, hypocrisy, and its bigotry. For Horne, a telling incident occurred at the home of Kelly and Blair. At one gathering, one of Blair's showgirl friends of the past had called to say she was in town with "mah new filthy rich Texan husband." Blair invited them over. Once they arrived, there "were greetings and oohs and aahs and thrilled to meet Gene and all that. The husband looked nice in a

A romance with Hollywood's "Boy Wonder," Orson Welles.

blazer and flannels and an ascot. Our housekeeper was off on Sunday, so Lena Horne and I went into the kitchen for more glasses, ice cubes, and a pitcher of lemonade. My showgirl followed us. We chatted about nothing. Then I asked, 'The tall glasses are in the cupboard right behind you—would you get out six for the tray?' She drifted languidly across the kitchen, looked pointedly at Lena, and said, 'Why doesn't she get them?' I dropped the ice cube trays, took her arm, led her forcibly back to the living room, and said to Gene, 'They are leaving—*now*,' Everything stopped. I glimpsed Lena, with a tolerant quizzical smile, shrug at Gene . . . Then they were gone. There was a curious lack of comment."

At the end of the evening, "Lena looked at me

softly, straight out of those big eyes in probably the most beautiful face ever, and said, 'Betsy, if you're really going to be a friend of mine, you must treat me exactly—and I mean exactly—like any other friend. But thank you.'" Said Blair: "I think she meant she could fight her own battles. I never asked. But I never forgot."

Lena became accustomed to dealing with prevailing attitudes in the social life of whites in the film capital. Not everyone was like Bogart when he denounced those petitioners as they tried to get Lena out of the neighborhood. Not challenging the racial attitudes of some of those she met socially was part of her strategy for the survival of her career. But those racial attitudes led to her ultimate disenchantment with Hollywood.

Repeatedly, as she found herself in the company of a Cole Porter or Noel Coward or any number of white personalities, the cultural differences between them and her time spent in Black Hollywood were apparent. It became second nature to her to shift to the differences. She did a form of code-switching. While everyone in her new crowd on the Hollywood scene might know of the Cotton Club, their view was that of an audience member—or an observer—not of the feelings and attitudes of Black performers backstage.

By the mid-1940s, the Lena who long felt like an outsider now assumed a new way of expressing herself, a new frame of reference, perhaps new mannerisms, a different tone of voice,

a different emphasis on certain words and their meanings. Out of necessity, she was carefully, artfully redoing, reshaping herself. The racism of the industry was not something generally discussed—although during the war years, thanks to Walter White, an awareness was growing of new "enlightened" attitudes and of the distortions in the movies in the treatment of African Americans. In time, such figures as Betsy Blair and actress Marsha Hunt would speak up about the inequities and injustices in the industry. But Horne held off raising her voice in these private settings. For her, an anger was slowly building up, but she was too invested in the rise of her career to make obvious waves.

Backstage at the premiere of *The Picture of Dorian Gray*—greeting the film's star, Hurd Hatfield.

Horne appeared still to be most at home with the down-to-earth, funny-as-all-get-out, insightful Marie Bryant. She also became close to Hazel Washington, whom she had previously met in Harlem. Washington had worked as a personal maid to Garbo and then as more of a personal assistant than maid to actress Rosalind Russell, with whom she developed a close friendship. Russell was a backer of a deluxe leather goods store that Hazel opened. Hazel's husband, Roscoe Washington, was one of Los Angeles's top police officers—the first African American lieutenant. Through her marriage to Roscoe, Hazel's nephew was Kenny Washington, the UCLA star athlete, who, along with Jackie Robinson and Woody Strode, was well known in Hollywood. For a brief time, Washington had an acting career. He and Horne also briefly dated.

In the larger world of Hollywood, Lena liked Ann Sothern, Lana Turner, Austrian-born actor Turhan Bey (known as "the Turkish delight"), John Garfield and Richard Conte and their wives, and for a time, Frank and Nancy Sinatra. She felt a special kinship with the rather insecure Kathryn Grayson. But in that world, she developed *close* relationships with only two of the important figures at the studio: one was Minnelli, the other was Ava Gardner. A down-to-earth North Carolina–born beauty, Gardner might have fallen through the cracks among Hollywood's starlets had she not surprised everyone when she married MGM's box-office star Mickey Rooney. Later she wed Artie Shaw and then was famously married to Frank Sinatra.

"Ava and I became close friends. She was a nice southern white girl. We liked each other because we both respected each other. Besides, we both knew that we were being screwed out there by MGM—I for racial reasons, she for being liberated long before it became acceptable. She was a unique person in that she felt that she had as much right to be human as a man had. I also think

Thriving in the company of musicians, here with jazz singer Johnny Hartman.

that in her pursuits, she wanted to be the hunter as much as she hunted, which for women was unusual then. And she was more open about it than some of her sisters who were doing exactly the same things. She was also open about her friendships with Blacks, like Sammy Davis Jr. That's why I admired her." Her friendship with Gardner also led her to reassess her feelings about Frank Sinatra. "I like him as a performer very much," she would later say. "We don't like each other personally; it's been that way for a very long time; it started with Ava Gardner."

Still, as her immersion in the social world of White Hollywood grew, Lena embarked on what appears to have been a fairly serious love affair with Joe Louis, the heavyweight champion from 1937 to 1949. Nicknamed the Brown Bomber, this world-famous boxer had been born Joseph Louis Barrow Jr. in 1914 in Chambers County, Alabama. During the war years, his cultural significance was at its greatest impact as a powerful symbolic force against the spread of Naziism that was sweeping throughout Europe. In 1936, his bout against German fighter Max Schmeling was viewed as a battle of political ideologies, of basically good against evil. Reported not to have trained as strenuously as he should have, Louis lost his first match. But when the two had a rematch in 1938, Louis pounded Schmeling and regained his title. Cheers, screams, shouts of glory could be heard everywhere as the event was broadcast on radio. It was a triumphant night, boosting the spirits and morale of the nation, especially African Americans. Few national heroes would be held in the esteem that Louis was. Moreover, publicly Louis retained a modesty and humbleness that made him endearing and relatable. He was known for having a country-boy charm—and for his devotion to his mother. Of course, there was more to Louis than the public saw. Though he was famously married to Marva Trotter, he was quite the ladies' man who had a series of hot and heavy affairs.

Louis was no stranger in the movie capital. In the fall of 1937, he had arrived in Hollywood to play a cameo in a Joe Palooka movie that starred blond hunk Joe Kirkwood Jr. as a boxing champ. Louis liked Kirkwood, and he also enjoyed the Hollywood experience, meeting a star like John Barrymore and being pursued by beautiful women. "A big movie star would see me, the Heavyweight Champion of the World and wonder how I am in the bed," recalled Louis. "I'd see a big beautiful movie star and wonder how she is in the bed. We would find out very easily. These were just one-night stands. But we both knew to keep it cool. Neither of us could afford to be out in America in those days. However some of those one-night stands went on for weeks." If word reached his wife, Marva Trotter, he'd buy her a present to placate her anger. "Marva got a lot of expensive presents," said Louis.

Louis returned to Hollywood to play a role in the movie *This Is the Army*, released in 1943. By then, he had become a sergeant in the army, stationed on the West Coast. He and wife Marva had also recently become the parents of a baby girl. But Joe found it impossible to resist temptation. "The picture took six months to make. Six long months," recalled Louis. "It's too long to be away from home."

Louis said he met Lena years earlier at the Cotton Club. But she recalled that they had met later through her father, who took her to Joe's training camp in Pompeo, New Jersey. Photos were taken by Carl Van Vechten of the two enjoying each other's company while in a rowboat in 1941. According

to Louis's recollections, a relationship started at this time. But Lena said little about the matter. Still, the two would meet again as her career was just starting to take off.

"Lena Horne was in town singing with the Charlie Barnett [sic] band," Louis recalled. "I purposely didn't go to the theater. But one night I went by to visit some friends on Fifty-fifth Street and Lena was there. I hadn't seen much of her until now; I'd heard she was going with Charlie Barnett [sic], so I wasn't too worried about talking to her. But, shit, it happened all over again. She was more beautiful than she'd ever been. Nice and sweet, but Lord, she had a filthy mouth. Could cuss better than any sailor wished he could. We started talking and talking; next thing I knew, we were getting real serious. We were planning all kinds of places and ways we could see each other."

Now on the West Coast, Louis soon resumed his affair with Lena. "I was so carried away with her it wasn't proper. Lena would fuss with me about not coming to see her on the MGM lot," said Louis. "The trouble was there was another star there, Lana Turner, asking me why I didn't come out and see her on her set. I decided the best thing to do was not to go at all. By this time I really felt I was in love with Lena, but I was feeling like a dog. I wanted to marry Lena, didn't want to leave Marva, especially now with my new baby."

Each found the fame of the other intoxicating. But the attraction was genuine, and passionate. They avoided public outings, much as Lena and Minnelli had. But the word got around town—and no doubt up to the executive offices of MGM. Louis B. Mayer always sought to avoid scandals and tales of "immorality" that might damage a star's reputation and thus damage the impact, or rather the box-office profits, of a film. "Everybody knew about it," recalled Fayard Nicholas. "You'd even see them together at the Mocambo." It wasn't long before the Negro press reported on the two.

"Hollywood Star and Heavy Champ Scoff at Claims." So read the headline in the November 14, 1942, edition of the *Pittsburgh Courier*. The paper's columnist, Billy Rowe, reported on the romance—and marriage rumors. "Contacted at Fort Riley where he is on active duty after a 15-day furlough here, Louis took less than three minutes to give his side of the story. Said he: 'People are always talking about things they know nothing about. I think that Lena is a grand person, on and off the screen, but that doesn't mean I want to marry her or vice versa. During my stay in Los Angeles I spent most of my time playing golf and thought about nothing else.'"

Lena told the paper: "I'm in the dark about all these rumors, and I don't mean because of the new blackout regulations that have come to this tinsel city. Sgt. Louis and I have been friends for several years and for me, like fifty million others, he's a symbol of greatness. I can certainly admire him and be in his company without hoppling off to the altar."

Denials aside, as Rowe's reporting pointed out, Lena was still married to Louis Jones. He noted that Lena "is planning a divorce this fall, an action that has been scheduled almost two years now."

The Lena-Joe Louis romance was tempestuous. "I have a hot temper," Horne often admitted. That temper shot up easily. Aware of the way Joe Louis was pursued by other women, she was determined to hold on to his affections. She found herself feeling possessive and in some ways consumed by their

relationship. She didn't hesitate to let Louis know of her feelings or her anger.

Nonetheless, the bond she felt with him was deep. "I would say that he was the best and closest friend that I had at that time. He was very supportive. He was the only man I was seeing at that time. We were very close friends."

But then, said Louis, "Fate decided everything."

When invited by Bing Crosby to play golf as part of a benefit for the USO, he happily accepted. Asked if he knew a well-known woman who could keep scores for the game—and get press attention—Louis suggested Lena, who agreed to be there. But at the last minute, she backed out. Over the phone, Louis protested that everything for the event had been set up. "Lena said she didn't give a damn. She wasn't coming."

Lena and boxing champion Joe Louis in the 1940s. Theirs was a stormy romance.

"Then she started giving it to me hot and heavy," said Louis. "Told me I'd been in town for a couple months and hadn't bothered to call her but a few times. She hinted about knowing that I'd been seeing other movie stars, too."

Louis went to her home to settle the matter. But by then Lena was packing her bags for a trip to entertain the army troops. She ignored his pleas for her to reconsider. Louis recalled: "One time Lena had given me a gold identification bracelet. 'Joe Louis' was printed on the front, and on the other side it said 'Lena.' I'd had it for at least three years. I took off the bracelet and dropped it in her suitcase.

"Well, then Lena started cursing me like nobody ever had. Before I knew it, I hit her with a left hook and knocked her on the bed. Then I jumped on her and started choking her." Fortunately, her cousin Edwina, who was in the house, rushed to pull him off Lena. When she threatened to call the police, "I stopped."

Louis recalled that he returned to his hotel. "I was so scared I was shaking," he said. "I got chills

because I realized I could have committed murder. I had never known such a feeling. What the hell made me do something like that? I'm not that kind of person. Passion can mess you up."

Years later Lena denied that Louis had struck her. She said she'd never let any man treat her that way. "I've never allowed anybody to strike me without a terrible kind of reaction," she said. "But Joe has never been unkind to me. I don't think he's a man who would ever hurt a woman. He was too big to do that to people outside the ring." Of course, she never actually stated flat out that Louis had not physically abused her. But perhaps she was embarrassed. Or perhaps she did not want to damage his reputation.

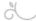

The end of her romance with Louis led perhaps to an altered consciousness in Horne. For Black female stars, it was always difficult to find Black men within the entertainment industry who had a comparable status. For such stars it was important to have someone who understood their particular professional conflicts and pressures—and also someone who was respected and who could, if necessary, shield them. It wasn't that these women were helpless or that they were shrinking violets. Instead, it was the idea of an equal partnership they were after. The women did not want a hanger-on who might use her, which indeed did occur. Seemingly simple things said much: Entering a restaurant and securing a table, not being turned away, being counsel during contract negotiations—as her father had done with Louis B. Mayer. Lena always knew, and later said, there were places a Negro man could not take her, could not demand respect for them

both. A major figure like Joe Louis, however, was commanding enough in his own right—recognized for his skills, achievements, and professionalism—that doors opened readily for him. Nor did she fear exploitation from him. Joe Louis was not someone riding on her coattails. Few Black men of Louis's stature existed.

Then there was Billy Strayhorn, who during these years she came to love deeply, profoundly. She confessed she wanted to marry Strayhorn. "He was just everything that I wanted in a man, except he wasn't interested in me sexually. If I could have had him, I would have taken him. We were in love, anyway. He was the only man I really loved." But Strayhorn also developed a significant relationship with the musician Aaron Bridgers. They lived together in New York.

On the subject of romance, she came to a difficult decision: "I callously realized that I would have to associate with a white person to get the things I wanted professionally. It was just that I was alone and I had two children and I was gonna take care of them."

If she crossed the color line—which she was hesitant to do—Vincente Minnelli came to mind. His name could open any number of doors. But it was clear that there would be no marriage to Minnelli. Following *Cabin in the Sky*, Minnelli's directing career began its upward climb. *I Dood It* may have been a dud, but it was followed by a major achievement, 1944's *Meet Me in St. Louis*. With a cast that included rising child star Margaret O'Brien, veteran Mary Astor, Leon Ames, Tom Drake, and Lucille Bremer, the musical classic marked the full emergence of Judy Garland to young adult stardom. Understanding Garland's self-doubts and

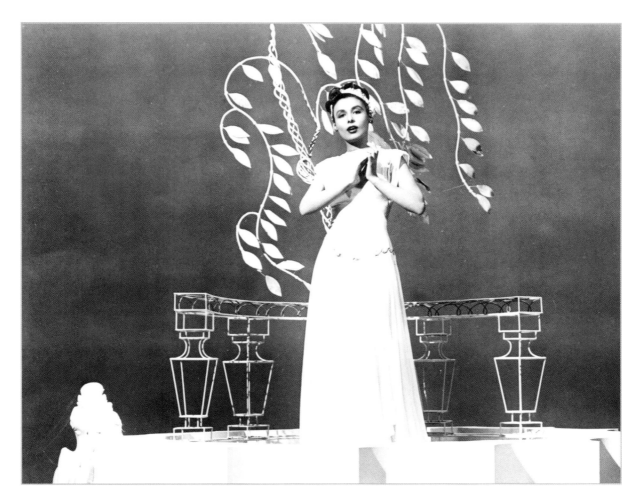

Performing a haunting version of "Why Was I Born?" in *Till The Clouds Roll By.*

fears—which were part of her appeal—Minnelli brought her vulnerability to the fore. Working closely together, Minnelli and Garland fell in love, married on June 15, 1945, and later gave birth to a daughter, Liza. The man who had spent evenings at dinner with Lena, who had enthusiastically discussed her career plans and the politics at MGM, who provided great support was now no longer such a vital presence in her life.

Lena found herself standing at a crossroads. She wanted a relationship, but front and center was her career. The ambition and drive—which rarely were apparent to her public or even to many in show

business—were embedded in her. There had to be a way to bring companionship and career goals together. Perhaps in this frame of mind, Lena Horne began a slowly evolving romance with Lennie Hayton, the white arranger and composer at MGM.

Those outside Hollywood might have had little awareness of Hayton. But within the music industry, and naturally at MGM, Hayton's talents were recognized and admired. Within the Freed Unit and the studio itself, he was a major figure. Born into a Jewish family in New York in 1908, the son of a restaurateur, Hayton was exposed to music early by both his parents, who were regular concert-goers.

Once he discovered jazz as a teenager, he knew he wanted a career in music. Having played the piano since childhood, he was skilled and talented enough to join the orchestra of Cass Hagen. In 1928, he moved on as a second pianist for the popular Paul Whiteman Orchestra, and then worked with another popular figure of the Depression era, Bing Crosby. As Crosby toured and performed on radio, Hayton and Eddie Lang provided musical support. Hayton led the orchestra for Crosby's big hit "Brother, Can You Spare a Dime?" When Crosby starred in MGM's *Going Hollywood* in 1933, Hayton served as his musical director. He continued to work for Crosby, but having enjoyed his experience at MGM and perhaps ready to get off the road, he signed on at the studio as a musical director. His very successful career ultimately included four Oscar nominations topped by a win for *On the Town* (1949) and later *Hello, Dolly!* (1969). When Lena met him, Hayton's awards lay ahead, but he was an indispensable part of MGM's music department. In 1943, his first wife, Helen Maude Gifford, died. He was now available.

An attractive man, Hayton often sported a goatee and later was almost always seen wearing a jaunty yachtsman's hat. Count Basie said he himself began wearing a yachtsman's hat after seeing the stylish way that Hayton wore his. Known for being rather low-key but witty and observant, with an excellent knowledge of music, Hayton was respected by musicians, Black and white. "Russian, Jewish, intellectual," said Betsy Blair, "he had played in many great jazz combos, even with the legendary Charlie Parker. He was a mysterious and charming fellow. 'Cool' and 'hip' could have been invented for him."

First to bring Hayton to Lena's attention was Kay Thompson, the arranger, composer, choreographer, and, most significant, vocal coach whom Lena always credited with teaching her to breathe while singing and how to reach notes she didn't realize she could. Supremely sophisticated and later the author of the classic children's book series *Eloise* about a little girl living at New York's ultra-plush Plaza Hotel, Thompson became one of Lena's close Hollywood friends.

During the filming of *I Dood It*, Thompson suggested Lena get to know Hayton better. But Horne found him distant and aloof. They saw each other frequently at parties and gatherings, at studio events, at the home of Gene Kelly and Betsy Blair. Gradually, Horne got to know him and enjoyed his company. Then a romance slowly blossomed.

But Lena had to deal with the ongoing problem of formally ending her marriage to Louis Jones. The August 21, 1943, issue of the *Chicago Defender* reported: "Lena Horne Sues Mate For Divorce." The November 7, 1943, issue of the *Chicago Defender* headline reported: "Lena Horne's Marital Woes May Prove Costly For Her." At this point, Louis Jones was "charging Miss Horne with desertion" in a suit "filed by her husband in Columbus, Ohio." The issue of custody of her children remained as it had been for years already: Teddy could stay, or rather visit, Lena and Gail at the house on Horn Avenue, but Louis would not budge in letting Teddy live with Lena. Jones would retain primary custody of their son. Lena's relationship with her son would trouble her for the rest of her life.

With Kay Thompson, arranger, composer, vocal coach, and a new friend at MGM.

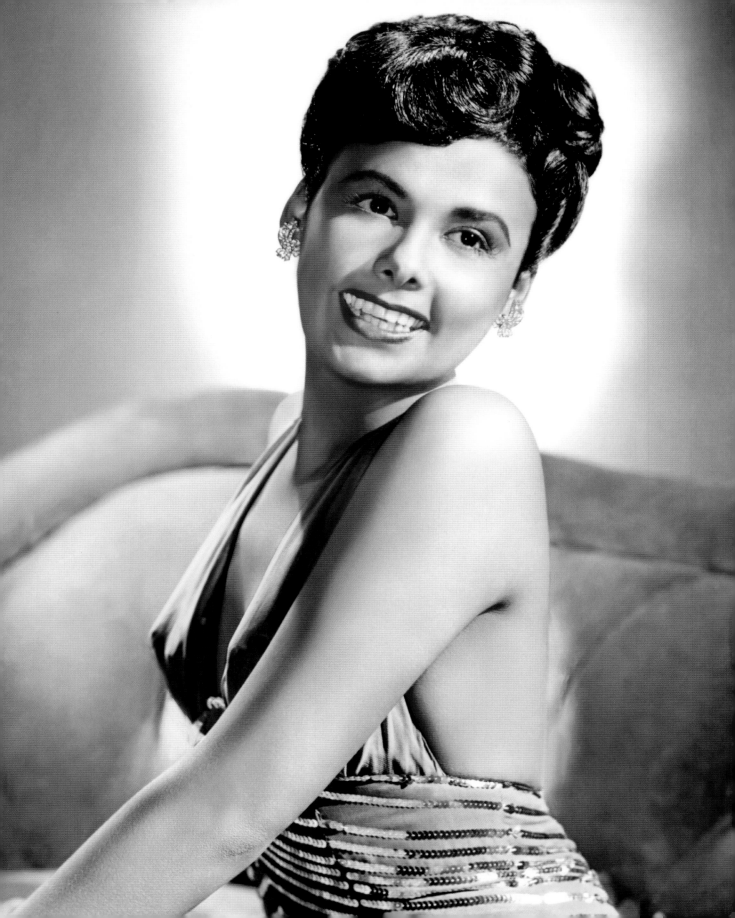

FINDING HER WAY

At MGM, Horne found herself falling into a routine, or perhaps more accurately found the studio falling into a routine in the way it handled her. Along with *I Dood It*, she appeared in four other films released in 1943–1944: *Swing Fever*, *Thousands Cheer*, *Broadway Rhythm*, and *Two Girls and a Sailor*. Their plots were perfunctory at best. Basically, the writers and directors relied on the stars to carry the films and breathe life into the proceedings. All had the quality of variety shows spotlighting various acts.

Swing Fever was a throwaway comedy starring a wacky and likeable Kay Kyser. Lena performed "You're So Indifferent," which may have summed up her feelings about the picture.

In the all-star *Thousands Cheer*, directed by George Sidney, the young romantic leads were Kathryn Grayson and at the time a relative new-comer, Gene Kelly. Grayson's character hailed from a military family that had been torn in half because of the father's (John Boles) focus on his professional duties, to the point where he neglected his wife (Mary Astor). Kelly's character is a member of a well-known but unconventional aerialist family, devoted to their sport. Fundamentally, he has to mature and accept the responsibilities and demands

of army life. It was as simple as that. Among the stars performing various bits were Mickey Rooney, Judy Garland, Lucille Ball, Eleanor Powell, June Allyson, Red Skelton, Marsha Hunt, and José Iturbi.

In a beautifully blocked and shot sequence, Lena sings "Honeysuckle Rose," accompanied by the great saxophonist Benny Carter and his band. In essence, the band introduces her musically as they appear first with their instruments gleaming and their sound a feast for the ears. Dressed in a white gown and standing before mirrors that reflect her image at every turn and with a background of red curtains that look like ancient Greek columns guarding a deity, she's a stunning vision in Technicolor. With her comprehension of the lyrics of this Fats

One among a steady lineup of publicity stills,
taken after the studio had signed her in the early 1940s.

Waller/Andy Razaf song and a jazzy big band beat, Horne was a stately and assured goddess. For GIs on military bases who yearned for their girlfriends and wives back home, she was a perfect wartime dream girl—more of a dream, of course, than a reality. Horne would perform "Honeysuckle Rose" other times—it became one of her signature pieces—and she might sing it even better, but here she was splendid, and there could be no complaints.

The sequence underscores the significance of Horne's movie appearances in another way. Because of Horne's success, highly talented African American musicians like Carter and Phil Moore had an opportunity to work in mainstream films. In this respect, too, moviegoers around the country were becoming accustomed to seeing first-rate Black musical talents at movie houses in their hometowns. Of course, Horne later heard that her sequences were cut from films in the South. Yet still her scenes had an impact in other parts of the country. Audiences had already heard Black talents like Ellington and Armstrong on the radio. But *seeing* the images of such musical stars was another story altogether. Though MGM might have used Black musicians with Lena to fend off any grumblings about integrated musical sequences with Horne and white musicians, who cares! A point was still being made.

By now Horne herself had mastered the demands of studio productions. One sequence could take hours, days, a week or more to shoot. Delays always popped up. Something might go wrong with the lighting. Her hair or makeup might need touch-ups. Her costumes might need adjusting. She understood that she had to maintain her energy and the mood and story of a song in ways quite different from the demands of nightclubs. Because songs were

Just your down-to-earth glamour girl at home, thanks to MGM's publicity department.

recorded in advance, she had to perfect performing to playbacks of recordings—looking natural and always in sync. Rehearsals and concentration were essential. She also had to create a *character* in her songs. There had to be backstories. Though musical backstories might be seemingly imperceptible to a moviegoer, they made the songs more personal, more engaging, more enveloping. As time went on, she got even better and was more self-assured.

That was clearly the case in the film *Broadway Rhythm*. Here Horne was not playing herself. Instead, the credits listed her as a character named Fernway de la Fer. The primary storyline is about a Broadway producer (George Murphy) pursuing a glamorous star for his show *and* his private life,

Ginny Simms. At the same time, he has to learn to appreciate the talents of his younger sister (Gloria DeHaven) and his father (Charles Winninger). Once again, the film didn't have much of a story.

One evening Murphy and Simms attend a performance at a place with Black entertainers, the Jungle Club. *Yes, the Jungle Club.* Outside the club is a placard announcing that nightly appearing is Fernway de la Fer. On stage, a bongo player exuberantly sets the tone and the beat (as had been done in *Panama Hattie*) just before Lena takes center stage, dressed in a bright yellow top that exposes plenty of midriff with a long dark skirt with slits up the sides to reveal her legs. In her hair are matching yellow flowers, and she wears hooped gold earrings. With dancers beside her, she performs the Hugh

Martin–Ralph Blane song "Brazilian Boogie"—and is rhythmically animated. Among the dancers: her friend Marie Bryant; Etta Jones, formerly of the Dandridge Sisters; Juliette Ball; Avanelle Harris; Mildred Boyd; Maggie Hathaway; and that sexy headliner of the Katherine Dunham company, Archie Savage—most familiar singers and dancers of the Black stock company of studio musicals. They might have benefited from better choreography. But Bryant, Jones, and Savage have spirit—as does Lena. Of course, Lena and the others are exoticized here similar to the way she was in *Panama Hattie.*

Also in the film was Eddie "Rochester" Anderson playing a servant to George Murphy. But Anderson, significantly, was depicted as having a life away from the boss. In another musical interlude, Lena

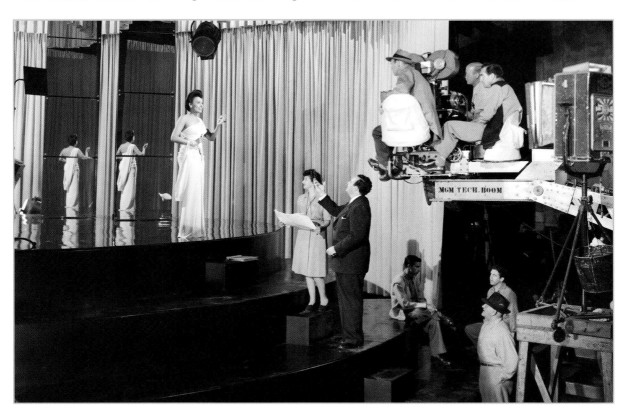

Mastering the intricate demands of performing on film.

performs Gershwin's "Somebody Loves Me" with Phil Moore at the piano—and with a spiffily dressed Rochester leaning back in a chair, smoking a cigar while listening. As it turns out, Anderson's there to persuade the producer of the new show to hire Lena. It's suggested he's her boyfriend and maybe her manager, too.

On another evening, Anderson is seen entering the Jungle Club dressed in a tuxedo with top hat and carrying a bouquet of flowers presumably for Lena's Fernway de la Fer. As he glides into the club, we see a sign letting us know this time around Hazel Scott is appearing there. Afterward Scott is seen at the piano—dressed in yellow—as she performs while supported by a Black orchestra. Wonderful as the Scott sequence is, unlike in *I Dood It*, she and Horne have no scene together. Both divas probably breathed a sigh of relief.

Hours spent rehearsing before stepping in front of the camera.

We never see Anderson present the flowers to Horne. And what might have been an interesting romantic subplot between the two Black stars was left undeveloped. Robert Osborne said that MGM chucked additional footage of Lena and Anderson together because the studio felt the relationship hadn't worked. Part of the problem may have been that Horne still hadn't found a director like Minnelli, who could sensitively draw a characterization out of her. Not having been trained as an actress, she was still in search of a technique to use for character creation. What she had found on her own as a singer was beyond her as an actress. From fellow musicians, she had already learned much and would continue to do so. She had also learned something from having acted with Anderson in *Cabin in the Sky*, as well as from her off-screen friendship with him. But she wasn't afforded enough acting roles to grow as an actress. After no doubt having hoped that finally she would have another role, it was disappointing and frustrating that the efforts she had put into Fernway de la Fer had been left on the cutting-room floor.

She also filmed a sequence for *Two Girls and a Sailor*, another wartime entertainment about two sisters—June Allyson and Gloria DeHaven—and the young men they fall for, Van Johnson and Tom Drake. In a nightclub scene, an elaborate camera setup was created for Lena's performance of "Paper Doll." Filmed in black-and-white, the sequence was shot

from high up, looking down, almost an aerial view, as Lena stood backstage. Long curtains looked once more like Greek columns heralding a deity to be worshipped and adored. As Lena sang "Paper Doll" in dreamy tones, Tom Drake was shown standing in the audience, watching intently, yearning to be near this implausibly beautiful woman. Clearly, it was being announced that this was a woman to be adored by all races.

Still, it was becoming all the more evident to Lena that MGM was not going to develop her into a movie actress or a movie star in the traditional sense. Indeed, she had proven herself a star in her musical interludes and in both *Cabin in the Sky* and *Stormy Weather*. But major-league movie stardom hadn't come—not even in the way it seemed to have briefly for Nina Mae McKinney and Fredi Washington, who both suggested moods, attitudes, and yearnings that were not in the scripts of the films in which they appeared. In an effort to stretch her wings, Lena appeared in a role on the episode "You Were Wonderful" on the radio program *Suspense* in 1944. But still Lena was left stranded. Horne kept working in Hollywood, and she kept performing in nightclubs, where she still was evolving as an important song stylist. But she turned her focus in another direction of equal importance: the war and the troops, the Negro troops in particular.

Because no one in MGM's hair department would touch Lena's tresses, the great stylist Sydney Guilaroff did Lena's hair and hired a Black hairdresser Tiny Kyle to be on set for touch-ups.

Learning the ropes of lighting and camera angles with master portrait photographer Clarence Sinclair Bull.

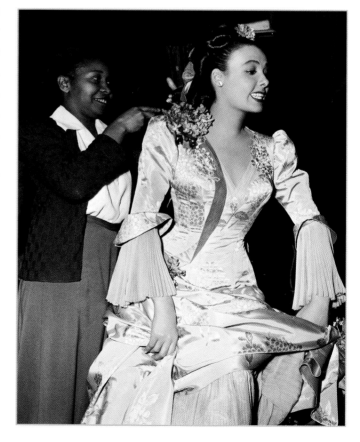

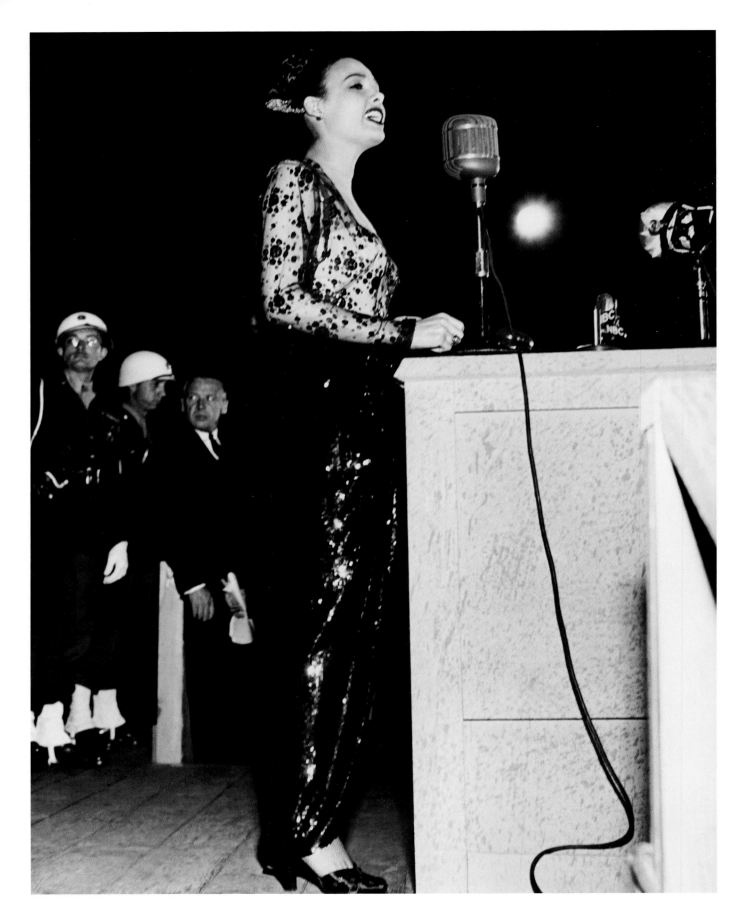

THE NEGRO TROOPS

ollywood immersed itself in the war effort in the early 1940s, doing all it could to trumpet its patriotism and its allegiance to struggles abroad. To be cynical, the film industry's war efforts could be viewed as good for business. But it was there nonetheless, and Hollywood's wartime activities proved significant. Such movies as *Bataan* (1943) and *So Proudly We Hail* (1943) celebrated the valor of those willing to sacrifice for their country. *Since You Went Away* (1944) and *Mrs. Miniver* (1942) dramatized heroism on the home front. Actors Clark Gable, James Stewart, Tyrone Power, and Henry Fonda served in the Armed Forces—and were photographed in their uniforms, looking ready for action. Other stars attended war rallies, sold war bonds, and entertained the troops.

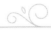

For Black Hollywood, there was always the knowledge that the American military still had segregated troops. Though African Americans enlisted to fight abroad for the freedom of others, it was assumed that white soldiers and airmen, especially those from the South, did not want Blacks fighting beside them. Often it appeared as if the Negro troops had to prove themselves—their courage, their bravery. Lena and other Black stars were determined that attention be paid to the Black military personnel. Emerging as a leader in Black Hollywood's wartime activities was Hattie McDaniel, who served as a captain in the American Women's Voluntary Services and headed a branch of Hollywood's Victory Committee, with support from Fayard Nicholas, Louise Beavers, Lillian Randolph, and actor Ben Carter.

Black Hollywood felt compelled in particular to provide encouragement and entertainment for Black soldiers before they left for missions abroad. While the military's USO clubs provided entertainment,

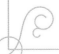

A performance at the homecoming for generals George Patton and James Doolittle at the Los Angeles Coliseum.

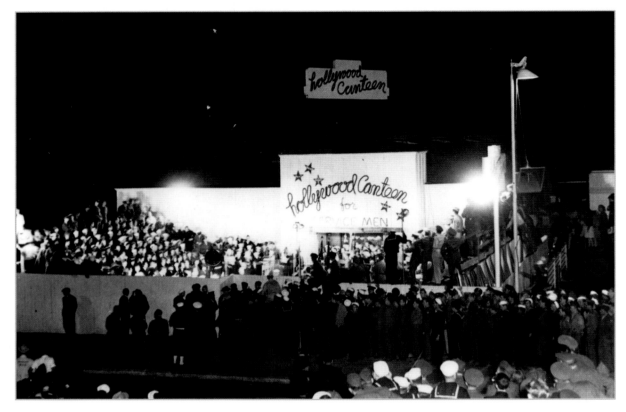

The World War II integrated gathering place for members of the armed forces and many of Hollywood's great stars.

refreshments, and opportunities for socializing, those clubs were openly segregated, with only all-white or only all-Negro venues. But two other establishments for the military during the war years were indeed significantly integrated. In New York, the Stage Door Canteen opened in the theater district. It was a place where military personnel and celebrities could mingle and enjoy food and music before many of the young members of the armed forces flew overseas to join the Allied fight. Among the Black stars providing entertainment were Duke Ellington, Katherine Dunham, the Berry Brothers, and Sid Catlett.

On the West Coast, Bette Davis and John Garfield founded the Hollywood Canteen in 1942. Located at 1451 Cahuenga Boulevard, the Hollywood Canteen also served as a gathering place for members of the armed forces, male and female, of all races. Bette Davis had insisted that it be racially integrated. The film industry pulled out all stops to ensure that the Hollywood Canteen be a major enterprise—with three thousand members of the unions and guilds donating their services. Stars, directors, producers, writers, costumers, technicians, and stand-ins all volunteered to offer meals and entertainment for the military. Music might be provided by the bands of Benny Goodman, Harry James, and others. Glamour and high spirits came by way of such stars as Rita Hayworth, Betty Grable, Anna May Wong, Fred Astaire, Lucille Ball, Charlie Chaplin, Barbara Stanwyck, Lupe Vélez, Esther Williams, Lana Turner,

Alan Ladd, Lauren Bacall, Marlene Dietrich, Hedy Lamarr—each of whom might be seen preparing or serving meals or even washing dishes. Or dancing with young soldiers. The idea was, of course, we're all in this together.

Lena and other Black stars enthusiastically participated in activities at the Hollywood Canteen. The Nicholas Brothers and their young wives, Dorothy Dandridge and Geri Nicholas (Branton), Eddie "Rochester" Anderson, Hazel Scott, Louise Beavers, Bill "Bojangles" Robinson, Butterfly McQueen, and Ethel Waters helped let Black soldiers know their efforts were valued and appreciated. The sounds of the bands of Duke Ellington, Cab Calloway, and Count Basie could be heard as well.

Lena sang at the Hollywood Canteen week in, week out. On one Christmas when some stars canceled their appearances at the Canteen, Lena received a call from the Canteen's program director. He apologized for giving her such short notice but wanted to know if she could step in to perform. "Are you sure the boys aren't tired of me?" she asked. The publication *Liberty* noted: "Half an hour later, her incandescent smile was brightening up the Canteen and the Christmas of hundreds of soldiers. It was after midnight when she returned home, to the remnants of her own Christmas party."

She also entertained frequently on the army's radio show *Command Performance*. Then there were her appearances on the radio show *Jubilee*, which aired from 1942 to 1951, with the desired effect

Special appearances on radio's *Jubilee*—here with Eddie "Rochester" Anderson, Max Baer, and Lionel Hampton.

of specifically reaching out to African Americans in the armed services. Taped before a live audience in Los Angeles and hosted by Black actor Ernest Whitman, *Jubilee* was broadcast abroad and was the creation of the young Black filmmaker Carlton Moss, who collaborated with director Frank Capra on the film *The Negro Soldier*. Spotlighting Black entertainers, Moss's *Jubilee* also featured commentary on the war. One memorable episode featured Lena with Eddie "Rochester" Anderson as she sent messages to the servicemen around the world. Her words were warm and genuine and no doubt lifted the spirits of GIs—as did performances on other episodes by Benny Carter, Ellington, Basie, Phil Moore, who was the musical director of *Jubilee*, and on a special occasion, Joe Louis.

Wartime volunteer activities brought out a fire and a sense of conviction within Lena. Her consciousness was raised by the plight of the Negro

soldiers, who were fighting for their country but were still relegated to second-class citizenship in their own nation. Whenever possible, she took a break from filmmaking to do something for the troops. In May 1943, she took time off while filming *Stormy Weather* to travel to Richmond, California, to christen the Liberty ship the *George Washington Carver*, named after the African American agricultural scientist and inventor. Surrounded by a rousing crowd of 1,500 at the Richmond shipyard, her smile reflected the pride and excitement she felt that day. The *Chicago Defender* reported that the event was sponsored by the United Negro Labor Committee.

Also in attendance were Dorothy Dandridge, Bill Robinson, and Etta Moten, as well as the first Black female welder, Beatrice Turner.

She also visited military bases where the excitement of the Black soldiers at seeing her was almost palpable. They cheered, stomped, shouted, and swooned in delight. While white soldiers had posted pictures of pinup girls like Hayworth and Grable on their foot lockers, the Black GIs had photos of Lena. "Now we have someone we can put on our lockers," read the letter that a Black GI wrote MGM. "Requests for her pinups are by no means confined to men of her own race, although she is a combined

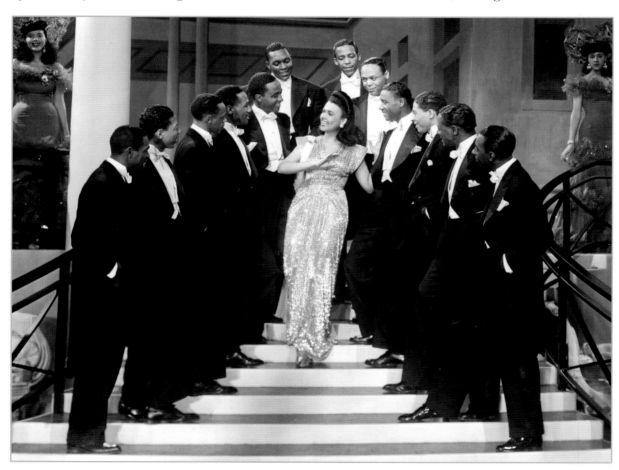

The movie goddess of every soldier's dreams, 1943.

Betty Grable, Hedy Lamarr, and girl-black-home to our 800,000 Negro soldiers," reported *Liberty*. "They've named their planes, their jeeps, and their daughters after her. There is even a Lena Horne Lane on an Italian mountainside. It leads to the camp of the 32nd Fighter Group, composed of four Negro pursuit squadrons."

The soldiers let her know of their thrill and pride at seeing her in *Cabin in the Sky* and *Stormy Weather*, which had been shown on their bases. More than ever, she was struck in a new way by the power of film. But she also learned that when the soldiers had seen her other films in their southern hometowns, her sequences were cut out. Minnelli recalled that later she "complained that because she was Black, her many numbers were never integrated into the script. They could thus be cut out of the film if Southern distributors objected. This was, of course, contemptible. Could it have been only thirty years ago that we considered it daring to cast a Black actress in a non-servile role? We were raising our puny voices for social progress. They should have been louder." Lena Horne may well have begun to see her Hollywood movies as a form of tokenism.

When she was invited to the graduation ceremony of the Army Air Corps at the Tuskegee Institute in Alabama, she was elated. In the past, African Americans had been prohibited from becoming military pilots. But at the Tuskegee Institute, future Black pilots were educated and trained. Known as the Tuskegee Airmen, the 99th Pursuit (or 99th Squadron) became the first Black flying squadron.

But en route to Tuskegee, Horne faced familiar bigotry. In the early morning hours as she waited in

Lena's performances lulled young military soldiers into a sweet reverie.

an Alabama airport for a connection to Tuskegee, she saw a lunch counter that was still open. Hungry and tired, she approached the white attendant. "I know I'm in the South," she said, "and I don't want to cause any embarrassment, but I'd like to have a cup of coffee. Do you think it would be all right for me to go in there?" The attendant expressed no concern as Lena took a seat at the lunch counter. Other customers entered and were cordially served. But she found herself ignored by the waitress, who finally said: "I'm sorry, but I can't serve you." Horne explained she was told she would be served. "If you'll go around back to the kitchen, I'll see what I can do." Horne told her not to bother. Ironically, a young boy, the son of the waitress, said: "Say, aren't

you Lena Horne?" He then asked for an autograph. Lena signed. Then she walked out of the restaurant.

During the military tours, she was shocked by other things she saw. When she performed at Camp Joseph T. Robinson in Little Rock, Arkansas, she could not fail to notice that no Negro soldiers were in attendance. Then she learned she was scheduled to entertain only the white brass. When she then insisted upon performing for the Black soldiers as well, arrangements were made. But the next day she was stunned to see that German prisoners of war were seated in the front of the gathering; Black soldiers had been moved to sit in the rear. Turning her back on the prisoners of war, she walked to the area where the Black soldiers were seated and sang to them. Afterward, she stormed off the base and asked that she be driven to the nearest office of the NAACP. There she met with the organization's Daisy Bates, who was to become a legendary figure in the fight for equal rights, notably during the desegregation of schools in Little Rock.

The incident was reported in the Negro press. Word also got back to executives at MGM, who were not pleased that she had ruffled the feathers of military leaders, who had been made aware of what had occurred. Thereafter she said she was dumped from military tours sponsored by the studio. Instead, she entertained at bases on her own time and her own money. The war years marked the start of her active involvement in civil rights issues and battles.

In retrospect, meeting and performing for Black soldiers must have been a release for Horne. With them, she could be more herself. And the early doctrines of social progress and political commitment instilled in her by her grandparents remained alive and vital. It must have been a relief too that she wasn't code-switching. "Racially I have never been any different than I was at the beginning," she once said. "I tend to care more for my own. I just happen to feel more in my own skin with Black people." She understood the pressure they experienced to prove their worth, that indeed they were as courageous and important to the war effort as any white military person.

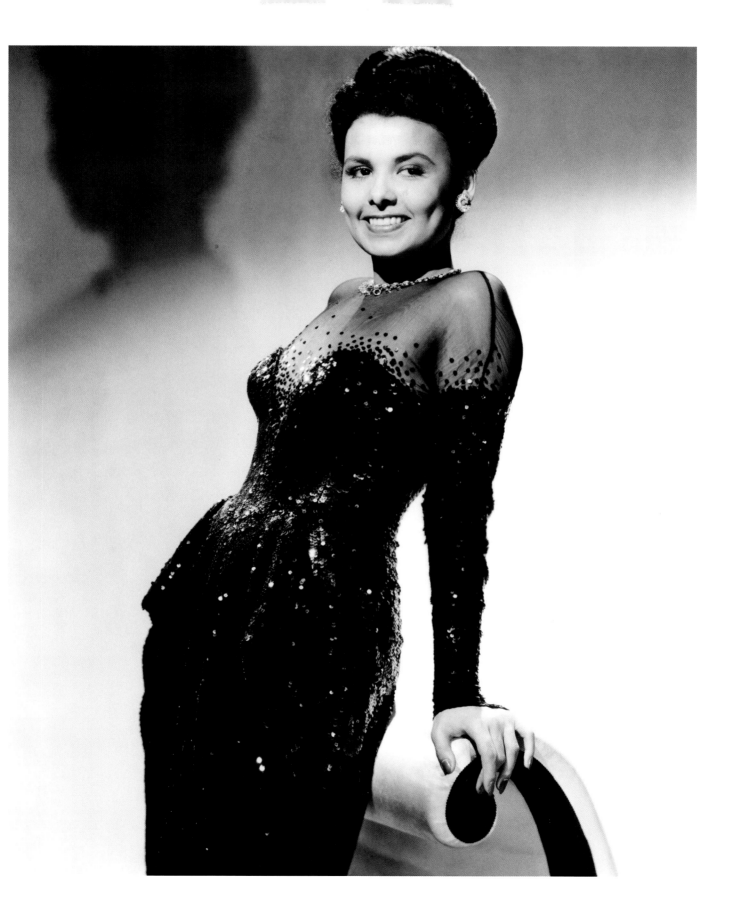

MOTION PICTURE

A FAWCETT PUBLICATION

MAGAZINE

OCTOBER
15c

LENA HORNE

LEW AYRES' SIDE OF THE STORY -- BY CABLE FROM NEW GUINEA
INTIMATE CLOSE-UP OF LENA HORNE BY SIDNEY SKOLSKY

INDUSTRY RECOGNITION, INDUSTRY POLITICS

By the mid-1940s, as dissatisfied as Lena was becoming with movie appearances, she understood their importance. Reaching an audience she otherwise would have been denied, she was also becoming an unprecedented fixture in the industry. In 1944, she became the first Black star to grace the cover of the fan magazine *Motion Picture*. As the mainstream press—from *Time* and *Newsweek* to *Life* and the *New York Times*—reported on her, her name became familiar in American households. Her face also adorned the cover of a publication launched in 1945, *Ebony*—which went into Black households and reported on a new day for Negro America, its accomplishments, especially of a growing middle class, and the heroes and heroines who led the way. Other *Ebony* covers followed throughout her career. So too did coverage in the Black publications *Our World*, *Jet*, and *Tan*—and of course, again such newspapers as the *Pittsburgh Courier*, the *Chicago Defender*, the *California Eagle*, the *Los Angeles Sentinel*, and the *Philadelphia Tribune*. The studios sought the support of the Negro press because of their awareness of a Black audience out there that could add to a film's profits. Though it was seldom openly discussed, Hollywood was aware that those low-budget all-Black race movies—exhibited in ghetto theaters and the Black belts in the South—drew in Black moviegoers; so too did those Black stars in

Hollywood, even when they played servants or other stereotyped roles. There might be criticism, but the actors still had their African American fans. The studios also wanted to avoid controversy in the Negro press. A reporter like Billy Rowe of the *Pittsburgh Courier* visited sets and met with stars and filmmakers. Press releases were sent to Black entertainment reporters. Thus, Hollywood took pride in its "creation" of Lena Horne, Black Movie Star. Whether she liked it or not, she had become a potent social symbol.

Speaking of the treatment of Lena in comparison with that of other African Americans working in movies, Phil Moore noted: "Lena was the first one I know given the star treatment in terms of having special designed gowns, of eating in the stars' part of the commissary and really associating in the upper echelons of the studio." Still, hairstylist Sydney Guilaroff recalled a day—early in her time at MGM—when she arrived at the commissary but was not seated. He waved to ask her to join him but was told by a producer: "I wouldn't do that if I were you. Not everyone feels the way you do." An enraged Guilaroff responded: "I don't care whether everybody does or not, I don't give a damn." He rose and invited Lena to join him for lunch. "I'd be very happy to," she said. He also told the hostess in the commissary: "I don't want you to do this ever again to Miss Horne." Horne never forgot his kindness throughout her MGM days. Years later, when she was invited to appear in *That's Entertainment! III*, she said: "If Sydney Guilaroff's alive, please get him to do my hair. And if he's dead, I'm not coming."

Still, in the 1940s, the industry was eager to acknowledge her presence as well as that of other African American performers who during the war years were changing the face of Hollywood cinema.

From MGM to Warner Bros. to 20th Century-Fox, the studios felt proud of such war-era films as *Casablanca* (1942), *Sahara* (1943), *The Ox-Bow Incident* (1943), *Crash Dive* (1943), and *The Negro Soldier* (1944). In them were serious depictions of Black characters that were a marked departure from the toms, coons, and mammies that were the traditional Hollywood representations of African Americans.

On April 23, 1944, a packed audience of more than 3,500 attended a special ceremony that lauded such new depictions. In a sense, it was Hollywood congratulating itself. Still, the ceremony was important. Under the headline "Lena Horne, Three Others Given Awards for Work in Hit Films," writer Leon H. Hardwick reported in the May 6, 1944, edition of the *Chicago Defender*: "One of the most historic events ever staged was held when Hollywood stars and topnotch officials participated in the first annual Unity Award assembly program, staged by the Committee for Unity in Motion Pictures."

Various artists were spotlighted for "Recognition of the screen as a construction for inter-racial Unity." Among those honored: Rex Ingram, Dooley Wilson, Hazel Scott, Ben Carter, and Bette Davis. Davis was unable to attend; her award was accepted by Hattie McDaniel, who was also singled out for "her

democratic attitude and her work in harmonizing relations between the races in Hollywood." But at the center of attention was Lena. Olivia de Havilland presented her with the Motion Picture Unity Award for "outstanding colored actress of the year, through whose unity and personal charm a new light has been cast on the American Negro race."

On the speaker's platform that day was thirty-four-year-old screenwriter Carlton Moss, cited for his documentary *The Negro Soldier*, which chronicled the heroism of Black military figures throughout history. Moss also produced the radio show *Jubilee*.

For the Hollywood establishment, Carlton Moss was a highly unusual figure who had made unexpected inroads in theater and film. Born in Newark, New Jersey, he had grown up in North Carolina and studied at the Black college Morgan State in Baltimore. As a student, he formed a troupe "Toward a Black Theater," which recruited actors from historically Black colleges. His troupe toured Black campuses and arrived in New York during the Harlem Renaissance. Moss met W. E. B. DuBois, wrote three radio series for NBC, and became a fixture in the Federal Theater of the Work Projects Administration. When producer John Houseman launched Orson Welles's legendary all-Black production of *Macbeth*, set in Haiti, Moss was Houseman's chief assistant at New York's Lafayette Theatre. Later he formed relationships with prominent figures such as Stanley Kramer. In the 1949 film adaptation of *Home of the Brave*, producer Kramer paid tribute to Moss by naming the beleaguered Black soldier enduring racism in the film Moss. When hired to help Elia Kazan write the 1949 film *Pinky*, about a young Black woman who passes for white, Moss was enraged by an early draft and

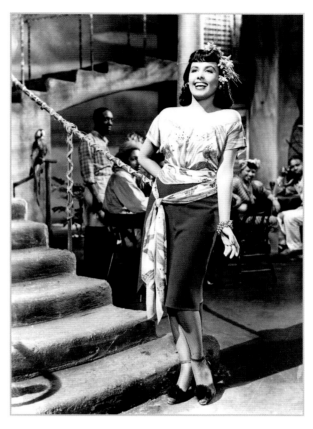

Singing "Love" in *Ziegfeld Follies*.

quit the film. The final rewritten version, however, nullified his objections.

Moss struck up a conversation with Horne, a serious one that Lena responded to enthusiastically. She was impressed with this young intellectual who had worked with Welles and John Houseman. Seeing her interest in politics and aware that she was still trying to make her way politically through the Hollywood system, Moss later informed her of the Hollywood chapter of a liberal organization, the Independent Citizens Committee of the Arts, Sciences, and Professions. Its aim was to bring to light the progressive policies of President Roosevelt for the studios and other artists. He succeeded in persuading Lena to join the group. Lena was elected to the

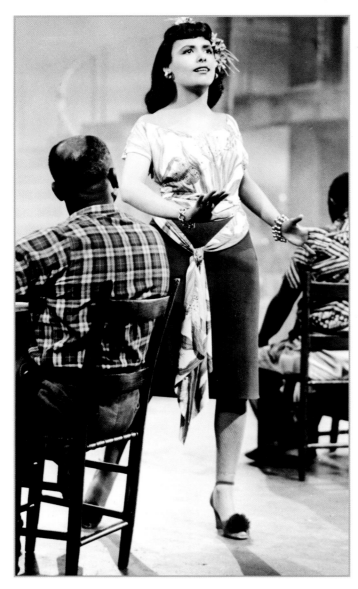

Lena strongly objected to the Martinique café setting in *Ziegfeld Follies*.

serving as a vice chair with Lena was Olivia de Havilland.

Lena and Moss developed a friendship. She looked to him for advice about the political and racial situation—in Hollywood as well as the rest of the nation. She valued her conversations with Moss in a way similar to her discussions with Robeson. As time moved on, she recounted to him her experiences— from Brooklyn to her childhood years on the road with her mother to her performances at Café Society when she spoke with Robeson. Thereafter Moss and an associate, Helen Arstein, occasionally traveled with Lena and recorded her recollections with the prospect of writing her memoirs. The free-wheeling discussions were a release for Lena of much that she had held back from examining and reflecting on.

On April 12, 1945, President Franklin Delano Roosevelt died of a cerebral hemorrhage in Warm Springs, Georgia. Harry S. Truman assumed the presidency as the nation mourned the loss of the man who had guided the country through the Great Depression and the Second World War. On September 2, 1945, War World II ended.

Citizens Committee's executive board. Other stars such as Humphrey Bogart, Bette Davis, Olivia de Havilland, and, for a short time, even Ronald Reagan also served in the organization. In time, Lena was made one of the Citizens Committee's vice chairmen. In its September 9, 1946, edition, *Time* reported on the Citizens Committee. Also

For Lena, the postwar years looked promising, although she would still take time to evaluate her career and her goals. One aspect of her personal life brought her a sense of relief. In 1944, her divorce from Louis Jones was at last finalized. She was granted full custody of Gail and partial custody of Teddy, who as before would stay with her at designated times.

Otherwise, she felt a certain security about her career and her finances. "Today Lena's Metro-Goldwyn-Mayer paycheck is $1,000 a week, forty weeks a year," reported *Liberty* magazine. "She supplements it with personal appearances in theaters and night clubs at $6,500 a week plus a percentage of the gate. Sometimes that percentage mounts up to $3,500 more. She did a dozen radio shows last year at $1,500 to $2,500 apiece. Royalties from sales of her records would keep a few families going."

In August 1944, Lena reported back to Metro for *Ziegfeld Follies*, which might best be described as an anthology film with no real storyline, featuring a lineup of stars in elaborate presentations: Judy Garland, Fred Astaire, Lucille Ball, Gene Kelly, Kathryn Grayson, Red Skelton, Esther Williams, Virginia O'Brien, Keenan Wynn, and an authentic star from the follies, Fannie Brice. Also appearing was William Powell, reprising his role as Florenz Ziegfeld from the 1936 Oscar-winning biographical film *The Great Ziegfeld*. Here in possibly the most stereotyped musical interlude of her MGM career, Lena's sequence was set in a sordid café in Martinique. As directed by Lemuel Ayers in vibrant and dark colors, it was a sexy, exotic portrait of island life with suggestions of illicit activities. One woman stands with a parrot perched atop her shoulder while two other women are seated at a bar, where they literally and ferociously fight it out over a man. One of the women, played by Marie Bryant, runs away and up a flight of stairs while beneath, Lena, in a colorful dress, soon appears and sings "Love," written by Hugh Martin and Ralph Blane.

"Lena disliked the number intensely," said Freed Unit authority Hugh Fordin, although MGM spent $29,725 on it. "She disagreed with the director's conception, objecting to the slum atmosphere of the Negro ghetto." At that time, she even refused to record the song commercially. "However, for a number of years she used the song in her nightclub act but in her own style."

In *Ziegfeld Follies*, Lena appeared in one other musical sequence, "Liza," that starred Avon Long along with ten other Black singers and dancers. She neither sang nor danced. Instead, she served as an adornment, the pretty girl of someone's dreams, whom moviegoers were encouraged to gaze upon. Ultimately, the sequence was cut out of the film.

The nagging awareness that MGM had yet to cast her in a new acting role frustrated her. If there was indeed a part she might be right for and which might offer her a rare opportunity and challenge as an actress, she felt it was the character of Julie, the troubled mulatto who passes for white in *Show Boat*. Based on the 1926 novel by Edna Ferber, *Show Boat* was adapted in 1927 into a groundbreaking dramatic Broadway show with music by Jerome Kern and lyrics and book by Oscar Hammerstein II. A generational story, it traced the lives of members of a company of performers on a Mississippi showboat from the late nineteenth century into the early twentieth century. Its lead character was the young Magnolia Hawks, who, after a series of trials and disappointments, becomes a celebrated star. But pivotal to the story were two Black characters: the dock worker Joe, who sings the powerful "Ol' Man River," and Julie, who performs "Can't Help Lovin' Dat Man of Mine." The most moving aspect of the show also

revolved around Julie—and the musical's theme of racial bigotry. When it is revealed that Julie, who is the headliner on the show boat's roster of stars, is actually a mixed-race woman (one drop of Negro blood makes you a Negro in Mississippi) married to a white man, she is expelled from the show boat, and thereafter finds her life spiraling into a sad decline.

Two film versions of *Show Boat* had already been released: in 1929 without the famous music; and then in 1936, starring Irene Dunne as Magnolia and Paul Robeson as Joe. In the original stage version and in both adaptations, Julie was played by a white actress, most notably Helen Morgan, who had created the part on Broadway and played it on screen in 1936. Never had a Black actress been cast as Julie, although Florenz Ziegfeld had wanted Isabel Washington to play the part in a road show version of the play. But Washington left her acting career behind when she became the first wife of Adam Clayton Powell Jr. For Lena, playing Julie could be a career-defining experience.

Already there were murmurings that MGM might do a remake.

Lena's hopes were high when the Freed Unit set out to film *Till the Clouds Roll By*, a biography of *Show Boat*'s composer, Jerome Kern. Freed and others in the unit had met with Kern, who appeared enthusiastic about the project. Thereafter Kern returned to New York in October 1945, then suddenly died in November. Now *Till the Clouds Roll By* was all the more important as a tribute to the memory of a great American talent. Typical of MGM, the film would be, what else, but another all-star musical, starring Robert Walker as Kern, along with Judy Garland, Angela Lansbury, Frank Sinatra, June Allyson, Van Johnson, Van Heflin,

and Dorothy Patrick. Throughout, musical numbers from Kern's shows would be performed. Lena was cast as Julie singing "Can't Help Lovin' Dat Man of Mine." Lena hoped Vincente Minnelli would direct *Till the Clouds Roll By*, but the film went through a series of other directors: originally Lemuel Ayers, who was replaced by Busby Berkeley. Then Henry Koster was brought in, and finally Richard Whorf, who received credit on the completed film.

The first fifteen minutes of the film paid tribute to *Show Boat* with Caleb Peterson performing "Ol' Man River." There followed a magnificent-looking Lena, beautifully gowned and expertly made-up—and with sensitive jaw-dropping closeups. Lena's appearance in *Till the Clouds Roll By* looked like a screen test for the role. Always an issue, though, was the fact that Lena had that beautiful coppertone *color*—unlike the very light-skinned Fredi Washington as Peola, who passes for white in the 1934 *Imitation of Life*. It was known that some audiences might believe Lena Horne was Brazilian or Mexican, but could she pass for white? That was unclear, but in her sequence in *Till the Clouds Roll By*, no one seemed to think much about Lena's coloring. There was also the issue of the show's presentation of interracial love. She performed another number, "Why Was I Born?"—originally by Kern and Hammerstein for the 1929 show *Sweet Adeline*.

In the mid-1940s, MGM and Freed also had another project for Horne that they believed could be a boost for her career *and* the studio. Freed had plans to invest in a new all-Black Broadway show, *St. Louis*

With Avon Long in the "Liza" number in *Ziegfeld Follies*.

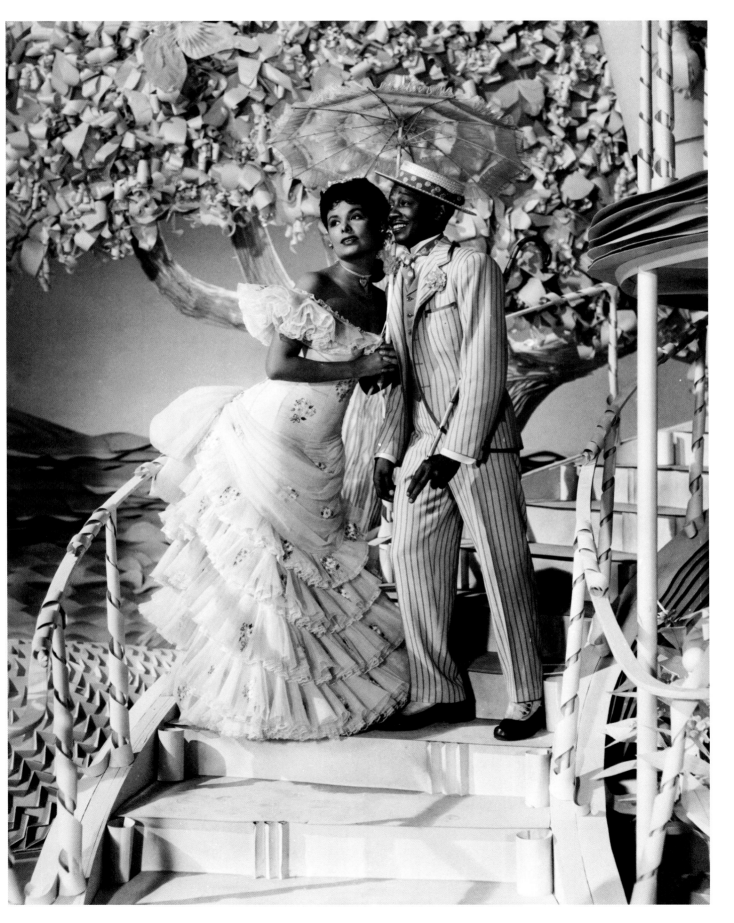

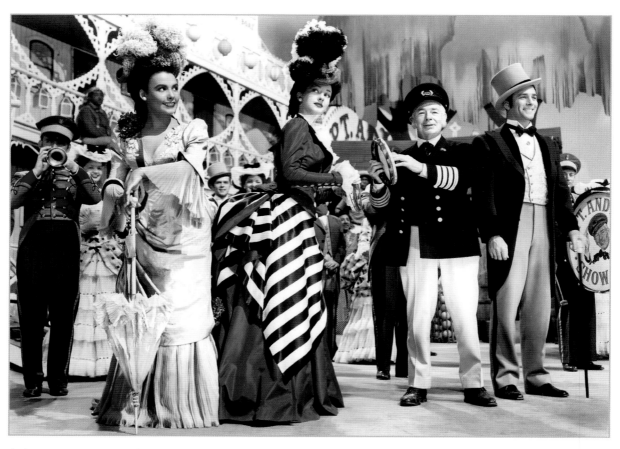

A dream come true—playing Julie in the *Show Boat* sequence of *Till the Clouds Roll By.*

Woman. Based on the Arna Bontemps novel *God Sends Sunday,* the story had been produced for the stage in the early 1930s with a script by Bontemps and poet Countee Cullen, both of whom had been well-respected figures in the Harlem Renaissance. Now Hollywood producer Ed Gross wanted to adapt the work as a musical. Cullen would write the book with music by the esteemed Harold Arlen and lyrics by Johnny Mercer. This new production had the potential to become a major Broadway event. At heart, *St. Louis Woman* would tell the story of a jockey, Little Augie, in love with Della, the girlfriend of the owner of a local bar—and the complications and problems that thereafter arise. Gross and then

Freed were most interested in producing the play as a vehicle for Lena as Della. It would mark her return to Broadway in almost a decade. If *St. Louis Woman* proved successful, the play might be made into another Black-cast movie by MGM.

But problems emerged. Countee Cullen died before rehearsals began—actually even before completing the musical version of the play. The venerated Rouben Mamoulian, who had directed *Porgy* on the stage in 1927 and 1929 and then directed George Gershwin's operatic *Porgy and Bess* on Broadway in 1935, came aboard as director. He and scenic designer Lemuel Ayers worked hard to restructure the musical. Eventually, an

impressive cast was gathered that included Harold Nicholas as Little Augie as well as his brother Fayard Nicholas, Rex Ingram, Juanita Hall, Maude Russell, and a young star then on the rise, Pearl Bailey.

But upon reading the play, Lena had serious objections. Believing the character Della to be another portrait of a "loose" Black woman, she could not see herself playing the role. Obviously, much of what her MGM career had been about was a change in depictions of African Americans. She saw this as a setback. Discussions followed. Pressure was exerted on her by Freed and others at MGM. Then she said flat-out that she would not appear in the play. No one could persuade her to do otherwise. At the time, she had not heard the Arlen-Mercer score for the show, which would include the future standard "Come Rain or Come Shine." Later Lena

Lena Horne as Julie and Kathryn Grayson as Magnolia during the *Show Boat* sequence of *Till the Clouds Roll By.*

would admire the score, and Arlen remained one of her favorite composers.

The production moved forward despite the problems. Mamoulian still struggled to pull everything together. Ruby Hill was cast as Della, then dropped, then rehired by the time *St. Louis Woman* opened on March 30, 1946, at the Martin Beck

Theatre. The reviews were mixed. The NAACP criticized the musical. There were protests. In the end, *St. Louis Woman* ran for 113 performances.

If anything caused ongoing friction for Lena at MGM, it was her open displeasure with *St. Louis Woman*—which was reported by the Black press. "Horne Refuses Lead in MGM's St. Louis Woman"

read the headline in the September 29, 1945, edition of the *Chicago Defender*. Then came another headline: "Disciplining of Lena Horne for Role Snub Denied." The paper reported: "Rumors of a 'disciplining' of film star Lena Horne for refusing the lead in the play 'St. Louis Woman,' are firmly denied this week by Louis B. Mayer, president of Metro-Goldwyn-Mayer, Miss Horne's employers."

The paper also commented: "The Mayer denial came in answer to a wire from Walter White, executive secretary of the National Association for the Advancement of Colored People, following a New York

Rehearsing with MGM musical director Lennie Hayton.

columnist's statement that the glamorous star would receive disciplining from MGM for turning down the stage role because it wasn't good for her race." The newspaper published Mayer's letter to Walter White:

Dear Walter:

The story is untrue. We are just anxious for Miss Horne to succeed and that is why we have her under contract . . . MGM has no connection with the play's production. The misunderstanding must come from the fact that one of our producers has invested in the show, but that in no way represents a company obligation or responsibility. Let me assure you with finality that any idea of discipline of this . . . is distasteful to us and inconsistent with our policies.

Mayer sounded as if he were indeed protesting too much. But he did not want to alienate the Black press, nor Black audiences. Nor Walter White. On the other hand, the studio no doubt believed that Lena's participation might have indeed saved the musical. Afterward, Horne always maintained that her refusal caused her career problems.

More conflicts and frustrations followed. When plans were being made for a Broadway revival of *Show Boat*, Jerome Kern specifically wanted her to star as Julie. But MGM blocked her. "They forbade me to work on Broadway in the revival of *Show Boat*," she said. Carol Bruce was cast as Julie. Once again, the character was not played by a Black actress. This was a major disappointment for Horne.

The studio also refused to grant permission for her to do cabaret engagements, said Horne. Now Lena's career seemed at a standstill. A surprising break in her professional dilemma occurred one evening at a party when she talked to a famous onetime MGM actress: "It was Joan Crawford who helped me out of the jam." Crawford stressed that Lena must talk to Louis B. Mayer. When explaining that she had already done precisely that and that nothing had changed, Crawford told her she must speak to him again—as she herself had done in the past. Crawford, however, had left or rather was ruthlessly dropped in the early 1940s by MGM. In 1943, she signed with Warner Bros. and starred in *Mildred Pierce* (1945) and walked off with an Oscar. Crawford understood studio politics. Never did she speak publicly against Mayer. She again urged Lena to appeal to him. Lena took Crawford's advice. Mayer listened intently to her. She remembered he even cried at the meeting. Permission was granted for her to do certain club dates. But still, MGM limited what she could do. Also stemming from Crawford's advice, Horne eventually signed with a more powerful agency, the Music Corporation of America (MCA), that helped her maneuver her way at the studio. But it cost Lena because she had to buy out her contract from her previous agency. Though the situation with the studio improved slightly, life at MGM was never the same. She performed with Billy Eckstine's Orchestra in 1945 and 1946.

Adding to her tensions at the studio, word spread of her growing involvement with arranger-composer Lennie Hayton, who was the musical director on *Till the Clouds Roll By*. Though Kay Thompson, Betsy Blair, Roger Edens, and others from the Freed Unit were aware of the romance, they weren't fazed by it. Edens even arranged for the couple to meet

Lena's budding romance with Lennie Hayton was frowned upon by the studio, to put it mildly.

The relationship with Hayton, however, caused friction in another very personal way. Horne herself understood that the public—both white and Black America—might not be pleased by such a union. She was sensitive to the manner in which the Negro press might write about it. For Black America, it could look as if she were abandoning her own race. Within her home, her cousin Edwina, who had been with Horne since the move to California, frowned upon the relationship. But no matter what her cousin Edwina thought, she was not going to break it off with Lennie. In the end, Edwina left the Horne household. Lena hired another woman, Ida Starks, to care for Gail. With her husband in the army, Starks and her own little girl moved into Horne's home. "We joined forces and she was a source of great, quiet strength to me in the next years," said Horne.

Horne was confronted with another conflict when her mother, Edna, suddenly arrived in Los Angeles from Cuba, where she and her husband, Mike, then lived. Having seen the publicity her daughter now garnered, Edna—the perennial romantic dreamer—wanted Lena to help her secure movie work. She was convinced her famous daughter could simply snap her fingers and have her cast in a film. It was a sad situation. Because her mother was staying at a hotel reserved for whites, Lena said she had to ask Lennie to enter the establishment and bring her mother out to the car where she sat. The two talked. But Edna was bitter.

Later, so Lena said, Edna went to Lena's home to insist that Ida Starks give her Lena's address book—no doubt with the intention of calling Hollywood agents or directors or MGM executives. Starks

secretly at his home. In her social world, Lena was not thought of as being Black. As Lena later realized, not even Hayton thought of her as Black in the same way he would think of other people of color. That eventually became problematic for Horne. Nonetheless, the executive offices of MGM did not view the relationship favorably, to say the least. According to Scott Eyman, Louis B. Mayer tried "to forbid Horne to date the white musical director Lennie Hayton because he was concerned about publicity about an interracial romance."

refused to give her the book. Finally, a disillusioned Edna left the city.

Lena feared that Edna might try to sell a story to the press about her ungrateful daughter, the Star. Lena said she had an attorney work out a financial arrangement to ensure that her mother not publicly discuss Lena with newspaper reporters. It had become a heartbreaking story.

By now, Lena had also grown concerned about the effect on Gail of the racial attitudes in California—blatantly apparent at her daughter's school. One day, Gail, then age six, asked: "What's a nigger, mommy?" The question—the word itself—startled Lena. Gail had heard the word at school. An angry Horne spoke to Gail's teacher, only to be told: "Well, really, Miss Horne, the children don't think there's anything wrong with the word. We don't have any course in what you call racial democracy. We couldn't just install it for your child. She's the only Negro here. The rest wouldn't need it." Horne said that her son, Teddy, when staying with her, as well as Ida Starks's daughter, who attended the school, had all heard the word used. Later Lena sent Gail to live at a home she had purchased in St. Albans, New York. Ida moved there with her own daughter and took care of both girls.

Amid all this chaos and emotional turmoil, there was a celebratory spot. In August 1947, Lena returned to Brooklyn for a special day in her honor.

"A Brooklyn Girl, Lena Horne, Comes Home," read the banner in the August 22, 1947, edition of the newspaper *PM*. "Yesterday was officially Lena Horne Homecoming Day in Brooklyn and the

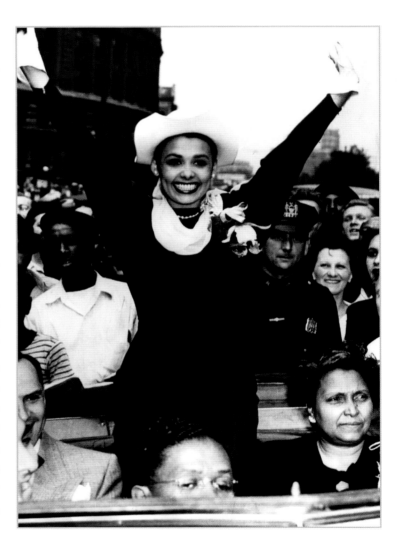

Lena returned home to Brooklyn for a day in her honor in 1947.

crowds turned out to cheer the home town girl who made good as a singer and film star. At Fulton St. and Nostrand Ave, near where she was born, the throngs—including some enthusiastic autograph seekers—blocked off auto and trolley traffic." On hand to join in the tribute was surprisingly Bill "Bojangles" Robinson himself. As she rode in an open convertible, a radiant and jubilant Horne waved enthusiastically to the adoring crowds.

In March 1946, *Ebony* ran Lena's picture on its cover. In November 1947, she was on the magazine's cover once again, indicating that she remained one of Black America's most popular stars.

Politics and social issues continued to broaden her ever-evolving perspective. Among the women she admired most were Eleanor Roosevelt and African American educator Mary McLeod Bethune. "I loved Mrs. Roosevelt and Mrs.

Concerned about her daughter's welfare because of racial attitudes at her school in Los Angeles, Lena arranged for Gail to live in New York.

[Mary McLeod] Bethune," she once said, "because they were so much like my grandmother with whom I had a marvelous love-hate relationship."

She continued her commitment to organizations that fought for changes in the industry. In 1944, she and actor Rex Ingram were elected to the board of the Screen Actors Guild. Once the war ended, a harder push for a transformation in the depictions of African Americans occurred. In the fall of 1946, a resolution was passed that "the Screen Actors Guild use all of its power to oppose discrimination against Negroes in the motion picture industry" and "a special committee be set up…to implement this policy and to meet with representatives of the Screen Writers' Guild and the Screen Directors Guild and the Motion Picture Producers Association in order to establish in the industry a policy of presenting Negro characters on the screen in the true relation

they bear to American life." An Anti-Discrimination Committee was established in November 1947, only to be dissolved shortly thereafter and then re-established.

Lena was bearing witness to possible changes. Her allegiance to Paul Robeson continued, as it did in the progressive wing of the Hollywood community. In June 1946, when Robeson appeared at the "Big Three Colonial Freedom" rally at Madison Square Garden in New York—urging that America's voice be raised on behalf of the people of Africa—Horne was in attendance, along with such luminaries as Mary McLeod Bethune and Judy Holliday. When Robeson came to Los Angeles, he attended a fundraiser for the Black newspaper *California Eagle*

that was organized by Geri Branton and Dorothy Dandridge. Betsy Blair organized a different fundraiser, a party held at her home "to raise as much money as possible" for the NAACP. Robeson was the guest of honor. As he "sang for us. Or rather, he sang for the NAACP," said Blair, the reverent guests sat spellbound by "the authority of Paul Robeson, and the power and warmth of his voice." But at the event, Blair also noted "there would be outsiders and, therefore, a chance for the FBI—or their informers—to get in." Unknown to Lena was the fact that not only was Robeson being observed by informers, but she too was being watched.

In the latter half of the 1940s, Lena eventually detected yet another shift in the political

President Harry Truman (center) surrounded by stars, including Lena (far left) and Dorothy Maynor (left of Truman).

environment, as fears were mounting within the nation about communist infiltration. During the war years, Russia had been an ally in the fight against Nazism. Now new attitudes led to suspicion—and what became known as the red scares—about the Soviet Union. In time, as Robeson remained an ardent supporter of Russia, attitudes about him grew hostile. When he was also falsely rumored to be a member of the Communist Party, the tide was turning against Robeson. And in Hollywood, Horne's loyalty to him did her no good.

But onward she went. At the same time, she remained career-driven. Still performing at nightclubs and theaters, she drew crowds. Lena enjoyed performing and loved packing in a huge turnout. In the late 1940s, she began playing Las Vegas, which was becoming a showplace for Hollywood stars. Her feelings about this desert town were mixed. At the hotels on the rise in the late 1940s, into the 1950s and 1960s, Negro entertainers could perform, but be it Lena, Nat "King" Cole, Sammy Davis Jr., or Dorothy Dandridge, for some time they could not stay at those hotels. Or if they did, their activities were restricted. Dorothy Dandridge's contract at the Last Frontier Hotel on the Strip in Vegas stipulated she could stay at the hotel, but management made it clear that she could by no means use the swimming pool. On one occasion, when hotel management thought she might take a dip in the pool, Dandridge's manager, Harold Jovien at MCA, said: "The hotel management responded immediately. They drained it, rather than let her go anywhere near it. A sign was put up saying 'The pool's under construction.'" For Black stars, Vegas, known for being segregated and racist, could be a demeaning experience. The same was true of Miami. Yet there was a demand for these stars and they commanded hefty paychecks. In that sense, certain barriers were being torn down.

"Where I got racism was in the clubs and cabarets," Lena later said. She recalled her experiences at the Chase Hotel in St. Louis: "The first time I worked at the Chase, I couldn't come in through the front door. There was the Clover Club in Miami. Sweet job, but no Blacks were allowed in the audience. And the Savoy-Plaza in New York. Sometimes the hotels would take me, but not the guys in the band. It wasn't until the late 1950s that things began to change, because we did business. Vegas started to swing open. But we couldn't have changed nothin' if we hadn't made money."

Horne's relationship with Hayton grew more intense. In later years, Lena confessed that the man she still loved most and would have been happy to have married was Billy Strayhorn. But she understood that would never be. Instead, she was resigned to a deep friendship with him. By now, Lena and Lennie considered marriage, even if that meant going against the odds, defying not only the studio but attitudes and bigotry all over the country. Interracial marriages were illegal in California. In early 1947, Lena accepted a series of engagements abroad. Traveling with her would be Hayton, as her musical director. He would also soon become her husband.

Katharine Hepburn and Lena at MGM's twenty-fifth anniversary luncheon in 1949.

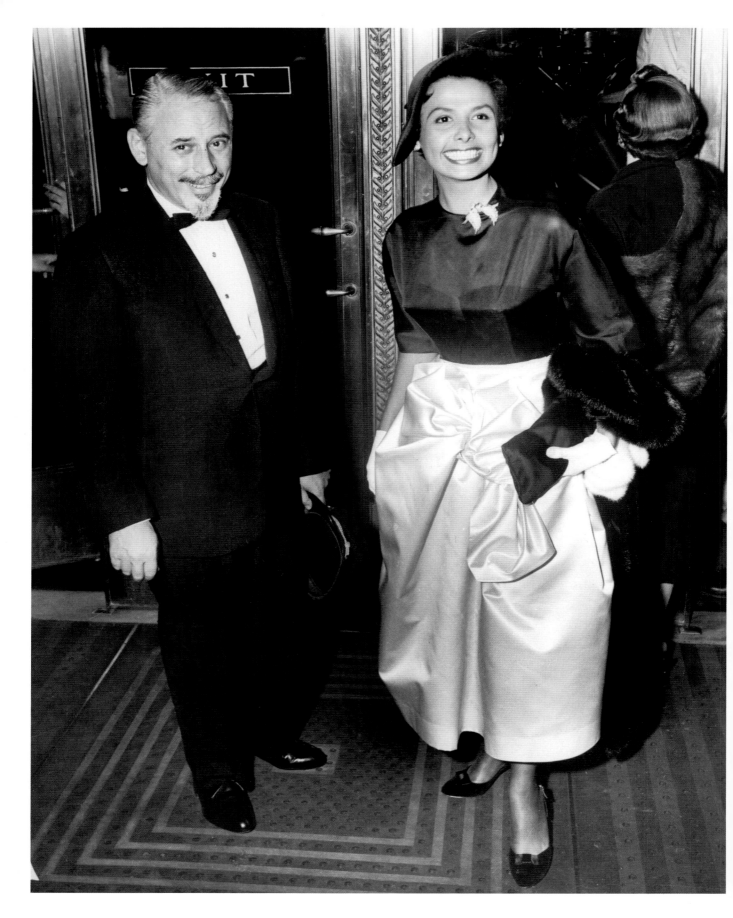

TRAVELS ABROAD, MARRIAGE ABROAD

In October 1947, Lena and Hayton set sail for England aboard the *Mauretania*. She still loved traveling in glamorous high style: still luxuriated in wearing the furs, the hats, the jewels, the latest designer clothes, the expensive luggage. It wasn't much different from that first trip she had made from the airport in Pittsburgh to Los Angeles to film *The Duke Is Tops*. "She liked glamour. She liked haute couture fashion," said her daughter, Gail, "and breakfast at 3 p.m." Now she considered it all a tribute when she entered a room, and everyone turned silent, awed by her appearance, aware that a goddess was in their presence. Never embarrassed by the stares and the adulation that her fame brought her, she enjoyed it to the utmost. Accompanying Lena and Lennie were Tiny Kyle and pianist-arranger Luther Henderson. This European trip was both a leisurely and hectic time.

Never having traveled abroad before, Lena was mesmerized by the sights and sounds of Europe: the historical landmarks, the posh hotels like the Piccadilly in London and the Raphael in Paris where they stayed, the clothes, the food, the cultural customs and manners—the sheer old-world elegance of so many settings. For three weeks, Lena performed at the London Casino in Soho,

Relaxing with Hayton, away from the prying eyes of the studio.

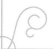

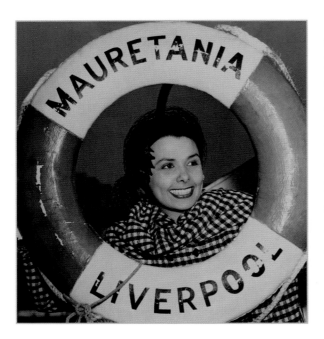

Looking forward to travels abroad—and a marriage abroad.

where she met or socialized with various artists and celebrities: photographer Robert Capa; writer Art Buchwald; African American actress Hilda Simms, then appearing in the Black-cast version of *Anna Lucasta*. In Paris, she performed at the Club Champs-Élysées. There she met Édith Piaf and Yves Montand and his wife, Simone Signoret. In Belgium, she was at the Old World Chaudfontaine. With Lennie as her musical director, she felt secure that he would find the best musicians to back her up. He also created arrangements that brought out the high points of her ever-evolving style.

The December 8, 1947, issue of *Time* let its readers know of her rousing success in Paris: "Lena Horne, a *café au lait* beauty, was not the kind of a girl to come onstage the way Josephine Baker had, with only a string of bananas girdling her hips. Obviously nervous, dressed in a square-shouldered white gown, Lena flashed her magnificent teeth in the spotlight and curtsied demurely. Then, as the lights went down and the rhythm began to pad out softly behind her, she slithered cozily up to *the mike* and began to sway. First she gave them *It's Just One of Those Things* in a low and sultry voice. By the time she came to the line, 'Our love affair was too hot not to cool down,' the French found Lena's English perfectly translatable. And when she finished *The Man I Love*, and followed it with '*Deed I Do*, *Stormy Weather* and *Honeysuckle Rose*, she had the Parisians in her hand."

The magazine added: "They shouted, cheered, and—a rare occurrence in France—whistled. Lena could do no wrong. She even got away with a song in schoolgirl French. After the show, admirers followed her to her dressing room. The next day *France Soir* splashed a three-column picture of her on Page One, and captioned it: 'A triumph.'" When Lena was asked if she would stay in Paris, following in the footsteps of Josephine Baker, she said with great exuberance: "Hell no! I got a family in Brooklyn."

But she had now conquered Europe!

Then on December 14, 1947, Lena Horne—wearing a black Balenciaga dress—and Lennie Hayton stood together, gazed into each other's eyes, and were married in Paris—with Tiny Kyle and Luther Henderson as witnesses at the ceremony. It was a day of celebration and joy. But the decision was made to keep their marriage a secret, mainly because Lena was uncertain about the response of the studio, the public, and the Negro press of the time. The marriage would not be revealed until three years later.

From the start, she was honest with herself—although not necessarily with Lennie. "In the

beginning I didn't marry Lennie because I was in love with him. I respected him because he knew a lot of music and I knew that I had to learn how to sing. I callously realized that I would have to associate with a white person to get the things I wanted professionally. It was just that I was alone and I had two children and I was gonna take care of them." She admitted: "I married Lennie, I guess, for selfish reasons. I knew that a white man could get me into places Black men couldn't. But you know I learned to love him completely because he took all this from me and went along with the flow and made me forget at times he was white."

On December 22, 1947, the couple arrived in New York. For each, this was a time of renewal and reassessment of their lives and their careers. Lena had to consider again her movie appearances. The musical segments gave her important exposure, and indeed they were skillfully produced. But she still longed for acting roles. Time

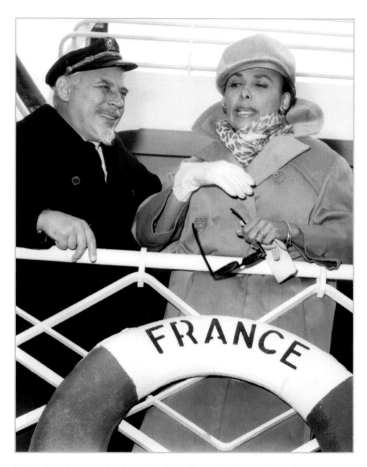

With Hayton, enjoying the luxurious lifestyle of a star.

was running out. Once more her thoughts turned to the character of Julie if MGM moved forward with a remake of *Show Boat*. Lennie also had to decide if he would stay at MGM. Lena's nightclub performances would continue, as would her album commitments. On December 26, she was back in a recording studio in New York.

She was reunited with Gail, who was informed of the marriage and appeared to have no problems with Lennie. She had already come to know her new stepfather. But others close to Lena, when informed of the secret union, were bitterly opposed. The objections of her father disturbed her most.

For a time, the two were estranged. He didn't want to see her.

Lena spent time in St. Albans with Gail and with Teddy during his visits. Her engagements also kept her on the road performing. It was at a New York engagement that the paths of Lena and Billie Holiday crossed again—at a difficult time for Holiday. Much had changed for the singer since the early 1940s, when she and Lena had first become friends. Holiday had struggled with her drug addiction, unable to beat the habit.

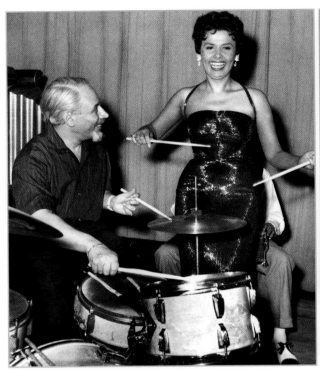

One rehearsal after another to groom herself always for a performance. It was never simply standing on a set or stage without preparation.

Learning from working with Lennie yet another new way of singing.

On March 16, 1948, Holiday was released from Alderson Federal Prison in West Virginia, after having served time for possession of narcotics in 1947. As she struggled to regain control of her life and her career, Holiday found herself ignored or snubbed by people she had once helped. When she saw Sarah Vaughan at a club, she was hurt when Vaughan "walked straight by me to her dressing room without a sign." Holiday said she "broke down and cried."

Yet Lena "made me feel like I'd never been away." Holiday had gone to the Strand Theatre, where Lena was performing. "After my experience with Miss Vaughan, I was naturally wary," recalled Holiday. Not wanting to be humiliated, she sat in the back of the theater following Horne's performance. "Anyway, somebody told Lena, 'Lady Day's out there.'"

"Lady Day?" said Lena.

"And that pretty little thing took off from that stage like a little bird," said Holiday. "She came running down the darkened aisles hollering for me. When she saw me, she was smiling and weeping at the same time."

Lena asked why Holiday hadn't come backstage to see her. "Honey, don't you know?" said Holiday. "I'm a jailbird." According to Holiday, Lena exclaimed: "Don't say that! You've been sick and away for a little while, that's all."

Holiday recalled: "Then she took me by the hand, back to her dressing room. After the first show she insisted on taking me out with her and bought me lunch, and we had a wonderful schmooze about the old days in Hollywood . . . We talked about all

this and more, and I was so happy I cried. People like Lena took the sting out of other little people."

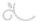

Horne's style in nightclubs and theaters had now evolved to a point of striking an all-enveloping disengagement or perhaps *distancing* from her audience, something a performer can rarely get away with. When she performed at New York's Copacabana in 1948, the reviewer for the *New Yorker* felt she was reaching a new artistic level. "Lena Horne, who for years has been honing and polishing a heavily charged hand-wringing style of singing, has, I feel, attained the peak of her powers in her present engagement," the critic wrote, "where, deep among the cellar-grown palm trees, she switches on her full voltage nightly, with immense success. Rapture, pain, delight, and a multitude of less easily identifiable emotions pass rapidly and unceasingly across her sleek and handsome countenance."

The reviewer astutely assessed an essential hallmark of her style: "Curiously, as her style has developed, she seems to have withdrawn further and further from her audience and into herself. She never addresses her listeners directly, and her eyes are closed, or nearly closed, a good part of the time. In acknowledging applause, she tilts her head, eyes, cast down, and bends and turns with a kind of Asiatic self-effacement."

Her style reflected her self-protective defense against the indignities placed upon her. It was a form of protection. "I developed an isolation from the audience that was actually only a sophisticated cover for hostility but the audience didn't see it; they were too busy seeing their own preconceived images of a Negro woman," she said. "The image that I myself chose to give them was of a woman whom they could not reach. I think this is why I rarely speak to an audience. I am too proud to let *them* think they can have any personal contact with me. They get the singer, but they are not going to get the woman. I think many Negro performers feel much the same way and they find their own methods of letting people know it. In other words we all find our own means of rebellion."

For Horne, there must have been thoughts of Black women on auction blocks, looked over and assessed. That she resented. Audiences, however, found the haughtiness, the untouchability, hypnotic.

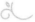

In Los Angeles, she and Lennie settled into their home in Nichols Canyon during her times on the West Coast. Keeping a low profile because their marriage remained secret, they entertained informally such friends as Marie Bryant and Ava Gardner, who had a home up the road, and musicians like Chico Hamilton and Jerry Wiggins. She enjoyed the company of actor James Mason and his wife, Pamela. Always present were plenty of great food and a steady round of cocktails. But Lena and Lennie were often on guard, not knowing what to expect from others in their deluxe neighborhood. Her husband "had to buy a shotgun to protect us from some of our neighbors. They were signing petitions against us and we were receiving threats." Carlton Moss and others launched a campaign to help keep her in the home. Horne had stayed in Nichols Canyon, and she appreciated Moss's support. Had anything changed since that time when a petition was circulated to force her out of her home on Horn Avenue?

At MGM, she was in front of the cameras for a sequence in *Words and Music*, a dramatization of the music partnership of Richard Rodgers and Lorenz Hart. The cast included Mickey Rooney (as Hart), Tom Drake (as Rodgers), along with guest appearances by Judy Garland, Gene Kelly, Cyd Charisse, Perry Como, Ann Sothern, and Lena. Directed by Norman Taurog in Technicolor, the story softened the troubled, self-destructive life of Hart, but the musical sequences were among MGM's best, especially Lena's.

Performing "Where or When" and "The Lady Is a Tramp," she was animated and fully connected to the lyrics. Costumed splendidly by Helen Rose in a white brocade dress—with a luxuriant red-and-purple lining—that flared out and with color-coordinated fabric flowers and bows in her hair, she used the dress and the flourishes of her hands dramatically as she sang and danced to "The Lady Is a Tramp," sometimes twirling around and slightly lifting the folds of the lower part of the dress. She *acted* out the lyrics—responding to the rebellious tone of the song, the tale of a woman who defies the accepted behavior of her social world to live her life on her terms. At times, her rendition can be read as a message to her studio. She would not be bound by its dictates as to what she could or could not do. She was her own woman. It was one of the most exciting sequences in her MGM career. "The Lady Is a Tramp" became a part of her nightclub repertoire. Lennie was credited with the film's

Other European tours would follow as nightclub audiences marveled over her style.

musical direction. Robert Alton staged and directed the musical numbers.

Later she also went before the cameras for *The Duchess of Idaho* (1950), a very light comedy that starred Esther Williams, Van Johnson, and Paula Raymond with musical performances by Eleanor Powell, Mel Tormé, Red Skelton, and Lena. She performed "Baby, Come Out of the Clouds" and "You Won't Forget Me." The latter was cut from the film. The former was hardly Lena at her most exciting. It was beginning to look as if to Metro she was old news.

Hollywood was undergoing its most daring transition in its depiction of African Americans. In 1949, four films were released that addressed "the Negro problem" in America: *Home of the Brave*, a war drama about a young Black soldier (played by James Edwards), who endures an emotional breakdown while on a special mission with white soldiers during which he is the subject of racial taunts and humiliations; *Pinky*, the story of a light-skinned young Black woman who, after living in the North where she is educated, returns home to her grandmother (Ethel Waters) in the South and finds herself repeatedly subjected to racist indignities; *Lost Boundaries*, an examination of the plight of a light-skinned family in a small New England community as it experiences racism directed at them from former white friends who have learned the family is Black; and *Intruder in the Dust*, based on the novel by William Faulkner and starring Juano Hernández as a proud, defiant Black man in Mississippi who may be lynched after being falsely accused of having killed one of his white southern neighbors.

Hernández was one of the performers Lena had met and admired at the Cotton Club. Receiving wide critical acclaim and reaching both Black and white audiences, these "problem pictures" indicated a new kind of film and movie audience during the postwar era. The old comic servant roles were increasingly figures of the past. In time, the problem pictures would lead to the rise of Sidney Poitier and Dorothy Dandridge as dramatic stars of the 1950s. In her own way, by not playing servants and maintaining a dignity in her film appearances, Lena Horne had helped clear the way for the new stars and era. But she may not have seen it quite that way at the time.

When MGM moved forward with the production of *Show Boat*, her hope for a film career with dramatic roles vanished. The studio announced that her friend Ava Gardner would play Julie. MGM would later say it had never considered Lena for the role. "Originally, Freed wanted Judy Garland to play Julie," said Freed Unit authority Hugh Fordin. Then there was talk of Dinah Shore. Then, said Fordin, "Freed wanted Ava Gardner for the part. [Director George] Sidney made a test with Gardner mouthing to a recording of Lena Horne." But Sidney said, "There wasn't much enthusiasm about Ava,

even making a test." Yet, said Fordin, "The test was very good, but [costume designer Walter] Plunkett reports that she didn't like her clothes, she didn't like anything. In fact, she wanted to be kicked off the picture." But with all that said and done, there must have been some thought of casting Horne; otherwise, why the elaborate opening sequence in *Till the Clouds Roll By*, in which great time and no doubt expense had gone into "casting" her as Julie. She was even billed as Julie in the credits. If anything, the studio feared problems from the Production Code Office, which upheld its ban on depicting "miscegenation"—mixing of the races—on screen. Though *Pinky* had an interracial love affair, a white actress, Jeanne Crain, had played the light-skinned Black woman. For Lena Horne, the loss of the role of Julie was a wound that she never got over. It had been her great chance.

In the next decade, she focused on nightclubs, notably Las Vegas, where she frequently headlined at the Sands, as well as abroad, and also on the new medium of television, which was about to become a potent force in the nation's cultural life.

Then came a publication that rocked Horne and others in the entertainment industry: *Red Channels*.

Still a musical star at Metro.

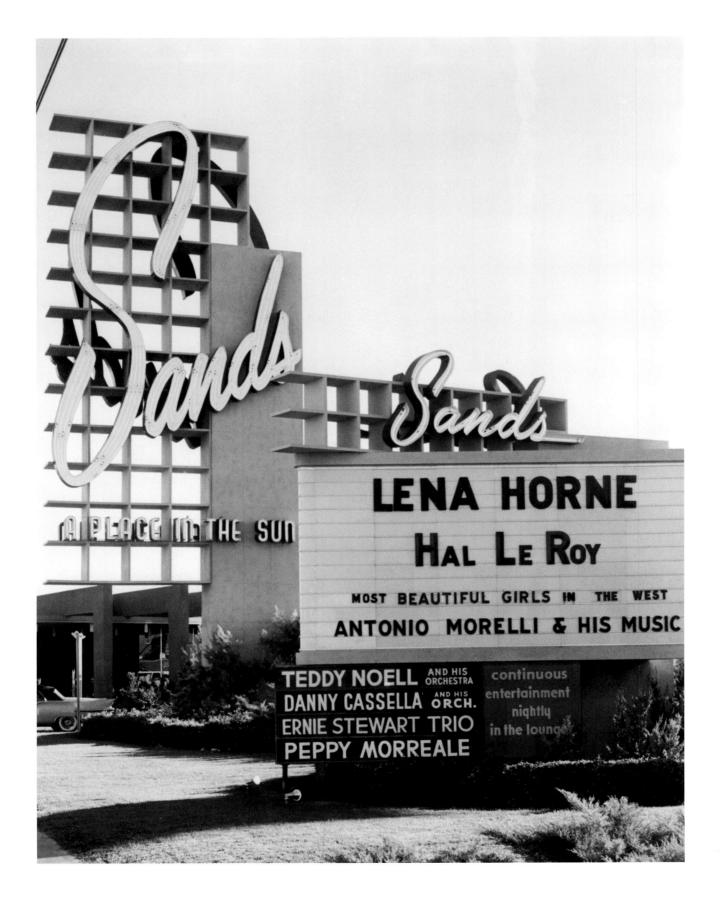

RED-BAITING, RED CHANNELS, THE BLACKLIST

As President Truman's years in the White House were nearing an end and as Dwight David Eisenhower prepared to assume the presidency, Lena Horne found herself in a tough battle to hold on to engagements—and in essence, hold on to her career. The 1950s proved to be one of her most difficult eras as Horne was consumed with new pressures and anxieties.

The nation had become consumed by fears and paranoia about a communist threat to democracy and freedom. In 1947, the House Un-American Activities Committee had begun investigations and hearings on the ways in which the Communist Party had infiltrated American entertainment, perverting the American way of life. Blacklisting of individuals believed to be communists had begun. During the late 1940s and 1950s—an era that saw the rise of McCarthyism and witch hunts—the right-wing newsletter *Counterattack* sought to identify and root out communists. Then on June 22, 1950, came *Counterattack*'s publication of *Red Channels:*

The Report of Communist Influence in Radio and Television. Basically, it was a listing of 151 individuals thought to be communist or communist sympathizers. It served as a blacklist that the studios, television and radio networks, and the theater world paid close attention to. Those artists listed were to be denied employment because of their support of "subversive" causes.

Major names appeared on the list: Orson Welles, Arthur Miller, Leonard Bernstein, John Garfield, Lillian Hellman, Dashiell Hammett, Dorothy Parker, Arthur Laurents, Vera Caspary, Garson Kanin, Marsha Hunt, and Burl Ives. Among

the African Americans listed were also important names: Langston Hughes, Hazel Scott, Fredi Washington, and Lena Horne. Under the names of each figure was a list of rallies, organizations, or benefits in which they had participated. Among the organizations named as communist or communist fronts were the Civil Rights Congress, the Hollywood Democratic Committee, and the Independent Citizens Committee of the Arts, Sciences, and Professions.

Reverberations were felt throughout the entertainment community. During hearings, some in the entertainment industry named names of communists—often to have their own name removed from the blacklist. Others, like Hazel Scott, defiantly blasted the House Un-American Activities Committee as being un-American itself. Scott's television series was canceled. Others saw their careers destroyed.

Performers sometimes were asked to sign loyalty oaths. Sidney Poitier and Dorothy Dandridge refused. Asked to repudiate Paul Robeson, Poitier refused that, too. Before Dandridge could work on the film *Bright Road*, she was asked to write a letter explaining some of her activities. Of special interest was her involvement with the Actors Lab, a very progressive acting school in Los Angeles, also attended by Marilyn Monroe, with whom Dandridge had been friends. Dandridge refused to repudiate the Actors Lab. Nor would she denounce the rallies and benefits she had attended, often with her husband, Harold Nicholas, or her friend Geri Branton. Interestingly, the Actors Lab was viewed as a school with left-wing ties because of its highly progressive founders and teachers. Much the same would be said of Café Society, where Lena had gotten her big break. Everyone was on edge.

Among the activities listed under Lena's name were: speaker for a rally of the American Committee

for the Protection of Foreign Born; speaker for the Civil Rights Congress in 1947; supporter for the Citizens Non-Partisan Committee for Re-election of Benjamin J. Davis to the New York City Council in 1945; performer for the Communist Party celebration in honor of Benjamin J. Davis in 1945; sponsor for the Council on African Affairs; participant on a radio program for the United Electrical, Radio and Machine Workers of America in 1948; fundraiser for the Southern Conference for Human Welfare in 1948; affiliated with the United Negro and Allied Veterans of America, Inc. in 1947. Unknown to Horne and others like Scott, Hughes, and Fredi Washington, their activities had been carefully observed and scrutinized for years.

By now, Lena had hired a tough, assured manager from MCA, Ralph Harris. He went into action, trying to counteract the charges.

Also in 1950, Horne had another problem that had to be addressed. A memoir titled *In Person: Lena Horne*, as told to Helen Arstein and Carlton Moss, was published. Having come to trust Moss since her long discussions with him and her days on his radio show *Jubilee*, she had confided in him the tensions and difficulties of her life. She had been fairly open—though not totally—about relationships and career hurdles. Her vulnerability and anger were revealed in the pages of the book, as she recounted details of her still secret marriage to Hayton, her feelings about race and democracy in America, her relationship with her parents, and her upbringing. Also discussed were her conversations with Paul Robeson, whom she still greatly admired. But now as Robeson endured severe political backlash, primarily for his continued support of the Soviet Union, Lena's friendship with the star might

Look

15¢ MAY 8 1951

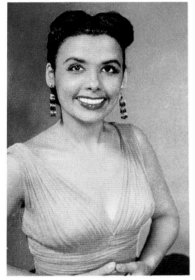

LENA HORNE and A SONG

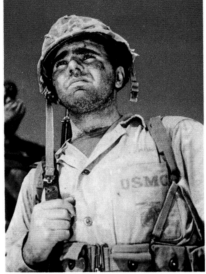

HOW THE MARINES BUILD FIGHTERS

BOB LEMON BASEBALL'S TOP PITCHER

JACK BENNY and MARY LIVINGSTONE

EXCLUSIVE:

First Pictures

of the

ATOM BOMB

What it Looks Like and How it is Delivered

Changing and optimistic times for Lena—until a new political atmosphere emerged in Hollywood during the Cold War and the rise of McCarthyism.

hurt her and also make her even more a target of red-baiters and witch-hunters.

The book's publication remains something of a mystery. Apparently, Moss had submitted the manuscript to a publisher without Lena's consent. She later said she'd never seen a word of it and felt enormously betrayed. Her daughter, Gail Buckley, was quoted as saying: "My mother was furious. She hated the book." Yet the book had been published. Exactly what kind of agreement had she made with Moss and Arstein that could have allowed this to happen without her involvement?

Still, the book had an authentic tone, as if she had been caught off-guard but intentionally spoke with a degree of candor, clarity, and honesty. Regardless of the distortions and lack of nuance and subtlety that Horne would have insisted upon had she given her stamp of approval to a publication about her life, it marked an early attempt at self-analysis. She was not an airhead of a star, blithely enjoying glamour and success without a moment of reflection. The book revealed a complicated woman seeking to come to grips with the meaning of her experiences. Lena Horne authored other lengthy articles about her life. In 1947, the *Chicago Defender* ran a series titled "My Story" by her, on her life, as told to Al Monroe. Another book appeared in 1965. And still later she famously examined her life in a hit Broadway show and a PBS documentary. But *In Person: Lena Horne* was not a part of the star's self-examination that could be dismissed.

In the spring of 1950, Horne had embarked on a concert tour in Europe—with Lennie by her side as her musical director. Upon her return to the States, she was hit hard by the shock waves caused by the publication of *Red Channels* and *In Person: Lena*

Horne. In a telephone conversation, she confronted Carlton Moss. Once back in Los Angeles, she met with him and openly expressed her anger and sense of betrayal. But nothing could be done. It remains unclear why there was not a lawsuit. Perhaps Horne was advised not to bring further attention to the book, especially at this precarious time. In the November 18, 1950, edition of the *Pittsburgh Courier*, however, P. L. Prattis wrote of revelatory personal aspects of the book that Lena may have regretted exposing. "Would it occur to you that Lena should regard herself as 'ignorant,' 'unwanted,' that she should be a lonely person fearful to intrude upon the great?" Prattis asked. "Would it occur to you that many, many times she has known the pangs of hunger, has walked the streets for miles and miles, job hunting, in order to save carfare?"

Prattis added that "the most important aspect of this book has to do with discrimination. Everywhere Lena turned, she found 'color' in her way. She was either too colored or not colored enough, North and South, East and West, her color interfered with her existence. She doesn't tell her story with bitterness, although at times, she was very bitter indeed. It is because her story rings so true and is told without rancor that it will do whites who read it a lot of good . . . They won't be able to excuse themselves and to say that she has a chip on her shoulder. They are bound to know she has caught them in the act."

Her manager, Ralph Harris, continued efforts to secure her nightclub engagements. For the most part, she had no significant problems with club bookings. In the August 1951 issue of *Ebony*, her groundbreaking appearance at the Coconut Grove

in Los Angeles was called "the greatest acclaim of her career." "With a new and excitingly sexy song style, Lena had night club critics and audiences groping for superlatives to describe her breathtaking once-nightly performances as the first Negro entertainer to perform in Hollywood's ultra-swank Coconut Grove." One critic proclaimed: "She delivers a song with the same knockout technique so smoothly perfected by Joe Louis." How she felt about the Joe Louis reference was anyone's guess.

But a stumbling block for Horne was television. Her agency, MCA, understood that bookings on television were now crucial to her survival. Her movie career was effectively over. She would make only one more film at MGM, *Meet Me in Las Vegas*. Now a huge audience could be reached on the tiny tube that sat in a big box in American homes. That audience would grow as more and more television sets were sold and consequently as the new medium culturally altered aspects of American life. Television did not provide much in terms of income for Horne. But it was important in terms of visibility, keeping her name alive, and crossing generations.

In 1948, Lena had performed on this new medium's popular variety show *Toast of the Town* hosted by Ed Sullivan—renamed *The Ed Sullivan Show* in 1956. The show aired on New York's WCBS station and was broadcast throughout the country. Sullivan was a well-known syndicated newspaper columnist, covering entertainment and sports, based at New York's *Daily News*. He would become celebrated for showcasing many "hot" talents—from Elvis Presley to the Beatles to the Supremes. He also brought on many talented African American performers, many famous but also others not so well known to the general white TV audience, such as

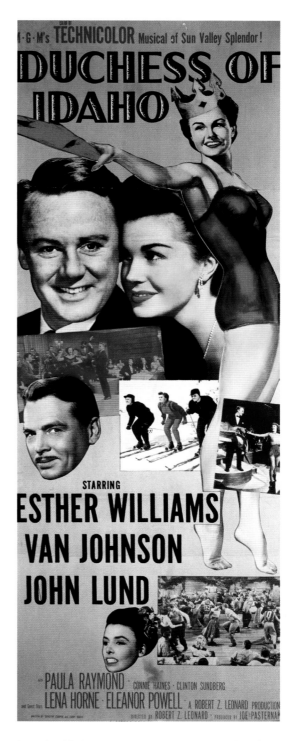

Lena's MGM career was nearing its end in the mid-1950s.

Fats Domino, Peg Leg Bates, Jackie Wilson, and Bo Diddley. Known as an equal opportunity employer, Sullivan was also an opponent of communism.

In 1951, Lena appeared on *The Colgate Comedy Hour* and *Your Show of Shows*. But the door to television and radio appearances was being shut in her face. That was evident when she was scheduled to appear on Sullivan's program in a tribute to Oscar Hammerstein. Sullivan always had to consider the reactions of his sponsors to stars on his show, especially during this period of blacklisting. But he liked Horne and apparently did not take the charges against her seriously.

The conservative Hearst newspaper the *Journal-American*, however, protested. By no means should Horne be on the program. A controversy and a battle followed. Under the headline "Attempt to Bar Lena Horne From TV Show Rebuffed," the *Daily Compass* reported: "*The Journal-American* had thrown the book at Sullivan, the network and the sponsoring Ford Motor Co., in an effort to force Miss Horne off the show. The 'book' in this case was 'Red Channels.'"

Lena, however, fought to stay booked for the broadcast. As the *Daily Compass* reported, Horne emphatically "stated that if her contract to appear were breached, she would sue for the limit." The paper further stated: "In this she had backing from her booking agency, the Music Corporation of America, of which she is a star money-making attraction."

The Hearst paper's television and radio columnist, Jack O'Brien, however, would not turn down the heat. The day before the scheduled program, O'Brien wrote: "It was no secret along radio and TV row today that the sponsor and the advertising agency were considerably perturbed about what was believed would be certain public resentment, and anxious to correct the latest display of Sullivan's booking genius." O'Brien, who took a swipe at Sullivan *and* CBS, added: "Amazing, isn't it, that so many of these pink teas seem to 'just happen' to the Columbia Broadcasting System?"

CBS came to Horne's defense and its own. The network's vice president in charge of television programs wrote: "The Columbia Broadcasting System wishes to point out that Miss Lena Horne has appeared recently as NBC's master of ceremonies on the NBC 'Show of Shows,' has appeared on NBC's 'Colgate Comedy Hour' with Eddie Cantor, previously appeared in July on 'Toast of the Town,' and has appeared on many other TV and radio programs on other networks without comment from the press. Ed Sullivan's record over the years as a vigorous fighter of communism, subversives and all un-American activities is too well-known to require further elaboration by CBS."

In the end, Horne appeared on the live broadcast. She had won the battle. But after the broadcast, the network knew it still had a problem on its hands. "The CBS switchboard had immediately started lighting up as viewers demanded, *Get that communist off the air*," John Meroney later reported in the *Atlantic*.

"By now, the mere hint that a celebrity might be a communist was enough to end her career," stated Meroney. "Nationwide boycotts were being organized against films connected with communists, and in an effort to protect their investments, executives and producers refused to hire people with communist connections. In that kind of climate, how could Lena Horne survive?"

Her name had to be removed from the blacklist. Horne was advised to seek help from the

influential *New York Herald-Tribune* columnist George Sokolsky, who was a staunch supporter of Senator Joseph McCarthy's red-hunting campaign. She had to have felt humiliated. Lena approached Sullivan. "He listened to her plight and suggested she repudiate communism in a statement for [Theodore] Kirkpatrick, the *Red Channels* publisher," said Meroney.

In his syndicated New York *Daily News* column on October 10, 1951, Sullivan published a statement by Horne. "No minority group in the country within the past ten years has made the advances scored by the Negroes . . . and we would have made even greater advances if the communists didn't deliberately try to confuse the issue and stir agitation."

It appeared to be a strong enough anti-communist statement. But, sadly, for Horne, she had to disavow her association and admiration of Robeson. She wrote of Robeson: "He, for whom I once had great admiration, does not speak for the American Negro , as Jackie Robinson told the House Committee on Un-American Activities and I would tell them, if invited. Agitation, however, will always be with us." This comment must have turned her stomach—no doubt it made her feel she had compromised herself in the worst way for the sake of her career.

Said Meroney: "The statement didn't help her. Horne's words were viewed as a calculated attempt at saving what was left of her career, and she'd sidestepped the larger issue of how she'd ended up in that grim place. Even with the wide circulation of Sullivan's column, networks and advertisers wanted nothing more to do with Horne." Meroney added: "She had one other option: appealing to Roy Brewer, the toughest anti-communist in Hollywood."

Entertainers at the end of their ropes would go to Brewer, who was a shrewd, committed representative of the stagehands' union. He thoroughly understood the ins and outs of the business as well as the ways, so he believed, that the Communist Party had used entertainers for a political agenda.

In November, Horne contacted Brewer. "She seemed exhausted, hurt, and angry, venting her sense of betrayal, and Brewer told her she wasn't alone," said Meroney. "He said he knew of many cases where the Communist Party had surrounded entertainers, leaving them trapped. He told her she would have to clear her own name but pledged to support her."

Brewer, however, did contact representatives at CBS and NBC, "sending them a copy of the Ed Sullivan column with Horne's 1951 anti-communist statement." There was further communication. But Horne's loyalty was still in question—seemingly because of her "friendship" with Carlton Moss and Helen Arstein, both considered "radicals."

Ultimately, she followed advice given to her by Brewer.

In June 1953, Horne wrote a letter to Roy Brewer on the Sands Hotel stationery in Las Vegas, in which she distanced herself further from Robeson *and* Carlton Moss. As with her previous statement, it must have been hard for her to make comments against Robeson, who had been so important to her and her evolving racial and political consciousness. But she knew if she hoped to salvage her career, she had no other choice. The twelve-page letter was addressed to Brewer:

Dear Mr. Brewer,

If at anytime I have said or done anything that might have been construed as

being sympathetic toward communism, I hope the following will help to refute this misconception.

She continued by clarifying her friendship with Moss—and the way he had betrayed her.

I suddenly realized that I had been used by someone cold bloodedly, one who had no scruples about my bearing the responsibilities of his actions.

Further she stated that Moss and Robeson had exploited her concern for "the Negro people." "I also realized that many actions I had assumed under his influence were all a part of the same pattern. I am angry that I did not immediately see through this pattern."

She added:

I have always known that America offers the greatest chance to all people, to achieve human dignity—and since this terrible experience I am more determined than ever to do what I can to impress these principles on the thinking of all people I come in contact with.

Most sincerely, Lena Horne

Brewer sent the letter, according to Meroney, "to at least nine of the top executives at studios and networks, places he thought would hire Horne if her communist ties weren't an issue. He also mailed Horne's letter to powerful political operatives, including Sokolsky, who had his secretary mail a copy to J. Edgar Hoover's assistant on July 21, 1953."

If the letter is read closely, one might feel that Horne could have come down harder on Robeson and Moss. Yet part of Lena Horne would still believe, apart from their support of the Communist Party, in their fundamental convictions and integrity. But she had no further contact with Moss.

A copy of the letter was put in a banker's box. It was "packed away in a children's playhouse on a dusty ranch in the San Fernando Valley." Unknown to others and perhaps forgotten by Horne herself, there the letter remained. Reportedly, her daughter Gail did not "get to see the letter until 2013."

Removal from the blacklist did not happen overnight. But, gradually, Lena's situation improved. In 1953, Horne was booked for another appearance on *Your Show of Shows* and also as the mystery guest on *What's My Line?*; in 1954, *The Tonight Show*; in 1955, the documentary series *See It Now*. She returned for performances on *The Ed Sullivan Show*, *The Steve Allen Plymouth Show*, *The All-Star Christmas Show*, and others. Throughout, she also appeared on the popular radio program *The Tex and Jinx Show*, starring Tex McCrary and Jinx Falkenburg, both friends and supporters of Horne.

She was back at MGM for an appearance in the 1956 *Meet Me in Las Vegas*, a pseudo–screwball comedy starring Dan Dailey and Cyd Charisse. Shot in Technicolor and the new widescreen process CinemaScope, the film was harmless enough. MGM appeared to be welcoming Lena back into the fold. At the start of the film, an actual

At a star-studded event in 1955 (from left): Joe E. Brown, Ray Bolger, Howard Keel, Connie Russell, President Dwight D. Eisenhower, Lena, Liberace, and Stanley Robinson.

marquee in Las Vegas proclaimed appearances by Lena Horne and Frankie Laine. Lennie was given special billing: "Lena Horne's Number Arranged and Conducted by Lennie Hayton." In her Helen Rose white gown, Lena looked svelte and glamorous as ever as she sang "If You Can Dream." But the number did not match the high point of her previous MGM appearances. Another number, "You Got Looks," was cut from the released film.

By 1953, Hayton had left MGM with a distinguished record, and the public knew of the Horne-Hayton marriage. Whether or not the union was accepted remained a question. Lena's career seemed on track again, but other challenges lay ahead.

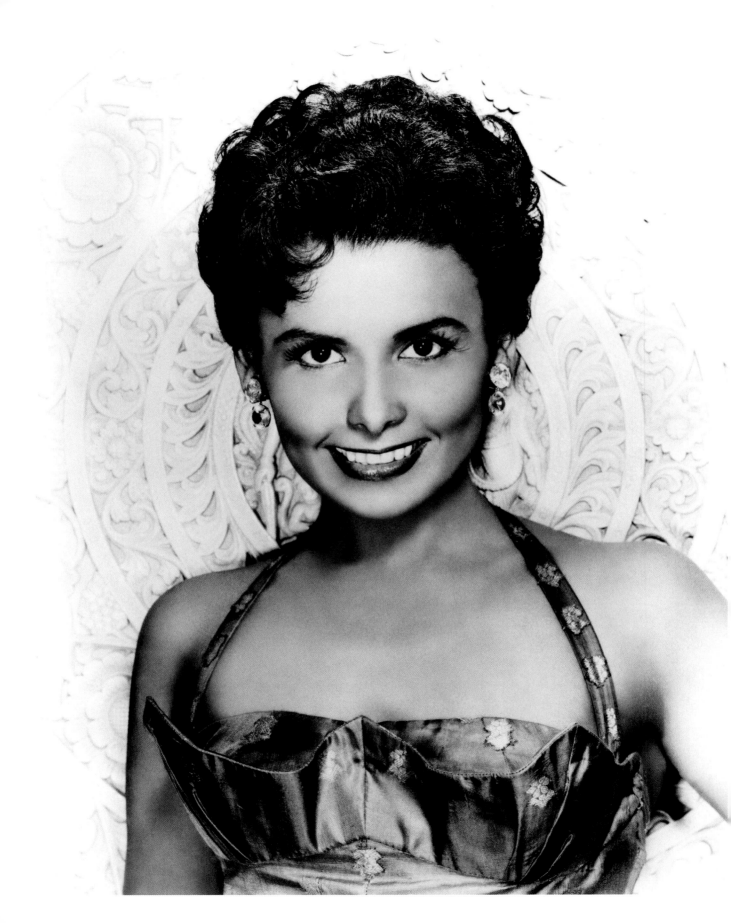

CHAPTER 14

NEW ERA, NEW STARS, NEW CHALLENGES

During the Eisenhower era, a new generation of stars emerged. In the past, Lena Horne had been aware and admiring of the talents of such singers as Ella Fitzgerald and Billie Holiday. She remained aware of long-standing professional realities: Never would she have the vocal skills of Fitzgerald; nor would she have the emotional power and technical wizardry of Holiday, whose interpretations turned songs inside out; nor would she have Holiday's tragic grandeur that could haunt patrons long after the performance ended. But unlike her contemporaries, Lena had an indisputable status as a larger-than-life goddess. The other women never had the glamour buildup that had always been essential to the Horne image and career. In nightclubs, patrons often simply wanted to be in her presence, to have a glimpse of someone who seemed to have temporarily descended from Mount Olympus. Her style itself still made her seem gloriously remote and unattainable.

Now such postwar performers as Dinah Washington, Eartha Kitt, later Olga James, Joyce Bryant, Dakota Staton, Gloria Lynne, and then Nina Simone and Diahann Carroll were taking center stage. The Black press excitedly covered some of them, on and off nightclub floors. Born in 1924 and having recorded in the 1940s, Washington reached new career heights in the 1950s with such songs as "What a Difference a Day Makes," "Manhattan," and "This Bitter Earth." She had a much-discussed private life that made her fodder for the tabloids. By some accounts, Washington had eight husbands and

At the height of her powers in the Eisenhower era, the fabulous 1950s.

could battle people with the fury of Ethel Waters. Yet onstage her style was innovative, mellow, and dreamy, with a vocal clarity that few could match. In supper clubs and on recordings, Eartha Kitt perfected a sex kitten persona—a pampered vixen born for a life of luxury with such songs as "I Want to Be Evil" and the naughty "Santa Baby." Kitt's career, her classy bookings, and her personal exploits would place her on the cover of *Ebony* and the new weekly Black publication *Jet* that debuted on November 1, 1951. Mainstream media also reported on these new stars.

Throughout her career, Horne questioned her own uniqueness as an entertainer. Working far harder to further develop as a singer and song stylist than most realized, she repeatedly sought the right arrangements that brought out the best in her voice, and she learned from Billy Strayhorn, Phil Moore, Kay Thompson, and her husband, Lennie. Lena was fully aware of the talents of the up-and-coming stars. Yes, the women were competition, but she could handle that.

The one star who appeared to challenge Lena's goddess position was a woman wholly unlike the others and similar in looks and appeal to Lena: Dorothy Dandridge. Comparisons between the two women appeared time and again. In its November 5, 1951, edition, *Life* magazine ran a feature on Dandridge in which it proclaimed Dandridge "the most beautiful Negro singer to make her mark in nightclubs since Lena Horne" and pointed out that Dorothy's newfound success had come about "under the tutelage of the same man who coached Lena Horne."

In the December issue of the Black publication *Our World*, a feature titled "Dorothy Dandridge Learns to Dance" commented: "She has the voice,

Oscar-nominated actress and nightclub star Dorothy Dandridge, Lena's only serious rival in the 1950s, with a similarity in style in the clubs.

looks and sophistication to rival Lena's. And she has something La Horne lacks—pretty legs." The article also stated: "There's something else Dorothy and Lena have in common—musician Phil Moore. He groomed Lena into a polished performer. Now he's shaping Dorothy's career as her pianist and song arranger." Moore's open fascination with Dandridge was apparent to everyone. Stated *Our World*: "In London this summer, they teamed up to introduce his new ditty 'Blow Out the Candle.' Instead of following the advice of his song title, Moore is carrying the torch for his pretty singer." Six months later, *Our World* ran a cover story on Dandridge with a picture insert of Lena and a headline that read: "Can Dorothy Dandridge Outshine Lena Horne?"

The media clearly enjoyed its own created

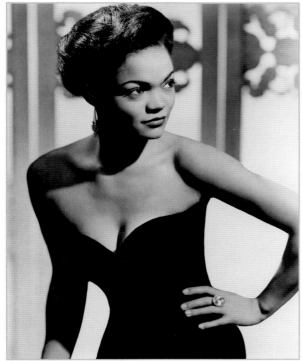

Eartha Kitt, star of nightclubs, movies, and TV, celebrated as the 1950s' sex kitten.

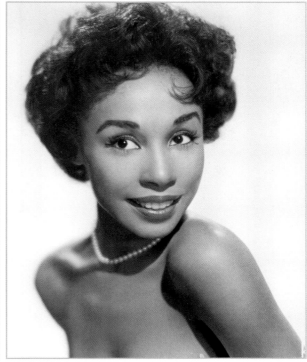

The up-and-coming young Diahann Carroll, also coached by Lena's early arranger, Phil Moore.

rivalry between the two women. Thrown into the mix to add sexy fuel to the fire was Phil Moore's name. Moore himself no doubt relished the attention. He had had to take a back seat in Lena's career as her husband, Lennie, moved to the fore. Consequently, he wanted it known that Lena realized his importance to the early years of her Los Angeles career. And he wanted it known that she might not have been thrilled with the way he had helped guide Dorothy to national success. "Word came from Lena's camp something like, 'She [Dandridge] ought to be doing something, *she's got my arranger!*" said Moore. "And Dorothy D. was saying, 'I can't see how Lena would say that. *No one can ever take her place.*'" Still later, Moore worked with the young Diahann Carroll. Horne, Dandridge,

and Carroll were well aware of one another—and of Moore's attentions to each. All three had similar nightclub images with a similar selection of songs, similar arrangements, and appeal to white patrons.

Both Lena and Dandridge may have been annoyed with the way Moore was credited with their success. And in the time to come, Moore no doubt noted the way Lena spoke more of the contributions of Billy Strayhorn and Hayton to her style than she did of him.

Moore was the link between Horne and Dandridge, but other similarities existed, aside from the fact that each was celebrated for her beauty. Both had had troubled childhoods. Both had grown up separated from their fathers. Both had demanding mothers who had pushed them into careers at

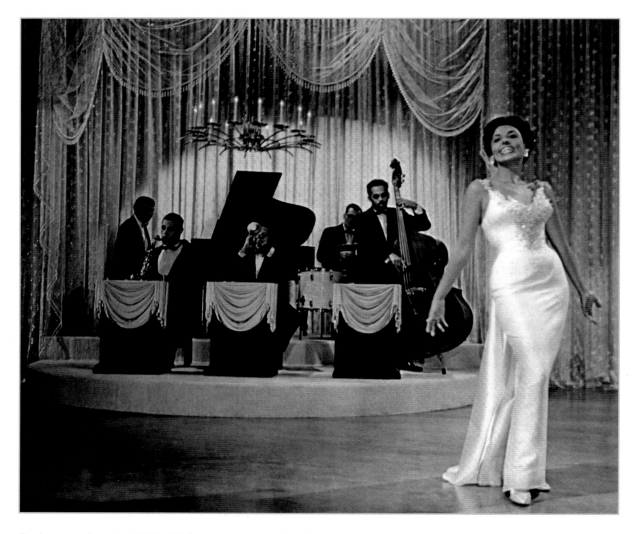

Saying goodbye to MGM with her appearance in *Meet Me in Las Vegas*, 1956.

young ages. Both sang standards rather than blues or rhythm and blues. Both broke down color barriers. Both had international reputations. In the 1950s, Dandridge's performance at London's Café de Paris was triumphant. Her face would adorn the covers of *Paris Match* and *Stern*.

But where Dandridge had the advantage was in her career as an actress. Appearing in films since she was a teenager, she won acting roles in *The Harlem Globetrotters* (1951) and even as the African princess/queen in *Tarzan's Peril* (1951). In 1953, Lena's studio, MGM, signed Dandridge to a two-picture deal. She was showcased in a musical segment in *Remains to Be Seen* and then in a dramatic role as the lovely young schoolteacher trying to reach a wayward student in *Bright Road*, opposite Harry Belafonte. Then in 1954, *Life* magazine ran Dandridge's picture on the cover, the first time a Black actress had ever been accorded such attention. Otto Preminger's all-star Black

musical *Carmen Jones* starred Dandridge—along with Belafonte, Pearl Bailey, Olga James, Diahann Carroll, Brock Peters, and in a spectacular dance sequence, the young Alvin Ailey, Archie Savage, and Carmen de Lavallade. For her performance, Dandridge became the first African American to garner an Academy Award nomination for a leading role in a film. The other nominees included Judy Garland, Audrey Hepburn, Jane Wyman, and Grace Kelly (who won). Dandridge had reached the heights of movieland stardom.

Afterward Dandridge signed a major contract with 20th Century-Fox. Taking an intense interest in her career was the director Otto Preminger, with whom Dandridge had a tempestuous romance. She soon embarked on a major nightclub tour, playing big hotels in Las Vegas—and making news when she became the first Black performer to play the exclusive Empire Room of the Waldorf-Astoria on April 11, 1955. None of this was lost on Horne.

"Who can improve on Lena Horne?" Dandridge told the Los Angeles *Daily News* in March 1951. Privately, Dandridge was flattered but uneasy about the comparisons. It simply added to the doubts of a very insecure woman. Said Nick Perito, who was Dandridge's musical director on her tours: "She seemed to be living in the shadow of Lena Horne. She didn't fully see her own gifts and what made her different from every other star, including Lena Horne."

Lena must have found it hard to read some of the stories. At age thirty-four, she was depicted as the "older," perhaps even dated, star who had to make way for the young beauty.

It may have looked at times to Lena Horne as if her days of glory had come and gone, that she might be yesterday's news. A crucial difference, however,

was that Lena had self-assurance that Dandridge lacked. To Lena's credit, she never allowed the comparisons to eat away at that confidence. She had developed a tough outer shell for protection that would serve her well.

Ultimately, Dandridge had a shocking, tragic decline and died at the age of forty-two, leaving behind a legend that would endure and that could not be competed with.

For Lena an engagement finally came in 1956 at the Empire Room of the Waldorf-Astoria, the most exclusive of nightclubs—and the one that Dandridge had led the charge integrating in 1955. Designed in an Art Deco style by Schultz and Weaver and located at 301 Park Avenue, the hotel's Empire Room seated about 400 people. Patrons paid a steep price for a meal, entertainment, and glamorous surroundings. It was always a memorable experience, especially for the out-of-towners who could go back home and say they'd been to the Waldorf, in this case to see the fabulous Lena Horne.

Lennie was her musical director, and pianist Nat Brandwynne with his orchestra accompanied her—and ultimately recorded four albums with her. With their support, Lena excitedly and meticulously prepared for the opening. She would perform the music of masters: Cole Porter, Ellington, Fats Waller. As Horne was often quick to say, she had to watch her expenses, everything from her gowns to the musicians she worked with to hotel accommodations, all of which ate into her earnings. Rehearsing strenuously, she went over arrangements with Lennie, confident as always that he understood best what she could and should not do with her voice.

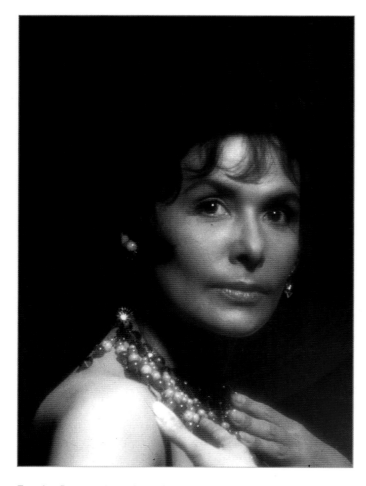

Empire Room triumph at the Waldorf-Astoria.

earth to make them smile and laugh. Or as the columnist Liz Smith explained it: "She would just build the audience up to a fever pitch where they all wanted to run up and tear her clothes off. But then she'd back away. It made her a real, real glamorous sex symbol. Mysterious. Erotic. All of the things that she was just totally contemptuous of."

Nightly, she was the star among stars as was evident by the excitement of the famous, like Ava Gardner, Marlene Dietrich, James Mason, Rex Harrison, and Kay Thompson, who rushed to see her—and by the patrons who packed the Empire Room. In the *New York World-Telegram and Sun*, critic Robert W. Dana called Horne's appearance "one of the greatest performances in café history." He added: "But I think Nat Brandwynne, the Empire Room's astute bandleader, sums up the Horne critique best when he says: 'She's the end—the beginning.' This certainly is borne out by the business the beauty is drawing. How often have you heard of an entertainer breaking all records? It seems the McCoy when they refer to Lena as doing so."

Opening night was December 31, 1956, the perfect way to ring in the New Year. A magnificent Lena appeared, stunning the audience. There was the woman they had seen for over a decade in MGM movies—the dream goddess. In top form, Horne sang such songs as "Today I Love Everybody," "Mood Indigo," "Honeysuckle Rose," "From This Moment On," and "New Fangled Tango." On brilliant display was Horne's nightclub persona of aloofness. But she also played here with audiences with sexy innuendoes—and sometimes executed playful banter in French and Spanish. The goddess had come to

Dana almost fell over himself in rhapsodizing about her. "I can't remember when I've so literally been swept off my feet by a feminine performance." Of course, he had qualified his praise in terms of gender. But her mesmerizing effect was nonetheless apparent. "The woman herself is so stunningly gowned to accent a beautiful figure that, in itself, would catch an audience's attention. But the ultimate hypnotic effect is the music, the arrangements and an intensity of delivery that finds its essence in eyes that seem to bore through you."

In the 1950s and 1960s, an unforgettable fixture on New York's social and theatrical scene.

Also acknowledged was Hayton's contribution. "Lennie Hayton's great arrangement of the next song 'Day In, Day Out,' leaves the audience breathless before it applauds thunderously."

But perhaps the sharpest observation came from Arthur Laurents, who recalled having seen her perform years earlier at Slapsy Maxie's in Los Angeles. "She wasn't Metro's Lena Horne," said Laurents. "The voice deeper, the lyrics almost bitten and spat out, the eyes glittering, this was a new Lena. This Lena was angry sex. I gave the credit to Lennie because that was all I knew then. What Billy Strayhorn did for her, I learned only after I met him with her at the Hotel Tremoille, April in Paris, 1954." He added: "In the early Sixties, when we were so close I asked her what was in her head when she came out on the elegant floor of the Waldorf in New York or the Fairmount in San Francisco. She bared her teeth in the smile those expensive audiences waited for. 'Fuck you,' she said. 'That's what I think when I look at them. Fuck all of you.' She meant it figuratively, they took it literally."

Giving two nightly performances during her eight-week engagement, Lena at the Empire Room was a blazing success. Audiences couldn't get enough of her. Any thoughts of political controversy, of the dreaded blacklist, had vanished. History was being rewritten.

Throughout much of her career, Horne had recorded actively—and had built up quite a body of recording work. RCA Victor made the decision to add to that body of work by recording her Empire Room performance on February 20, 1957, with Lennie conducting and with Brandwynne's orchestra accompanying her in stereophonic sound.

When released, "Lena Horne at the Waldorf Astoria" was a smash success. It peaked on Billboard's 200 at number twenty-four, becoming the best-selling album by a female artist on RCA records up until that time. It rapidly achieved classic status. Thereafter Horne still recorded actively, building up an even more impressive body of work.

The success of Horne—and Dandridge—opened the portals of the Empire Room to such other Black performers as Ella Fitzgerald, Count Basie, Pearl Bailey, and Joe Williams. And afterward Lena herself would return frequently to the Empire Room.

Resolved to take her career—and glamorous image—in a new direction.

BROADWAY CALLS

In 1957, plans were on the horizon for a Broadway show with music by Harold Arlen and E. Y. "Yip" Harburg. The libretto was to be by Harburg and Fred Saidy, who previously had written the libretto for *Finian's Rainbow*, in which their gift for satire and their social consciousness were apparent. Having been listed in *Red Channels*, Harburg was successfully climbing back into show business. The idea among the artists was to create "a simple folk tale" set on a West Indian island. It told the story of an island guy whose girl, Savanna, yearns for the "complexities" and conveniences of urban "civilization." To be called *Pigeon Island*, the show was to make use of popular Calypso music. In fact, originally it was to star popular Calypso singer Harry Belafonte. But when Belafonte suffered a medical emergency that required an operation, he had to withdraw from the production. Thereafter the producers tried frantically to sign Sidney Poitier, but he was not available. Then Arlen suggested Lena, whom he had known since both their days at the Cotton Club.

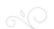

Lena had just completed her engagement at the Empire Room when Arlen asked her to do the show—playing the now revamped leading role of Savanna in the production which would ultimately be called *Jamaica*. Eager to do Broadway, she immediately expressed interest. She also loved the music of Arlen, who was the composer of a lineup of American classics: "It's Only a Paper Moon," "Get Happy," "I've Got the World on a String," "Come Rain or Come Shine," as well as "Somewhere Over the Rainbow" and all the other songs in *The Wizard of Oz*—and, of course, "Stormy Weather." Horne rhapsodized that Arlen's music was "soul rewarding. Harold doesn't write the cheap commercial tripe that is always recorded. Harold writes a song, not a mood coloring for a scene—and his songs are

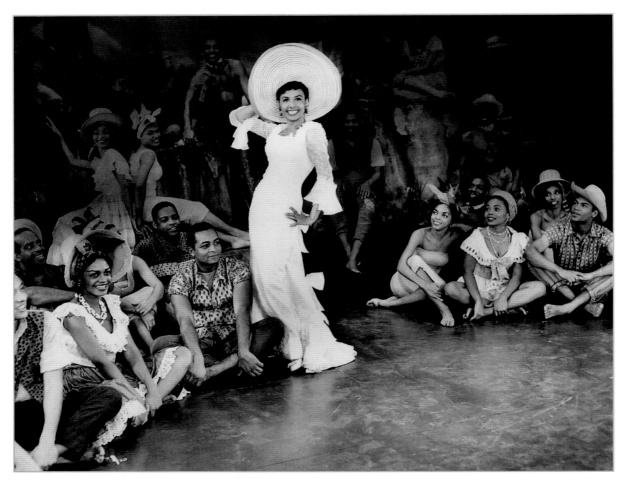

Lena dazzled audiences in Broadway's *Jamaica*.

singable away from the story. But, oh—their excruciating range!" This new show promised to be an exciting venture.

Previously, producer David Merrick had announced plans for the production with a projected 1958 opening. Now thrilled to have Lena onboard, everyone involved was aware of new demands.

Soon after signing for the musical, Horne appeared on *The Ed Sullivan Show*—where she announced she'd be coming to Broadway in *Jamaica*. Advance ticket sales soared close to a million dollars. Without so much as a tryout or preview, *Jamaica* looked like a box-office hit. Now came the challenge of fully restructuring *Jamaica*—integrating the new lead character into the story and within the context of the other characters. Also, new songs would be required for Lena. "The presence of a personality of the stature of Lena Horne did not solve all problems," said Arlen's biographer, Edward Jablonski. "A giant also introduces problems and Miss Horne is a giant. While she had kept aloof from Broadway, an aloofness not necessarily of her own making, the fact that she was now to make the plunge contained within it the seeds of tension, of a greater striving for perfection." In other words, problems and conflicts might possibly lie ahead.

An impressive cast was gathered that included another former MGM star, Ricardo Montalbán. Mexican-born, the son of Spanish immigrants, Montalbán had a long and varied career from his time in Mexican films to his success in Hollywood in the late 1940s in such films as *Neptune's Daughter* and *On an Island with You* opposite Esther Williams. For moviegoers, Montalbán often epitomized the sexy yet elegant and suave Latin lover, as he romanced such gorgeous stars as Lana Turner, Anne Bancroft, and Cyd Charisse. Having suffered a spinal injury in 1951, Montalbán lived in constant pain during the entire production and indeed for the rest of his life.

Two of the supporting players were Ossie Davis, now a theater veteran, and Josephine Premice, a Haitian-American actress who had studied dance with Katherine Dunham and had performed successfully abroad. Joe Adams, who had appeared as Husky Miller in *Carmen Jones*, joined the cast. Also, as lead dancer, was Alvin Ailey, who had previously appeared in the Arlen show *House of Flowers*. Cast as Lena's aunt was a touching "sentimental" favorite for Lena: performer Adelaide Hall, whom she had first met at the Cotton Club and whose kindness and encouragement she remembered. It was Harold Arlen, however, who brought Hall, then living in England, into the production. Though rumors persisted of friction

between Montalbán and Horne, basically the cast was in support of Lena, appreciative of her longevity in show business, and her star power. Everyone wanted to be in a smash hit, and Lena was assurance that *Jamaica* was a smash in the making.

With Robert Lewis signed to direct, Harburg and Saidy made changes in the book—rearranging and rewriting everything to revolve around Lena. Merrick was known as a sometimes difficult producer, eager to do publicity stunts to ensure theatergoers knew about his productions. He could

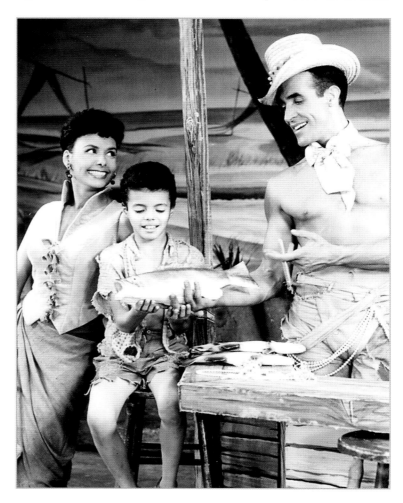

With *Jamaica* costar Ricardo Montalbán.

be explosive and next to impossible to reason with. Now with Horne, however, he wanted nothing that rattled or displeased her. "Merrick naturally tended to slant the entire production in her direction, as did director Robert Lewis," said Jablonski. "Soon the work of librettists Harburg and Saidy was reshaped to fit the handsome form of the star."

Clearly aware of her power, Lena had long wanted such control, to be able to call the shots, to feature herself best on *her* terms, not someone else's. In nightclubs, she had been able to have that control, but in Hollywood, she had never been able to fully assert herself. Now she would not lose an opportunity she had been waiting for. She voiced her opinions, wouldn't back off from a fight if necessary, and used language that could be jarring to those around her.

Like many theater productions, *Jamaica* traversed a rocky road before it reached the great white way. "That show's problems were among the most convoluted and bitter in theater history," said critic Steve Cohen.

"Staging was planned so that Miss Horne could stand and sing as she had done so successfully at the Waldorf," stated Jablonski. "Songs that had been planned for others were given to her, and by the time *Jamaica* opened, Miss Horne was literally singing half the show. This was, of course, fine for Arlen and Harburg, song writers, but not so good for Harburg and Saidy, librettists."

Harburg and Saidy hoped to endow the play with a social commentary about the commercialization of island life—and the way the non-white islanders were exploited. "But Merrick disliked such

Magnetic, glowing, mature—a stunning couple.

Lena and Montalbán, a sexy inter-ethnic pairing without controversy for Broadway audiences in 1957.

moralizing. Harburg and Saidy refused to let anyone doctor with their words," said Cohen. Not the least interested in their complaints or concerns, Merrick threatened to shut down the production and brought in Joseph Stein to rewrite their book. Stein had written *Plain and Fancy* and would later score a major hit with his book for *Fiddler on the Roof*. "The revised script was basically a showcase for Horne's songs," commented Cohen.

The first tryout was scheduled for September in Philadelphia. Rehearsals were set. Merrick wanted Lehman Engel to conduct the musical, but Harold Arlen protested and insisted that his brother

With a new cast of dancers, including Alvin Ailey (r.) and actor Joe Adams in the foreground.

Jerry, who had conducted *House of Flowers*, serve in that capacity. But Lena wouldn't agree to Jerry Arlen. "Three weeks before rehearsals started, Harold Arlen was forced to take the job away from his brother," according to Steve Cohen, "apparently for spite, Harold wouldn't allow Engel to take over." Instead, Jay Blackton was brought in for the Philadelphia tryout.

By the end of April, the score had basically been completed. But Lena was requesting two more songs from Arlen. Harold Arlen, however, took ill. An earlier Arlen song, "Ain't That the Truth," which had been cut from *Cabin in the Sky*, was by now included in the show. That had pleased Lena. But now the star clashed with conductor Blackton. "Blackton was in a no-win situation because Horne insisted on being in charge and the producer acceded to her wishes," said Cohen. "So Blackton was fired."

Though Lena was clearly still *Jamaica*'s great asset, the effects of a show in chaos were evident during the Philadelphia tryout. Writing in Philadelphia's *Evening Bulletin*, Wayne Robinson commented that "Lena Horne, making her debut in her first major role on the stage, understandably put a lot of real meaning into her song ('Push de Button') of an islander wishing for life in Manhattan where a push of the button could turn on an air conditioner." He added that Horne had "the flash and fire

of a truly professional performer. She never lets her audience down." Yet Robinson also noted: "*Jamaica* has three weeks to get ready for Broadway, and from the evidence last night it is going to need every minute of this time."

Next stop was Boston for another tryout. There, Arlen stayed out of the fracas. But he well understood the position of the writers. He hated what might have been a thoughtful piece of theater being used as a star turn for Lena. "Because it was obvious that *Jamaica* 'needed work' by the time it reached Boston, warring factions had sprung up and there were high winds indeed." Merrick and associates didn't want to hear griping from Harburg. Ultimately, Harburg and Saidy were locked out of the theater.

On October 8, the play opened in Boston.

With Blackton gone, Engel was brought back in. But tensions with Lena continued. "Lehman was an easy guy to get along with, but she gave him problems too," said conductor Sherman Frank. Arlen also remained resentful of Engel. Lena then suggested that Sherman Frank be the conductor.

"Lena was a dynamic personality," said Frank, "but she came from nightclubs and was used to a lot of freedom. I led a 25-piece orchestra which included four of Lena's personal musicians. She told them they should follow her. Her, instead of me. We had clashes over that." Hovering around the production was Lennie, determined to support Lena, to ensure her wishes were followed. "Sometimes I was summoned to her dressing room, where she and her husband, Lennie Hayton, told me what I should do

differently," said Frank. "But I adapted, and I stayed."

Gail Lumet Buckley remembered the tryout was a disaster. "In Boston they said, 'Thank God for Josephine Premice,' who was brilliant and got all her laughs. Lena was frozen in fear and on the verge of a breakdown. I witnessed it." She also knew of the nonstop battles between the writers and the producer. "Script changes were constant." Lena looked near collapse. "She simply broke down in sobs, saying, 'I can't do it. I can't do it.'"

The Boston reviews pointed out the assets and problems of the play. "Although the libretto is

Lena with jazz pianist Charlie Beal.

Backstage with her daughter, Gail, at the time of *Jamaica* in 1957.

silly and the director has yet to harness properly the remarkable talents of Lena Horne, *Jamaica* is potentially a fine musical comedy," commented Eliot Norton in the *Boston Daily Record*. Arlen's score was lauded as "entrancing" and "highly inventive." Despite her fears, Horne was praised as "fascinating" and "breathtaking."

Jamaica had started getting into at least reasonable shape. Horne delivered a satirical and sexy rendition of "Take It Slow, Joe." Her love of the song "Cocoanut Sweet" turned it into a warm lullaby. In the first act, Adelaide Hall, playing the character Grandma, performed "Cocoanut Sweet." Lena joined Hall for a duet of "Cocoanut Sweet" and then sang it on her own. All renditions were considered lovely. Another standout was Lena's "Push de Button."

Other aspects of the show were falling into place. Montalbán as Koli was a relaxed, highly likable island man. Ossie Davis as Cicero provided warm comedy. And Josephine Premice proved to be a delightfully arch scene stealer. It was hard for anyone to completely command attention when she was on stage—that included Lena. Later in the *New York Times*, Premice was called "a razzle-dazzle lead performer who was hot flame to Horne's cool fire." Nor could anyone take their eyes off the sets of Oliver Smith. Keeping the play in motion was Jack Cole's choreography, which perfectly utilized the talents of the twenty-six-year-old Alvin Ailey. Cole, who was Ailey's idol, would take the dancers through intricate, sometimes seemingly impossible maneuvers which he himself could coolly execute, said the *New York Times* "with the calm expertise of a bridge builder walking his 20th sky-high girder of the morning." Ailey learned much. A year later he formed his own company, the Alvin Ailey American Dance Theater.

The play opened on Broadway on October 31, 1957, at the Imperial Theater. Sitting out front were Marlene Dietrich, Kirk Douglas, Walter Winchell, and Louella Parsons. "When you make your entrance tonight," director Lewis told Lena in her dressing room, "make it like you belong there and stand still." Recalled Gail: "Lena did as she was told. The standing ovation, before she said a word, was deafening."

"*Jamaica* is a beautiful, jovial, old-fashioned musical comedy," wrote Brooks Atkinson in the *New York Times*, "that has been produced and staged with taste and style." Other critics had mixed responses—mostly about the libretto. "The story got lost," wrote John Chapman of the *Daily News*. In the *Herald Tribune*, Walter Kerr lamented that Harburg and Saidy "haven't even begun to think about supplying their fishermen, pearl-divers, and writhing young ladies with as much as the ghost of a plot." For the writers who had struggled hard to keep their story relevant, *Jamaica* was a major disappointment. But most critics concurred in their praise of Lena. "A hurricane named Lena (Horne) blew into the

Fans from the navy outside the theater, jubilant to see the dream girl of the war years.

Imperial Theater and proceeded to provoke some of the stormiest applause heard hereabouts in quite a spell," wrote Robert Coleman in the New York *Mirror*.

"Needless to say," said Jablonski, "Lena Horne stopped the show several times, which resulted in a great personal triumph."

While *Jamaica* brought out the steely, demanding side of Lena—the quick temper, the frank language, a side that now would be a dominant part of her backstage professional identity and not always win her new friends—Ossie Davis observed something else: "Lena was more than a talent; she was an institution . . . she knew how to protect herself in the clinches as if she were her own daughter. There are those who, having been stung by Lena's verbal punches, swear the woman is made of iron. Well, that may be so, but such female iron is elegant, and calls for lovers. Approach the lady with flattery or with flowers, tell her she's beautiful, and how much you admire her, but unless you speak from a basis of true respect, you'd better duck." There was a point to her demands that could not be overlooked. Said Horne: "I fought for a Black stage manager, for mixing minority musicians from the union and for a multiracial show, with Asians, Blacks, whites, Mexicans, Puerto Ricans. You broke down the wall and opened another door." Indeed, Charlie Blackwell became the first Black stage manager in Broadway history.

From the time of the rehearsals to the actual run of the play, Horne won admirers among the

More glamorous than ever throughout the 1950s.

Lena and Lennie, part of a glittering social world.

young cast members, who detected a softer, generous, and graceful side. "The dancers soon discovered that Horne had a good deal more to her than the glossy allure of a famous club singer and film star," commented Jennifer Dunning in the *New York Times*. "Horne encouraged them all to think beyond the Broadway stage, pushing the modern dancers to plan on doing their own choreography and concert performing. When they did, they were almost sure to see her in the audience and to receive congratulatory notes from her."

At her large ten-room apartment at 300 West End Avenue, Lena often entertained the cast on Saturday nights. "We had big spreads," said Horne. "We danced all night. We didn't have to work on Sundays. I didn't get to be with dancers until *Jamaica*. They became family to me."

During this time, she also gave lavish gatherings for friends at her apartment. "Parties meant Broadway friends like Gwen Verdon, Noel Coward, Richard Burton, and Laurence Olivier," recalled Gail, "and family like Uncle Frank and Uncle Burke

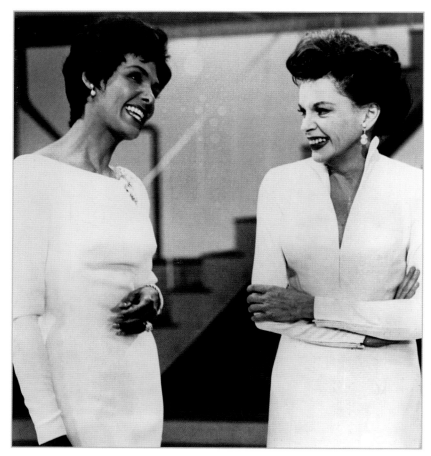

Appearing with her friend from the MGM days, Judy Garland, on *The Judy Garland Show* in 1963.

Best Musical—and the performances of Ricardo Montalbán, Ossie Davis, and Josephine Premice were nominated as well. In total, there were seven nominations. But, alas, none won the big award. Nonetheless, *Jamaica* ran well over 500 performances before closing on April 11, 1959.

By the decade's end, Lena Horne had moved past the blacklist. She also had survived a familiar roadblock for women in entertainment. On June 30, 1957, she turned forty. That could be a cut-off age for a glamorous star, but she was still going strong—and as critics pointed out, she looked magnificent. Performances in Vegas continued until she grew tired

and wives, with lots of singing around the piano, tons of food and drink, and dancing in the foyer— Arthur Mitchell of the New York City Ballet taught us the boogaloo, a line dance of fleeting popularity. Or maybe it was the mashed potato." While Richard Burton appeared in *Camelot* on Broadway, at the same time, his wife, Sybil, would stop by Lena's dressing room at the theater "to have a civilized drink with Lennie."

For her role in *Jamaica*, Horne became the first Black woman to be nominated for a Tony for Best Actress in a Musical. *Jamaica* was also nominated as

of the desert city. Her recording career flourished. More albums followed. And in the 1950s through the 1960s, she was a fixture on television variety shows: from *The Ed Sullivan Show* to *The Dean Martin Show*, *The Andy Williams Show*, *The Hollywood Palace*, *The Jack Paar Program*, and *The Bell Telephone Hour*, and a personal favorite, Perry Como's *Kraft Music Hour*. She also appeared on such game/quiz programs as *What's My Line?* and *To Tell the Truth*.

One of her best appearances was on a 1963 episode of the short-lived *Judy Garland Show*—despite

preshow conflicts. Serving as the program's musical director was singer/writer Mel Tormé, who was thrilled that Lena agreed to appear on the show and would perform a duet with Garland. But in the rehearsal days at the CBS Television Studio in Hollywood, Garland had been absent. Tensions mounted as the taping date grew closer. Still no Garland. Lena had to perform in rehearsal with Garland's stand-in. When Tormé explained that Garland had been under the weather, "Lena in turn coolly expressed the hope that Miss G would be well enough to show up tomorrow since they hadn't sung a note together yet," recalled Tormé. On the day when Garland came to the studio for a rehearsal, she sat in the back watching her stand-in go through the rehearsals. She was making note of the blocking.

"Lena, the consummate pro, maintained her cool admirably, even singing the duet with the stand-in. But later that afternoon, her fiery temper got the best of her," said Tormé. "She was hopping mad now, and the target was Judy."

"God damn it!" Horne exploded, according to Tormé. "Who the hell does she think she is? We're doing this show tomorrow! I don't even know if we sound good together. Man, in all my life, I've never seen anything like this. It's the height of unprofessionalism."

Tormé and others met with Garland, who did not seem greatly perturbed. When told that Horne was upset, Garland said, "Ah, screw her." She added, "Don't worry about it. It'll be just fine. I'll take care of Lena." Later in studio for the dress rehearsal, Garland "went immediately to Lena, all smiles and loving affection, and charmed the dress off her back. Or so it appeared," said Tormé. There was still concern if the show would ever be taped. But the next day it was indeed taped. Lena understood that this was show business. You worked your way around conflicts—and gave a performance. In the end, the two women sang a medley in which each performed the other's signature songs; Judy doing "Honeysuckle Rose" and Lena doing "The Trolley Song." In a musical sketch with Judy and British comic Terry-Thomas, she proved perfect as they performed Noel Coward's "Mad Dogs and Englishmen." She also had a sequence in which she stood, splendidly gowned, and performed on her own. So stunningly beautiful was she that it was easy to lose track of the song she actually sang—"That Old Black Magic." But she was in top form vocally and stylistically. Horne lamented that the American networks did not want to give her her own TV show. On the Garland program, she showed exactly all she could have done on a weekly program, and the manner in which, despite any adversities, she would come through magnificently as a performer.

First with the movies and now with television, Lena emerged ever more as a part of the culture, as part of the collective unconscious of American life. Certainly, within the African American community, she became a one-name star: all anyone had to say was *Lena*; there was no need for her last name to be uttered for people to know who was being discussed. Her one-name identification by this time was the same for the general population as were names like Rita, Lana, Ava, and Liz.

She had weathered personal and professional storms. Perhaps now she could sit back and rest on her laurels. Yet the next decade would be one of personal challenges.

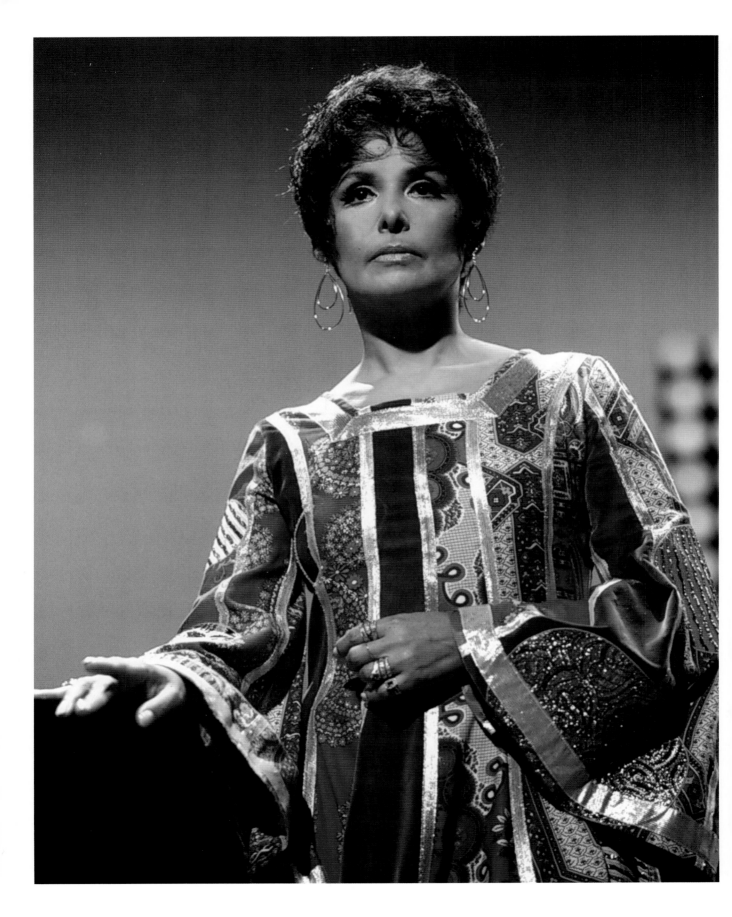

RESTLESSNESS, DIVISIONS, 1960S

At the start of the 1960s, Lena Horne appeared to be on top of the world. Her life and career were seemingly in splendid order. By now, her daughter, Gail, was a young adult, a graduate of Radcliffe College; her son, Teddy, had studied at UCLA then Berkeley and also the Sorbonne. "He had grown from a hopelessly ill-groomed, annoying young boy to a Brooks Brothers–clad young man who towered over me," recalled Gail, "and was found to be quite irresistible by females of all ages and nationalities."

Lena and Lennie had settled into a seemingly secure and comfortable marriage. Both enjoyed fine food and drinks. With each well attuned to the needs of the other, they traveled together for her career, and Hayton appeared to have no problems giving his wife the spotlight. At this point, she still played Las Vegas and was still a favorite at Jack Entratter's Sands, where she appeared for a decade. "At the Sands" was a hit album for her, recorded November 3–5, 1960, released on RCA in 1961. After his days at MGM, Lennie still had an active career scoring movies and such television programs as *The Virginian, Kraft Suspense Theatre, Daniel Boone,* and *Bob Hope Presents the Chrysler Theatre.* In 1969, he won a second Oscar for the Barbra Streisand film *Hello, Dolly!* (co-composed with Lionel Newman). In music circles, he remained a respected, vital force. In social circles, it was always Lena and Lennie. Or Lennie and Lena. They were thought of as a glamorous pair, as they continued to mix and mingle with glittering artists and celebrities in New York, Los Angeles, and Europe. Their New York social crowd included columnist Dorothy Kilgallen and her husband, Dick Kollmar;

Jinx Falkenburg and Tex McCrary, the radio personalities who had been supportive of Lena during the period of blacklisting; Jock and Betsy Whitney; and Bill and Babe Paley. Everything seemed to be going swimmingly well. Yet beneath the surface, the Horne-Hayton marriage was not without tensions that would simmer and then boil over during this new decade—conflicts that ultimately strained their marriage to the breaking point.

What Lena and Lennie soon dealt with—which had an effect on their marriage—were the demands and anxieties of a changing society, a shift in cultural life, and a very open racial and political divide. Long festering social problems erupted in a way America had not witnessed before. In December 1955, when activist and seamstress Rosa Parks had refused to give up her seat to a white passenger on her bus in Alabama, she was arrested and booked. Thereafter Black residents in Montgomery, Alabama, boycotted the city's buses in protest, led by a young, then unknown minister, the Reverend Martin Luther King Jr. Now a national spotlight was shone on Jim Crow laws in the South, and ultimately, the blatant bigotry, discrimination, and segregation (open and de facto) throughout the country. Black America also remained haunted and angered by the shocking killing of teenager Emmett Till in Mississippi in 1955 by two white men.

More protests followed. When schools and lunch counters were being desegregated in the South, violence broke out. Images of billy clubs, fire hoses, and attack dogs being used on nonviolent Black protestors stunned the nation. Young students, Black and white, formed the Student Nonviolent Coordinating Committee (SNCC) and protested in parts of the South. The peaceful protests and the shocking violent reactions were reported nightly on television's evening news programs. Ultimately, television helped lead to a new awakening about race and racism in America. At the other end of the spectrum, Black leader Malcolm X called for another type of resistance and protest: no longer nonviolent.

The civil rights movement hit home with Lena Horne. Perhaps she had been waiting for this movement from the time she discussed race problems with Robeson at Café Society back in the early 1940s. She found herself angry and often enraged when reminded that the "old" familiar racism was sickeningly alive and well. Then, in February 1960, an incident occurred that put her in the headlines. While in Los Angeles for a series of performances at the Cocoanut Grove, one evening around midnight Horne and Hayton were seated at the Luau restaurant in Beverly Hills—where they were to meet Kay Thompson. But Thompson was late. When Hayton left the table to call her, Horne heard a remark made by a white patron who was at another table with a friend. When one man commented, "There's Lena Horne," the other referred to Lena as a *nigger*. "I can hear what you are saying," Horne was reported to have said. "Please stop."

"He said something about not liking niggers, and she asked him to stop," a police officer later stated. "But he said it again, and that's when the action started."

"This is America," Horne was reported to have shouted. She stood up from her table. "You cannot insult people like that." Then a justifiably enraged Lena picked up the nearest object—a hurricane lamp—and threw it at the man, along with dishes and ashtrays. One object hit the man, causing a small wound above his left eye.

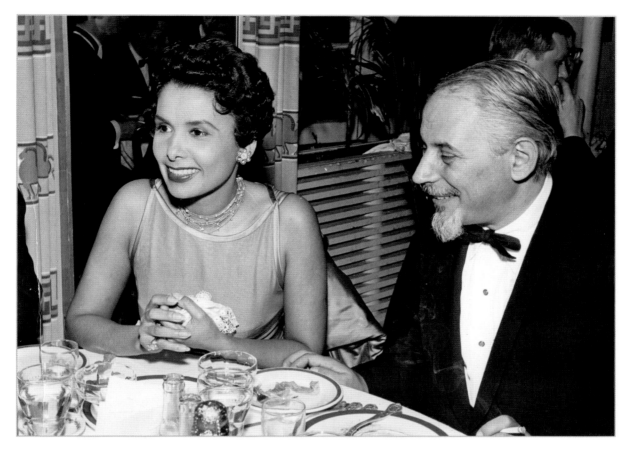

A late-night dinner with Lennie makes headlines.

Upon returning and seeing the disruption, Hayton asked the restaurant's management to have the man, who was later identified as the vice president of an engineering firm, thrown out. "But the management declined to do so."

The police were called, whereupon the man was asked if he had used that language. "Well, she is a *nigger*," the man shouted.

"I lost control," Lena told the police.

Later the restaurant's maître d' said that the man eventually moved to another table. He took the incident "very gentlemanly" and declined medication, stated the maître d'. The man took it *very gentlemanly*. Those words no doubt angered Horne all the more.

After giving their version of the story to the police, Horne and Hayton left the restaurant.

Years later Horne's daughter, Gail, in whom she had confided about the incident, said her mother's language was actually stronger than reported. "Here I am, you bastard!" Gail quoted her mother as saying. "Here's the nigger you couldn't see!"

When Lennie returned to the table and asked if she had hit the guy, she said firmly: "Hell, yes!"

No charges were filed, but newspapers around the country had a field day covering the story.

"Lena Horne Hurls Objects in Offense to Man's Slurs" was the headline in the February 17, 1960, *Chicago Defender.* "Lena Horne Hauls Off

Over Night Club Crack," read the headline in the February 16, 1960, edition of the *New York Post*.

Sometimes the press treated the incident insensitively, even comically. In its February 17, 1960, edition, the *New York Herald Tribune* commented in reference to the slight injury of the engineering executive: "Police gave this score: three misses, one hit." Interestingly enough, at the time of the occurrence, reported the *New York Post*, "in the east, tele-viewers were watching her on the [Frank] Sinatra show."

In 1963 Lena Horne was back in the news following a meeting with Attorney General Robert F. Kennedy in New York. Seeking solutions for America's ever-deepening racial divisions, Kennedy arranged a meeting to discuss the current racial climate with a group of prominent Black Americans. On May 24, 1963, they gathered in an apartment owned by the Kennedy family on Central Park South. In attendance were James Baldwin; playwright Lorraine Hansberry; Harry Belafonte; sociologist Kenneth Clark; David Baldwin, the brother of James; southern-born white actor Rip Torn; Jerome Smith, a young Freedom Rider; and Lena—who had been urged by James Baldwin to attend.

The general feeling was that Kennedy was naïve and rather than seeking hard-line discussions, he wanted "approval" from this seemingly "moderate" group about the justice department's handling of civil rights. Kennedy found himself in for a rude awakening. The group felt not enough was being done, and Lorraine Hansberry and others openly expressed their anger. They were riveted, however, by the impassioned comments of Jerome Smith, who spoke of having been beaten during protests—while

Contemplating her future, the 1960s.

nothing was done by those in power. Fervently, he argued with Kennedy, and those in the room agreed with Smith's position. After two and a half hours, Hansberry and others walked out. In retrospect, the meeting may have opened the door to a new perspective in the justice department, which in turn ultimately led up to the presidency itself.

Fired up by the protests, Horne sought even more involvement in the civil rights movement—first with performances on behalf of the NAACP and the National Council of Negro Women, then with another form of action. Aware that celebrities and stars helped put a spotlight on rallies and brought in protestors, she and Billy Strayhorn traveled south

on June 5, 1963, for a rally in Jackson, Mississippi. En route, she and Strayhorn arrived by train in Atlanta, where they met with the eloquent twenty-three-year-old Julian Bond and made donations to his organization, the Student Nonviolent Coordinating Committee. Later she organized a special benefit for the organization at Carnegie Hall. Frank Sinatra joined her at the event. Leaving Atlanta, Lena and Strayhorn flew to Jackson. Also with them was the prominent educator Jeanne Noble. Lena also invited her son, Teddy. There the group lent support to Medgar Evers, the NAACP's first field secretary in the state of Mississippi. On June 7, Horne performed a cappella for some two thousand supporters in Jackson. The event energized her. Almost a week later, however, on June 12, 1963—the day after President John Fitzgerald Kennedy had delivered his nationally televised civil rights address—Evers stepped out of his car in the driveway of his home and a gun was fired at him, striking him with a bullet in his back. The thirty-seven-year-old Evers died from the wound.

Lena learned of his death while having her makeup applied just before an appearance on the *Today* show.

"The whole experience was a turning point in my life," Horne said.

"Medgar Evers's death was probably the defining moment of her life," said columnist Liz Smith. "I think she had sort of been struck down like Saul on the road to Damascus. She was in a kind of crossroads, trying to decide if she was just going to live in a Black world or Black and white world or whatever."

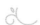

On August 28, 1963, she joined such other prominent Americans as Mahalia Jackson, Harry Belafonte,

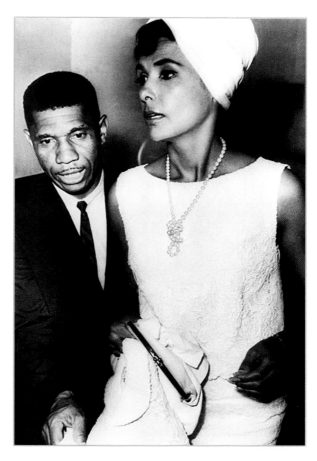

Lena with civil rights leader Medgar Evers in 1963 in Mississippi shortly before his assassination, which left her devastated.

Sidney Poitier, Daisy Bates, Ruby Dee, Ossie Davis, Marlon Brando, Charlton Heston, and Josephine Baker to attend the massive March on Washington for Jobs and Freedom. Organized by Bayard Rustin and A. Philip Randolph, a gathering of some 250,000 stood in front of the Lincoln Memorial, where Martin Luther King Jr. delivered his "I Have a Dream" speech. Generally, women had a limited role as speakers in the day's proceedings, but Josephine Baker and Daisy Bates did make brief speeches.

On November 20, 1963, Lena returned to Washington for a meeting at the White House with

Lena was a civil rights–era heroine.

President Kennedy and others to discuss fundraising plans for the Democratic Party. Both a serious yet relaxed gathering, the event signaled once again her work for social and racial change. She had supported the Democratic Party since the era of Franklin Delano Roosevelt's presidency. Like many, she saw in Kennedy possibly a move forward in the civil rights struggle.

Two days later, Kennedy and first lady Jacqueline Kennedy flew to Dallas. That afternoon he was assassinated.

Other shocking assassinations followed in that decade. On February 21, 1965, Malcolm X was shot at the Audubon Ballroom in New York City.

On April 4, 1968, Reverend Martin Luther King Jr. was shot and killed on a terrace of the Lorraine Motel in Memphis, Tennessee. Almost two months later—on June 5—Robert Kennedy was shot at the Ambassador Hotel in Los Angeles.

Other shocking events left Horne stunned. On August 11, 1965, the Watts section of Los Angeles exploded in anger following an altercation between a twenty-one-year-old African American man and members of the California Highway Patrol. The incident escalated with crowds gathering to denounce law enforcement for its brutal treatment of the young man. Over the course of six days, there were riots, or as some said, an uprising in the city

following decades of discrimination and racism. Some 3,438 citizens were arrested. Over a thousand people were injured. There were thirty-four deaths. There was nearly $40 million in property damage.

America's civil rights movement had evolved into the Black Power movement as a younger generation of Black Americans was demanding its rights—and rejecting the doctrine of passive resistance.

Other aspects of Lena's life weighed heavily on her. Foremost, she was dealing with domestic dilemmas.

In the summer of 1962, Lena's daughter, Gail, met the film director Sidney Lumet at the East Hampton home of producer Kermit Bloomgarden. Born in Philadelphia in 1924, Lumet had grown up on New York's Lower East Side. His parents were veterans of Yiddish theater, and Lumet himself made his acting debut at age four on the radio and then, at age five, his stage debut with the Yiddish Art Theatre. After serving for four years in the military during the Second World War, he returned to New York and was an inaugural member of the Actors Studio. He began his directing career with off-Broadway plays, and with episodes of such early television series as *Playhouse 90* and *Studio One*.

By the time Gail met him, Lumet was the director of such critically praised films as *12 Angry Men* (1957), his first film, which starred Henry Fonda, and the adaptation of Eugene O'Neill's *Long Day's Journey into Night* (1957), starring Katharine Hepburn and Ralph Richardson. Later he would direct *The Pawnbroker* (1964), *Serpico* (1973), and *Dog Day Afternoon* (1975), the latter two starring Al Pacino, and *Network* (1976), starring Faye Dunaway and William Holden. During his long career, Lumet

would earn four Academy Award Best Director nominations. Heralded for the superior way in which he captured the rhythms of life in New York City, he was also considered an actor's director, creating an environment in which male and female actors gave some of their most intense and illuminating performances. Gail found herself in a heady, all-enveloping new world. She was soon head over heels in love with Lumet. The two decided to marry.

"Lena was not thrilled by the prospect of Sidney as a son-in-law," said Gail. That was putting it mildly. The age difference between Gail and Lumet staggered Lena. Gail was still in her twenties; Lumet was close to forty. "I was fourteen years

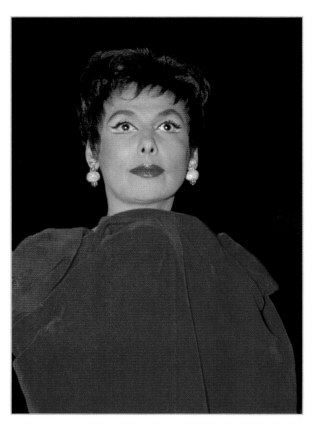

In the 1960s, Lena questioned if her glamorous image and lifestyle alienated her from a new generation.

younger than Sidney," commented Gail. Lumet also had been married twice: to actress Rita Gam from 1949 to 1955; and, in 1956, to heiress, socialite, and future businesswoman Gloria Vanderbilt—whom he was presently divorcing. Nor did the relationship please Lennie, whom Gail always felt was more like a father to her than her actual father, Louis Jones.

"But the more Lena tried to dissuade me, the more I dug in my heels" were the words of Gail. No way could Lena talk her daughter out of marrying Lumet.

But other issues with Gail rose to the surface. Lena admitted she always had problems showing affection "with anyone who mattered to me." But she felt secure that Gail understood she meant more to Lena than anyone else—then Gail spoke to her frankly about their relationship. "The worst hurt I've ever known was the day Gail told me that although she felt I had always been her best friend, she nonetheless felt I hadn't loved her—didn't love her." Stunned, Lena struggled with feelings of guilt and failure. "I just didn't know what to say. How do you tell your daughter that you didn't just love her but you adored her? How do you explain? How do you say to someone you love, 'I don't show it because so little was shown to me?'" Ultimately, mother and daughter came to a new understanding of each other. Gail became "very sympathetic towards me and my fumbling attempts at affection."

Gail proceeded with her plans to marry Lumet. The marriage ceremony was set for November 23, 1963. As it turned out, that was the day after the assassination of President Kennedy. The ceremony still took place on that day, although it was a gloomy occasion. Later Gail and Lumet would have two children: Amy, born in 1964, and Jenny, in 1967.

The 1960s proved to be a period of great self-examination. Throughout much of her life, Lena had reflected on the forces that influenced her and led to the paths she had taken. For the Black press, she had written articles about the arc of her life and career, going back and forth over key moments, key people, and key situations. That had been true of the book she had chosen to forget: *In Person: Lena Horne.*

In 1963, "I Just Want to be Myself," an article she had written with the help of Black writer Louis Lomax, author of *The Negro Revolt*, appeared in the spring issue of *Show* magazine, a publication that covered the arts. That proved to be the foundation for her autobiography. Working with the writer Richard Schickel, then the film critic for *Life* magazine and who would later become *Time* magazine's film critic, her memoir was simply called *Lena.* Published by Doubleday in 1965, *Lena* chronicled her childhood in Brooklyn and traveling in the South with her mother. It followed everything from her experiences as a teenager at the Cotton Club to her first marriage, Hollywood recollections, and the early civil rights movement. Fairly forthcoming, *Lena* was earnest in its attempt by the star to come to terms with so much of what she endured and achieved. Of course, like any star memoir, *Lena* did not tell *everything,* and it stopped short of conveying the anger she carried within herself. Horne herself realized the book could have used even more candor. She wasn't finished with examining her life publicly, as events in the years to come would indicate.

During this period of acute self-exploration in terms of race and race history in her life and in the nation, Lena was approached about a starring role in a new musical that could mark her return to Broadway. The idea of work that would keep her in one place and out of the nightclubs appealed to her. Also appealing was the fact that this ambitious project had major talents involved. Key artistic figures—Arthur Laurents and Jule Styne—were two of the creative forces behind the vastly successful Broadway musical *Gypsy*, which had starred Ethel Merman as the clawing, domineering mother Rose, who foists all her ambition and drive onto her two daughters, determined that they make it in show business. Loosely based on the memoirs of Gypsy Rose Lee, *Gypsy* had a powerhouse energy and pull. It was considered one of the great American musicals with one of the most complicated leading characters, the formidable Rose. *Gypsy*'s libretto was by Lena's friend Arthur Laurents; its music was by Jule Styne with lyrics by Stephen Sondheim.

Now Laurents, Styne, and the lyricists Adolph Green and Betty Comden—whom Lena knew well from MGM—were at work on a Black musical titled *Hallelujah, Baby!* Comden and Green had scored triumphs with such classic films as *Singin' in the Rain*, *The Band Wagon*, and *It's Always Fair Weather*. Like *Gypsy*, *Hallelujah, Baby!* would showcase a woman's drive through several decades—from the Great Depression into World War II to the civil rights era—as she pulls herself up from work as a domestic to become a musical star. Through those years, the character Georgina would be pursued by two men: one white, who could offer her comforts and opportunities; the other Black, who rises from a position as a porter on a train to the rank of an army captain and then a civil rights activist. The latter represents the woman's conscience and connection to her community. In the musical, Georgina also has a submissive mother, who encourages her to remember her place, to try not to rock the boat.

In the minds of the creators, only Lena had the talent, persona, stature, and box-office clout to play Georgina, and to turn *Hallelujah, Baby!* into a bona fide hit—as she had done with *Jamaica*. Theatergoers were ready for a new type of Black musical that was specifically tied to the nation's social changes then very much in the news. From the perspective of Laurents, Styne, Comden, and Green, the play would provide Lena with precisely the kind of role that MGM had denied her.

Once Horne expressed interest, it was assumed that everything was a go. But then she wavered, wanted changes, and ultimately, no one was able to please her. Laurents believed the real reason for Lena's indecision was due to the influence of an esteemed educator and friend of Horne's, Jeanne L. Noble. Deeply committed to studying and confronting challenges that faced educated African American women, Noble had an impressive list of accomplishments. Born in Albany, Georgia, in 1926, she was the oldest of four children, and the only daughter in a rambunctious family of boys. When the father of the children deserted the family, they were reared by their hardworking mother and grandmother. In the home, education was always stressed; it could offer them a new way of living. A serious student, Noble graduated from Howard University, then earned a master's degree and later a doctorate from Columbia University.

Her dissertation was the basis of her first book, *The Negro Woman's College Education*, that broke ground by examining the issues of gender and race. Other books followed. Excelling in the world of academia, Noble became the first Black woman to be a full professor at New York University's Steinhardt School of Culture, Education, and Human Rights. An activist, she served on prestigious commissions and boards. President Lyndon Johnson requested her help in planning the Women's Job Corps. From 1958 to 1963, Noble also was the president of the Black sorority Delta Sigma Theta.

Hardly a stodgy academic, Jeanne Noble gave the appearance of being a well-heeled socialite, a solid member of the Black bourgeoisie—poised, articulate, outgoing. It would be fair to say that Noble had long idolized Horne, probably from the time of her girlhood. The two had met in the 1950s, and Noble became increasingly significant in broadening Lena's political perspective, and especially in Lena's growing activism. When Horne traveled to Jackson, Mississippi, Noble was also on the trip. She encouraged Horne to put aside any doubts about speaking publicly for civil rights. Noble also persuaded Lena to become a member of the sorority Delta Sigma Theta. It would be a sign of Horne's growing sense of sisterhood. What was the basis of Noble's influence on Horne? Aside from her intelligence and well-informed view of American history and culture, Noble brought to mind Lena's grandmother. Here was a contemporary, educated social and racial fighter. Noble's fierce convictions may also have brought to mind Paul Robeson for Lena.

Portraying the love interest of Richard Widmark in *Death of a Gunfighter*.

Noble was introduced to various friends and associates of Horne—a number of people who had known the star for years and even decades. Lena's newfound "militancy" may not have gone over well with such friends; not so much the "militancy" itself, but that it seemed to pull Lena away from them. All those years in which Lena had substituted her cultural references, even her language, in social circles with those from MGM and within the entertainment industry in general—all of that code-switching could be put aside now. Noble struck a chord in which Lena returned to those roots instilled in her by her grandmother. Interestingly, in the years to come, Horne's very way of speaking changed. Suddenly, she seemed to have a forceful southern accent. For a time, her hairstyle changed. In the forthcoming period of *Say It Loud/I'm Black/I'm Proud* and *Black Is Beautiful*, Horne sometimes wore a curlier hairstyle; not an Afro but seemingly influenced by the Afro.

Some of Lena's longtime friends may have believed Noble was a wedge between them and the star. Arthur Laurents certainly did. Apparently, it was felt that while *Hallelujah, Baby!* presented itself as an advanced new-style brand of Black entertainment, at heart—in terms of images and cultural attitudes—the musical was old-school. Not lost on anyone was the fact that the creative forces behind the musical were white, not African American. Ultimately, nothing seemed to satisfy Lena. She withdrew from the play.

"Jeanne Noble's sudden, fiercely Black influence I felt full force in New York in the Sixties," recalled Laurents "when it derailed, besides the personal, *Hallelujah, Baby!* which I had written for Lena."

Behind the scenes of the production, dismay and panic overcame everyone. *Hallelujah, Baby!* was financed and too far along to be dumped at this stage in production. Finally, Leslie Uggams was brought in to play Georgina. Harlem-born in 1943, Uggams had been in show business since she was a child, appearing on the television series *Beulah*, which starred Ethel Waters, in the early 1950s; *The Arthur Godfrey Talent Scouts*; *The Lawrence Welk Show*; and then as a regular from 1961 to 1964 on the Mitch Miller series *Sing Along with Mitch*, which made her a household name and an emerging star. Uggams had also studied at the Professional Children's School and Juilliard. *Hallelujah, Baby!* could launch her into full-fledged stardom. Appearing with her were the young Black actor Robert Hooks and white actor Allen Case.

Opening on April 26, 1967, at the Martin Beck Theatre, *Hallelujah, Baby!* pleased audiences and critics. It ended up garnering nine Tony nominations, winning five, including Best Musical. Leslie Uggams also won the Tony as Best Actress in a Musical.

Though *Hallelujah, Baby!* was successful, Arthur Laurents said in later years that he believed the production was "too soft in its take on black social progress during the first six decades or so of the twentieth century." He also believed that when "the steely Horne" dropped out of the production, they should have abandoned the play. "Instead it was rewritten for a woman who is one of the nicest women I have ever met in the theatre, Leslie Uggams—and, God knows, she has a beautiful voice." Good as Uggams was, he believed the intent of the original show had vanished. It "lost its edge, and I must say I lost interest in it."

Of Lena, Laurents also commented: "I was as unprepared as she was for an indefinable relationship that lasted fifteen years and then collapsed in a week."

Further cause for yet more self-reflection and great sorrow occurred when, on May 31, 1967, Billy Strayhorn died of esophageal cancer at the age of fifty-one. At the time, Lena was on tour in Europe. "It tore me apart that I couldn't be with him," Lena was quoted as saying. "I was heartbroken about it." She had lost her soul mate.

After his death, she found it hard to return to work. Comedian Alan King helped persuade her to perform again.

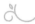

During the 1960s, the other great personal dilemma for Lena was her deteriorating relationship with Lennie. On reflection, she believed her high-voltage lifestyle, with its luxuriant glamour, had drawn her away from the Black community itself, from her cultural roots. She was convinced that Hayton failed to understand her anger about the racial situation. Nor could he understand her feelings of emptiness. In this period she came to the sad conclusion that Lennie had never really thought of her as a *Black* woman. Few of her white friends would understand how she could identify with the anger and dissent and revolt within Black America.

"Lennie had washed me," she later said. "He didn't see me as Black, and I realized that that was part of my feeling this whole sterility. I suddenly wanted him to see how different I was. I wanted him to *feel* I was Black. That he could say to me the day that Malcolm X was killed—'those radicals, they're always killing each other off'—as though I were

With Dean Martin on *The Dean Martin Show* in the late 1960s.

another white person was like a blow. He didn't see that to me Malcolm was a kind of hero. I knew it was wrong to feel that anger against him, but I was sick of being taken for granted. I was sick of conforming."

Quietly, the two separated. Lennie took up residence at their home in Palm Springs.

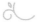

Unexpectedly, Lena returned to filmmaking in the late 1960s. She accepted a role in a movie initially to be called *Patch* but released as *Death of a Gunfighter* in 1969. Its star was Richard Widmark. Early on, problems sprang up. Its original director, Robert Totten, clashed with Widmark and was

dropped from the film, only to be replaced by Don Siegel, who did not want his name in the credits. Instead, a pseudonym—Allen Smithee—was used for the directorial credit. Later Siegel would direct such Clint Eastwood classics as *Dirty Harry* (1971) and *The Beguiled* (1971).

A western with a modern twist, *Death of a Gunfighter* told the story of a marshal (Widmark), a man of conviction, who finds himself no longer needed or of value to his community. Horne was cast as Claire Quintana, the marshal's mistress, then his wife, who is the madam of the town's saloon/bordello. Carefully made-up and filmed, she was visually striking, and having worked with a drama

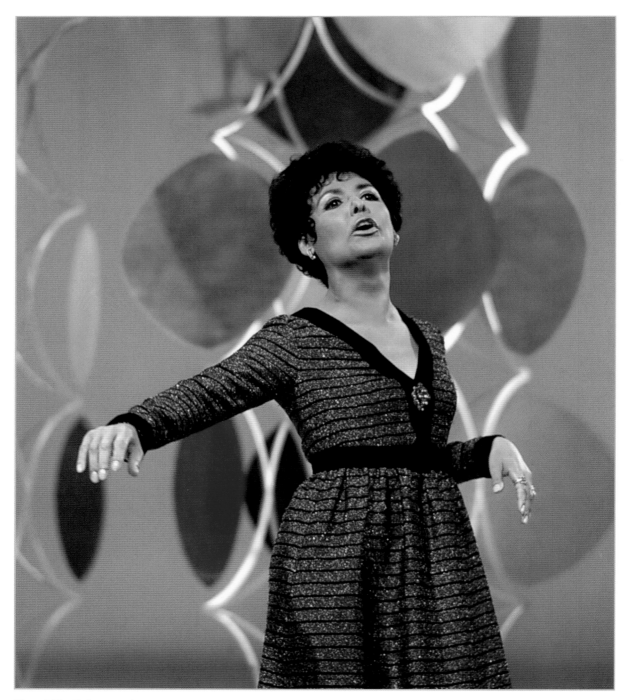

The 1969 NBC special *Monsanto Night Presents Lena Horne.*

coach, she handled the dialogue fundamentally well, although she was cautiously laid-back and rather impassive. Her voice had changed over the years. On screen, she sounded more natural. Appropriate for the role was her maturity—one sensed this woman had seen much, yet the movie provided the character

with no significant backstory. It was a familiar problem. Script-wise, Horne was left without an anchor to give the character more weight. Instead, she relied on her own persona to carry her through.

The relationship between Widmark and Horne was meant to show the integrity and "decency" of Widmark—who will not hide his feelings for this woman of color that he loves. Yet *Death of a Gunfighter* was woefully evasive and did not comment in any way on this open interracial coupling in the nineteenth century. Such a relationship would not have gone unnoticed at that time—any more so than Horne's real-life marriage with Lennie had gone unnoticed. The movie asked moviegoers to believe that racism did not exist at that earlier time.

"Backed by a hard-selling exploitation campaign, *Death of a Gunfighter* should prove a handy entry for Universal," wrote the reviewer for *Variety* in its April 30, 1969, edition. Though Horne received top billing with Widmark, she had little to do. As *Variety* noted, Lena was cast "obviously for name value only, for her footage is comparatively brief. She sings one song 'Sweet Apple Wine,' over opening credits and finale."

In some ways, it's hard to understand why Horne was chosen for the film. Though as *Variety* indicated, her name was known to audiences, Horne was hardly a box-office draw. The role might have gone to Dorothy Dandridge were she still alive. In 1965, Dandridge had died at the age of forty-two, having been left stranded in a film industry that didn't have much of a place for her. But with the changing social/political/racial atmosphere of the late 1960s and soon in the 1970s, Hollywood found itself using more Black actors and Black film-makers than ever before in its history. So Lena had an opportunity that had been denied her in the past. Yet the racial issues that were not addressed here would be explosively examined within the next few years, notably in Blaxploitation cinema, which Horne herself was not thrilled with.

In 1969, she also recorded her first album in four years, *Lena & Gabor*. Performing with the renowned Hungarian guitarist Gabor Szabo, with whom she had previously worked, she sang wholly "new" material, quite different from her past repertoire—such Beatles songs as "Something," "Yesterday," "Rocky Racoon," and "The Fool on the Hill," as well as pop hits of then recent years, like "Message to Michael," "Everybody's Talking," and "Watch What Happens." The results were a marvel. She somberly revealed a depth of emotion, employing her familiar perfect diction to bring a late-in-life melancholic tone to the lyrics. She seemed to be looking back on her life almost as if the end to living was slowly approaching. "In My Life" was Lena Horne dramatizing personal experiences with perhaps sorrow and regret, yet a hard-won knowledge. In splendid sync with the extraordinary Szabo, she had stepped away from the world of her elegant nightclub performances to a more soulful, direct line of communication. Arranged and produced by Gary McFarland, *Lena & Gabor* was one of her best in years, and it allowed her to touch base with a new generation. The single of "Watch What Happens" made the charts. Initially released on the Skye label, which went bankrupt, the album was later released as "Watch What Happens" in 1971 on Buddha Records. Still later it became a CD titled *Lena Horne & Gabor Szabo*.

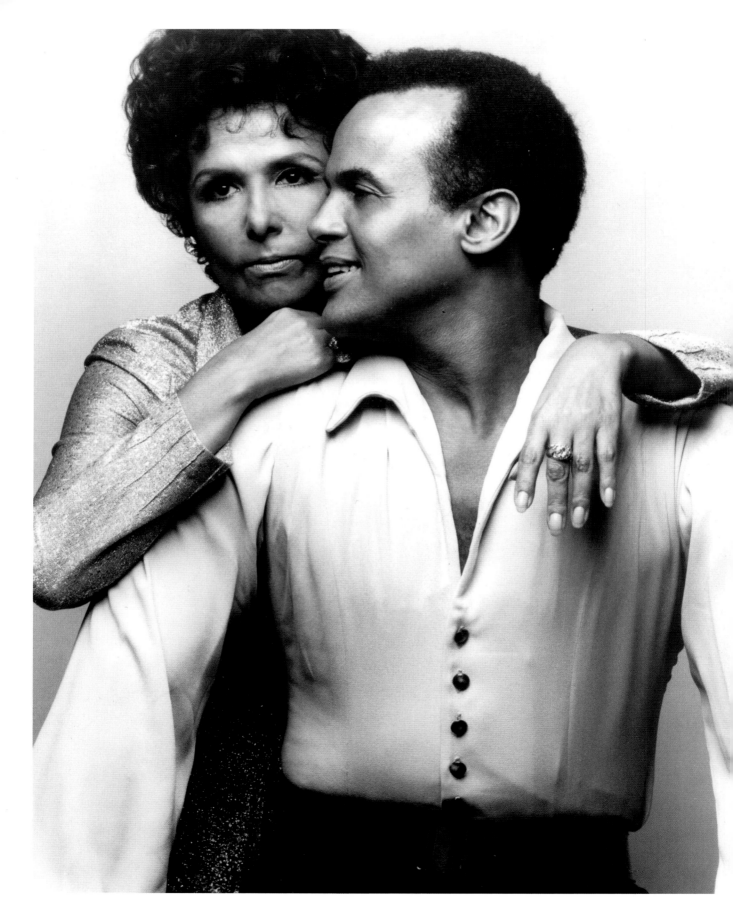

LOSS AND REFLECTION

Following the political turmoil of the 1960s, Lena Horne might have hoped for a new balance in her life. Having become a grandmother, she doted on the children. Gail remained the person closest to her. Occasionally, she gave the impression that she wanted to keep working, to remain visible to generations past and present, and to bring in an income. In this decade and into the next, she turned up in television commercials for such products as Schaefer Beer, Tang, Skippy peanut butter, and in print ads for American Express, Omega watches, Post Bran Flakes, and other brands. Without a doubt, the splashiest advertisement was the "What Becomes a Legend Most" campaign for Blackglama minks—which was also a status symbol. Photographed by Bill King and Richard Avedon, the ads featured only great stars draped in luxurious furs: Elizabeth Taylor, Marlene Dietrich, Leontyne Price, Judy Garland, Martha Graham, and Lauren Bacall. Horne's photo caught her exuberantly in motion. Yet with all that said and done, she still had career aspirations—she was not *done* yet—and her performances were never perfunctory, never tired or without her dramatic stylistic stamp. In 1969, she had starred on the television special *Monsanto Night Presents Lena Horne*. Launching her into a new decade—on March 22, 1970—ABC aired *Harry & Lena*, a successful joint concert by Lena and Harry Belafonte.

With all she had going on, Horne had no clear vision of where the 1970s would lead her. Then she was hit with personal grief that left her first shaken, then devastated. In April 1970, she received the news that her father, Teddy, had died. He was, of course, the man she idolized, the bond to her grandparents

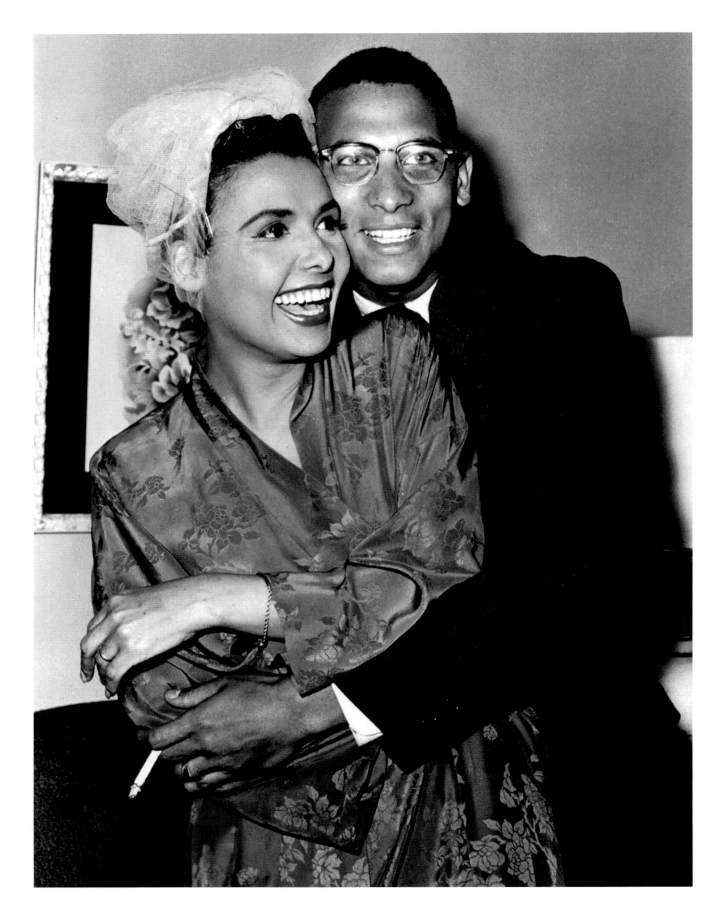

and her family history. Because of her marriage to Lennie, she and her father experienced rocky times. Things may never have been quite the same between them, but their love had been an anchor for them both. He was seventy-eight.

Lena hardly had time to mourn for Teddy when she received word in September 1970 of another death that jolted her to her core. Her son, Teddy, had died of renal failure in California. Throughout his childhood and his adolescence to his young adulthood—when he had lived with his father, Louis, and when she had to settle for visitation rights—she had longed to be closer to him, to know him better, to understand what made him tick, perhaps to comprehend even his deepest feelings about her. She respected his intellect, his unusual way of looking at his experiences, his determination to explore and examine the world around him. Having married twice, he left behind four children—William, Thomas, Samadhi, and Lena—and his wife, Faye. The death of Teddy, age thirty, haunted her the rest of her life.

Then in April 1971, she learned that Lennie, having always been a heavy smoker and drinker, had suffered a heart attack in Palm Springs. It was said that before the attack, he had met with Frank Sinatra. Ironically, it was apparently Sinatra—the man Lena didn't like personally—who advised her to come immediately to Lennie's bedside at Palm Springs's Desert Hospital. He provided his private plane to fly Lena, Gail, Sidney, and Gail's daughters to Palm Springs. She arrived to spend time with Lennie, but he didn't last long. On April 24, Lennie Hayton died. He was sixty-three years old.

Lena and her son, Teddy Jones.

Lena agonized over his death. She credited him with having taught her a new way to sing. Following their marriage, he had been supportive of her career in every way, but when a more openly politicized Lena spoke out publicly *and* at home about the nation's racial divisions, he had never known how to handle the situation. He didn't seem capable of saying the right thing. Lena realized why she had married him—for career advancement—which she wasn't particularly proud of, but she also said she had come to love him very much.

Once again television was turning its lens on African Americans. New series and variety shows starred Black performers and were pulling in viewers. Hugely successful was *The Flip Wilson Show*. A skilled and inventive comic, Wilson created such widely popular characters as Reverend Leroy of the Church of What's Happening Now and most comically outrageous, the feisty Geraldine—an outspoken, bold, and brassy young woman, played by Wilson in drag. "Don't you touch me, honey, you don't know me that well" was a catch phrase. Weekly, he also brought in famous guest stars: Muhammad Ali, Bing Crosby, Johnny Cash, Sammy Davis Jr., Aretha Franklin, and Joan Rivers. Though Wilson was criticized for feeding into stereotypes, his program shot to the top of the ratings. Lena was a guest star on several episodes. She was now venerated by a generation that had grown up seeing her, and now new powerful African American entertainers treated her as the major star she was.

She also appeared on the hit sitcom *Sanford and Son*. Starring comedian Redd Foxx as the beleaguered Fred Sanford, who weekly berated his

son Lamont, played by Demond Wilson, *Sanford and Son* brought the veteran Foxx to mainstream culture. For decades he had played Black clubs and theaters in Los Angeles and Las Vegas, part of what was referred to as the "chitlin circuit." He had also made comedy albums in which his "dirty" blue humor won him a huge fan base that included hip white stars like Sinatra; and he had attained stardom on his own terms. In 1972, Norman Lear had brought Foxx to television where his humor and language had been "cleaned up." Yet Foxx knew his way around a funny line, and he was still able to elicit howls of laughter from viewers in their homes. Lena had long been aware of Foxx's comedy—since his performances at the Plantation Club, when she first came to Los Angeles. On *Sanford and Son*, Foxx's character has visions of his dream girl—Lena Horne. In one episode, he spoke of wanting simply to stay at home and watch the movies of *the* Horne on television. But on the 1973 season two episode "A Visit from Lena Horne," Lena actually appeared—as herself. Meeting Horne, Fred Sanford is in delirious seventh heaven! Horne was lively and sweetly funny, giving Foxx room for his humor to flow. Horne is Sanford's ultimate goddess, and episodes with references to her as well as her appearance on the show were homages to her history and enduring appeal.

In 1973, Lena joined Tony Bennett for the television special *Tony & Lena*. Here she was in fine form as these two seasoned pros gave masterful performances. Her repertoire now included Beatles music such as "Something," which she had recorded on her *Lena & Gabor* album. In this setting, the song was all the more surprising and breathtakingly engaging again as one bore witness to her feeling for newer

songs as she moved away from, without ever truly abandoning, the classic standards. With a deeply felt emotional commitment, her style seemed refreshed and current. Afterward, she and Bennett took their presentation on the road, touring the United States and the United Kingdom.

Just as she had once "learned" from the sounds of Billie Holiday and Dinah Washington, Lena Horne was also now meeting and enjoying the work of such contemporary singers as Dionne Warwick, Donny Hathaway—with whom she recorded—and Aretha Franklin. Astounded by Aretha's vocal powers and her emotional depth, Lena would say that Franklin was the role model for the work she later did. And in time, she would be an admirer of Whitney Houston and dramatic actress Cicely Tyson.

Having lost her father, her son, and Lennie, Lena also had to face another death, that of her mother, the perennial dreamer, Edna. "The love-hate thing I had with my mother just kept me going . . . It happened just a few years before she died," she said in 1981. "I went to see her and I said, 'Mommy, do you love me? And she said, 'No.' I just broke down. 'Lena, I wanted a career,' she told me. 'I wanted what you have. I wanted to be glamorous. To be famous.' I asked her, 'Why did you have me?' and she said, 'I only married your father because he was the best-looking guy in our set. We wanted a boy and we got you and you got my career.'"

"'Mommy,' I told her, 'I didn't want the career. I never wanted to be a singer. I only wanted you to

Still going strong in the 1970s, working with new music and a still-evolving style.

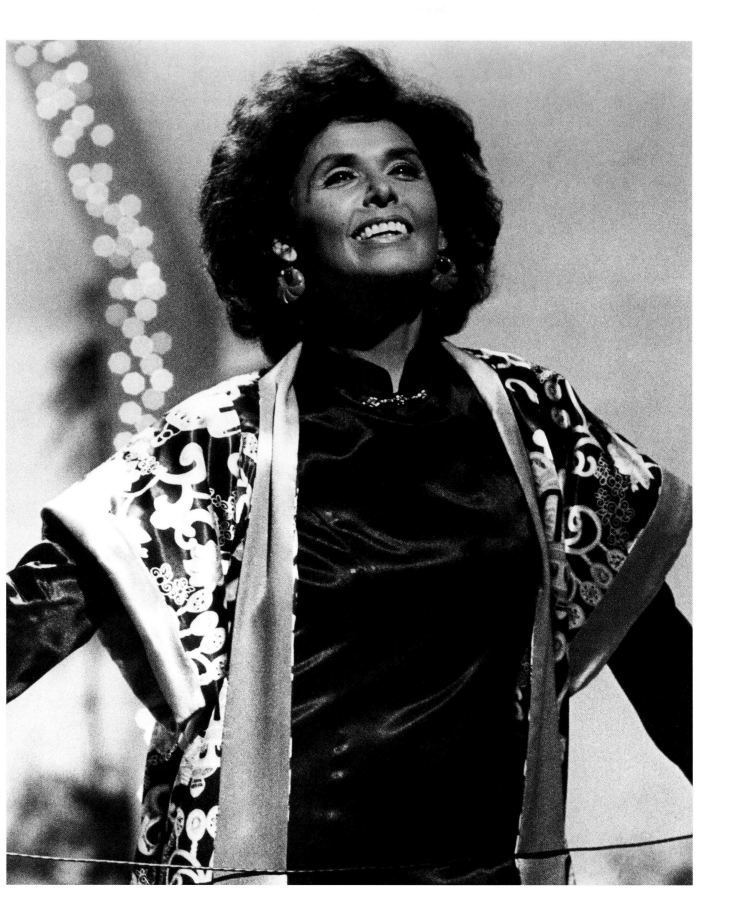

love me. I would give you every bit of it if I could. You could have had all of it, if only I thought you cared about me.' My mother looked at me and said, 'It's over now, Lena. Just forget about it.'"

In her mother's final days, issues between them seemed to be resolved. "I felt good because she let me make a fuss over her. I thought it meant that maybe she did care about me after all." Edna died in 1976.

Lena returned to the movies in the 1978 adaptation of the hit Broadway musical *The Wiz*. The idea for the Black stage version of Hollywood's classic *The Wizard of Oz* had been the brainchild of Black producer Ken Harper. L. Frank Baum's story of a girl's journey in search of herself—her identity, her meaning in life, her goal for happiness—that ultimately leads her back home had appealed to children for decades. It was tied to Judy Garland's movie stardom and her great appeal. But to fashion such an odyssey specifically for African Americans—with a set of African American cultural signs and references—was unimagined. Harper believed such a new slant on an American classic with new music and an altered perspective might reach audiences in a distinct way. Generally, it was thought such a replay of *The Wizard of Oz* would be a dud that would fall flat on its face. Why tamper with a perennial favorite? With music and lyrics primarily by Charlie Smalls, a book by William F. Brown, and starring Stephanie Mills as Dorothy, who goes off to find the Wizard of Oz, *The Wiz* opened on January 5, 1975, at Broadway's Majestic Theatre. Geoffrey Holder, who had replaced Gilbert Moses, was credited with directing. *The Wiz*

became a hit that won seven Tony Awards, including Best Musical.

In 1977, Motown Productions acquired the film rights to the musical and ambitiously set out to produce it as a multi-million-dollar movie that would again star Stephanie Mills. But the company's biggest star, pop goddess Diana Ross, informed Motown chief Berry Gordy that she wanted to play the girl Dorothy. As might have been expected, Gordy balked at the idea: Ross was thirty-three at the time. Why she wanted the role was anyone's guess. But Gordy capitulated to her wishes. The all-star movie would also include Nipsey Russell as the Tin Man; Ted Ross as the Cowardly Lion; and, surprise, another great Motown star, Michael Jackson, as the Scarecrow. Also in the cast: Mabel King as Evilene, the Wicked Witch, and the warm-hearted Theresa Merritt as Aunt Em. Signed to play the Wiz was Richard Pryor. This fascinating lineup of talent was to be directed by Sidney Lumet. Skilled and brilliant a director as Lumet could be, he seemed all wrong for a musical that needed an ethnic beat and at times a playful, light touch with flashes of humor and then pathos as Dorothy discovers her dream of finding home about to dissolve.

The film was shot entirely in New York at the Astoria Motion Picture and Television Production Center in Queens. This historic studio had been constructed in 1920 for Famous Players-Lasky. It also became known as the Paramount Studio for Paramount Pictures. Among the classic stars to film there were Rudolph Valentino, the Marx Brothers, and Gary Cooper. Now joining the list of Old Hollywood luminaries at the Astoria was Lena

Refusing to slow down, despite personal tragedies, as vital and vibrant as ever.

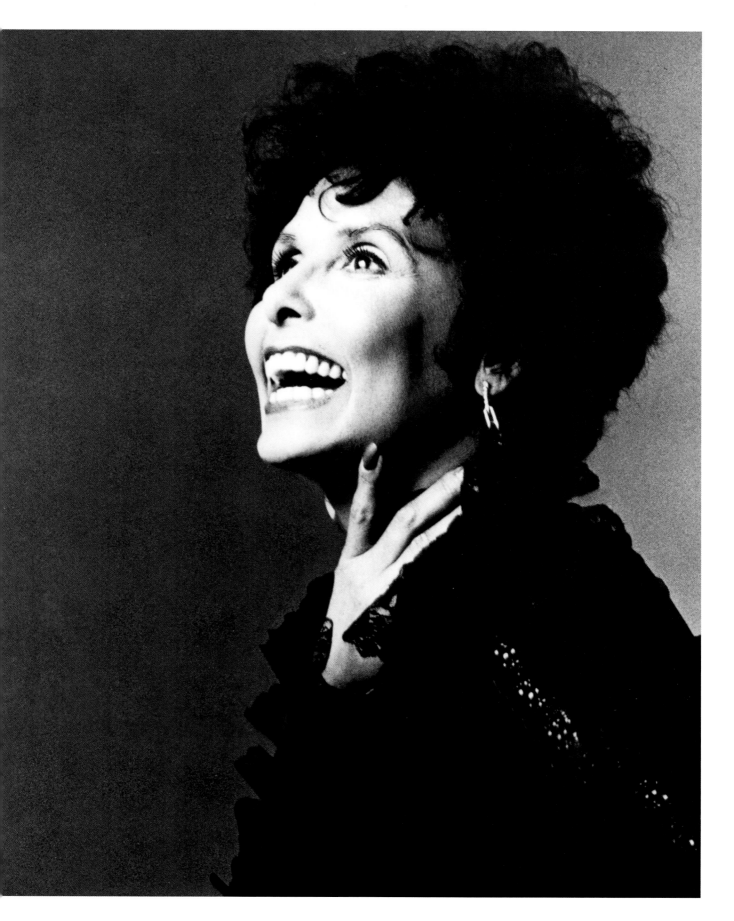

Horne. In a piece of unexpected yet inspired casting, she was set to play the good witch Glinda, who provides Dorothy with the message on how to get back home. Horne would have a few lines of dialogue and the glitzy production number "If You Believe" (sometimes known as "Believe in Yourself"). On the set of *The Wiz*, everyone was eager for a glimpse of Lena. The question some pondered: How would the so-called divas, Ross and Horne, work together?

If anyone was expecting fireworks, they were disappointed. Ross was willing, even eager, to let Horne shine—without interference. Horne later told *Ebony*: "When I came to shoot that little bitty scene, Diana was sweet as pie to me. She only laughed and told me that Berry Gordy told her to 'get your act together cause Mama has sung this song.' But it certainly didn't create any problems between Diana and myself. I have always been fond of Diana—as I am of all these young children of mine, as I call them."

Working with Joel Schumacher's script, Sidney Lumet had dropped the Kansas setting of the 1939 movie, replacing it with a strange type of fairy-tale Manhattan that at times also seemed to be Queens, or even the Bronx. Because of the casting of the mature Ross, Dorothy was now a repressed schoolteacher whose Aunt Em believes she needs to get out, have some fun, and find herself. Or maybe a young man. Ross brought an endearing warmth and perhaps an appropriate jittery timidity to the character. Though Richard Pryor started with some spark and energy, his performance turned rather lackluster—in part because of the dull script. Missing was all of Pryor's spontaneous, crazed, manic, edgy drive that audiences had always enjoyed. Michael Jackson, who longed to play Peter Pan on screen,

attained his wish of working in the movies. The audience seemed pleased just to see him as the touching Scarecrow in search of a brain. Following *The Wiz*, he would be on the way to mega-stardom as a recording artist—among the greatest in the history of popular culture—and as an extraordinary dancer who dazzled even the likes of Fred Astaire. This marked the start of Jackson's association with Quincy Jones, who did the music for the film.

Conscious of the opportunity to possibly reach a large audience spanning generations, Horne knew exactly how she wished to project herself and how she wanted to look. Her costume was an elaborate concoction: a sky-blue billowy gown with a matching headdress. Lumet's camera stayed often on the fabulous face but with distance enough to capture her jaunty moves and maneuvers as she performed "If You Believe." With her eyes flashing and fully alive, she captured the song's emotion and its meaning. Unlike much of her Hollywood interludes, she was performing "If You Believe" on her terms, providing a soulfulness, and it helped guide the film to its climax.

In October 1978, *The Wiz* opened to less than stellar reviews, and it failed to have the commercial success that Motown had hoped for. "This film brings out all of Sidney Lumet's weaknesses as a director and almost none of his strengths," wrote the insightful critic Pauline Kael in *The New Yorker*. "Style, sensitivity, attention to detail, a fine ear—these are what he gets along without in his commercial successes. His gift—and it's not a minor one—is for urban animal energy, for drive. But in a musical the energy springs from style." Of Lena, she added: "Surely, the moviemakers should have learned from the mistakes of the M-G-M team and make Glinda

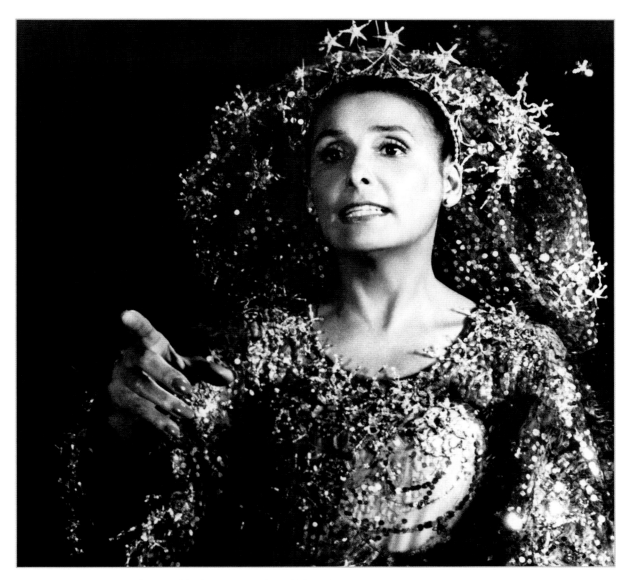

As Glinda in *The Wiz*, directed by her son-in-law, Sidney Lumet.

a sexy Good Witch; Lena Horne could certainly have played her that way. Instead she's done up like Elizabeth Taylor in *The Blue Bird*—in lyrical glitter . . . she says, 'Hello, Dorothy' with a condescension that leaves you breathless. After that, she makes a speech that sounds like a sermonette for the human-potential movement, and sings a gospel version of 'Believe in Yourself.' . . . She's in beautiful deep voice, but gospel isn't what we want from Lena Horne, and it doesn't go with the tight muscles in her face." Kael noted the important aspect of Horne in song here. "Only the energy and anger emanating from Lena Horne—and cutting through the cloying effects—save her."

Energy and anger emanating from Lena Horne. Kael's words would echo into the next decade.

Though the industry was willing to dismiss and forget *The Wiz* as a failure, it proved to have another life as time moved on. Black families and Black children in subsequent generations responded to it emotionally, enjoying the *Black* aspect of the retelling, giving *The Wiz* a special, near-classic status for Black viewers. And "If You Believe" became a part of the Horne repertoire.

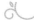

Before the decade's end, the marriage of Gail and Sidney Lumet would end in divorce. Later Gail married the journalist and foreign correspondent Kevin Buckley.

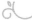

As the era wound to a close, Lena Horne searched for a project that would take her in a new direction—and that might also get her back to Broadway. Promising was an update of the famous Richard Rodgers and Lorenz Hart musical *Pal Joey*. Based on stories John O'Hara had written for the *New Yorker*, it told the story of Joey, a louse who never hesitates to use anyone nearby. He has a relationship with a young chorus girl, Linda English, *and* with a sophisticated older woman, Vera Prentice-Simpson, formerly a stripper, now a wealthy widow. Not hesitating to embark on an affair with Joey, Vera knows the rules of the game: basically, she'll pay for what she gets. Opening on Broadway in 1940, *Pal Joey* startled theatergoers, intrigued by the theme and entranced by the music. Among its memorable songs was "Bewitched," sung by Vera, expressing what has drawn her to Joey—in rather provocative lyrics: "Horizontally speaking, he's at his very best" and "Vexed again/perplexed again/thank God

I can be/oversexed again!" Gene Kelly had starred as Joey. It made him a star and led to his career at MGM.

Not until 1957 did *Pal Joey* make it to the big screen—albeit cleaned up with the unsavory aspects wiped out—under the direction of George Sidney. Playing Joey Evans was Frank Sinatra, actually too old for the twenty-six-year-old character of the play. Kim Novak was cast as Linda. And in the role of Vera was Rita Hayworth, who gave an underrated performance as a woman taking a last stab at some companionship in her life. She was glorious to watch. Other Rodgers and Hart songs, not from the original *Pal Joey*, were sung in the movie: "There's a Small Hotel," "My Funny Valentine," and "The Lady Is a Tramp." The last had been forcefully performed by Lena in clubs and in the film *Words and Music*.

Lena agreed to do the new stage version, now titled *Pal Joey '78*, which was scheduled to run first in Los Angeles at the Ahmanson Theatre and then in San Francisco at the Civic Light Opera, and hopefully afterward onto Broadway. Cast as Joey was Clifton Davis, who had worked successfully in theater and on television. Also cast were Marjorie Barnes as Linda and Josephine Premice, who had appeared in *Jamaica*. Now Premice played Vera's friend, Melba, and served as Lena's understudy. Directing this new version was Gower Champion, whose astounding credits included Tonys as director and as choreographer for *Bye Bye Birdie* in 1960—and Tonys as director and choreographer for 1964's *Hello, Dolly!*, which ran on Broadway for almost seven years. The new *Pal Joey '78* was a top-of-the-line production. Champion was acutely aware, as were others, that the musical

Pal Joey '78 with Clifton Davis (l.) and hopes for Broadway.

had to be given a more current flip. No longer shocking was the prospect of seeing an older woman in pursuit of a younger man—and ready to pay the bills. Motown's Gil Askey was brought in to spruce up the music.

Speaking of updating the musical, Lena told *Jet* magazine in its September 28, 1978, cover story: "I guess in those days it might have been daring, but not now," she said. "Now, with women's lib there are more and more of us buying what we can pay for. What we can't afford, we do without." She added: "I'm very hip that a lot of that kind of attraction might be because he wants a little money, or something, which is fine, as long as it's right out there . . . If we both understand where it's at." Lena also spoke of her age. She was about to turn sixty-one. "Oh, I can't wait to get my Social Security, honey. I've been working all my life. I'm so glad I'm getting to the point

where I can go and collect some of it. I had to wait a long time to get there." Expressing her unease with having been the only Black goddess in Hollywood in the 1940s, she said, "I guess it made me—the movies and all that—and the Black guys who saw me had no one else. It was just before Dorothy Dandridge and those other lovely girls came along. But I didn't enjoy being the one that was the 'only' one."

On her mind was the idea of time moving forward—and of perhaps soon leaving the entertainment scene. Nonetheless, excitement grew about *Pal Joey '78*.

But problems plagued the production. Horne clashed with director Champion, who was replaced by director Michael Kidd, with whom Lena also did not see eye to eye. Lena grew determined to call the shots, which was understandable. Hers was the name that would bring patrons into the theater. She wasn't hesitant about making demands. "Once you get over the hang-up about the fact that she is indeed great and indeed legend, it's like working with any tough professional," Clifton Davis told *Jet*. "She demands a great deal and she gives a great deal, as long as you come up to it. And hopefully, I usually do. I find myself hearing a hell of a lot from her." It was not hard to read between the lines.

Stories about the Horne temperament during *Pal Joey '78* circulated for some time—just as had those rumors about her flashes of anger during rehearsals for *Jamaica*. But the difference was that *Jamaica* had proven to be a hit. *Pal Joey '78* was not. Out of whack without a consistent dramatic flow, the musical hobbled along. Neither critics nor audiences were thrilled. The box office turned tepid. By the time the musical stumbled into San Francisco, it looked dead on arrival. The glamorous, sexy role of Vera, who is hellbent on living on her terms, might have been perfect for Lena Horne, but it turned sour, and the update was sadly and badly misconceived. *Pal Joey '78* was not headed for Broadway.

Lena's insistent demands—and her refusal to budge from her view of the way the production should proceed—brings to mind comments made by Phil Moore about "star power" and sometimes a "star's self-destructive edges." Phil Moore had learned over the years to try to diplomatically reason with a star about what they might be doing wrong—but ultimately to understand that a production or a nightclub performance falls on the shoulders of the star, whether it be criticism or praise. He came to understand that at a crucial point, no matter how strongly he felt, he had to step back with both Dandridge and Horne. Each woman had something at stake that he didn't. Sometimes they became resentful at having to listen to the opinions of others—what to wear, how to make up, how to move, what material worked best—and operating in an entertainment profession controlled so thoroughly by men. Sometimes they seemed adversely affected by the tough stance they had to take, when they had to forgo any "ladylike" attitudes to express themselves. Lena had her temper and her ability to curse like a sailor. That helped but she may not have always enjoyed being put into such a position. Sometimes the judgments of Horne and Dandridge were wrong, but other times those judgments were absolutely right. In his long career, Phil Moore respected their decisions and was never openly critical in any way of Horne or Dandridge.

Performing with her friend Alan King.

COMING TO TERMS, TRIUMPH

*E*nergy and anger emanating from Lena Horne. Pauline Kael's words had hit the nerve that would propel Lena Horne in this new decade—and which would lead her to an extraordinary success.

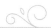

In 1980, Horne appeared ready to hang things up and call it quits. Appearing at the Fairmont Hotel in San Francisco, she announced her retirement as she embarked on a two-month farewell tour. On June 16 at Los Angeles's Music Center, Vincente Minnelli introduced her. The director who had meant so much to her at MGM was now appropriately giving her a fond send-off. From her home in Santa Barbara, she gave a candid interview to *Ebony*—her tenth appearance on the magazine's cover—on some familiar topics and on some subjects she generally did not discuss: such as her ill-fated romance with Joe Louis and the stories that he had once physically abused her (which she denied); her experiences on *The Wiz*; her friendships with Minnelli and Ava Gardner; her first marriage (in

which she said she had been a "lousy" wife to Louis Jones); her marriage to Lennie, admitting that initially it was not a marriage of love on her part but of her hope for possible career advantages. Of her father, she said: "In a way, I'm still looking for my father. In fact, if I could have married my father, I wouldn't have married my first husband."

When questioned about the constant focus on her beauty, she answered: "I don't resent it, but I try not to pay too much attention to it. I have always worked on the assumption that whatever looks I'm supposed to have, they aren't going to last forever. I deliberately matured myself so that when I reached the age I am now, I don't care. And I'm happy with my age. I've been lucky because no matter how the years come, my head tries to keep up with what's

happening. I'm not going to let myself become a dumb old broad or a glamorous old bat."

Not all her comments were as forthcoming as one might have wanted, but she was still examining her life, as she had done in previous interviews. Lena Horne still had more to say about her experiences. She was also grieving the loss of those three important men in her life. And quiet as it was kept, she was most likely still upset and angered by the failure of *Pal Joey '78*. Was there some way to channel her experiences into her work—into a performance? Was there some way to get to Broadway?

Soon she backtracked on talk of retirement. The idea for a new performance piece was germinating.

"Homesick in California, she had wanted to spend the summer touring in *Pal Joey*," reported Marie Brenner in *New York* magazine. "Jimmy Nederlander had other ideas. Why not try a one-woman show? He had some persuading to do." Actually, the idea for a one-woman show about her life started with Sherman Sneed, part of Horne's management team since 1972. A show business veteran who had grown up in Oklahoma City, Sneed had played football at Dillard University in New Orleans, had sung in college choirs and during World War II performed with the Army USO. Later he was part of a choral group on CBS radio, and upon moving to Brooklyn, played Jim in a production of *Porgy and Bess*, and then spent fifteen years as a backup singer for Harry Belafonte and as a management assistant. He had a feel for what audiences would like.

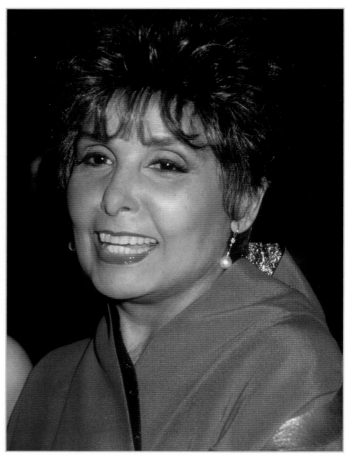

With thoughts of retirement in the early 1980s but then a change of mind.

Lena had been in a funk, indecisive about her next career move. She was weary of being on the road, and now in her mid-sixties, she was aware time was moving on. Sneed discussed the prospect of creating a production around her but was emphatic: "You've got to let yourself be heard in New York, where it means something." Discussing the idea with theater impresario James Nederlander, he also brought in two others to develop a show. "They're young and dumb," Horne would later say fondly. "And they all decided to produce a Lena Horne show. Jimmy Nederlander, of the theatre-owning Nederlanders,

Broadway bound.

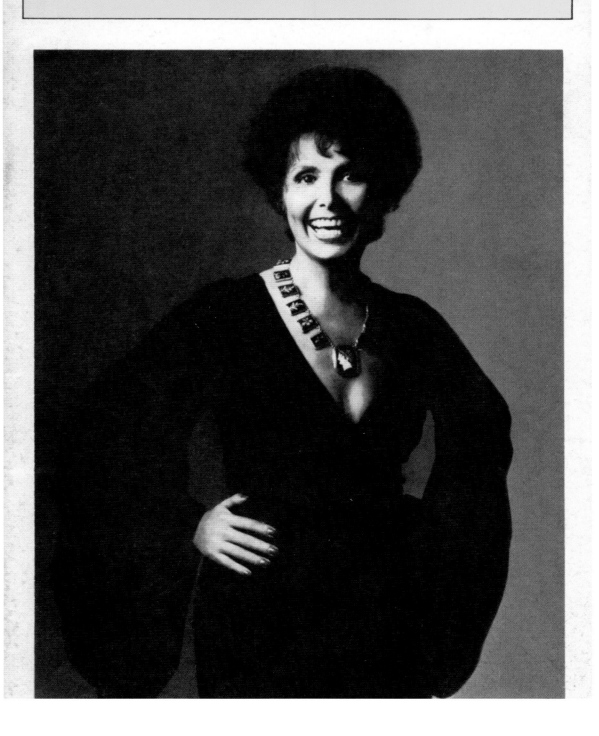

liked the idea too." She added: "I was willing to do a play. I loved doing *Pal Joey*." But they liked the idea of a show on her life and career.

On February 2, 1981, John Corry in the *New York Times* reported that Arthur Mitchell of the Dance Theatre of Harlem would direct such a show from a script written by Samm-Art Williams. "Much of the idea for the show grew out of conversations between Miss Horne and Luther Henderson," reported the *New York Times*. At one point, the production was a multi-character presentation to be called *Lena's World*. But when choreographer Arthur Faria came on board—as a de facto director—the decision was made to let Lena carry the whole production with a chorus that provided comments at key points. That was precisely what Sneed and others wanted.

Much changed. Neither Mitchell nor Williams remained attached to the show. "Samm got interested in my life and the black experience," said Lena, "but that's not the way I wanted to do it. You know, I talk a lot now. I

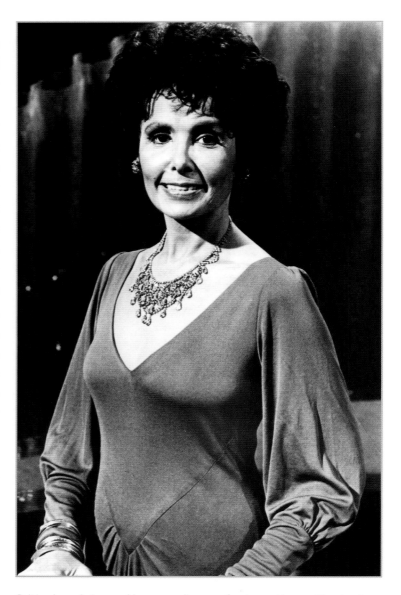

Critical acclaim and huge audiences for *Lena Horne: The Lady and Her Music*.

never used to open my mouth. The first time I talked I was 50. I don't know—I can make people laugh. When I hear the audience laugh, I think, Oh, my god! I'm funny." Sherman Sneed was quick to add: "There were always some people saying you must do this or you can't do that because it's Broadway." He pushed for Horne to sing "Stormy Weather" more

than once in the show. One day some songs were in. The next day they were out. Of course, Lena Horne herself was making the decisions, and no doubt was considered demanding, domineering, and unyielding as she had been on *Jamaica* and *Pal Joey '78*. But this clearly was *her* show. Musical direction was credited to Harold Wheeler. Production was staged

Three generations—Lena with her daughter (l.) and granddaughter.

by Arthur Faria. But in the end, the show listed no formal director nor any writer. Soon *Lena Horne: The Lady and Her Music* took shape and went into rehearsals. Nederlander was enthusiastic. The production was set to begin previews and then—with a one-million-dollar advance—to open on May 12, 1981, at the Nederlander Theatre.

No one could have been fully prepared for *Lena Horne: The Lady and Her Music*. From her very first appearance as she entered the stage and sang "From This Moment On," she was at the height of her powers, inviting patrons to join her on a journey, tracing her career from the days at the Cotton Club onto Hollywood. She revealed her career longings—wanting

to play Julie in the 1951 version of *Show Boat* and her disappointment when MGM cast Ava Gardner in the role. *But* she and Ava were sisters who understood Hollywood and each other. "We didn't have *tact*," said Horne. She performed such songs as "Where or When," "Can't Help Lovin' Dat Man of Mine," "Love Me or Leave Me," "Surrey with the Fringe on Top," and "The Lady Is a Tramp," which displayed the Horne repertoire in classic form and then in the way it had broadened with "I've Got a Name" and her triumphant rendition of "If You Believe."

Throughout she poked fun at herself—as a klutzy dancer at the Cotton Club and as a rather bewildered young woman being told to find her klieg

With Quincy Jones who produced the Grammy-winning album of her show.

of whom she knew she was. But as Phil Moore might say: That's the prerogative of a great star. But her humor, her energy, edge, and rich insights, her enduring glamour and beauty, and her still brilliant way with a song turned *Lena Horne: The Lady and Her Music* into a blazing triumph. Her struggles and career anguish and will-to-be had led up to this transcendent, highly moving performance.

"Lena: spell her D*Y*N*A*M*I*T*E," read the headline of Douglas Watt's review in the *New York Daily News* on May 13, 1981. "Lena Horne is the season's best musical, Tonys or no Tonys," wrote Watt. "As a matter of fact, they should invent a whole new category for her: something like Best of Broadway, period. At Monday's preview at the Nederlander, where she officially opened an unlimited engagement last night, she literally took the house by storm. She left the audience standing and cheering. They loved her . . . The lady, one of the two or three most beautiful women of our time, is at the peak of her artistry."

light on an MGM soundstage. When she performed her signature song "Stormy Weather" the second time around, she told the audience, "I had to grow into this song." It proved mesmerizing. Foremost, this was a Hollywood story, a Black Hollywood tale—without much about her personal life. There was anger. There was a history lesson on the movies and the way African Americans had been treated. Of course, she still was not telling everything. Edited out were more unpleasant aspects of her story—and

"Lena Takes Broadway by Storm" read the headline of Clive Barnes's review in the *New York Post* on May 13. "Sorry, this has to be a love letter," wrote Barnes. "The sexiest woman on Broadway is a 63-year-old grandmother. The name is Lena Horne. She opened last night at the Nederlander Theatre in her own show, and she was bewitching making stormy weather into blue skies. Her talent is cyclonic—on this viewing she is quite simply, here and now, one of the greatest entertainers of our time."

With Whitney Houston, a young star she admired.

"She is ageless. More young than old, perhaps, but tempered like steel, baked like clay, annealed like glass; life has chiseled, burnished, refined her," wrote John Simon in the May 25, 1981, issue of *New York*. "You can see conflagrations of girlishness in her, but also hints of the crafty old woman, aflicker with a flame that can ride out the wind, stay undoused by stormy weather. That lithe, sinewy body is a cunning wick that has soaked up enough experience to yield a perpetual light. She bends a little toward her fans, inextinguishable Lena of the smile that devours. And it is as if the world said: What a way to go."

For those who had followed Lena Horne at the posh nightclubs where she performed so elegantly, they may have been taken aback by the new earthy, down-home Lena. Gutsiness and even a rejection of her past Hollywood experiences, which after all had introduced her to a vast audience, may not have been what they wanted to see or hear. It was reported that Arthur Laurents found her fake, adopting a new "Black" persona. She seemed to be throwing something in the faces of those she had worked and socialized with during the days of Lena and Lennie. There was another Lena they had never fathomed or understood. She was on a new course now.

That same season on Broadway, Elizabeth Taylor starred in *The Little Foxes* and Lauren Bacall in a musical version of *Woman of the Year*. Ads promoted the three together: "Lauren, Lena and Liz Light Up Broadway." In the May 25, 1981, *New Yorker*, Brendan Gill proclaimed, "Writing to a friend in praise of Ibsen's plays, the youthful Bernard Shaw burst out, 'I say, Archer, my God! What women!' I am tempted to echo Shaw when I consider some of the women performing on Broadway this season, among them Lauren Bacall, Elizabeth Taylor, and, opening last week at the Nederlander, Lena Horne. They have in common exceptional energy and stage presence,

Backstage with Cab Calloway and Elizabeth Taylor following a performance of *Lena Horne: The Lady and Her Music.*

and to a remarkable degree they are able to convey to us a sense of their knowing precisely who they are." He added: "Seemingly, they have learned to take the measure of every day of their lives, and to our profit as well as theirs. They are not only entertaining but hortatory, for what they offer is the possibility that the world can indeed be forced to find room for us and, with luck to do so on our terms."

As she had been at Little Troc when Hollywood stars clambered to see her, again she was a star of stars. Coming to the Nederlander Theatre to see, to praise, to pay tribute were: Elizabeth Taylor, Jacqueline Kennedy Onassis, Diana Ross, Sammy Davis Jr., Cab Calloway, Sidney Poitier, Harry Belafonte, Aretha Franklin, Michael Jackson, Carmen de Lavallade, Geoffrey Holder, Kirk Douglas, Suzy Parker, Debbie Reynolds, Dionne Warwick, Paul Robeson Jr., Bobby Short, Katharine Hepburn, Martha Graham, Hedy Lamarr, Sidney Lumet, Jinx Falkenburg, and a host of others. One evening First Lady Nancy Reagan attended the show with an entourage that included conservative writer William Buckley and his wife, Pat, and Ron Reagan Jr. and his wife, Doria. Secret service protection was so tight that after the performance such luminaries as Redd Foxx and his wife; choreographer Jerome Robbins; and Lady Keith could not get backstage.

In 1981, Horne won a special Tony Award, a special award from the New York Drama Critics Circle, and the Drama Desk Award for Outstanding Actress in a Musical.

Lena Horne: The Lady and Her Music closed on June 30, 1982. It was the star's sixty-fifth birthday. There to celebrate with her were Gail and her daughters and the children of Lena's son, Teddy. Lena looked radiantly happy that evening.

In 1983, she took the show to Washington, D.C. Tributes and accolades followed.

In 1981, Lena was at her dazzling best when interviewed for *The Dick Cavett Show* and later by Ed Bradley for *60 Minutes*. In December 1981, Horne was honored at New York's City Hall, where she was awarded the prestigious Handel Medallion for her contributions to the city's cultural life.

A live two-record album of *Lena Horne: The Lady and Her Music*, produced by Quincy Jones, was released in late 1981. Jones and Horne won the Grammy for Best Musical Show Album. Lena won the Grammy for Best Pop Vocal Performance in the female category. The show was even filmed and aired on Showtime in 1984.

Vogue and *New York* ran splashy color layouts of Lena and her granddaughters Amy and Jenny Lumet. Her face graced the covers of *Ms.*, *Essence*, and *Jet*.

The accolades kept coming. In 1983, she was awarded the NAACP's Spingarn Medal for outstanding work in civil and human rights. In 1984, she was the recipient of the Kennedy Center Honors, along with Gian Carlo Menotti, Arthur Miller, Danny Kaye, and Isaac Stern. In 1984, she received the Paul Robeson Award from Actors Equity.

In 1985, she appeared as herself on the hit *Cosby Show* and a few years later, in 1993, on the spinoff *A Different World*, again as herself.

In 1986, Gail Lumet Buckley published the book *The Hornes: An American Family*, a chronicle of the family history Lena had grown up hearing about. Lena helped Gail publicize the book.

During this time, Horne also toured in *Lena*

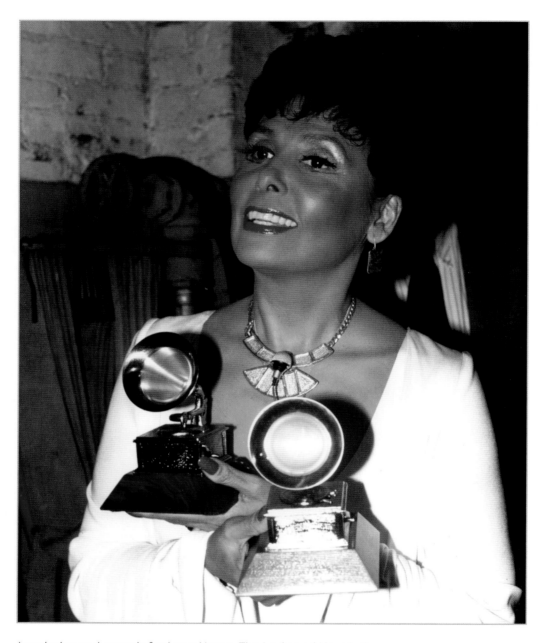

Accolades and awards for *Lena Horne: The Lady and Her Music*.

Horne: The Lady and Her Music, in San Francisco and Los Angeles as well as New Orleans and Canada. In 1984, the show opened at the Adelphi Theatre in London. There she saw her friend Ava Gardner, then living in the city, who attended a performance. That same year she took the show to Stockholm.

With this new career high and all the praise, Lena Horne, however, seemed restless. At one point, she moved from Santa Barbara to a

condominium in Washington, D.C., which it was said she never actually lived in. After a time, she moved back to New York. In 1986, she broke off relations with her manager Ralph Harris, who had guided her through pivotal times and engagements in her career. Horne herself had said that Harris and Lennie were known for keeping a wall up against people trying to reach her. That she had considered a good thing. Why she parted from Harris remains unknown, but she appeared to be liberating herself from past entanglements—and setting out on yet another new course. Though Jeanne Noble was still a friend, the two did not seem as close. Noble died in 2002. Set to do a new book on her life, to be written with her by onetime *Essence* magazine editor Marcia Gillespie, after a time she dropped those plans.

In 1988, she recorded a new album, *The Men in My Life*, with guest performances by Sammy Davis Jr. and Joe Williams. Several other albums were released into the new millennium. She also performed in Bermuda, San Diego, and other cities at engagements for high-paying companies. In 1993, she returned to MGM to film a segment for the studio's anthology series *That's Entertainment! III*. Touchingly, at the 1993 JVC Jazz Festival she performed a special concert: *A Tribute to Billy Strayhorn: Lena Horne Sings for Swee'pea.*

A major project came with the 1996 PBS documentary *Lena Horne: In Her Own Voice*, directed by Susan Lacy as part of the American Masters series. Again her life and career were tracked with exciting footage from the past and interviews with Gail, entertainer Bobby Short, actor Ossie Davis, Josephine Premice, columnist Liz Smith, and others. Lena herself performed. Other than having

the pleasure of seeing the footage and hearing the warm reminiscences, viewers did not find much new material.

In 1998, Horne appeared on *The Rosie O'Donnell Show*. With her gray hair stylishly swept back, she looked regal. At one point, O'Donnell showed Horne a copy of the 1944 movie magazine *Motion Picture* with Lena's groundbreaking cover portrait. O'Donnell asked if she wanted the magazine, to which Horne said, "Not really." As she lingered on the picture of herself, she told O'Donnell that her hairdo had been modeled at that time after Rita Hayworth's hairstyle in the film *Cover Girl*. She answered O'Donnell's questions in the here-and-now. But on the show Lena Horne appeared to be looking back in a very personal way. Memories were coming to her. But she also appeared to be keeping them to herself.

Perhaps that guardedness is what led to the cancellation of a proposed TV biopic for ABC based on her book *Lena*. In 2002 *Variety* reported that African American director Roy Campanella Jr. planned to direct the project. When pop star Janet Jackson was set to star, Lena at first *seemed* cooperative, but later backed out after the controversy that followed Jackson's unfortunate "wardrobe malfunction" during the halftime special of the 2004 Super Bowl XXXVIII. But in the end, did the woman who had so restlessly examined her life in interviews and autobiographical pieces simply decide she did not want her story told—without her control, if at all?

For many it looked as if *Lena Horne: The Lady and Her Music* had announced to the world that she had finally worked out issues in her life; that she was *free*. But once, when an insightful magazine editor who had worked with Horne heard a comment that

Lena was in a new psychological place, that things were settled for her, the woman commented: "You think so? I don't think so at all. It's like someone living in a house with all the shades down. You don't know what goes on inside." Ultimately, Lena Horne remained something of a mystery.

In 2006, she recorded what would be her last album, *Seasons of My Life*, for Blue Note. As time moved on, she made fewer public appearances. Occasionally, she might see a Broadway play or attend a concert. But most of her time was spent in her apartment on Manhattan's Upper East Side—reading. Alice Walker was a favorite. So too were volumes of French history, according to her daughter, Gail. Horne also said that show business had been "a great job." Yet she regretted that she did not have "the nerve to go to some other avenue." "She feels uncomfortable advising young performers because the challenges they face are so vastly different than those she encountered," reported the *New York Times*. "I have no advice," she said. "Isn't that awful?"

The focal point of her life, what brought her strength and pride, appeared to be her family: Gail, her grandchildren, and great-grandson Jacob Cannavale, born in 1995, the son of screenwriter Jenny Lumet and her husband, actor Bobby Cannavale. "I had no brothers or sisters," she said. "I was hungry wanting to see generations of me. I wanted to find family, and that's what I really did."

As health problems consumed her, she retreated further from life. She continued to spend time reading, perhaps still reflecting on her experiences, but her eyesight began to fail her. Unconfirmed stories turned up on the Internet that she suffered from multiple sclerosis. Struggling with arthritis, she was seen using a walker as well as a wheelchair on those rare occasions when she ventured out of her apartment. Her daughter, Gail, was devoted to Lena. There were heart problems as well. Then came the end—quietly and solemnly, with her family nearby.

On May 9, 2010, Lena Horne died of heart failure in New York. It was Mother's Day. She was ninety-two years old. At a funeral mass at St. Ignatius Loyola Church, attended by her family and friends, the beloved retired pastor of the church eulogized her. Audra McDonald sang "This Little Light of Mine." In attendance was a troop of former Tuskegee Airmen, there to pay tribute to the dream girl who had entertained them during the war years of the 1940s.

Obituaries in the States and abroad saluted the life, struggles, and triumphs of the lonely little girl from Brooklyn who reached the heights of success and fame through her talent, her drive, and her personal vision.

And so the end had come to an extraordinary life. For Lena Horne it had always been an adventure, a journey—sometimes rocky, sometimes troubling, yet through it all she was ever on a search to learn more about her art, about the racial dilemmas in her country, and about the inner workings of her soul. She accomplished far more than she may have known. In life, Lena downplayed what she achieved. In 1997, when the jazz critic Don Heckman said that as a singer she "belonged in the pantheon of great female stars" such as Ella Fitzgerald, Billie Holiday, Sarah Vaughan, and Carmen McRae, he said Lena Horne's response was, "Oh, please, I'm really not Miss Pretentious. I'm just a survivor. Just being myself." Actually, she belonged in something larger:

in the pantheon of America's great cultural icons; a vital, forever vibrant symbol that has endured for one generation after another.

When Lena was a sixteen-year-old chorus girl at the Cotton Club and then the girl-singer with the bands of Noble Sissle and Charlie Barnet and then a singer on her own in the sophisticated venue of New York's Café Society, she might easily have performed her numbers and completed her engagements, and then, as time moved on, vanished from sight, but she was breaking new ground. When she arrived in Hollywood in the 1940s, Lena found herself proclaimed a goddess, yet one who would never be treated by her studio as the full-fledged movie star she was. She might have caved in or wilted and ultimately faded from view then, too, but when her years at MGM were over, she continued on. With her tenacious determination to create something in song, in nightclubs, and on the stage, she kept growing as an artist, kept pushing herself to perfect her style, to test her vocal range, and to give utterly original interpretations of her music.

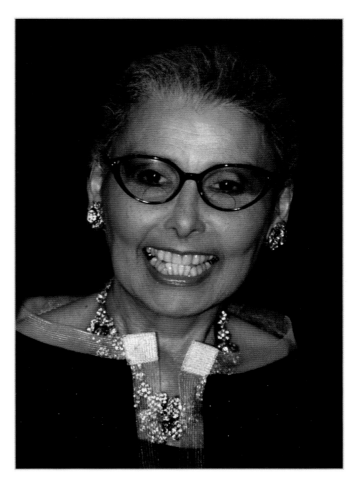

Stately and majestic with the celebrated beauty and glamour intact, circa 1997, at the time of her eightieth birthday.

Those working with Lena may have found her demanding and difficult at times, but she could always see precisely what it was that she hoped to attain and to communicate in her music—and with her image. Never did she take herself or her audiences for granted. She always believed that she had to give the best of herself. This resulted in her ushering in a polished, assured, and brazenly dignified new image for African Americans in Hollywood. She helped change the face of Black women on the silver screen and in nightclubs everywhere. And through the way she fought the battle for civil rights and repeatedly sought to overturn bigoted ideas and concepts, Lena proved herself a champion. In the end, she also set the stage for new generations of artists and activists to follow, letting them know that with conviction and fortitude, something distinct could indeed be achieved. She remains one of the great glowing legends of the twentieth century with a light that has never dimmed.

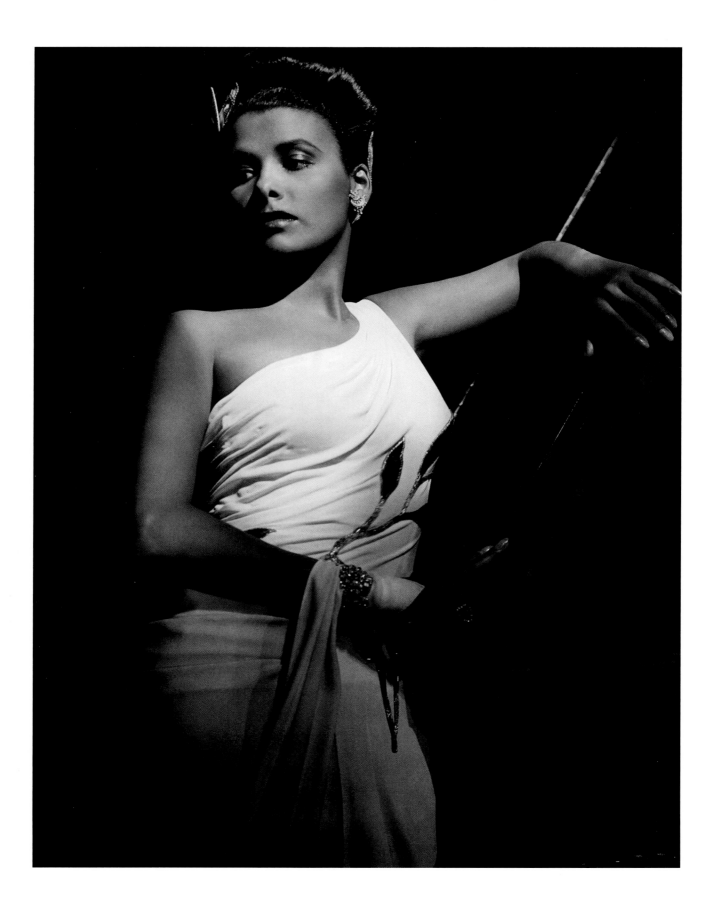

Acknowledgments

Every author understands that a book is the result not just of one person's efforts but of those who assist, encourage, motivate, and inspire that person. Thus it is a pleasure to acknowledge and express my gratitude to the various people who have helped me bring *Lena Horne: Goddess Reclaimed* to fruition. Foremost I'd like to thank my tenacious and forever-on-the-case editor, Cindy De La Hoz Sipala. From the minute I expressed my interest in doing a book on Lena Horne—with a multitude of rare and magnificent photos that, along with an enlightening commentary, would tell the story of her career, personal conflicts, and unprecedented success—Cindy was onboard. Throughout, her knowledge of movie history and her enthusiasm for the book, despite delays and a pandemic, inspired me to keep writing. The same can be said for my supremely supportive literary agent, Jennifer Lyons. Whatever hassle or problem may arise, Jennifer somehow sees her way around it and confidently reassures me that every conflict can be resolved—and to my advantage. She's had faith in this book, and as always, she has proven herself to be a terrific negotiator.

From Running Press, I want to thank designer Amanda Richmond, production editor Melanie Gold, and publisher Kristin Kiser.

In researching this book, I have dug deep into my personal archives, stretching back over numerous years, reviewing previous interviews and conversations with people whose paths in some way or another crossed Lena Horne's. Some knew her during her Hollywood years at MGM, and some were a part of her Los Angeles social life. Others knew her from her theatrical experiences or those fabulous nightclub performances. Once again, I must thank such remarkable people as Geri Branton, Phil Moore, Robert Osborne, Marian Etoile Watson, Fayard Nicholas, Ossie Davis, Ruby Dee, Sydney Guilaroff, Bobby Short, Harold Jovien, Lennie Bluett, Herb Jeffries, Avanelle Harris, Cicely Tyson, Kathryn Grayson, and the phenomenal late Fredi Washington.

During a time of the lockdown due to the pandemic, I've also again resorted to articles and interviews in my in-house personal archives—including the results of research I previously conducted at the New York Library for Performing Arts at Lincoln Center and at the Schomburg Center for Research

in Black Culture. I was repeatedly excited and thrilled at what I had in-house, including material I've found within my personal library: biographies, autobiographies, histories of movies and the theater, and critical studies.

I also must express great gratitude to my former student Zoe Mitchell, who provided excellent research from online sources: reviews, interviews, articles. She became fascinated by Horne. I must also express my great gratitude to dear friend, music critic, and historian Sally Placksin, author of the classic book *American Women in Jazz*. It's always rewarding to discuss music figures with Sally. In this instance, when I found myself in a bind for additional research on Lena, Sally offered her services, and on short notice, she was able to come up with some remarkable information. She worked quickly and went the extra distance.

My gratitude is also extended to Eileen Flanagan, who was extremely helpful in my quest for images of Lena Horne—from her early years until the end of her life. Eileen always had fine suggestions and aided in navigating the TCM archives. Also I want to thank Howard Mandelbaum of Photofest, an absolutely excellent and dazzling source for photographs past and present.

As always, I want to thank for their encouragement and wise counseling two mighty titans of the publishing industry: Marie Dutton Brown and Elisabeth Dyssegaard.

I am happy to express my appreciation to the staff at Turner Classic Movies for their great continued support. Foremost I extend my gratitude to TCM's astute John Malahy and resourceful Heather Margolis, who have long been supportive of my work. I also want to offer thanks to Dori Stegman and Susan

Biesack; Genevieve McGillicuddy; Mark Wynns; Angela Carone; Kristen Hassell; Quatoyiah Murry; Courtney O'Brien; Anne Wilson; Nicole Hill; Jacob Griswell; TCM's general manager Pola Changnon; Susana Zepeda Cagan; Liz Winter; Darcy Hettrich; and primetime host and friend Ben Mankiewicz with whom it has always been a pleasure to work. My great gratitude is reserved for my good friend, the remarkable Charlie Tabesh, TCM's Senior Vice President of Programming and Production. It's always a pleasure to discuss films and television with him as well as an array of other topics: politics, sports, social trends. His insights are illuminating and endless.

Of course, providing assistance with or without their awareness (I almost never discuss what I'm working on) were a group of friends and associates. Foremost my gratitude goes to my former researcher and now an important director, Phil Bertelsen. Also Bruce Goldstein of New York's Film Forum, which has the finest repertory cinema programming in the country, who is a fountain of knowledge about movie history. Then there is Jerald Silverhardt, an actor's manager in Los Angeles, who actually discovered an unknown Tom Cruise decades ago and remains keenly aware of the Hollywood scene past and present.

Then there is my dear friend, the remarkable film/television producer Debra Martin Chase, who has retained her lifelong enthusiasm for the movies and Hollywood history. It is a sheer pleasure to discuss films, personalities, and social and political history with Debra, who is not only exceptionally knowledgeable but also graced with vast insights and a terrific sense of humor.

Other friends and associates who proved important during the researching and writing of this book include: Carol Leonard; dear Sarah

Orrick; Catherine Nelson; Ronald Mason; Edythe Mason Brooks; Kim Mason; my longstanding friends from a special summer at Harvard—Susan Peterson and Nigel Forrest; Tink Alexander; Julia Forrest; my good friends from my days at *Ebony*, Steve Morris and Barbara Reynolds; Robert Katz; Martin Radburd (always coming to my rescue when there are computer challenges); Alan Sukoenig and Hiroko Hatanaka; Mikaela Bender; my friends on the board of the Newark Museum's Black Film Festival—Gloria Hopkins Buck, Mary Sue Sweeney Price, and of course, Pat Faison; Nels Johnson and Cathie Nelson; Elliot Thompson; Jim Malcolm; Jeff Christiansen; my neighbors Joyce and Philip Settel; dear Monica Freeman; and of course, Emery Wimbish, who has regaled me with stories of having seen Lena Horne's nightclub performances.

Also of great encouragement are my friend Enrico Pellegrini and his wife, Katrina Pavlos, as well as my former editor Evander Lomke and his wife, Fotini Lomke, and with memories of their daughter Elizabeth Lomke; dear Irene Mecchi; and my good friend Joerg Klebe of German Educational Television.

Very special thanks are extended: to Dr. Tina Wong; Maggie Huang, and especially Dr. Steven Hobson; to my colleagues at the University of Pennsylvania, Gale Garrison and Carol Davis; to my colleague at New York University's Tisch School of the Arts, Richard Wesley; to such former students as Marcel Salas, Kyle Webster, Wesley Barrow, Judith Osborne, David Aglow, and especially Robin Williams; and my former Penn students with whom I used to have regular roundtable lunches with lively discussions—Gigi Kwon, Raj Gopal, Jake Stock, and Nadine Zylberberg. Also the wondrous Deesha Hill. And great thanks to the very best of my teaching assistants, Mia Simone Moody. I've learned much from them all.

Other associates, friends, and family members, whom I cannot thank enough for their patience and enthusiasm include: Jacqueline Bogle Mosley; Robert Bogle, publisher of the *Philadelphia Tribune*; Jeanne Bogle Charleston and her late husband, Fred Charleston; Janet Bogle Schenck and her husband, Jerry Schenck, both of whom have always been supportive and encouraging—and who are true movie people; Roger Bogle; Gerald Grant Bogle; Jay Kevin Bogle; Fred "Pele" Charleston Jr.; Ayana Charleston; Hassan and Denise Charleston; Bettina Glasgow Batchleor; Mechelle and Hermond Palmer; Robert Bogle Jr.; Mariska Bogle; Luellen Fletcher; Sherea Mosley; Janelle Mosley; Jackie Palmer; Jordan Palmer; Sean and Shari Batchleor; Shaaron Boykin; Jaidyn Bogle; Mark Mosley; Sylvia Gholston; Carol White; Tony and Vanita Nicholas; Carolyn and Chris Jackson; Patricia Ferguson; Margaret Crosthwaite; David Crosthwaite; Michael Pascuzzi; Denise Pascuzzi; Josslyn Luckett; Jennifer Calderone; Heidi Stack; Doug and Liza Rossini; dear Rae Taylor Rossini; Meghan Rossini; the Lagow family—Barbara, Ellen, James, Molly, and Steven; Linda "Doll" Tarrant Reid and Stuart Reid; Franklin Lara; film historian Dr. Ed Mapp; Keiko Kimura; Mimi Goldstein; Eric Di Bernardo; Adrienne Halpern; Merleann Taylor; Simon Aminzade; Karin Leake; Alex Bogle, Margaret McDowell, and to the dearest of the dear, Yemaya Bogle.

Final special thanks to Lori Stimpson Guile—and the Guile girls Koryn, Kamryn, Kori, and Kaylin; also Kevin Guile; Winsome Carey; Michael Suarez; Greg Cromartie; Dick Cornet; Clifford Laurent; Rigmor Newman Nicholas; and two remarkable friends Jeanne Franz and Clerio Demoraes.

Selected Bibliography

Belafonte, Harry, with Michael Shnayerson. *My Song: A Memoir*. New York: Alfred A. Knopf, 2011.

Blair, Betsy. *The Memory of All That: Love and Politics in New York, Hollywood, and Paris*. New York: Alfred A. Knopf, 2003.

Blauvelt, Christian. *Hollywood Victory: The Movies, Stars, and Stories of World War II*. Philadelphia: Running Press, 2021.

Bogle, Donald. *Bright Boulevards, Bold Dreams: The Story of Black Hollywood*. New York: Ballantine Books, 2005.

——. *Brown Sugar: Over One Hundred Years of America's Black Female Superstars*. New York: Bloomsbury, 2007.

——. *Dorothy Dandridge : A Biography*. New York: Amistad Press, 2022.

——. *Heat Wave: The Life and Career of Ethel Waters*. New York: HarperCollins Publishers, 2011.

——. *Hollywood Black: The Stars, The Films, The Filmmakers*. A TCM Film Book. Philadelphia: Running Press, 2018.

——. *Toms, Coons, Mulattoes, Mammies, and Bucks: An Interpretive History of Blacks in American Films*, 5th ed. New York: Bloomsbury, 2016.

Bryer, Jackson R. and Richard Allan Davison. *The Art of the American Musical: Conversations with the Creators*. New Brunswick: Rutgers University Press, 2005.

Buckley, Gail Lumet. *The Black Calhouns: From Civil War to Civil Rights with One African American Family*. New York: Atlantic Monthly Press, 2016.

——. *The Hornes: An American Journey*. New York: Alfred A. Knopf, 1986.

Callow, Simon. *Orson Welles*. New York: Viking, 1996.

Calloway, Cab, and Bryant Rollins. *Of Minnie the Moocher & Me*. New York: Thomas Y. Crowell, 1976.

Chilton, Karen. *Hazel Scott: The Pioneering Journey of a Jazz Pianist from Café Society to Hollywood to HUAC*. Ann Arbor: University of Michigan Press, 2008.

Cooper, Ralph, with Steve Dougherty. *Amateur Night at the Apollo: Five Decades of Great Entertainment*. New York: HarperCollins Publishers, 1990.

Davis, Ossie, and Ruby Dee. *With Ossie and Ruby in This Life Together*. New York: William Morrow, 1998.

Duberman, Martin Bauml. *Paul Robeson*. New York: Alfred A. Knopf, 1988.

Ellington, Duke. *Music Is My Mistress*. Garden City, N.Y.: Doubleday, 1973.

Eyman, Scott. *Lion of Hollywood: The Life and Legend of Louis B. Mayer*. New York: Simon & Schuster, 2005.

Fales-Hill, Susan. *Always Wear Joy: My Mother Bold and Beautiful*. New York: HarperCollins Publishers, 2003.

Fordin, Hugh. *The World of Entertainment!: Hollywood's Greatest Musicals*. Garden City, N.Y.: Doubleday, 1975.

Gavin, James. *Stormy Weather: The Life of Lena Horne*. New York: Atria Books, 2009.

Guilaroff, Sydney, as told to Cathy Griffin. *Crowning Glory: Reflections of Hollywood's Favorite Confidante*. Los Angeles: General Publishing Group, 1996.

Hajdu, David. *Lush Life: A Biography of Billy Strayhorn*. New York: Farrar, Straus and Giroux, 1996.

Harvey, Stephen. *Directed by Vincente Minnelli*. New York: The Museum of Modern Art, 1989.

Haskins, James. *Lena Horne*. New York: Coward-McCann, 1983.

Heimann, Jim. *Out with the Stars: Hollywood Nightlife in the Golden Era*. New York: Abbeville Press, 1985.

Holiday, Billie, and William Dufty. *Lady Sings the Blues*. Garden City, N.Y.: Doubleday, 1956.

Horne, Lena, as told to Helen Arstein and Carlton Moss. *In Person: Lena Horne*. New York: Greenberg Publishers, 1950.

Horne, Lena, and Richard Schickel. *Lena*. Garden City, N.Y.: Doubleday, 1965.

Jablonski, Edward. *Harold Arlen: Happy with the Blues*. New York: Da Capo, 1961, 1985, 1986.

Jaglom, Henry, and Orson Welles. Edited and with an Introduction by Peter Biskind. *My Lunches with Orson*. New York: Metropolitan Books, Henry Holt, 2013.

Laurents, Arthur. *Original Story By : A Memoir of Broadway and Hollywood*. New York: Alfred A. Knopf, 2000.

"Lena Horne: In Her Own Voice," *American Masters*, Thirteen WNET, 1996.

Louis, Joe, with Edna and Art Rust. *Joe Louis: My Life*. New York: Harcourt Brace Jovanovich, 1978.

Minnelli, Vincente, with Hector Arce. *I Remember It Well*. Garden City, N.Y.: Doubleday, 1974.

Moore, Phil. *Things I Forgot to Tell You*, unpublished autobiography, 1986.

Tormé, Mel. *The Other Side of the Rainbow: With Judy Garland on the Dawn Patrol*. New York: Bantam Books, 1970.

Washington Powell, Isabel, with Joyce Burnett. *Adam's Belle: A Memoir of Love without Bounds*. Springfield, Va.: DBM Press, 2008.

Waters, Ethel, with Charles Samuels. *His Eye Is on the Sparrow*. New York: Da Capo, 1992.

Woll, Allen. *Black Musical Theatre: From Coontown to Dreamgirls*. Baton Rouge: Louisiana State University Press, 1989.

Notes

CHAPTER 1: BROOKLYN

page 7 *Most of my successes*: Horne and Schickel, pp. 1–2.

page 8 *Mostly, however, she was*: Buckley, *The Black Calhouns*, p. 94.

page 10 *It was not that*: Horne and Schickel, p. 41.

page 11 *I didn't know that*: Horne and Schickel, p. 42.

CHAPTER 2: COTTON CLUB

page 16 *The bandstand was a*: Calloway and Rollins, p. 88.

page 16 *The Cotton Club and*: Washington Powell with Burnett, p. 45.

page 18 *I was tall and*: Horne and Schickel, p. 47.

page 18 *I cried when my*: "Lena Horne: In Her Own Voice."

page 18 *Working conditions were terrible*: Horne and Schickel, p. 51.

page 20 *Before she became of*: Ellington, p. 167.

CHAPTER 3: GIRL-SINGER

page 24 *Remember, you are a*: Lena Horne with Louis Lomax, "I Just Want to Be Myself," *Show*, September 1963.

page 24 *We represented quality*: Horne and Schickel, p. 65.

page 29 *There were all sorts*: Bobby Short in conversation with Donald Bogle.

page 29 *I had known Lena*: Cooper with Dougherty, p. 129.

page 30 *Helena Horne*: Moore, p. 3.

page 32 *one of my dear*: Horne and Schickel, p. 157.

page 33 *I'd become intrigued by*: Minnelli with Arce, p. 103.

page 35 *If you go, you*: Buckley, *The Hornes*, p. 137.

page 35 *I married a man*: Lena Horne with Louis Lomax, "I Just Want to Be Myself," *Show*, September 1963.

CHAPTER 4: ON HER OWN

page 37 *to lose myself in*: Horne as told to Arstein and Moss, p. 170.

page 38 *Wow! Who are you*: Horne and Schickel, p. 108.

page 39 *I knew enough about*: Horne as told to Arstein and Moss, p. 178.

page 39 *Lena never kissed and*: Buckley, *The Black Calhouns*, p. 172.

page 40 *There's a girl singing*: Helen Lawrenson, "Black and White and Red All Over," *New York*, August 21, 1978.

page 40 *I wanted a club*: John S. Wilson, "Barney Josephson, Owner of Café Society Jazz Club, Is Dead at 86," *New York Times*, September 30, 1988.

page 41 *was printed on our*: Helen Lawrenson, "Black and White and Red All Over," *New York*, August 21, 1978.

page 42 *She was not, even*: Horne and Schickel, p. 116.

page 43 *Duke saw me*: Hajdu, p. 94.

page 43 *the racism she faced*: John Meroney, "The Red-Baiting of Lena Horne," *Atlantic*, August 27, 2015.

page 43 *own people because*: "Meet the Real Lena Horne," *Ebony*, November 1947.

page 43 *Finally, he exhorted her*: John Meroney, "The Red-Baiting of Lena Horne," *Atlantic*, August 27, 2015.

page 44 *It would never have*: Duberman, p. 675, n31.

page 47 *One night I was*: Moore, p. 5.

CHAPTER 5: NEW SINGER IN TOWN

page 51 *Once there was a*: Moore, p. 2.

page 52 *Los Angeles was a*: Branton in conversation with Donald Bogle.

page 52 *There had been a*: Phil Moore in conversation with Donald Bogle.

page 53 *attempt to correct the*: Ellington, p. 175.

page 54 *Billy Strayhorn was my*: Ellington, p. 156.

page 55 *Miss Horne, I've been*: Hajdu, p. 94.

page 55 *When I introduced Strayhorn*: Ellington, p. 167.

page 55 *We talked about everything*: Hajdu, p. 95.

page 56 *When I first went*: Moore, p. 6.

page 56 *Felix said Lena had*: Moore, p. 7.

page 56 *I told Lena and*: Moore, p. 8.

page 58 *At first the audience*: Moore, p. 10.

CHAPTER 6: MGM CALLING

page 62 *Here we go again*: Fordin, p. 53.

page 62 *So instead of hiring*: Fordin, p. 54.

page 63 *I finally got home*: Lena Horne interviewed on *The Dick Cavett Show*, November 1981.

page 64 *You're our test case*: Buckley, *The Black Calhouns*, p. 154.

page 64 *I was just a*: Horne on *The Dick Cavett Show*.

page 65 *It was almost feudal*: Eyman, pp. 3–4.

page 66 *Herb devised a make up*: Branton in conversation with Bogle.

page 66 *No one wanted to*: Sydney Guilaroff in conversation with Donald Bogle.

page 70 *a cross between a*: Heimann, p. 196.

page 71 *The crowning point of*: Heimann, pp. 197–199.

page 71 *Every evening was star*: Heimann, p. 199.

page 71 *She did fabulous business*: Moore, p. 12.

page 72 *Often when I start*: Moore, pp. 8–9.

page 72 *I was going to*: Horne on *The Dick Cavett Show*.

page 72 *Lena Horne and*: Minnelli, p. 121.

page 72 *He was a decent*: Hans Massaquoi, "Lena Horne on Her Loveless Childhood, Her Durable Beauty, Sex and the Older Woman, Her Life's Triple Tragedy," *Ebony*, May 1980.

page 74 *They had protest meetings*: Horne on *The Dick Cavett Show*.

page 74 *It seems significant to*: Horne and Schickel, p. 138.

page 74 *You've got to stay*: Horne on *The Dick Cavett Show*.

CHAPTER 7: POSSIBILITIES

page 77 *During my first months*: Minnelli with Arce, pp. 115–116.

page 78 *I was orchestrating more*: Moore, p. 8.

page 83 *If I was going*: Minnelli, p. 121.

page 84 *We started shooting the*: Minnelli with Arce, p. 126.

page 86 *All through that picture*: Waters with Samuels, p. 258.

page 86 *If I had imitated*: Horne and Schickel, p. 152.

page 86 *Rochester made a joke*: Horne and Schickel, p. 153.

page 86 *Ethel couldn't have liked*: Lennie Bluett in conversation with Donald Bogle.

page 86 *Miss Waters started to*: Horne and Schickel, p. 154.

page 88 *I won all my*: Waters with Samuels, p. 258.

page 91 *I understand that you're*: Buckley, *The Hornes*, p. 169.

page 92 *Two weeks ago she*: Mike Levin, "Lena Horne Now Hears Society's Coveted 'Ah's,'" *Down Beat*, reprinted in the *Pittsburgh Courier*, December 19, 1942.

page 95 *once or twice, the*: PM (New York), December 15, 1942.

page 96 *She went home unmolested*: Buckley, *The Hornes*, p. 174.

page 96 *I spoke to her*: Frank Nugent, "She's Nobody's Mammy," *Liberty*, April 7, 1945.

page 97 *Cab's idea of a*: Buckley, *The Hornes*, p. 173.

page 97 *Could be, of course*: Frank Nugent, "She's Nobody's Mammy," *Liberty*, April 7, 1945.

CHAPTER 8: A NEW LIFE

page 107 *She always lived in*: Branton in conversation with Bogle.

page 107 *was totally for Black*: Bogle, *Dorothy Dandridge*, p. 115.

page 108 *All the Negro entertainers*: Bogle, *Dorothy Dandridge*, p. 116.

page 108 *Oh, it was wonderful*: Branton in conversation with Bogle.

page 108 *They'd be friendly*: Bogle, *Dorothy Dandridge*, p. 116.

page 108 *She was all bubbles*: Bogle, *Bright Boulevards, Bold Dreams*, p. 242.

page 109 *framed pictures on her*: Bogle, *Bright Boulevards, Bold Dreams*, p. 242.

page 109 *The town was very*: Branton in conversation with Bogle.

page 110 *Hedda had always been*: Jaglom, p. 254.

page 111 *Gene and Betsy held*: Laurents, p. 92.

page 112 *It would be more*: Laurents, p. 290.

page 112 *It wasn't a love*: Laurents, p. 291.

page 112 *mah new filthy rich*: Blair, p. 150.

page 114 *Ava and I became*: Hans Massaquoi, "Lena Horne on Her Loveless Childhood, Her Durable Beauty, Sex and the Older Woman, Her Life's Triple Tragedy," *Ebony*, May 1980.

page 115 *I like him as*: R. Couri Hay, "Lena!," *Interview*, January 1973.

page 115	*A big movie star*: Joe Louis with Edna and Art Rust, *Joe Louis*, p. 132.
page 115	*The picture took six*: Louis with Edna and Art Rust, p. 182.
page 116	*Lena Horne was in*: Louis with Edna and Art Rust, p. 154.
page 116	*I was so carried*: Louis with Edna and Art Rust, p. 182.
page 116	*Everybody knew about it*: Fayard Nicholas in conversation with Donald Bogle.
page 116	*I have a hot*: Hans Massaquoi, "Lena Horne on Her Loveless Childhood, Her Durable Beauty, Sex and the Older Woman, Her Life's Triple Tragedy," *Ebony*, May 1980.
page 117	*Fate decided everything*: Louis with Edna and Art Rust, p. 182.
page 118	*I've never allowed anybody*: Hans Massaquoi, "Lena Horne on Her Loveless Childhood, Her Durable Beauty, Sex and the Older Woman, Her Life's Triple Tragedy," *Ebony*, May 1980.
page 118	*He was just everything*: Hajdu, p. 95.
page 118	*I callously realized that*: Hans Massaquoi, "Lena Horne on Her Loveless Childhood, Her Durable Beauty, Sex and the Older Woman, Her Life's Triple Tragedy," *Ebony*, May 1980.
page 121	*Russian, Jewish, intellectual*: Blair, p. 152.

CHAPTER 9: FINDING HER WAY

No notes.

CHAPTER 10: THE NEGRO TROOPS

page 131	*Are you sure the*: Frank Nugent, "She's Nobody's Mammy," *Liberty*, April 7, 1945.
page 132	*Now we have someone*: Buckley, *The Hornes*, p. 178.
page 132	*Requests for her pinups*: Frank Nugent, "She's Nobody's Mammy," *Liberty*, April 7, 1945.
page 133	*many numbers were never integrated into the script*: Minnelli with Arce, p. 116.
page 134	*Racially I have never*: Hans Massaquoi, "Lena Horne on Her Loveless Childhood, Her Durable Beauty, Sex and the Older Woman, Her Life's Triple Tragedy," *Ebony*, May 1980.

CHAPTER 11: INDUSTRY RECOGNITION, INDUSTRY POLITICS

page 138	*Lena was the first*: Phil Moore interviewed by Donald Bogle.
page 138	*I wouldn't do that*: Guilaroff, p. 242.
page 141	*Today Lena's Metro-Goldwyn*: Frank Nugent, "She's Nobody's Mammy," *Liberty*, April 7, 1945.

page 141 *Lena disliked the number*: Fordin, p. 134.

page 147 *They forbade me to*: Horne and Schickel, p. 189.

page 147 *It was Joan Crawford*: Horne and Schickel, p. 190.

page 148 *to forbid Horne*: Eyman, p. 320.

page 148 *We joined forces*: Horne and Schickel, p. 168.

page 149 *What's a nigger, mommy*: "Meet the Real Lena Horne," *Ebony*, November 1947.

page 150 *I loved Mrs. Roosevelt*: Hans Massaquoi, "Lena Horne on Her Loveless Childhood, Her Durable Beauty, Sex and the Older Woman, Her Life's Triple Tragedy," *Ebony*, May 1980.

page 150 *the Screen Actors Guild*: Blair, p. 150.

page 151 *to raise as much*: Blair, p. 154.

page 152 *The hotel management responded*: Bogle, *Dorothy Dandridge: A Biography*, p. 239.

page 152 *Where I got racism*: David Richards, "Lena Horne, Sophisticated Lady," *Washington Post*, April 29, 1982.

CHAPTER 12: TRAVELS ABROAD, MARRIAGE ABROAD

page 155 *She liked glamour*: Buckley, *The Black Calhouns*, p. 313.

page 156 *In the beginning I*: Hans Massaquoi, "Lena Horne on Her Loveless Childhood, Her Durable Beauty, Sex and the Older Woman, Her Life's Triple Tragedy," *Ebony*, May 1980.

page 157 *I married Lennie*: "Lena Horne: In Her Own Voice."

page 158 *walked straight by me*: Holiday and Dufty, p. 144.

page 158 *made me feel like*: Holiday and Dufty, p. 145.

page 159 *Lena Horne, who for*: *New Yorker*, October 30, 1948.

page 159 *I developed an isolation*: Lena Horne with Louis Lomax, "I Just Want to Be Myself," *Show*, September 1963.

page 159 *"we were receiving threats"*: Ibid.

page 162 *Originally, Freed wanted Judy*: Fordin, p. 133.

CHAPTER 13: RED-BAITING, RED CHANNELS, THE BLACKLIST

page 168 *My mother was furious*: John Meroney, "The Red-Baiting of Lena Horne," *Atlantic*, August 27, 2015.

page 169 *the greatest acclaim of*: "Comeback for Lena Horne," *Ebony*, August 1951.

page 170 *the* Daily Compass *reported*: John Roddy, "Attempt to Bar Lena Horne from TV Show Rebuffed," *Daily Compass* (New York), September 10, 1951.

page 170 *The CBS switchboard had*: John Meroney, "The Red-Baiting of Lena Horne," *Atlantic*, August 27, 2015.

page 171 *Dear Mr. Brewer*: Horne's letter to Brewer appears in the *Atlantic* 2015 article. An edited version also appears in Gail Lumet Buckley's *The Black Calhouns*, pp. 241–242.

CHAPTER 14: NEW ERA, NEW STARS, NEW CHALLENGES

page 179 *She seemed to be*: Nick Perito in conversation with Donald Bogle.

page 180 *She would just build*: "Lena Horne: In Her Own Voice."

page 180 *one of the greatest*: Robert W. Dana, "Lena Horne Packs 'Em in at Waldorf," *New York World-Telegram and Sun*, January 14, 1957.

page 182 *She wasn't Metro's Lena*: Laurents, p. 93.

CHAPTER 15: BROADWAY CALLS

page 185 *soul rewarding. Harold doesn't*: Jablonski, p. 202.

page 189 *That show's problems were*: Steve Cohen, "*Jamaica*'s Troubled Past," *The Cultural Critic*, https://theculturalcritic.com/jamaica-returns-after-a-troubled-past/.

page 189 *Staging was planned so*: Jablonski, p. 205.

page 189 *But Merrick disliked such*: Steve Cohen, "*Jamaica*'s Troubled Past," *The Cultural Critic*, https://theculturalcritic.com/jamaica-returns-after-a-troubled-past/.

page 190 *Lena Horne, making*: Jablonski, p. 207.

page 191 *Because it was obvious*: Jablonski, p. 208.

page 191 *Lehman was an easy*: Steve Cohen, "*Jamaica*'s Troubled Past," *The Cultural Critic*, https://theculturalcritic.com/jamaica-returns-after-a-troubled-past/.

page 191 *In Boston they said*: Buckley, *The Black Calhouns*, p. 247.

page 191 *Although the libretto is*: Jablonski, p. 209.

page 192 *a razzle-dazzle lead*: Jennifer Dunning, "Why Alvin Ailey Wasn't Blinded by Broadway Lights," *New York Times*, October 6, 1996.

page 192 *When you make your*: Buckley, *The Black Calhouns*, p. 247.

page 193 Jamaica *is a beautiful*: Brooks Atkinson, *New York Times*. All excerpts from *Jamaica* reviews, including this one and those that follow, are from "Jamaica: Lena Horne Scores Hit," *Los Angeles Evening Citizen News*, November 7, 1957. Excerpts are also found in Jablonski, pp. 209–210.

page 195 *Needless to say*: Jablonski, p. 209.

page 195 *I fought for a*: Jennifer Dunning, "Why Alvin Ailey Wasn't Blinded by Broadway Lights," *New York Times*, October 6, 1996.

page 195 *Parties meant Broadway friends*: Buckley, *The Black Calhouns*, p. 248.

page 197 *Lena in turn coolly*: Tormé, pp. 61–63.

CHAPTER 16: RESTLESSNESS, DIVISIONS, 1960S

page 199 *He had grown from*: Buckley, *The Black Calhouns*, p. 250.

page 200 *There's Lena Horne*: The incident at the Luau was reported in numerous newspapers, including "Lena Horne Hurls Objects in Offense to Man's Slurs," *Chicago Defender*, February 17, 1960; and "Lena Horne Hurls Lamp at Diner in Racial Slur," *New York Herald Tribune*, February 17, 1960.

page 201 *Here I am, you*: Buckley, *The Hornes*, p. 242.

page 201 *Hell, yes*: Joan Barthel, "Lena Horne: Now I Feel Good About Me," *New York Times*, July 25, 1968.

page 203 *The whole experience was*: Hajdu, p. 227.

page 203 *Medgar Evers's death was*: "Lena Horne: In Her Own Voice."

page 205 *Lena was not thrilled*: Buckley, *The Hornes*, p. 248.

page 206 *with anyone who mattered*: Alan Ebert, "Sometimes Sunshine, Most Times Storms," *Essence*, May 1973.

page 209 *Jeanne Noble's sudden, fiercely*: Laurents, p. 93.

page 210 *too soft in its*: Bryer and Davison, p. 133.

page 210 *I was as unprepared*: Laurents, p. 289.

page 210 *It tore me apart*: Hajdu, p. 254.

page 210 *Lennie had washed me*: Michiko Kakutani, "Lena Horne: Aloofness Hid the Pain, Until Time Cooled Her Anger," *New York Times*, May 3, 1981.

CHAPTER 17: LOSS AND REFLECTION

page 218 *The love-hate thing I*: Marie Brenner, "Lena on Her Own," *New York*, May 4, 1981.

page 222 *"When I came to"*: Hans Massaquoi, "Lena Horne on Her Loveless Childhood, Her Durable Beauty, Sex and the Older Woman, Her Life's Triple Tragedy," *Ebony*, May 1980.

page 222 *This film brings out*: Pauline Kael, "Saint Dorothy," *New Yorker*, October 30, 1978.

CHAPTER 18: COMING TO TERMS, TRIUMPH

page 229 *"I'm still looking for my father"*: Hans Massaquoi, "Lena Horne on Her Loveless Childhood, Her Durable Beauty, Sex and the Older Woman, Her Life's Triple Tragedy," *Ebony*, May 1980.

page 230 *You've got to let*: Chris Chase, "Lena Horne Reveals How T*he Lady and Her Music* Came to Broadway in 1981," *Playbill*, June 30, 2010.

page 232 *Much of the idea*: News of the Theater, *New York Times*, February 2, 1981.

page 232 *Samm got interested in*: John Corry, "An Anatomy of Lena Horne's Triumph," *New York Times*, May 15, 1981.

page 240 *She feels uncomfortable advising*: Fletcher Roberts, "The Voice and the Spirit of Lena Horne," *New York Times*, November 24, 1996.

page 240 *"I'm really not Miss Pretentious"*: Don Heckman, "Lena," *Los Angeles Times*, May 31, 1998.

Index